PIMLICO

58

THE FLORENTINE RENAISSANCE

Vincent Cronin was born in 1924 and educated at Ampleforth, Harvard and Trinity College, Oxford. From 1943 to 1945 he served in the Rifle Brigade. He is the author of a number of distinguished works of history and biography, including *The Golden Honeycomb, The Wise Man from the West, A Pearl to India, Louis XIV, Napoleon, Louis and Antoinette* and *Paris on the Eve. The Flowering of the Renaissance*, also in Pimlico, concludes his two-volume study of the Renaissance.

THE FLORENTINE RENAISSANCE

VINCENT CRONIN

PIMLICO

For Chantal

PIMLICO

20 Vauxhall Bridge Road, London SW1V 2SA

London Melbourne Sydney Auckland Johannesburg
and agencies throughout the world

First published by Collins 1967
Pimlico edition 1992
Reprinted 1993

Printed and bound in Great Britain by
Mackays of Chatham PLC, Chatham, Kent

ISBN 0-7126-9874-4

Contents

Illustrations

Battle of Nude Men, by Pollaiuolo
(*British Museum*)

Drawings of legs, by Leonardo da Vinci (Windsor 12625)
(*Reproduced by gracious permission of H.M. Queen Elizabeth II*)

Roman sarcophagus, Pisa
(*Foto Ente Provinciale Turismo, Pisa*)

Battle Scene, by Bertoldo
(*Mansell-Alinari*)

Sacrifice of Isaac, a mosaic in S. Vitale, Ravenna
(*Mansell-Alinari*)

Sacrifice of Isaac, by Ghiberti
(*Mansell-Alinari*)

Sacrifice of Isaac, by Brunelleschi
(*Mansell-Alinari*)

Creation of Adam and Eve, and the Expulsion, by Ghiberti
(*Mansell-Brogi*)

Creation of Eve, and the Expulsion, on Modena Cathedral
(*Bildarchiv Foto Marburg*)

Diadumenos, a marble copy about 200 B.C., after Polyclitus
(*Mansell Collection*)

David, by Donatello
(*Mansell-Anderson*)

Interior of S. Croce
(*Mansell-Alinari*)

Interior of S. Lorenzo
(*Mansell-Alinari*)

Palazzo Davanzati
(*Mansell-Alinari*)

Palazzo Rucellai
(*Mansell-Anderson*)

Cafaggiolo
(*Mansell-Alinari*)

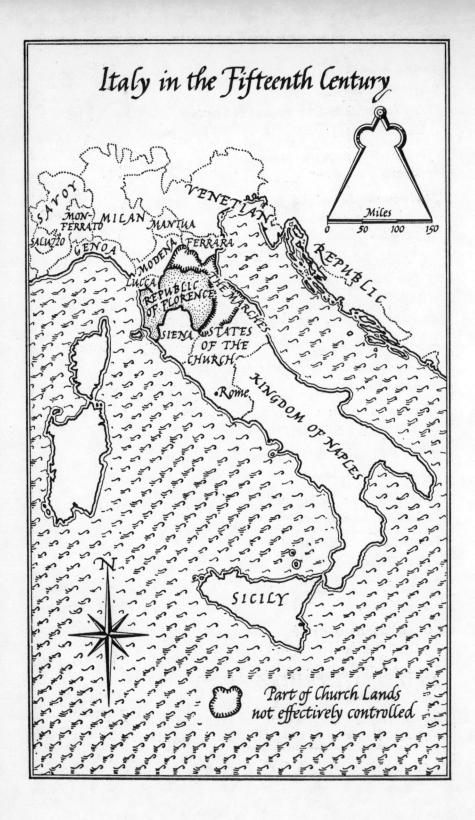

Italy in the Fifteenth Century

Miles
0 50 100 150

SAVOY
MON-FERRATO
SALUZZO
MILAN
GENOA
MANTUA
VENETIAN
REPUBLIC
LUCCA
MODENA
FERRARA
REPUBLIC
OF FLORENCE
THE MARCHES
SIENA
STATES
OF THE
CHURCH
Rome
KINGDOM OF NAPLES
N
SICILY

Part of Church Lands
not effectively controlled

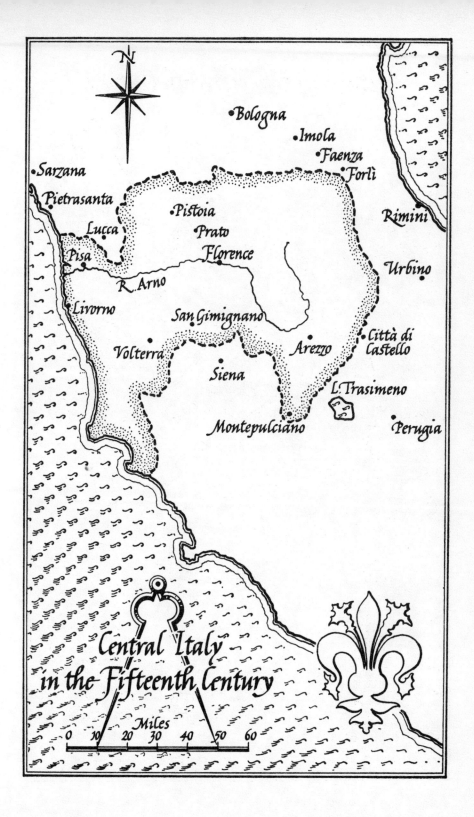

Central Italy
in the Fifteenth Century

Preface

THE FIFTEENTH CENTURY in Florence has long been recognized as one of the brilliant periods not only in European but in world history. Voltaire, writing in 1751, claimed it to be one of four happy and exemplary epochs; the Florentines themselves believed they were living in a golden age. But its interest for us today is more than historical: it is a watershed from which flow many of the beliefs and values we treasure most. A demonstration of the effectiveness of personal liberty, an articulate defence of republican principles, a generous attitude to other religions, art as a form of discovery, patronage of the experimental: these are only a few of the good things we owe in large measure to the Florentines, either directly or as interpreters of the classical past.

The paradox of Renaissance studies is that although in recent years many aspects of the period have been analysed by specialists in meticulous detail, there exists no work on Florentine civilization as a whole during the fifteenth century, for even Burckhardt's *Civilization of the Renaissance in Italy* is only in part concerned with Florence and its author was never to add those sections on the fine arts called for by his original plan. My book is an attempt to meet this need. It is based on primary sources, both the Greek and Roman texts which played so important a part in the period, and Latin and Tuscan works by Florentines, ranging from family letters to diplomatic manifestoes, from anatomical notes to treatises on painting and town-planning. In interpreting such a wide range of material I am indebted to the many specialized books and articles in which the subject abounds and which collectively represent perhaps the most sustained international historical research in this century. Painting as it were a mural, I have had to choose, without discussion in the text, what seems to me

the probable truth on many points still much debated by scholars, and for so doing I must ask their indulgence. The book expresses my own views; for this reason and because it is a general work covering a controversial period, it cannot hope to win assent at every point. I hope all the same that it will succeed in its main task of providing both the general reader no less than students of the period with a fair and balanced picture of the Florentine achievement.

'Florence is the heart of Italy,' said Savonarola, himself Ferrara-born, and indeed during the fifteenth century nearly all Italy's original thinking and techniques took place in the city by the Arno. I centre attention on Florence, though where they throw light on my subject I notice developments elsewhere. The relation between the Florentine Renaissance and the Italian Renaissance as a whole, and my reasons for dating the former to the fifteenth century, involving as they do the discussion of specialized matters, are set out in an appendix.

'Renaissance' of course is a metaphorical term but, as I hope to show, a valid and useful one, for which within the context of Florence my book is an attempt to find a definite meaning. But I refrain from using the word 'Renaissance' in the pages that follow, because, coined in the eighteenth century and first popularized by Michelet in the nineteenth, it would be an anachronism and because the many different interpretations given to the word in recent years might well cloud the text and confuse the reader. I have preferred, wherever possible, to let persons and events speak for themselves, adding my own voice chiefly in order to draw, whenever they seem warranted, certain general conclusions.

I wish to express my warm thanks to Professors Eugenio Garin and Alessandro Perosa for useful advice during the early stages of research, to the Directors of the Archivio di Stato and the Biblioteca Nazionale for their assistance while I was working in Florence, and, for their courteous resourcefulness, to the staff of the London Library.

CHAPTER I

The City and its Citizens

THE FLORENTINES we usually think of first in terms of their own art. We call to mind some well-loved picture or statue and, moved by a beauty so convincing that we forget it is ideal, tend to consider the Florentines as different in kind from ourselves. We easily imagine that most Florentine men possessed the energy of Pollaiuolo's Hercules and most women the perfect proportions of Botticelli's Graces. Sometimes, under the spell of a masterpiece, we even think of the Florentines as timeless beings.

This view is fostered by the unusual character of Florence today. Almost everything of importance is still there, so that to the miracle of achievement is added the miracle of survival. As though under a Victorian cloche, we still see Giotto's rose and white marble bell-tower, Brunelleschi's dome, the bristling Palazzo della Signoria, the shrewd wool-merchants in their scarlet hooded gowns as Ghirlandaio depicted them, and their wives in the Tornabuoni chapel dressed in flowered brocade with laced bodices; we still see the choir boys with pulsing throats on della Robbia's organ-screen, and the swaddled foundlings on the Loggia degli Innocenti. We can even recognize individuals: tousle-haired Masaccio in the Carmine, Bruni the patriot with his long eager nose and eloquent lips, and, in his own house, young Lorenzo de' Medici, astride one of the fast horses he loved.

There is a second reason why the Florentines seem to have a life of their own, outside time. Many of their works draw on Greek and Roman originals. Donatello's *David* has one foot in fifth-century Athens, and Bertoldo's *Battle Scene* derives from a Roman sarcophagus. Botticelli intended his *Calumny* to be a restatement of a lost painting by Apelles described by Lucian: it is Florentine, but it is

17

also partly Greek. In looking at such works we enter not only fifteenth-century Florence but also an earlier classical world. This fosters an impression of timelessness and an ideal life which was already apparent in Michelangelo's day, when he called Ghiberti's second bronze doors 'the gates of Paradise'.

It is a measure of the Florentines' power over our sensibilities that we should thus accord them the admiration they themselves reserved for the Athenians and the Romans of the Republic. The people who gave unrivalled visible shape to so many myths have themselves become almost a myth. Yet when we come to lay reverence aside and examine the Florentine achievement as an historical phenomenon which had a beginning, a rise and a fall, we find the truth to be no less extraordinary than the myth. Here was a people living in an inland town among the Tuscan hills, no bigger than one of our provincial towns today, surrounded by enemies and hostile ideologies, dependent upon imported food and imported raw materials, battling to survive in a world where economic forces were against it, struggling with problems of conscience and day-to-day life that we can understand and sometimes have to face ourselves, yet producing within three generations, a greater number of original thinkers and artists than any place of its size has ever done in a comparable period, enriching the world with objects that, seen once, count always among our most prized memories, and, in the last resort, forging a new way of life for man. When we add that bubonic plague was frequent and life-expectancy much shorter than it is today, that Masaccio died at twenty-seven, Desiderio da Settignano at thirty-six, and Lorenzo de' Medici at forty-three, the achievement appears still more astonishing.

How did it happen? And what, in fact, did happen? What did the Florentines really do that has influenced living men and women ever since? What forces brought them to undertake their experiment and what virtues enabled them to bring it to a triumphant conclusion? What sort of people really were the Florentines? What were their hopes and ambitions, and their hidden fears? What were the material conditions of their life? These are some of the questions that have to be answered if the Florentines are to emerge from the myth of their own creations.

The Florentines, in common with other peoples, were marked by the character of their land. Tuscany is a country of hills and valleys contained between the diagonal range of the Apennines, lesser hills to the south, and the sea. It thus forms a natural unit. It is fortunate in occupying a doubly central position, east–west within the Mediterranean, Cadiz and Constantinople being about equidistant, and north–south within populous Europe, traffic between transalpine countries and southern Italy finding its speediest route through Tuscany. But the Apennines, though they form a distinct northern and eastern frontier, are not an effective barrier against invasion. Tuscany can be entered up any one of several river valleys, as well as along the coast, while the southern frontier is even more vulnerable.

Tuscany is a hard, impoverished land. In the valley of the Arno wheat and maize will grow, while some of the hill-slopes will support vines and olives, but most of the region is stony or sandy, patched with scrub and occasional cypresses or clumps of pine. The mountains offer greater abundance: excellent building stone, white marble at Carrara and in the south deposits of iron and copper.

The very features which make Tuscany a hard land also make it beautiful. The valleys set off the hills, which in turn divide the low ground into distinct units satisfying to the eye. To this fundamental contrast of planes is added the contrast of vineyard and rock, of squat silvery olives and slender dark cypresses. There is no drama of giant peaks and sheer gorges, no soft lushness of pasture, but instead the harmony of moderate shapes and limited vegetation. Further beauty is added by the Tuscan light. Here there is rarely mist as in the north, and none of the bluish haze of Umbria. The Tuscan light is clear and sharp, revealing objects uncompromisingly. As for the climate, it too is moderate. In spring plentiful rain colours the slopes with wild flowers; in summer skies are blue and the sun shines for weeks at a stretch, while winter adds a tang and stimulus: it is then sometimes so cold that snow drives off the Apennines and the Arno freezes.

Such a land produces a distinctive breed of men. To drive a straight furrow on steeply terraced hills, to cut stone from the mountainside, to heave loads along these rocky tracks, strong muscles are needed. Every jar of oil, every cask of red *trebbiano* has to

be won by hard work from a grudging soil. Against the cold winter nights solid houses have to be built, and firewood found for heating. Hail may destroy a whole year's vintage overnight, rivers in sudden flood can sweep away ill-made terraces. To flourish in such a land men have to be sturdy, prudent and thorough.

The first inhabitants of Tuscany about whom anything is known are the Etruscans. They probably came by sea from Lydia, in Asia Minor, around 1,000 B.C. They built towns on several of the Tuscan hills, including Fiesole near the Arno, and protected them with walls of unusually large right-angled stones. They mined copper, mixing it with tin and zinc to produce bronze, from which they cast fine small statuary, much of it for export. They traded as far afield as Egypt and Spain. Though their language has not been deciphered, they seem to have given much thought to the underworld and, if their smiling tombstone figures are any indication, were a gay people. But their religious federation of twelve cities proved incapable of concerted military action and in the third century B.C. was easily subdued by the Romans.

The Etruscans, though no longer powerful, continued to inhabit Tuscany and to intermarry with Italians. Some of their customs, including divination from livers of sheep and from the flight of birds, passed to the Romans, and other gifts, such as skill in bronze statuary, were to reappear in the Tuscans. Perhaps it is no mere fancy to see in Dante's preoccupation with the underworld a trace of Etruscan ancestors.

In or shortly after 59 B.C. in accordance with a law proposed by Julius Caesar, the Romans founded a colony where the Arno winds out of the Apennines into a wide plain. This is the best crossing of the river and lies close to the destroyed Etruscan town of Fiesole, about 165 feet above sea-level, backed by the Apennines and looking down the Arno, which reaches the sea some fifty miles west. The colony was called Julia Augusta Florentia, the last name being simply a word of good omen. It was square-shaped, like an army camp, with an aqueduct, baths, theatre and temples. It enjoyed self-government but in foreign policy had to follow Rome. Rome being the *communis patria* of all Italy, the people of the town were Florentines but they were also citizens of Rome.

Christianity came to Florence in the fourth century. In the fifth the Roman Empire crumbled; in the sixth Florence was devastated by the Goths and all her Roman buildings razed. After a long period of darkness Florence emerges as part of the Holy Roman Empire, the *imperium* having been transferred to the Germans. But by the twelfth century she had begun to assert her right to self-government. The next 250 years were a period of intense struggle. Florence had to fight for her independence from the German Emperor and also from increasingly powerful Popes. War followed war. Her vines and olives were cut down, her houses burned, her walls shattered. Throats were slit, heads stuck on pikes; prisoners had all their teeth ripped out, toads were laid in their mouths, the soles of their feet burned over a slow fire—and these were the milder forms of reprisal. It became easy for a Florentine to imagine Hell.

But the city retained its independence and in course of time expanded. When the Dominican John of Vicenza proposed a visit, the Florentines cried in mock alarm: 'For Heaven's sake let him stay away! We have heard that he raises the dead, and we are already so many that our city will scarcely hold us!' To feed her growing population, the Florentines turned increasingly to trade. At first they dealt in unfinished cloth from France and the Low Countries, which they dyed and finished in various styles, exporting it to the East in exchange for spices, incense, pearls and gems. Then about 1200 Florence began to manufacture her own cloth, and for the next three centuries this was to remain her chief industry. It was a bold move because she possessed none of the necessary raw materials. The wool had to be bought in England—heavy fleeces from the green, rain-swept Cotswold hills. In 1273 an eighth of English wool exports came to Florence, some 4,000 sacks. On arrival it was washed in lye to remove grease, dried in the sun, and spread on boards where soil and other particles were removed with forceps and small shears. Then the wool was carded into thread, ready for dyeing.

The materials for dyeing also came from afar. The main material was alum, a colourless crystalline substance which makes dyes fast and vivid. There was only one large source of supply, Phocoea in Asia Minor. The mineral-bearing stone was cooked for eighteen

hours in a furnace, stacked in heaps and watered daily for four months. It was then boiled in a cauldron, impurities being skimmed off, and emptied into an oak tank lined with plates of lead, where after a fortnight it became solidified into alum. Every year Florence imported some 200,000 pounds; to dye one piece of scarlet cloth alone, fifty pounds of alum were required. As for the dyes themselves, the scarlet in which Florence excelled was produced from madder or from kermes—dried bodies of the female coccus insect. Bright yellow came from fields of crocuses at San Gimignano, purplish red from a lichen called *oricello* which grew in Majorca, vermilion from the Red Sea, carmine, crimson, henna, lake and saffron all from the East. The formulas were treasured secrets, and many dyes have come down to us simply as names: *rosa secca di turchino*, and the pale blue with metallic lights called *alessandrino*, both also of Eastern origin.

Expertise in dyeing was matched by expertise in working the dyed thread. Florentines early adopted the treadle loom, which saved time and manpower. A single worker could make intricate figured fabrics on a treadle loom surmounted by a frame containing several hundred pulleys. Later the Florentines pioneered silk-twisting mills with a total of 480 spindles, allowing two or three operators to do the work previously done by several hundred hand throwsters. The finished textiles, which made even a poor man feel rich and a sad one gay, were prized everywhere. Florence could be said to live by colour and pattern, for a third of her population worked in the cloth industry, mostly for firms with fewer than ten employees. They manufactured 70,000 pieces a year, 16,000 of these for export to Africa and the East.

Foreign trade led to an important discovery. While working in the Asia Minor town of Bugia a Tuscan named Leonardo Bonacci heard about 'Arabic numerals', really Indian in origin. At that time only the Roman system of numbering was used in Europe, and all calculation was with the abacus. The Arabic system not only possessed the zero, unknown to the Romans, but decimally related the value of the digit to its position. In 1202 Bonacci wrote a book advocating the system, giving, among his examples, a method for calculating the capacity-value of alum in a cargo. The Florentines

lost no time in adopting Arabic numerals, and became experts at quick and exact calculation.

The Popes needed agents to collect their increasingly rich tithes and forward them in manageable form to Rome, and since clerics might not engage in business, the Florentines, with their long trading experience and new skill at accounting, undertook this job. They sold at a profit tithes in the shape of furs, skins, wool, even of whalebone from Iceland and Greenland, and the proceeds they changed, again at a profit, into an Italian currency for the account of the Apostolic Chamber.

The Florentines next took a bold and imaginative step. All European currencies at this time were silver. The Tuscan hills held no gold but through exports of cloth Florence had amassed enough of the precious metal, mainly from Africa and the East, to begin, in 1252, to mint a small gold coin, the size of a finger-nail, of seventy-two grains weight, twenty-four carats fine, stamped with the city's patron, John the Baptist, and her emblem, the lily. This was the famous florin. It quickly replaced the English silver mark sterling as Europe's preferred currency and, though imitated even to its name, gave Florence a lead over all commercial rivals.

When first coined, the florin had the same value as the *lira*, and was therefore worth 20 silver *soldi*, but a century later the value of gold had increased to the point where it was worth roughly 4 *lire*. During the fifteenth century a steel cuirass weighing thirty pounds sold for 20 florins, a damask gown lined with green velvet for 23 florins, a war-horse for 42 florins, a fair-sized house for 870 florins. Conditions have changed so much that exact comparisons are impossible, but it would be fair to take the purchasing power of the florin during the fifteenth century as roughly equivalent to that of £3 sterling today.

It was the gold florin and the bill of exchange—an early form of traveller's cheque which could be cashed in any city from London to Constantinople—which enabled Florence to extend her money-changing and banking services from the Popes to most of the princes and merchants of Europe. She did so in the face of intense opposition from the Church. Canon lawyers classified the banker with the despised usurer who sat in the market-place with money-bag and

ledger, demanding interest of up to 40 per cent and, as a pledge, a poor man's last patched tunic, or a widow's only bed. They argued that it was wrong to make money speculatively, that is from the future, since the future belonged to God. Dante wrote of the 'accursed flower', symbol of greed, and consigned money-lenders to the seventh circle of Hell, where they would stare for ever amid murky vapours on the money-bags hanging round their necks. No sermon excited more shivers than the usurer's death—a man so obsessed with his ill-gotten gains that 'he made his servants rattle upon the tables purses containing 14,000 gold florins; and he would say that one of these was Jesus Christ and the Virgin Mary, and the others the twelve Apostles'. The preacher would then whip out a skull, while assistants below groaned and clanked chains to simulate Hell.

The bankers, however, were not dissuaded. Reasonable interest, they claimed—up to 20 per cent—was justified by the risks involved. One such risk occurred in 1340, when Edward III of England assumed the title of King of France, quartered the lilies with the leopards on his arms, and turned to Florence in order to pay his longbowmen in the first stages of what was to become the Hundred Years' War. In 1343 Edward defaulted. As a result, the greatest Florentine banking houses, the Peruzzi, Acciaiuoli and Bardi, went bankrupt, entailing the collapse, over a generation, of almost every smaller trading company in Florence. By 1346 losses totalled 1,700,000 florins. Then followed the Black Death, killing five Florentines in eight. It is a remarkable sign of the city's resilience that by 1370 Florence had again become a flourishing centre. Looms were busy, foreigners borrowing. In 1373 Geoffrey Chaucer, Collector of the Customs of London, rode in to Florence 'on the King's business', and kept his head about Dante, now the subject of public lectures:'. . . there nis noon that dwelleth in this countree That either hath in Hell or Heven be.'

The textile trade and, despite Church opposition, international banking were now the assured bases of Florentine prosperity, and were to remain so throughout the fifteenth century, with silk, particularly brocades, joining scarlet cloth as a principal export. These activities demanded, and fostered, distinctive qualities in the men of Florence. First comes boldness, which Leonardo Bruni in 1400

described as the chief Florentine trait: the boldness of the merchant adventurer prepared to take risks. This boldness was controlled by prudence. A bold action had to pay, and therefore had to be based on prudent planning. The Florentine's prudence was proverbial, and one of the forms it took was a dislike of pomp or ostentation.

The next quality is exactness. The distinctive Tuscan light makes for clear-sightedness and clear-thinking and these were sharpened by trading requirements. The handbook of a merchant named Pegolotti is filled with exact advice on how to judge merchandise: pepper should be dry and without trace of powder; if it should get damp in transit exact instructions are given for salvaging it; cinnamon should have a thin bark and be of a colour between red and grey; fresh dates should be large and reddish; and a drawing of how all this should look accompanies the description. Every piece of imported cloth sold in Florence was by law ordered to have attached to it a label containing every item of its cost from the first purchase in England, France or the Low Countries until re-sale beyond the Alps, including all the duties, tolls, taxes, package, cartage, and even the wine and expenses at taverns in transit. It is no accident that a Florentine banker, Giovanni Villani, first introduced accurate statistics into the writing of history. He gives hundreds of exact figures, from the number of churches in Florence to the quantity of musk melons sold in the month of July. How rare such exactitude then was can be gauged from a discussion held in 1415, when England was pressing her claim to be counted a separate 'nation' at the Council of Constance. Her delegates argued that Britain was 800 miles long, or ten days' journey, while France 'was not generally supposed to have such a great extent', and that Britain possessed more than eight times as many parish churches as France: 52,000 in all. The correct figure is now known to have been 9,000.

Closely linked with exactness went the virtue of honesty. The Florentine had to be honest beyond reproach. He must pay when payment was due, and claim no more than he was entitled to. Only so would his bond be honoured in all places and at all times. Honesty was particularly important when he found himself, as so often happened, a stranger subject to alien laws, purchasing wool in Southampton or the Algarve, or selling Milanese armour to lords of the

Morea. These travels, in turn, served to wrest him from the petty provincial round and to give him broad interests.

If the nature of his business widened the Florentine's intellectual horizons, it also served to point the uniqueness of his birth-place. The Florentine constitution will be considered later; for the moment it is enough to glance at a few distinctive features. First of all, Florence possessed no class privileged by birth. Noblemen with titles granted by the Emperor had formerly been powerful in and around the city, but in 1293, at a time when the rest of Europe clung to a feudal structure and a chivalrous contempt of commerce, the Florentines quietly passed a truly remarkable series of laws. The 'Ordinances of Justice' forbade any feudal lord to exercise a magistracy; as a nobleman he was proclaimed a nobody, so that if he wished to hold office he must enter the ranks of the citizens by matriculating into one of the *arti*, or guilds: that is, by turning his hand to any one of seventeen (later twenty-one) useful professions or trades, from selling cloth to keeping an inn.

All citizens enjoyed political rights. Any citizen might hold the highest offices, and stood a fair chance of doing so, since the Florentines changed their chief magistrates every two months. The citizens, sitting in council, themselves passed their own laws. Yet until the fifteenth century this system worked very imperfectly. Family was pitted against family, faction against faction in bloody rivalry, and the city lost many of its best citizens through execution or exile, the most notable being Dante, who shared his banishment with 600 other 'Whites'. Yet it is no accident that the greatest Florentine poem is an epic about justice, the apportionment of due rewards and punishment, for Dante had been educated in a society which believed in the ideal of justice between equals, though he saw no promise of its fulfilment in Florence, and had to call in the next world to redress the balance of this.

Despite its failure in practice, the system had many good points. Men mixed freely as equals, subject to each other's scrutiny and criticism. One man called another plainly by his name or surname and spoke to him in the second person singular. He tipped his hood to the Gonfalonier, to a bishop or to a cardinal—but to no one else. As an active participant in government, he had an unusual insight into

political problems and was able to cast his votes responsibly. Since he might have to serve one year as tax assessor, the next on a war committee, the system demanded, and created, considerable versatility.

His political role also made the Florentine a good speaker. If he wished to carry weight in the various councils, he had to express his views clearly and forcefully. The skill in speaking acquired at home made him an effective diplomat abroad at a time when the word for ambassador was *oratore*. In 1300 Pope Boniface VIII remarked that among the ambassadors paying their respects to him no less than twelve, including those of the Kings of England and of France, were Florentines. 'You are the fifth element,' he told them, meaning that Florentines had a hand in everything.

The language used in the home and in councils was Tuscan. It was only one of many Italian dialects, but it had distinct advantages over its rivals. North Italians spoke a harsh, jagged dialect, with many German accretions, while the Neapolitans' speech, though mellifluous, had a soft, melting quality unsuitable to clear statement. As in landscape and climate, Tuscany offered a moderate balance. The Tuscan tongue is so musical that it constantly tends to poetry, but it possesses a natural strength and firmness. In the mouths of Florentines it gained a distinctive touch, for they used the palatal fricative instead of the letter *c* or *q*, as *sehonda* for *seconda*, *huesta* for *questa*.

The second commonest word in Dante's *Comedy* is, surprisingly, *terra*, and long after Dante had shown its capabilities Tuscan remained close to the soil, the home and market-place, a spoken rather than a written language. All serious thinking, writing and often even speaking were conducted in Church Latin, a static language deemed suitable to those unchanging truths which formed the preserve of man's 'higher reason'. If this facilitated a free exchange of ideas throughout Europe, in Florence it erected two regrettable barriers: between man's thinking self and his day-to-day sense experience; secondly, between clerics and all but a very few laymen. The use of two languages was ultimately to have a very important result. The grace and aptness of Tuscan showed up the cumbersome ugliness and excess of abstractions in Church Latin and created a need for a third language with some of the virtues of both.

Towards the end of the fourteenth century Florence had a population of some 50,000, which would rise to about 60,000 in the next two generations. The city covered an area fifteen times as large as the original Roman settlement. Partly through conquest during the long struggle between Popes and Emperors, partly by purchase, she had gained all north Tuscany save Lucca. The towns in her rule included Prato, Volterra and Arezzo. They were allowed to govern themselves, but in foreign affairs were bound to Florence. The whole territory of Florence contained some 630,000 inhabitants.

In appearance, the most striking feature of Florence was the crenellated brick and stone wall, five miles long, which ringed the city. Six feet thick and forty feet high, it was protected by a deep moat and seventy-three machicolated towers. East and west it was interrupted by the passage of the Arno, whose waters were essential in the process of dyeing, but even so the wall presented a formidable obstacle to any invader.

In the Middle Ages Florence had bristled with the tall towers of family fortresses. Such towers still remained in some Tuscan towns, such as San Gimignano, but in Florence they had been swept away with feudalism. Now there were only two dominant towers, that of the Palazzo della Signoria, whose bell, named from its mooing tone Vacca, summoned the citizens to assemble in times of crisis, and Giotto's marble campanile, whose bell called the people to prayer.

Four stone bridges linked the main part of the city to the Oltrarno. The whole was divided into four quarters, each named after a prominent church: S. Giovanni in the centre, S. Croce upstream, S. Maria Novella downstream and, across the river, S. Spirito. Each quarter was again divided into four wards, named after heraldic signs such as Dragon, Unicorn, Keys. The heraldic sign of the city's liberty was the lion. One or more pairs of lions was kept in a public enclosure near the Signoria, and in winter when snow fell children would build snow-lions.

Whereas the original Roman town had possessed straight streets crossing at right angles, the city plan was now disorderly. Narrow alleys, darkened by overhanging balconies, twisted and turned helter-skelter before finding an outlet in one of fifty piazzas. At

night they were unlit, save by a chance votive candle burning beneath a corner shrine. Many, however, were paved and possessed sewers, for the Florentines by the standards of the day were a clean people, and it was a cause of pride to them that their butchers' shops were sited away from houses, on the Ponte Vecchio.

The city and immediate surroundings were divided in fifty-seven parishes, containing one hundred and ten churches, twenty-four nunneries, five abbeys, and two priories, not to mention various houses belonging to ten different orders of friars. The most striking feature of the oldest churches was the boldness with which the Florentines had decorated the outside walls. This boldness took the form of geometrical patterns of dark-green or rose marble inlaid on white. The more recent churches, such as the cathedral—still, after almost a hundred years, unfinished—had been built in the Gothic style, and here the bold design merged uneasily with statuettes, tracery and floral motifs. Attached to the churches and convents were welfare institutions. These included two orphanages and a 200-room home for aged women. A Russian delegate to the Council of Florence was to note 'a hostel for pilgrims with 1,000 beds where even the poorest has a feather mattress and expensive trappings'. The sick were cared for in twenty-eight small hospitals by sixty physicians and surgeons.

Business was conducted in the neighbourhood of the communal granary and oratory called Orsanmichele, near the Signoria. Here the bankers had their offices—there were seventy-two of them in 1421—and in fine weather would sit at tables set up in the street, changing money or arranging loans. Here too were the offices of the cloth and silk merchants. Round the corner lay the market, to which vegetables, fruit and bread from 146 ovens were brought fresh daily. In the surrounding streets were the shops of goldsmiths, furniture-makers, mercers, feather merchants and many others. In the candle-makers' shops lived the better class prostitutes, hence their name of *cortegiane di candela*.

Even the poorest houses were stone-built, giving the city an air of great solidity. The richest houses had as many as twenty rooms arranged in three storeys. Their façades were as sober as those of the churches were ornate, though on gala days they would be

brightened with tapestries and bedspreads. The main room some-times had murals depicting feats of French chivalry; one, in the house of the Teri, told the love-story of Tristan and Isolde. Similar subjects decorated the big wooden marriage chests in which a bride brought her trousseau to her new home. By far the most important piece of furniture was the master's big double bed, which stood on a raised platform. It might have a canopy with curtains, and candle-sticks attached to the canopy. A cloth of arras generally hung at the head, and an Eastern rug covered the step of the platform. There were few chairs—people sat on benches or chests—and tables were often planks on trestles. However, the bed would have fine sheets decor-ated with drawn thread, and the table embroidered cloths. Baths were taken, usually on Saturday night, in shallow metal basins filled with water heated in the kitchen, or else at one of four public baths kept by the barbers. However, Michelangelo was advised by his father 'never to wash'; 'have yourself rubbed down, but do not wash'.

As soon as a merchant became well-off he invested some of his money in farm-land, often with a small villa, where his family would spend the hotter months of summer. The slopes of the surrounding hills were dotted with such villas. The farm was run according to the *mezzadria* system, whereby proprietor and peasant shared the profits, though in practice the turnips, beans, water-melons, figs and other fruit were often divided when the peasant and his family had already taken all they wanted. The peasant was obliged to manure a third of the farm every year and for this often used the *borracino*, or clippings of wool from the workshops. Pro-prietor and peasant divided incidental expenses, such as the mixture of resin and mistletoe which was smeared on vines after they were grafted.

As for the inhabitants of this rich city, in appearance they were generally of middle height, seldom tall, quite often stocky; for example, Antonino, Florence's saintly Archbishop, who owed his diminutive to his short stature; Marsilio Ficino, who was only five feet tall; and Fra Angelico. Although he no longer farmed, the Florentine usually had a robust physique, equal to the demands of a manual trade or, if he were a merchant, to long journeys on horse-

back over rough tracks, and by ship in pirate-infested seas. Facial structure differed widely. Giovanni de' Medici had a round head, so did Ghiberti. Dante had a long head, as did Cosimo de' Medici, and the self-portraits of Botticelli and Filippino Lippi both show long faces; however, by that time the long face had become a recognized ideal in art. Hair was more often dark than blond, and the rather matt complexion ranged from dark honey to olive. Dark eyes were usual. If the average Florentine man possessed good looks, he was by no means the perfectly proportioned figure of familiar paintings: Ficino had a too-big nose and receding chin, Poliziano's lips were fleshy, and Brunelleschi had a flattened nose. But even the less handsome faces seem to have been redeemed by the eyes: often keenly intelligent, never less than shrewd.

White teeth, white skin and blond hair: such was the criterion of Florentine feminine beauty, and if her hair was not naturally blond, a woman did not hesitate to dye it, sometimes three times a week. At least two prominent (and charming) Florentine women were not beauties: Cosimo's wife Contessina, an expert at making olive oil and very jolly but also very fat, and Piero's wife Lucrezia, whom Ghirlandaio portrays with a long nose and round eyes. But since the Florentine woman in art differs much more from classical proto-types than her male counterpart it is probable that artists evolved their various types from actual women. If so, many Florentine girls must have possessed striking beauty—a fine nose, rising slightly at the bridge, and sensitive lips being particularly noticeable—as well as an unusual degree of innocent sweetness, to inspire for example the Madonnas of Luca della Robbia and Agostino di Duccio. This innocence came partly from sheltered lives. From the age of twelve until marriage a girl remained at home. If she attended church—and oftener than not she was told to read her Mass in her bedroom—she went as heavily veiled as a Muslim. She used rouge and powder, but not to excess, since Florentines had a proverb for coquettish ladies: 'Whitewash a house when you want to let it.'

Though feminine beauty was so much admired and depicted so memorably, it played almost no part in determining a girl's future. Marriage depended on a suitable dowry, sometimes as much as 1,700 florins. It was arranged by the couple's parents through a

go-between, and the bride did not even attend the first of the four ceremonies: a formality called *impalmare*, when the written agreement was ratified. A solemn betrothal in church was followed at an interval by the actual marriage, which a notary performed in the bride's house. The Mass of union, the only religious rite, was said *after* the marriage had been consummated.

Even now a lady remained indoors on weekdays. She had two meals to provide, the first at about ten, the second at dusk. It was typical of Florentines that, unlike most Italians, they should have preferred their food plain, without sauces. The meat they ate most often was lamb—the arms of the Butchers' Guild showed a ram rampant—followed by pork, kid and veal in that order. They also liked cheese and *pasta*, often with a filling of spiced meat. They preferred white wine to red, drinking it in moderation. In preparing such meals a Florentine lady could count on the help of a slave girl. Since 1366, when a decree authorized the importation of slaves, a small but steady stream had arrived from Spain, Africa, the Balkans, Constantinople and the shores of the Black Sea. Circassians had a reputation for being hot-blooded, Tartars for hard work and Russians for quickness. The Church countenanced this traffic, its attitude here as so often being legalistic: provided they were infidels, the slaves were devoid of rights. Indeed, Archbishop Antonino was more rigorous than many laymen in holding that even baptism did not set a slave free, because slavery was introduced by divine law. However, these disinherited slave girls appear to have been well cared for and on occasion could evidently stand up for themselves, for Alessandra Strozzi wrote of her Cateruccia: 'She treats me as if I were the slave and she were the mistress.' She adds that she did not sell Cateruccia because she was a backbiter and might slander her unmarried daughter, who would then probably lose her chance of a husband.

Florentine women were known for their love of clothes and dressed stylishly. In summer they wore a dress over a fine linen chemise, and in winter added the *fodero*, a garment of cloth or fur, between the chemise and the dress. The sleeves of the dress were sometimes made separately, so that they could be attached at will. In Botticelli's day they were slashed to reveal lining of another shade, and

the slash drawn together by several bows. Velvets, damasks, silks of every shade and pattern were worn, as well as block-printed fabrics, which came in at the end of the fourteenth century. In this respect Florentines cast aside their usual frugality and plain living. Brocades *sopra ricci*, or *ricci sopra ricci*, were embroidered or woven with eagles, pheasants, peacocks, tigers, leopards, or with some favourite emblem. Ornaments ranged from topazes, believed to ward off impure love, to silver buttons, sometimes as many as 170 small ones on a single dress. So valuable did these dresses become, with their quota of gems or pearls, that often a bride might go to her husband 'with 400 florins on her back'.

The men too liked finery, their usual dress being trunk-hose and jacket under an ankle-length gown with long flowing sleeves, and on their head a hood. For holidays such as St John's Day and at Carnival the gown would be scarlet, and in winter would be covered with a violet mantle. When leaving on a diplomatic mission, a Florentine would receive honorary knighthood wearing a green tunic sewn with pearls, gold-hilted sword and ornate sword-belt, and gold spurs. Tunics could be so precious that Alessandra Strozzi made her son 'two little napkins for the shoulders, when you comb your hair'. The Gonfalonier, as head of state, wore a long loose crimson velvet coat lined with ermine, embroidered with golden stars; his cap was turned up with ermine and trimmed with gold lace, pearls and silver embroidery. The coats of crimson cloth worn by the Priors—the Government—also had ermine linings, as well as ermine collars and cuffs.

The Church had long taken the view that dark simple clothes were the mark of a Christian. When at the age of forty Louis IX of France began to lead a devout life, one sign of this was that 'he never again wore ermine or miniver, or scarlet, or gilt stirrups or spurs. His clothing was of undyed or dark-blue wool.' And so the Church attacked the Florentines' rich dress and new fashions with all the weapons at her command. San Bernardino denounced their hats and hairstyles: 'I know some women,' he said, 'who have more heads than the Devil: each day they don a new one.' As for their trains, these were the Devil's invention: 'God made men and women without a tail.' To wear a train was to sin mortally. He told them

that if he were Emperor or Pope he would compel them all to dress in one single fashion, preferable plain linen.

Occasionally in the fourteenth century, at the Church's instigation, the Florentine Government passed sumptuary laws. Sacchetti tells of a notary trying to enforce them:

I stop a woman with many buttons on her dress. 'You must not wear those buttons.' 'Sir,' she replies, 'they are not buttons, they are studs. If you don't believe me, look and see. They have no shanks, and besides, there are no button-holes.' I go to another who is wearing ermine and say, 'How is this, you are wearing ermine', and I ask for her name. The woman says, 'You can't take my name, because they aren't ermine, they are sucklings.' 'And what is a suckling?' The woman replies, 'It is an animal.'

The Florentines loved their fine dress and clearly intended to keep it.

Greek delegates to the Council of Florence were to be struck by two things: how hard the Florentines worked, and how luxurious was their dress on Sundays and holidays. The two of course were linked, as the preachers very well knew. Cathedrals, mosaics, painting, carving—all the beautiful things Christian man had ever toiled to make with his hands he had made for God, save only fine clothes. The preachers believed with reason that the pearl-encrusted brocades and scarlet gowns represented an attitude of mind that would require watching.

CHAPTER 2

A Turning-point

THE TREADLE LOOMS AND BANKERS' TABLES brought their chief reward in leisure. By the third quarter of the fourteenth century not a few Florentines, in the evenings and on holidays, found themselves free from business and household tasks. Some diced and played backgammon, some read Boccaccio's racy tales or the trifles of Sacchetti; others sang to the lute or listened to story-tellers improving on Orlando's exploits at Roncesvalles. But a small group sought more intellectual pursuits. They had received the usual education at the city's expense in reading, writing and arithmetic, and some had taken a degree, usually in civil law or medicine at near-by Bologna. In theory they had a small university of their own, founded in 1321 and known as the Studium Generale, but civil disturbances and war had stunted its growth, and for lack of funds lecturers were only intermittently appointed. The truth is that Florentines did not wholly believe in university education as it then was—the imbibing of scholastic texts in so sheepish a manner that on occasion the student had to promise solemnly not to contradict his master; they preferred to build from their own experience, and Florentine learning for long remained in the hands of dedicated amateurs.

Left to themselves, lawyers would puzzle out forgotten allusions in the *Codex* and the *Digest*, notaries would discuss some ancient will or title-deed found in the archives. Always the trail led back to the past, of which tantalizing vestiges remained: a bronze coin bearing Caesar's head turned up by a plough, a sarcophagus depicting the temple of Janus, an inscription of Hadrian's reign used—upside down—by the builders of Pisa cathedral. Being family men the Florentines felt a natural curiosity about their distant forebears, but

when they came to probe further they found this remote past not so much a closed book as a lost one.

Very few authors of the classical period remained in circulation. Some, such as Catullus, had been so systematically destroyed that only one manuscript existed anywhere. Virgil had survived continuously, but his *Aeneid* revealed very little about Italy's history. And who, in fact, was Virgil? So shadowy a figure that Neapolitans believed him to be a magician who kept Naples free of snakes and Vesuvius from erupting. The few other classical authors of whom one or more works survived in entirety, notably Ovid, were used by churchmen to demonstrate hidden prophecies of the Incarnation or examples of natural man's disgraceful ways. An embarrassing phrase was simply turned on its head: Ovid's *lusisset amores* became *dampnasset amores*, while his *Art of Love* was held, against all probability, to describe the soul's journey to God. Ovid's name of Naso was taken as an allusion to a physical characteristic and one particularly suited to the poet on account of the moral sagacity which enabled him to smell out the differences between virtue and vice. His two divorces were never mentioned. But by far the largest part of classical learning took the form of snippets or tags, a sentence or two quoted by the Fathers or such encyclopaedists as Vincent of Beauvais to ram home a point in moral theology. Figures in classical history had no existence of their own; oversimplified to the point of falsification, they were pinned down within the established clerical framework as neatly as Dante had pinned down Brutus in the ninth circle of Hell. Diogenes, for example, had been a good man, so far as pagans could be: he chose a life of poverty and lived in a barrel; Damon, who offered to take the place of Pythias under sentence of death, was a useful example of friendship, Plato of celibacy. Twice married and the father of two children, Marcus Tullius Cicero had been rigged up, through a biased choice of passages taken from context, as the arch-despiser of marriage and of women: St Jerome ascribed to him a saying which became the weightiest proverb of the Middle Ages: 'No man can serve both a wife and philosophy.' Clerics had found it comfortable to consider Cicero a recluse like themselves, quietly philosophizing in his country villa. Only in 1392, with the discovery of a long lost work, the *Epistolae Familiares*, did the real Cicero come

to light: a successful public-spirited barrister, a consul who served his country well and eventually paid with his life for his devotion to political liberty.

The man who discovered Cicero's letters, a soldier's son named Coluccio Salutati, was born in the Tuscan town of Stignano in 1331. Big-boned, slightly above middle height, with a full, rather pale face, strong jaw and protruding underlip, he trained in Bologna, then became the town notary in Stignano. He married rather late, at thirty-five, and it is typical of the *Trecento* that almost our only glimpse into the private life of so famous a figure is that although not rich, for his marriage feast he bought 3,000 oranges, then a luxury. This and a second marriage gave Coluccio ten sons.

In 1375 Coluccio became Chancellor of Florence, the only permanent post in the republic and one he was to hold for thirty-one years. He handled the paperwork connected with the drawing-up of the secret ballot purses for public office, attended all meetings of the executive councils, and dictated the Signoria's correspondence to Florence's ambassadors. He drew an annual salary of 100 florins tax free, part of which he spent building up a library of 800 manuscript books at a time when even one book was a rarity, to be inventoried alongside furs and jewels. Most were works by Fathers of the Church, sermons and theological treatises. Coluccio studied them thoroughly, corresponded with scholars throughout Italy on points of grammar or interpretation, and himself wrote on political and ethical problems.

This statesman-scholar had a most likeable character. He was energetic, brave in adversity and, despite his important office, deeply humble. He preferred to be addressed as 'friend' rather than the usual *dominus*, since that implied that his correspondent was a slave. He had a spirit of tolerance unusual then. A correspondent having demurred at the union of Aeneas and Dido as a stain on the character of Virgil's hero, Coluccio pointed out that in those days polygamy may well have been permitted.

Coluccio was an intrepid thinker. As a family man and one responsible for the welfare of 50,000 Florentines, he objected to the Church's view that the clerical life (especially in a cloister) is the highest form of human activity. 'To devote oneself honestly to

honest work may be holy,' he wrote, 'and holier than laziness in solitude. For holiness in a busy life raises the lives of many.' To a friend thinking of taking orders he gave, for that age, a surprising piece of advice: 'Do you really think that St Paul the Hermit, solitary and inactive, was dearer to God than Abraham who worked hard? Don't you think that the Lord felt greater affection for Jacob with his twelve sons and two wives and wealth of flocks than for the two Macarius, Theophilus or Hilarion? . . .'

And true wisdom, was that to be found only by clerics studying the Bible and Fathers? Coluccio doubted it, for he had run across wise passages in the few pagan authors on his shelves. Unfortunately his clerical friends denied him the right to answer the question thoroughly. Like the majority of conscientious churchmen, they held the reading of books that described pagans as living men and women to be an unchristian activity. Such works would addle his mind with bad examples and false statements, jeopardize his faith and perhaps lead him to Hell. Look at St Jerome, they warned, who had taken his library into the desert. 'And so, miserable man that I was, I would fast only that I might afterwards read Cicero.' After days and nights of remorse Jerome would fall again, and read Plautus. At last, during a fever, it seemed to him that he was summoned by Christ at the Last Judgment. 'Who are you?' 'I am a Christian.' 'You lie. You are a follower of Cicero and not of Christ.' Thereupon he was ordered to be scourged. At length Jerome cried out: 'Lord, if ever again I possess worldly books, or if ever again I read them, I have denied you.' And he evidently kept his word, for his letters after that contain few classical quotations.

This and similar warnings still made many a sensitive soul shrink. In 1362 a Sienese Carthusian who had been permitted to see the face of Christ and thus acquired the power of prophecy, with his dying breath warned Boccaccio that his days were numbered and that unless he renounced poetry and the non-religious books from which he picked up plots for his tales he would burn for ever. Despite his calm temperament, which as a young man had won him the nickname *Johannes tranquillitatum*, Boccaccio grew terrified. He decided to sell his library and abandon the world, and would have done so had he not been dissuaded by Petrarch,

the scholarly Florentine exile whom Coluccio looked upon as his master.

The Church's restrictions had applied well enough in a society where knights fought and clerics studied but they did not suit Florence's new class of scholarly laymen. Coluccio felt cramped by them. But instead of paying lip-service to the Church and surreptitiously reading in private, this soldier's son decided to contest the whole notion of a division into literary sheep and goats. He took what was in effect a momentous step by launching the first considered attack ever made against the virtual ban on pagan, that is to say, classical literature. Coluccio argued that secular learning was nowhere expressly forbidden either by the Bible or canon and civil law, in fact it corroborated the Faith. Truth, whatever its source, came ultimately from God, and much of the learning imparted by the *quadrivium* was of pagan origin. No one believed any longer in Jupiter, Venus and Mars, so they presented no danger. As for shocking or immoral passages, there the Old Testament did not lag behind.

But Coluccio's main argument, the one which sprang from his own experience and ultimately proved most telling, was that rulers, and politicians generally, had a real need of 'secular' learning. Classical historians could provide lessons in practical politics, statecraft and political philosophy which simply did not exist in Christian works. The study of such authors would obviously enable a statesman to do his job better. Moreover, since the style of classical writing was less cumbersome and so more convincing than that of medieval texts, a statesman should study and adopt it in his own diplomatic correspondence, again because it would enable him to do his job better.

These bold claims the Church was quick to resist in the person of Florence's leading Dominican. Born in 1356 of middle-class parents and self-educated, Giovanni Dominici as a young man committed all the psalms to memory. He suffered an impediment of speech which for two years prevented him taking orders until miraculously cured by St Catherine of Siena. He then made his name as a forceful preacher and a strict reformer of Dominican houses, notably of S. Maria Novella. Now he wrote a long book entitled *Lucula Noctis*—*The Fire-fly*—in which, having stated Coluccio's dark views, on each point he emitted the full light of Christian truth.

Dominici argued that man's final end was beatitude and that every-thing which did not foster that end was vain and superfluous. No pagan had been a philosopher according to the true meaning of philosophy, for any truths or virtues in his writing were tainted with errors, from which stemmed heresy and superstition. St George slaying the dragon, for instance, was a legend which would never have arisen had not a pagan poet invented the myth of Perseus. 'It is better for a man to plough,' wrote Dominici, 'than to read the books of the Gentiles.' Since the *History* of Livy mentioned early pagan rites, St Gregory did well to burn it, and in a burst of ferocity Dominici declared that he would prefer some new Pharaoh to slaughter all new-born babes than that they should be brought up on Terence, Ovid and Virgil.

Coluccio's arguments, even when they invoked the Surrey Fran-ciscan, William of Ockham, carried little weight against the fierce Dominici, the serried ranks of the Fathers, Aquinas, a millennium of tradition, a conservative not to say sacrosanct educational curriculum and, indeed, against a wave of fanatical hostility which broke at this time against even the mildest of 'the Gentiles', and which reached its climax when a devout, usually sensible layman, Carlo Malatesta of Rimini, angrily toppled a statue of Virgil into the river Mincio, at Mantua. The dispute, so fraught with implications, might well have dragged on a very long time had not the whole question of the study of the classical past been shifted to a different plane, where it was finally resolved. This happened in 1390, when Florence entered the most profound crisis in her history, one that was to last twelve years.

In 1390 most of Italy north of the Po belonged to a thirty-nine-year-old tyrant, Giangaleazzo Visconti. His portrait by Pisanello shows a stout man, forehead sloping steeply back, frizzy red hair parted in the centre, calculating eyes, full lips, chin of moderate size but thrust forward, with a tuft of beard. He lived in the family castle of Pavia, a square battlemented red-brick fortress protected by a deep moat and drawbridges, its park enclosed by a thirteen-mile wall. He rarely left the castle save at night. He was a cold, withdrawn, solitary man, indifferent to religion and extremely ambitious.

Giangaleazzo had begun to extend his power five years before. In the great arms centre of Milan, famous for war-horses, breastplates, helmets and swords, ruled Giangaleazzo's uncle and father-in-law, Bernabò Visconti, a savage creature who once threw a peasant to be devoured by his dogs for poaching a hare, and who invented what he humorously called his 'Lenten treatment', forty days of slow torture. One May morning in 1385 Giangaleazzo rode out of Pavia ostensibly on pilgrimage to the Madonna del Monte at Varese, beyond Milan. He had an unusually strong escort—1,200 men—but their daggers and breastplates were hidden by pilgrims' robes, they carried olive branches and sang hymns. So that when Giangaleazzo approached Milan and invited his uncle to a meeting outside the walls, Bernabò suspected nothing. He and his two sons were greeted with a smile, then in a flash their sword-belts were cut and their arms pinioned. Milan was seized that same day and Bernabò thrown into a dungeon, soon to die, poisoned, as many including Chaucer believed, by his nephew Giangaleazzo.

Seizing with equal guile Verona, Vicenza and Pavia, by 1390 Giangaleazzo had become the most powerful Italian since the fall of the Roman Empire. He saw himself as heir to the now effete German Emperors' trans-Alpine ambitions, and who indeed could oppose them? Of the other four major powers, Venice, wedded to the sea, remained neutral; Rome and the Papal States were in turmoil through the claims of a French anti-Pope; while the kingdom of Naples was torn by civil war. Only the rich republic of Florence remained a potential barrier.

Giangaleazzo gloried in a cruel emblem: an azure serpent coiling its body seven times downward to a pointed tail engulfed in its gaping mouth a small red human figure that struggled in terror. On 1 May 1390 Milanese heralds sporting this emblem appeared in Florence and announced their master's declaration of war against the republic, and against Bologna. Soon well-trained cavalry, encased from head to toe in Milanese steel, were pouring across the Apennines. 'Italians!' proclaimed Coluccio, 'at last the Viper is leaving his insidious hiding-place. Now it is very clear what the Serpent has been attempting with his flatteries. The great secret which he masked with a stupefying hypocrisy . . . is at length

revealed. He wants the crown of Italy to give a colour of respectability to his title of tyranny. But we that are the true Italy, by defending our very existence, shall defend all Italians from falling into servitude.'

Florence possessed no standing army. She preferred at this period to employ free lances, usually under a foreign commander. Since the Pope could not aid his fief Bologna, the Florentines sent troops there under their Essex-born *condottiere*, Sir John Hawkwood. Hawkwood met the Milanese cavalry by dismounting his men and fighting English-fashion: 'With their lances pointed low—as though hunting wild boar—and with slow steps, they marched up to the enemy with terrible cries and very difficult it was to break their ranks.' Hawkwood saved Bologna and at one point marched to within sixteen miles of Milan, but the war dragged on indecisively, with periods of uneasy truce. In the first twenty months alone payment of mercenaries and loss of trade cost Florence 1,000,000 florins.

It was a war of ideologies. Giangaleazzo worked out a fantastic family tree which showed him to be a direct descendant of Aeneas, heir therefore to all the promises in Virgil's national epic. In 1395 he bought from the Empire for 100,000 florins the title of Duke of Milan, henceforth quartering his serpent with the imperial eagles. The Duke's poet-propagandist, Francesco di Vannozzo, represented all the cities of Italy, Florence included, as dreaming of an Italian kingdom with Rome as its capital. Dante had once hailed an invading Emperor, Henry VII, with the extravagant phrase '*Ecce Agnus Dei*,' and now Vannozzo saluted Giangaleazzo as 'the Messiah who has arrived' for Italy. It was a heady tonic, and often it worked. Even a citizen of an old and proud Tuscan republic, Saviozzo da Siena, prayed in a sonnet sequence for the success of Giangaleazzo's enterprise 'in the name of every true Italian', while deprecating 'the detestable seed, enemy of quietude and peace, which they call liberty'.

As the ruinous war dragged on, Florence sought to convince uncommitted cities and States that her cause was just and her will to win inflexible. In this new war of words she needed all the resources of learning and style. She could not afford to be put off by ecclesiasti-

cal taboos about licentiousness or heresy. Drawing on classical models and couching his arguments in the style of Cicero, Coluccio defended his city's cause in ringing manifestoes. 'Liberty is properly obedient to the laws, while tyranny is obedient to one single man who governs everything according to his caprices. Tyranny equals fear; fear of the signore, of his suspicions, of his fickle motives, of his humours ... This is the destiny that awaits every people that Giangaleazzo succeeds in conquering.' To the wavering Lucchese Coluccio wrote: 'The liberty of this city appears to be all the more secure the broader the belt of free peoples surrounding it. Therefore everyone ought to be readily convinced that the Florentine people are defending the liberty of all, since in defending others they make the defence of their own freedom less difficult.'

Giangaleazzo's propagandists invoked the magic word Empire. The Empire was a continuous institution, part of God's order for the world, accepted as such even by Dante. A republic like Florence, on the other hand, could find scant justification among theologians, and even less among contemporary States. True, many Italian cities had once been staunch communes, but all save a scattering—and these Ghibelline in sympathies—had long since yielded their rights to despots. That appeared the norm, the inevitable pattern. For this reason, when Florence asked help of her traditional allies, Venice and the Papacy, they turned away as though from a city doomed.

Yet Florence desperately needed an ally. Having sought one in vain among the States of Italy, she eventually found one in the past. The more Coluccio and his friends read about Cicero and his age, the more similarities they perceived between Florence and Republican Rome. Each accorded its citizens law-making powers and access to the highest offices, each prized liberty, each had had to defend itself against tyranny from within and without. However, it became important to discover a precise link. Florence had been founded from Rome, but exactly when remained uncertain. Coluccio and his friends studied the earliest texts then available, Sallust's *Bellum Catilinae* and Cicero's second oration against Catiline, and concluded, with only slight inaccuracy, that their city had been founded by veterans of Sulla's victorious army shortly after the beginning of the

first century B.C. Florence, then, was the offspring of the Roman Republic, not of a period when Rome began to obey emperors.

Well pleased with this piece of historical research, Florentines now bound themselves in spiritual alliance to Republican Rome. They adopted the name of 'new Romans', using it not only among themselves, but as an official description. Coluccio in his manifestoes repeatedly refers to his fellow-citizens as 'the new Romans', and even Giangaleazzo's propagandists accepted the term: when Florence made an unsuccessful attempt to enlist French help, they gibed at this sign of weakness by 'the new Romans'.

Florentines went on to argue that it was under the Republic, not under the Empire that the Roman people achieved their mightiest deeds. 'The Roman *imperium*', wrote Leonardo Bruni, 'began to go to ruin when the name of Caesar fell like a disaster on the city.' The Republic had seen eminent talents in every field, but 'after the republic had been subjected to the power of one man, those brilliant minds vanished, as Cornelius [Tacitus] says'. Bruni was thinking of an early passage in the *Histories*, where Tacitus is discussing historiography, and referring exclusively to brilliant historians, but this slip did nothing to lessen the importance of Bruni's claim, or of its implication that Florence, successor and spiritual ally of the Republic, was mightier than Giangaleazzo's would-be Empire.

Coluccio's public letters arguing this case were eagerly read for their wit and erudition. Giangaleazzo found them very damaging— he said they 'did him more harm than a thousand cavalry—and cunningly tried to ruin their author. He caused 'a letter counterfeiting the hand of Coluccio and containing many treasonable expressions to be laid before the Signoria. This letter was shown to Coluccio in the presence of a highly excited assembly and he was asked in whose hand it was written. Coluccio, stoop-shouldered now in his sixties, read it through without batting an eyelid and replied in a steady voice. "The handwriting is mine, but I never wrote the letter." Such was his reputation that this answer alone freed him from all suspicion.'

In 1399 Florence's situation worsened. Frost and snow in April reduced her harvest of corn and wine by half, while the betrayal of

Pisa to Milanese troops cut her off from the nearest port. When Siena also declared for Giangaleazzo in September of that year, Florence found herself blockaded south as well as north. She faced also a more insidious threat. As the century neared its close a belief took hold of many that the world too would end. Throughout Italy men, women and children, stirred by religious fervour, formed penitential groups. Wearing a plain, rough sheet drawn over the head with holes cut for the eyes, they walked barefoot, fasted and abstained from meat, slept on the ground, visited shrines and sang hymns imploring mercy of the God who was soon to come: '*Miseri-cordia, eterno Dio, Pace, pace, Signor pio.*' One of their number composed the '*Stabat Mater dolorosa*', condoling with Mary at the foot of the Cross. Some claimed to raise the dead, but mostly they patched up differences between hereditary enemies—in Coluccio's eyes an even greater miracle. Pisan *Bianchi* walked to Florence and embraced the Florentine penitents, while groups from Florence did the same in Siena. Let war end, they pleaded, since the world itself was ending.

The year 1400, when it came, proved Florence's year of crisis, the climacteric. Bubonic plague swept Italy, that same Black Death which had carried off so many thousands during 1348. Plague is caused by bacilli that inhabit the parasites of rodents, especially the rat-flea, and although Florentines took the usual precautions—spoonfuls of treacle, rosewater sweetened with sugar—it was doubtless because they kept their city cleaner than most that they escaped more lightly than Tuscany as a whole. Even so, up to 200 a day died and famine weakened the rest. Many listened readily to the *Bianchis*' hymns in praise of peace, and their powers of resistance began to flag.

It was now that Coluccio and his growing circle combed the available classical texts for examples of patriotism. In fighting for the liberty of the Republic, said Coluccio, Cicero had acted like Brutus and Cassius, neither of whom thought it permissible for Roman citizens to retire into solitude while the world was in flames. In Aristides' *Praise of Athens* young Leonardo Bruni found the vocabulary of patriotism and perhaps during 1400, nadir of the city's fortunes, began that trumpet-call of freedom, his *Praise of Florence*, likening his city within its ring of walls and mountains to a castle defending reason and liberty, to a buckler sheltering all free men

against the despot, and characterizing the Florentines by their bold-
ness and indifference to danger—qualities inherited from the Romans.

The Florentines needed all the patriotism, all the self-confidence
these scholars could muster, as Perugia raised the standard of the
coiled viper, Bologna fell to a massive army of 15,000 horse and
20,000 foot, and Giangaleazzo, having surrounded Florence, settled
down to starve its people into surrender.

For fourteen months Florence endured this tighter blockade,
suffering much from famine, her trade at a standstill, her treasury
empty, Hawkwood dead. Italians everywhere were convinced she
would surrender, but 'to be conquered and become subjects—this
never seemed to the Florentines a possibility. Always they comforted
themselves with the hope, in their eyes a certainty, that a common-
wealth cannot die, while the duke was one single man whose end
would mean the end of his empire.'

Quite unexpectedly, as though this hope had been prophetic, the
whole situation changed. On 13 August 1402 Giangaleazzo fell ill,
not of the plague, which was keeping the death-carts busy through-
out Lombardy, but of fever. He was only fifty but the strain of
building up a new empire and constant war had taxed his strength.
His condition grew worse and despite the medicines of Marsilio di
Santa Sophia, the best physician of the day, on 3 September he died.

Giangaleazzo had wished to be interred in the Charterhouse of
Pavia, the monument he had designed for the glorification of the
Visconti. But to gain time in which to strengthen her power as
Regent, his widow Caterina had him hastily buried in a country
grave. Only a week later was the news released in Milan, where the
official funeral took place in October. Twenty thousand people
followed the sumptuous coffin to its mausoleum, and the rites
lasted fourteen hours. It was Giangaleazzo's final unwitting act of
deceit, for the coffin was empty.

This hollow ceremony marked the end. Giangaleazzo's heir was
only fourteen and, the son of first cousins, already displayed to an
insane degree the Visconti streak of violence. Caterina tried to hold
the empire together but by becoming the mistress of her chief
minister she precipitated unrest and faction. Cremona, Brescia,
Parma—one by one the towns fell to this or that general. By early

1403 Giangaleazzo's empire was in ruins, his army disbanded and the blockade of Florence lifted.

When they heard of the Duke's death, Florentines sang in the streets the psalm, 'Our bonds are broken and we are now free', and when the blockade was lifted they believed—as did most Italians— that they had gained a momentous victory. But they had gained it in a peculiar way, not on the battlefield, for they were not so strong a military people as the Milanese, but in the city itself. It was a victory of morale. All the citizens had gained it together, by their resistance. It seemed to the Florentines that their twelve years' ordeal crowned by a fortunate triumph justified the title 'new Romans'. It justified also all that Coluccio had told them about active citizenship and the political necessity of probing the past.

The question of classical studies had now been resolved. If a Florentine wanted to know who he was and what his city stood for, he must turn to the old Romans—to the classics. He did so eagerly. He could not learn enough now about the men and women who were his forebears and spiritual allies, from whom his principles stemmed. What had begun as the cautious hobby of a small group spread to many. Dominici continued to fulminate until 1408, when he left to become a Cardinal of one of the three rival Popes, and thereafter opposition to 'pagan studies' ceased to be effective.

Latin books evidently contained the secrets of success. But they were still hard to come by. In 1406, when the Florentines finally dislodged the Ghibelline government and brought Pisa into her own dominion, it was a notable victory, not least because it gave Florence an outlet to the sea. But it was neither the military victory as such, neither prisoners nor bullion that the Florentines chiefly prized. When Gino Capponi, who had treated with the Pisans for the surrender of their city, returned to ride in triumph with Lapo Niccolini, one of the Ten of War—the city's committee in charge of military operations—he carried in his hand a manuscript found in Pisa, believed to be the only complete copy in existence of Justinian's *Pandects*, the great summary of ancient Roman law, and it was for this book that the Florentines reserved their loudest cheers.

CHAPTER 3

The Classical Ideal

WITH PEACE began an intensive search for classical manuscripts: both lost works and full versions of truncated texts. A friend of Coluccio named Niccolò Niccoli directed the search. Born in 1364, the son of a cloth merchant, Niccoli left his five brothers to carry on the family business and led a withdrawn life devoted to classical studies. Strikingly handsome and dignified, he was most fastidious about the cut of his long crimson dress, the whiteness of his table-linen and the turn of a Latin sentence, and so sensitive 'he disliked the braying of an ass, the grating of a saw and the squeaking of a trapped mouse'. He hid a generous heart under a gruff, Cato-like exterior. He did not write books himself, being unable to satisfy his own high standards, but he sold off strips of farm-land in order to obtain books, which he was notorious for lending left and right (at one time 200 were out on loan); he was equally notorious for not returning books he borrowed. Whereas most of Coluccio's circle was married, Niccoli kept a pretty but insolent mistress, to the in-dignation of his brothers, who one day in Niccoli's presence hauled Benvenuta out of the house into the crowded street, turned up her skirt and spanked her. Niccoli wept, shut himself in his room, vowed vengeance and finally forgot the spanking in a good book. He was almost unique among Coluccio's friends in not being a man of action.

The man of action Niccoli needed and eventually worked with was Poggio Bracciolini. Born in Terranova, near Florence, in 1380, Poggio was the son of a debt-ridden notary and came to the city with only 5 *soldi* in his pocket. While he followed the two-year notarial course, Coluccio gave him part-time work as a copyist and eventually found him a job as a writer of letters at the papal

court. Poggio was highly intelligent and enterprising. The sculptor Ciuffagni portrayed him as Joshua: tall, commanding, with careworn lines running from nose to jaw, but at heart he was a very gay person who liked white wine, especially the vintages of Crete, facetious jokes and pretty women. He scorned and constantly scored off the Curia which employed him. One day, when Poggio had entered middle age, the Cardinal of S. Angelo reproached him with having children, 'which was unbecoming to a cleric, and with having them by a mistress, which was unbecoming to a layman'. 'True, I have children,' Poggio gaily replied, 'twelve sons and two daughters—but that is quite becoming to a layman, and I have them by a mistress, which is a long-established custom of the clergy.'

In 1414 Poggio accompanied John XXIII,[1] whom Florentines believed to be the legitimate Pope, to the Council of Constance. There John was accused of a variety of crimes ranging from murder to the seduction of 200 women of Bologna, deposed and imprisoned. Since Poggio was now out of a job, Niccoli asked him to search for manuscripts at his expense. Poggio agreed. A first expedition to Cluny yielded two unknown speeches of Cicero. Then, in the summer of 1416, accompanied by two Tuscan friends, Poggio visited a Benedictine monastery twenty miles from Constance up a winding, precipitous road. St Gall, a seventh-century Irish foundation, manufactured high-quality linen and was very prosperous. Poggio asked leave to visit the library, which turned out to be the most neglected room in the monastery: 'a most foul and dimly lighted dungeon at the very bottom of a tower'. There he began to turn over the dusty manuscripts, some, by Anglo-Saxon scribes, dating from the Dark Ages. He found them in a deplorable condition, though not actually mutilated, as Boccaccio had once reported from Monte Cassino: 'the monks, seeking to earn a few *soldi*, would cut off pages and make psalters, which they sold to boys; the margins too they manufactured into charms, and sold to women'.

Among the litter of neglected books Poggio made an important

[1] Baldassare Cossa (*ca* 1370–1419). He was known as Pope John XXIII until 1958, when Angelo Roncalli took this title. The Church holds that Cossa's rival Corrarrio (Gregory XII) had the better claim to be called Pope, but the matter is still disputed.

discovery: a complete manuscript of Quintilian's *The Training of an Orator* which Florentines for some years had been hoping to obtain in its entirety, for they knew it to be the fullest handbook about the Roman system of education. Here is Poggio describing his find:

I truly believe that, had we not come to the rescue, this man Quintilian must speedily have perished; for it cannot be imagined that a man magnificent, polished, elegant, urbane and witty could much longer have endured the squalor of the prison-house in which I found him, the savagery of his gaolers, the forlorn filth of the place. He was indeed a sad sight: ragged, like a condemned criminal, with rough beard and matted hair, protesting by his expression and dress against the injustice of his sentence. He seemed to be stretching out his hands, calling upon the Romans, demanding to be saved from so undeserved a fate. It was hard indeed that he who had preserved the lives of many by his eloquence and aid should now find no redresser of his wrongs, no saviour from the unjust punishment awaiting him.

Poggio borrowed the manuscript (doubtless the monks, like any-one else in northern Europe, considered him a crank), took out his goose quills and ink-horn, and copied the whole work himself in thirty-two days. Then he sent his copy to Niccoli in Florence.

Fired by his big discovery, Poggio made other expeditions: to Einsiedeln and Reichenau, to Weingarten and Langres on the Marne. In the past men had prospected for gold and silver, gems and iron and even alum, but never like this for old parchment. In January 1417 Poggio found a Latin work on agriculture—Columella's *De re rustica*; the *Silvae* of Statius, which are miscellaneous poems of the Silver Age; the *Astronomica* of Manilius, which describes the movement and influence of the planets and stars; and Silius Italicus's heroic poem about the Punic Wars. Yet another expedition that spring, again to St Gall, yielded a most varied haul: a history of the fourth-century Roman Empire by Ammianus Marcellinus, a work on cookery by Apicius, and, side by side with that, one of the two greatest Latin poems, Lucretius's *De rerum natura*, which opens with a deeply felt invocation to Venus, life-giving force of the universe. All these works Poggio copied and sent to Florence. Since the originals

were often later lost or destroyed, some of Poggio's transcripts in Florence are the oldest texts we have.

After four years in England as the guest of Cardinal Beaufort— a visit which yielded a good crop of stories for the *Facetiae* he was compiling, but no manuscripts—Poggio returned to Italy and in 1429 discovered at Monte Cassino Frontinus's treatise *On Aqueducts*, a key book for the understanding of Roman architecture. Meanwhile Cicero's *Brutus*, a work dangerous to all who believed in monarchical government and for centuries conveniently forgotten, was discovered at Lodi, in north Italy, as well as the full text of the *De Oratore*, while a German monastery yielded twelve comedies of Plautus, four of them previously unknown.

Often these manuscripts did not disclose their secrets immediately. The plays of Plautus, for example, reached the Florentines as a continuous unpunctuated and garbled rigmarole: almost a message in code, which it was up to them to decipher. They did so with the help of inscriptions, other texts and makeshift philology. Since they had to allot to each character his appropriate lines, this demanded insight into the author's mind and the behaviour of typical Romans of Plautus's day. Thus, discovery was partly a constructive process, and one which entailed thorough understanding.

These and later finds came as a kind of revelation to the Florentines. They were now able to follow the Roman people battle by battle through the dark days of their resistance to Hannibal and the steady conquests of their legions until they ruled from Britain to Persia. Cicero's speeches showed them the endless struggle at home against conspirators, would-be tyrants and corrupt officials; Suetonius the vices and madness of the Caesars. In Vitruvius they found a system of architecture based on columns and round arches. Celsus added to their knowledge of medicine. In Plautus and Terence they discovered Roman comedy, with its plethora of foundlings and identical twins and coincidental meetings. They encountered new poetical forms: the barbed and bawdy epigrams of Martial, the satire with which Juvenal flayed gluttons and affected women. Above all, they came to know individual Romans: Horace, the man of the world, relaxing on his Sabine farm; Seneca amassing a fortune at court, then losing Nero's favour and opening his veins with Stoical

courage; they came to know Catullus in his agonies of jealous love, and the garrulous Pliny, whose interest in science cost him his life when he sailed to observe the eruption of Vesuvius in A.D. 79. They came, in short, to know a whole new world of unprecedented variety and interest, which had achieved great things in many fields, often in fields where the Florentines had never dreamed to venture.

But this was only one part of the Florentines' discovery, in many respects the lesser part. The more closely they read the newly found Latin books, the more obvious it became that the Roman achievement was not a sudden creation, but owed a heavy debt to Greece. Cicero kept quoting Plato, Terence was said to have adapted Greek comedies, even the constitution of Republican Rome owed much to Athenian democracy.

In the fourteenth century Greek was a dead language in the West. Since the Greek Church was in schism with Rome, the Curia had no use for it. For 700 years no Florentine had read Greek. When a copyist met a Greek phrase he would write: 'Græcum est—non legitur.' Petrarch possessed a manuscript of Homer whom, on the authority of the Romans, he believed to be a fine poet. He would kiss the book reverently but could not read more than a few words of it. In the depths of southern Italy were a few scattered Basilian monasteries where the monks still spoke an impure Greek. One of these monks, Leontius Pilatus, Petrarch and Boccaccio commissioned to translate Homer. Pilatus was a queer-looking fellow, with long tangled rusty-black beard and hair, dirty, always hungry and grumbling—Petrarch called him 'the concierge of the Cretan labyrinth'. Boccaccio lodged him in Florence in 1360 but such was the lack of interest in Greek authors at this early period that in order to get the Signoria to sponsor some lectures from Pilatus, Boccaccio had to argue that a knowledge of Greek would help merchants to sell their cloth in the Eastern Mediterranean. Then Pilatus left for Constantinople and died on the return voyage, struck by lightning while he stood against the ship's mast. Serious study of Greek had to wait until 1397 when, thanks to Coluccio's influence, the Florentine Signoria decided to establish a chair of Greek in the Studium, and invited a sound scholar, Emmanuel Chrysoloras of Constantinople,

to occupy it. Chrysoloras lectured in Florence for three years, formed a group of citizens with a knowledge of the language, and left behind him the first Greek grammar.

The Florentines now had the key they needed. They sent agents to the East to transplant books as once the Crusaders had transplanted shallot, buckwheat and apricot. The richest man in Florence, Palla Strozzi, procured from Greece Plutarch's *Lives*, the works of Plato, the *Politics* of Aristotle, and Ptolemy's *Cosmography*. In 1423 Giovanni Aurispa arrived in Italy with 238 manuscripts from Greece: most of the major literary works and many minor ones as well, including the histories of Arrian and Diodorus Siculus, the poems of Callimachus, Oppian and those attributed to Orpheus. The shock of discovery was here far more dramatic in that very few complete Greek works of the classical period were known or studied: little of importance save Euclid and part of Aristotle, available since the thirteenth century through often inexact Arab translations, and Plato's *Timaeus*. So immense horizons were suddenly opened. The *Iliad* and the *Odyssey*, the tragedies of Aeschylus, Sophocles and Euripides, the comedies of Aristophanes, the odes of Pindar, the eclogues of Theocritus, the histories of Herodotus, Thucydides and Xenophon, the character studies of Theophrastus, the speeches of Demosthenes, the dialogues of Plato, the writings of Cynics, Stoics and neo-Platonists, the speculations of the Ionian philosophers, the medical writings of Hippocrates and Galen, the geography of Ptolemy and Strabo—it was as if these masterpieces had been written all at once and suddenly given to Florence.

Even when the views of a Greek author had already been briefly known through Christian sources, the gain was immeasurable, for now the very texture of Athenian life could be felt. What a difference between the bald statement by some Augustinian scholastic that Plato believed in the immortality of the soul, and the actual elaboration of this theme by Plato himself. In the *Crito* and the *Phaedo*, which were among the earliest Greek works to circulate in Florence, Socrates could be followed stage by stage after his condemnation: rejecting his friends' plan for escape to Thessaly, on the grounds that he had been condemned by due process of law and it would be wrong to do anything illegal to avoid punishment; rejecting suicide

also; arguing that knowledge is recollection, and therefore that the soul must have existed before birth; then developing the idea that only what is complex can be dissolved, and that the soul, being simple, belongs to the group of things that are eternal; and finally the moving farewell of one who has been delivered from life's fitful fever and therefore must pay a thankoffering to the god of healing: 'Crito, I owe a cock to Asclepius; will you remember to pay the debt?'

The Florentines' first reaction to these discoveries was admiration and awe. Whatever field they turned to, from poetry to oratory, from mathematics to medicine, they found that the Greeks and Romans had surpassed them. Not only stylistically, as Petrarch had said, but in substance also they were forced to the conclusion that their own immediate past had been an age of darkness, and classical times an age of light. It seemed to them shameful that their forebears had allowed this great age to be forgotten.

The result was an intense enthusiasm for the classical achievement. In every field from architecture to zoology what the Greeks and Romans had done was considered exemplary. But for a people so practical and with such character as the Florentines there could be no question of merely enshrining the new ideal, of revering it from a distance. With characteristic boldness, they wanted to make something of it. And so the classical ideal became for them a stimulus, a challenge, a model.

A model, first, in education. In 1428 a committee called for an expansion of the Studium to include certain 'honoured' studies, such as were described in the complete Quintilian found by Poggio. One of the Studium's trustees, a young banker living in Rome named Cosimo de' Medici, managed to persuade Pope Martin to levy a tax on the wealthy clerical institutions of Florence yielding 1,500 florins annually and this was used to add to the existing chairs of grammar, logic (the lowest paid), law, astrology, medicine and surgery, two new chairs: one of moral philosophy the other of rhetoric and poetry. The latter carried a salary of 140 florins, second only to that paid to the professor of medicine.

Niccolò Niccoli arranged for a young Greek-speaking scholar to hold the chair of rhetoric and poetry, and, until the chair of moral

philosophy was filled, to lecture on that subject also. Francesco Filelfo was born in Tolentino, in the Marches, perhaps of Florentine parents, as he himself claimed. He had lived in Constantinople, served as ambassador to the Greek Emperor, and married a Greek girl named Theodora, choosing her, he said, for her impeccable Attic accent. Now aged thirty-two, he bounded into Florence in a blaze of activity. At dawn he lectured on Cicero's *Tusculan Disputations*, the first Decade of Livy's *History*, Cicero's *Rhetoric* and Homer's *Iliad*. After a few hours' interval he expounded Terence, Cicero's letters and speeches, Thucydides and Xenophon. All this he capped with a daily lecture on moral philosophy.

The subjects taught by Filelfo formed a radically new syllabus, to which the Florentines, again imitating the Romans, gave the name *studia humanitatis*, the 'humanities'. Coluccio defined *humanitas* as 'moral learning', but the next generation attached a wider meaning to the humanities. '*Litterae humanae* are so called', said Bruni, 'because they bring our humanity to completeness.' Logic and scholastic philosophy had been partial education; this was education for the whole man. Later in the century the word *umanista* came into use, to denote a teacher at first of Latin grammar then, more generally, of Latin literature as the expression of human character in all its aspects.

Formerly, and throughout the Middle Ages, the term 'liberal arts' described the *trivium* and *quadrivium*, that is, the study of speech and number: those arts or sciences that were considered 'worthy of a free man', as opposed to servile or mechanical trades. The Florentines appear to have been the first to apply the term 'liberal arts' to the new syllabus—rhetoric, history, poetry and moral philosophy. These were the subjects now considered suitable to a free citizen. Bruni, who had a passion for liberty, went even further. 'The liberal arts', he says, 'owe their name to the fact that they liberate man and make him master of himself in a free world of free spirits.'

The civic advantages as well as the spiritual satisfaction afforded by the new syllabus were stressed by Niccolò Niccoli in an incident which became famous. One day, as he passed the Palazzo del Podestà, Niccoli noticed a fine-looking youth. He asked whose son he was and what he was doing. The youth replied that he was Piero, son

of Andrea de' Pazzi, a rich, highly-placed citizen, and passed his time as best he might. 'A pity you don't study Latin literature,' Niccoli gruffly observed. 'Without Latin you will reap no honour and remain without inner resources when the bloom of youth has vanished.' The sequel shows the direction in which things were moving, for Piero heeded Niccoli's advice, hired a Latin tutor at 100 florins a year, learned by heart a number of Cicero's speeches, entered the Signoria in 1447 and later served his city well as an ambassador.

More important than training for any specific function, and under-lying its wide repercussions in every other field, the new education brought Florentines face to face with Greeks and Romans, that is with laymen, not clerics or saints, and these laymen acted in an unfamiliar way. The Greeks pursued honour through action, and honour they attained, in the last resort, by strength of will. It is will that distinguishes Prometheus and Heracles, Jason and Ajax. With the Romans daring is replaced by dogged perseverance, but they too set high store by will. Both Greek and Roman historians tell the history of their peoples in terms of men forging their own destiny as individuals. It is human will that prevails, not the will of the gods, who are seldom on stage. All this contrasted sharply with the medieval view. When clerics wrote history or considered individual lives they stressed the action of Providence or Fortune. Every man of course possessed free will, but this was a faculty which should be made to conform with the will of God. God's will being inscrutable, too often the result was passivity, drift and resignation, as counselled by that favourite bedside book, Boethius's *Consolation of Philosophy*.

The different attitude to will emerges in the meaning of a key word: virtue. Dante understands by this one or all of the seven cardinal virtues. He often refers to virtue as coming from heaven, and the basic virtue, Faith, '*sopra la quale ogni virtù si fonda*', is 'in-fused': it operates in us without active participation, though not without our consent. Sassetta gives visual expression to this in his *Marriage of St Francis with Poverty*, where three virtues are seen flying back to heaven after visiting Francis. For classical authors, on the other hand, *virtus* is a perfection attainable in this world by man's own will, not a plurality of virtues derived from and re-

flecting that perfection which is Christ. *Virtus* then comes to mean 'moral worth', all the robust moral qualities that go to make a man in society, and 'moral power', particularly fortitude.

Virtue in this, the classical, sense came to play an important part in Florentine thinking. Soon after 1400 Florentines of the old school complained that the young generation were beginning to gather from Cicero's *De Officiis* that 'happiness and virtue were bound up with position and reputation in political life'. They were forgetting the philosophic truth that the 'perfect life' is contemplation and inner peace. A Florentine polymath, Leon Battista Alberti, equates *virtù* with man's will, and believes it 'capable of scaling and possessing every sublime and excellent peak', while Poggio, in his dialogue *De Nobilitate* defines nobility exclusively in terms of active personal *virtù* and points with scorn to such a kingdom as Naples, where the barons believe that nobility consists in superior birth and will not even farm. Lorenzo Valla went so far as to argue that *virtù* is not painful renunciation but fulfilment of innate capabilities and so is always accompanied by pleasure, either physical or mental.

Thinking along such lines as these, the Florentines soon evolved from Greek and Latin texts a highly selective notion of classical man—'the complete man', as they called him. He possessed a strong will, practised the natural virtues and took pleasure in realizing his innate capabilities; he engaged in civic affairs and through hard work enriched the community. Such was the classical ideal, very different from that which had inspired Europe for a thousand years, and the Florentines looked on it with fervent admiration. But because they were sincere Christians, crucial questions arose. Did the new ideal square with Christian principles? Could it be made to square with them? Or did some fundamental incompatibility separate this ideal of natural man, with the emphasis on will and action, from the Christian ideal of man graced, with the emphasis on humility, resignation and orthodox belief?

A simple example of tension that could arise appears in the following incident. In 1426 a high-spirited Sicilian named Beccadelli, who dated his letters '*ex mediis poculis*'—'in the middle of a drinking session'—and claimed that the Trojan War could have been avoided had Menelaus given Helen to Paris for a month, wrote a poem

entitled *Hermaphroditus*, praising, in the manner of Catullus, the pleasures of physical love between two young men. Some humanists hailed it as a masterpiece and Cosimo de' Medici accepted the dedication, but the Minorite friars burned copies, together with portraits of Beccadelli, on the squares of Bologna, Milan and Ferrara; while Pope Eugenius declared that anyone who read the poem would *ipso facto* be excommunicate. Poggio, who was no prude, also denounced the *Hermaphroditus* and put his finger on the crucial point: 'We Christians are not allowed to do everything that was permissible to poets ignorant of God.' But where should the line be drawn?

The Dominican Giovanni Dominici had warned against the indecency of certain classical poems. Events had proved him right. But ill-effects in this direction would not gravely damage the Church. Far more potentially dangerous was the new tendency to assess a man by his conduct rather than by his beliefs. The tension here between the classical outlook and Christian teaching is illustrated by Poggio's experience at the Council of Constance.

It was typical of traditional thinking that this Council should merely depose and for a short time imprison a Pope accused of every crime, while burning others accused of errors of belief. Having consigned John Huss to the flames for denying transubstantiation and the validity of sacraments administered by a priest in a state of mortal sin, in the following year they arraigned Huss's chief disciple, Jerome of Prague, a layman of noble birth who had studied at Oxford and brought back to Bohemia copies of Wycliffe's books. A big muscular fellow and by temperament a fighter, on one occasion Jerome had tied a Carmelite to a length of rope and ducked him in the Moldau until he would call Wycliffe a saint. At the beginning of 1416 disturbances had broken out in Bohemia in protest against the burning of Huss, and the Council, alarmed, were determined to make an example of Jerome. They drew up 102 charges, chiefly of following Wycliffe and Huss on heretical points. Broken in health by eleven months in prison, Jerome nevertheless defended himself with a will. 'Remember', he warned his judges, 'that you are men and not gods, liable therefore to mistake and error.' But there could be only one verdict. The Council found Jerome guilty, pro-

claimed him 'a dead and sterile branch no longer belonging to the vine', and handed him over to the secular arm with the usual hollow recommendation to clemency. A pyre was built of wood, straw and tar, in the centre of which rose a stake. To this Jerome was attached. He was about fifty years old.

To members of the Council, to spectators from all over Northern Europe and Italy, the scene appeared banal. Justice was being done in accordance with centuries-old practice; there was no cause for uneasiness. But one man, Poggio of Florence, saw the scene differently:

Jerome's voice was soft, clear and resonant [he wrote to Leonardo Bruni]: he had the dignity of an orator in expressing indignation or in exciting pity; he stood fearless and intrepid, not afraid of death, but even welcoming it like another Cato; a man worthy of being for ever remembered. I do not praise him if he held anything contrary to the Church; but I admire his learning and his knowledge, his eloquence and his skill in argument. . . .

As the executioner was about to light the fire behind his back so that he should not see it, 'Light it in front of me,' Jerome exclaimed, 'for if I had been afraid, I could easily have escaped it.' . . . Such was the end of a man excellent beyond belief. I was an eyewitness of every scene. I do not know whether he was impelled by obstinacy or by unbelief, but you might have fancied the death of some ancient philosopher. Mucius Scævola thrust his hand into the fire, and Socrates drank poison with less fearlessness and intrepidity than were exhibited by Jerome of Prague at the stake.

For Poggio Jerome's courage—his *virtù*—is a verifiable fact, whereas his beliefs, he seems to suggest, are not verifiable, or at least were not proved at the trial. As a Christian Poggio has to deplore Jerome's heresy, if such it be, but as a classical scholar who has recently copied out Quintilian's *The Training of an Orator*, he admires Jerome the man, since he believes that men are now to be judged by their conduct, especially by their fortitude.

This tension between the classical ideal and Christian teaching will last as long as the fifteenth century. It will not be confined to

ethics and individual conduct; it will mark almost the whole range of human activity and knowledge. It will entail such questions as whether Christian churches should be round, like Roman temples, and whether there can possibly be inhabited islands in the Western Ocean, as Columbus asserts and St Augustine denied. In whatever field the classical revival takes place, the tension will be present. At one moment the classical ideal will be in the ascendant, at another it will almost disappear, as when Savonarola comes to power and demands the burning of 'vanities'. But always the tension will remain between nature and grace, between the newly risen Hercules and Christ, between man increasingly conscious of his own powers and man the child of God. The tension, on the whole, will prove immensely fruitful. To reconcile the two forces, to make them inter-act in such a way as to draw out the best in each, will require a long and strenuous effort. This the Florentines are peculiarly suited to make. Sometimes they will fail, sometimes they will succeed brilliantly, but it is the effort itself, in almost every field of human activity, which will be their great and lasting achievement.

The Republic and the Medici

THE POLITICAL DEVELOPMENT of Florence in the fifteenth century is intimately linked with three generations of a single family.

The first Medici of consequence probably practised medicine, for the name is a shortening of *dei Medici*—'of the doctors'—and the family blazon, five red roundels or *palle*, probably represents pills or cupping glasses, though snobs were later to claim them as dents in the shield of one of Charlemagne's knights. The Medici are heard of as a middle-class family during the fourteenth century, with political leanings towards the *popolo minimo* or lesser guilds, but they remained unimportant until Giovanni di Bicci de' Medici founded a bank specializing in accounts with the Roman Curia. Giovanni's portrait shows a pear-shaped face, thin lips, high cheek-bones and kind, troubled eyes. Troubled doubtless because this was a period of schism, with two and sometimes three Popes popping up, and because bankers, still classified as usurers, had to get round the ban on interest-taking with clever dodges: calling interest '*discrezione*' (favour, yield), and claiming it as a free gift, not a contractual obligation. Giovanni occasionally held office but took no prominent part in politics, leaving this to the more highly-thought-of wool-merchants. He kept quiet and piled up a fortune of well over 100,000 florins.

Giovanni married Piccarda, daughter of one Odoardo Bueri. Her piquant name she doubtless owed to the commercial travels of Odoardo, just as the saint of Assisi received the name of Francesco from a father who bought cloth in France. In 1389 Piccarda gave birth to her first son, Cosimo. He received the usual primary education, then took a step that influenced him for life: from the ages of fourteen to seventeen he studied the classics in the house of

Roberto de' Rossi, a rich bachelor who had learned Greek from Emmanuel Chrysoloras and gave free lessons to a few bright pupils. Cosimo became an enthusiast for the new learning and planned a journey with Niccolò Niccoli to look for Greek manuscripts in the Holy Land, but his father, whose shelves held only three books—the Gospels, the Legend of St Margaret and a sermon in Italian—doubtless did not sympathize with this new kind of pilgrimage. Anyway, Cosimo started at once in the family bank.

'[Cosimo] was of fine physique and more than average height;' writes Pius II, a Sienese who seldom praised Florentines; 'his expression and manner of speech were mild; he was more cultured than merchants usually are and had some knowledge of Greek; his mind was keen and always alert; his spirit was neither cowardly nor brave; he stood up easily to hard work and hunger.' He also had simple habits—he rode a mule in preference to a horse—and used homely images: a quick-witted fellow he described as 'having his thoughts in ready cash'. He made friends easily—usually the right ones—for he was gifted with exceptional judgment of character and was said to be able to sum up a man by his face. He disliked clowns, jugglers and all pastimes except occasionally one game of chess after dinner.

In 1414 Cosimo made an excellent marriage to Contessina Bardi, whose family were Giovanni's partners, and undertook his first important job. John XXIII, a Neapolitan who had started life as a gentleman-pirate and, with Florentine backing, had been elected Pope, borrowed 15,750 florins from Giovanni de' Medici, leaving as surety a pearl-encrusted papal mitre; he then set off for the Council of Constance with Cosimo to handle his money and, soon, his lack of it. Upon John's deposition Cosimo travelled in Germany, France and perhaps Flanders before returning to Florence, where he and his father arranged a loan of 38,500 Rhenish florins in order to ransom John from the castle of Heidelberg. Cosimo was present in Florence in 1419 when John made his submission to his newly elected successor Martin V, and was rewarded with the see of Tusculum, which prompted the Florentines to quip that a bishop had become Pope and a Pope bishop. The Medici harboured John in their house opposite the cathedral until his death in 1420. Superstitious as only Neapolitans can be, the Pope had carried on his person a finger of

John the Baptist and this precious relic he bequeathed to Cosimo. Though John had proved a very expensive client, Cosimo remained a good friend to him even after his death and gave him a magnificent tomb in the Baptistery. There remained the pearl-encrusted mitre. Martin V claimed it, but Giovanni said the mitre was now his and would not give it up until threatened with excommunication.

In 1424 Cosimo became branch agent of the Medici bank in Rome, a responsible post because Rome was the most profitable branch in relation to invested capital, the yield exceeding 30 per cent. Contessina, who now had two small sons, remained in Florence. This was usual practice. She dictated letters to Cosimo and concerned herself that he should be well fed and warmly clothed. But after three years Cosimo grew tired of having no one to keep house in Tivoli and bought a slave girl in Venice for 60 ducats. She was a hot-blooded Circassian of twenty-two who at some point had picked up the name Maddalena. It turned out to be apt. Maddalena's duties extended in time from dusting and cooking, and presently she bore Cosimo a son. Such an occurrence was very common; doubtless Contessina minded, but Florentines in general did not think any the less either of Cosimo, or of the son, who was named Carlo, educated with his two half-brothers, and later became a papal protonotary and Archpriest of Prato.

On his father's death in 1429 Cosimo became head of the bank and Florence's second richest citizen. The classics—particularly a treatise on economics attributed to Aristotle—had given him a different attitude to wealth from old Giovanni's. Cosimo believed that in so far as virtue was action, money could foster virtue. As his friend Poggio expressed it in a dialogue *Concerning Avarice*, private and public life would be ruined if each man earned only what is strictly necessary. 'Money is an indispensable goad for the State, and those who seek money must be considered its basis and foundation.' This more positive outlook towards money combined with Cicero's more positive outlook towards citizenship. Cosimo had already stood for, and held, office; now, as head of the family, he decided to follow an active political career. Here it becomes necessary to look at Florence's constitution.

Citizenship was confined to members of the guilds, that is, to men

following a recognized profession or trade. Out of an estimated male population over twenty-five of 14,500, perhaps 6,000 were citizens: that is, they had the right to vote and hold office. But the important thing is that the ranks were open. Anyone, whatever his birth, might become a citizen by matriculating into one of the guilds. When it came to filling Councils or magistracies, members of the greater guilds—wool and cloth merchants and professional men —were given a marked numerical advantage—roughly in the ratio of three to one—over members of the lesser guilds—carpenters, blacksmiths, harness-makers and so on. Florence, then, was a republic with, for that time, a widely based franchise, but its constitution favoured the merchant class.

At the age of thirty the best qualified citizens became eligible for election to the Signoria, or government. Election was by lot. The eight purses containing the names of eligible candidates were taken from the sacristy of S. Croce, where they were kept, to the Palazzo della Signoria. Here the Podestà, or Chief Justice—a foreigner and presumably impartial—would, in the presence of the highest magistrates and anyone else who wished to attend, draw names from the purses, until candidates were found who were not barred by temporary disqualifications, such as tax-debts, having held the office recently, or from having family connections with others already elected to that period of office.

The Signoria comprised eight Priors and the Gonfalonier of Justice, who was the city's formal head of state and kept in his room the city's standard emblazoned with a red lily on a white field. The Signoria was counselled by two auxiliary 'Colleges', one of twelve Buonomini, the other of sixteen Gonfaloniers of Companies, one from each ward of the city. Both Colleges were chosen by lot.

The Signoria and Colleges, once in office, elected from the body of citizens, for four-month terms, the two legislative assemblies, the Council of the People and the Council of the Commune. The former comprised 300 citizens, including the Signoria, the Colleges and other ex officio delegates; the latter 200—though these figures, like all aspects of the constitution, could and did vary: Dante pokes fun at regulations made in October being out of force by mid-November. Bills were presented to the Councils by the Sig-

noria, with the consent of the Colleges, and on these Council members debated and voted. They recorded votes with beans, a black bean signifying Aye, a white one No. When passed by a two-thirds majority in both Councils, a bill became law.

A new Signoria was elected every two months, and other office-holders were changed almost as frequently. Nor could a Prior return to the Signoria before three years had passed. Though this proved an admirable safeguard against tyranny, it meant that the executive lacked continuity, and therefore strength. In times of crisis an ill-assorted Signoria might undo the work of its predecessor or fail to agree on any action at all. If the crisis became dangerous or prolonged, the Signoria would ring the great bell, the *Vacca*: every citizen then had to hurry to his proper place in the quarter of his residence, and report for duty to the Gonfalonier of his company. With banners flying, the sixteen citizen companies would march to the great square, shouting 'Viva il popolo e la libertà'. Meeting thus in *parlamento*, the citizens had the right to suspend, for a limited period, the ordinary working of the constitution by establishing a *balìa* or commission.

The *balìa's* chief importance lay in a subcommittee of ten *Accoppiatori*—officials responsible for drawing up electoral lists—with special powers to short-list candidates for the Signoria. This did not mean that the *Accoppiatori* could choose any names they wished—their choice was restricted to eligible citizens—but it did make more probable the election of responsible men and consistent government. On one typical occasion from a total of 560 candidates the *Accoppiatori* short-listed 38. Short-list elections were confined to the Signoria; the Colleges and nearly all magistracies continuing, even under a *balìa*, to be appointed by lot, without a scrutiny.

Such was the system. To make it work in practice, one family tended, informally and unofficially, to direct policy in the interests of a dominant group. The family at present was the Albizzi, rich wool merchants, and the dominant group the seven greater guilds (headed by the textile manufacturers and importers), who already possessed certain advantages under the constitution. A portrait of the head of the family, Rinaldo, shows a strong fleshy face, haughty eyes, a small pettish mouth and stubborn chin. Rinaldo was a

reactionary who upheld the ideals of the now extinct nobility. In a dialogue of the period he argues that profane learning is harmful to Christian faith; he secretly planned to reduce the power of the lesser guilds by halving their number from fourteen to seven; he liked pomp, jousting and military display, and he believed that Florence should expand through war.

Cosimo felt no sympathy with these ideals. Despite his wealth and the fact that he belonged to one of the greater guilds, he favoured not the *magnati* but the *popolo minimo*, hard hit by a five-year war with Milan into which Rinaldo had dragged Florence. However, being cautious, Cosimo did not oppose Rinaldo openly and in 1430 when Rinaldo launched a full-scale attack on Lucca, Florence's chief rival in the fast-growing silk trade, Cosimo agreed to serve as one of the Ten of War. The campaign went badly. Florence's *condottiere* proved feckless, and Milan sent troops to Lucca's help. Cosimo and his colleagues authorized the architect Brunelleschi to divert the Serchio river in order to inundate Lucca's stout brick-and-earth ramparts. But the garrison sallied forth as the work was nearing completion, demolished the containing wall, and flooded the camp of the besiegers, who beat a retreat to higher ground. In 1433 Florence had to patch up a hasty peace, Cosimo being one of the delegates.

The Lucca war had proved an expensive failure and Rinaldo needed a scapegoat. On 7 September 1433 a Signoria favourable to Rinaldo ordered the arrest of Cosimo on a charge of plotting to overthrow the Government. He was imprisoned in a tiny cell, eight feet by six feet, called the *Alberghettino*, the Small Inn, in the bell-tower of the Signoria. Two days later he heard the great bell *Vacca* boom out its summons to the people. Formed in their companies, they marched to the piazza below and there in *parlamento* suspended the ordinary working of the constitution in favour of a *balìa* of 200 citizens.

The *balìa* sat down to determine Cosimo's fate. Rinaldo's partisans accused Cosimo of having financed enemy troops: a charge easy to believe of an international banker, who necessarily transferred money between cities. Cosimo denied the accusation, and pointed out that he had actually advanced large sums to the Florentine

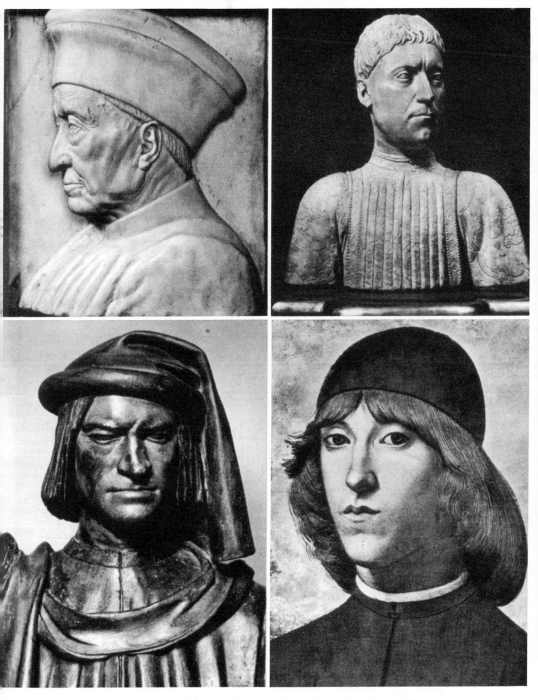

Four generations of the Medici. Cosimo, Piero the Gouty, Lorenzo,
Piero di Lorenzo

tissime uolens infamem filii uitam parentii
tum uerecundiam esse tum crimen. Vnde
non inconuenienter philosophus in rhetori
cis inquit. Necesse erubescere qdem in talibus
maloҁ que uidentur turpia esse ipsis aut hi
de qbus curant. uel secundum aliam translati
onem. Erubescet quis proculdubio secundum

rebus, ual memor nostri xv° kł febr.

Ad Philippum caualicen. familiaris epła . V.

IN elicona nostrum transalpinum q est ad faucem sorgie, iam senesce
tibus musis sacer uenire ibiq me sine quinqz dies agere potuisti, nec
uenit in mentem pater amantissime, dum ego absum, uel amenissimis
ipsis illis locis, uel animo saltem tuo, ut ad me efficitur, deesse aliqd
quod suppleri facillime potuisset, cum essem adeo propinquus ut pe
ne uiuis possem uocibus excitari, Quid igitur rei est, an inter tot
curarum estus, breue mihi ruris tui refrigerium inuidisti, sed tale
aliquid suspicari prohibet spectatissima uirtus tua. An indignum
censuisti, sed id amor notissimus uetat credi, uulgatumqz de me tuii

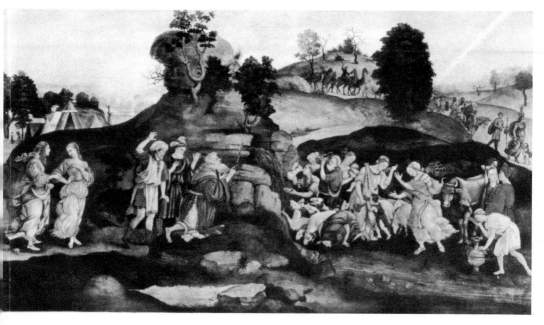

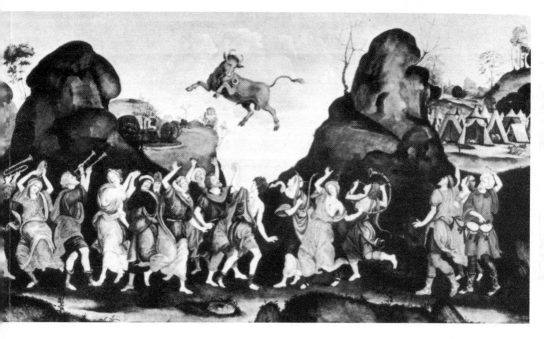

Florentine thinkers sought links between world religions. This pair of pictures by Filippino Lippi relates Moses's striking of water from the rock to the miracle of the bull-god Apis, who annually rose from the Nile to prance in the air above his worshippers

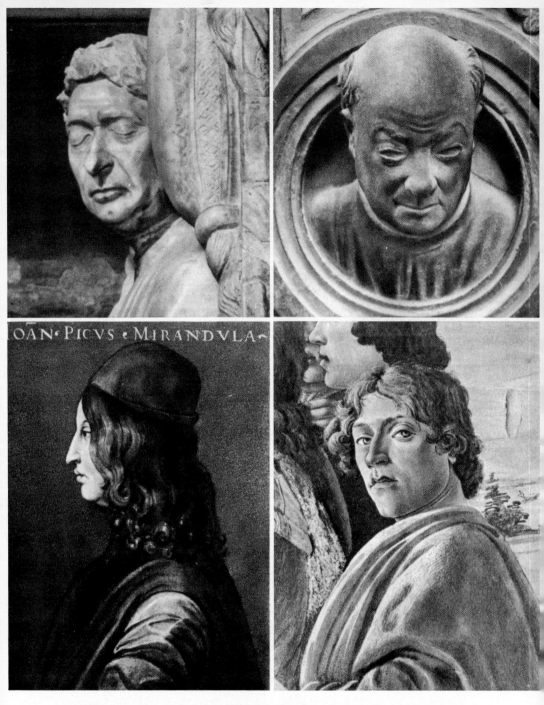

OAN · PICVS · MIRANDVLA ·

Writers and artists. Leonardo Bruni, who advocated a citizen army; Lorenzo Ghiberti, who made the Baptistery doors; Giovanni Pico della Mirandola, who attacked astrology; Sandro Botticelli, who, like Pico, was a follower of Savonarola

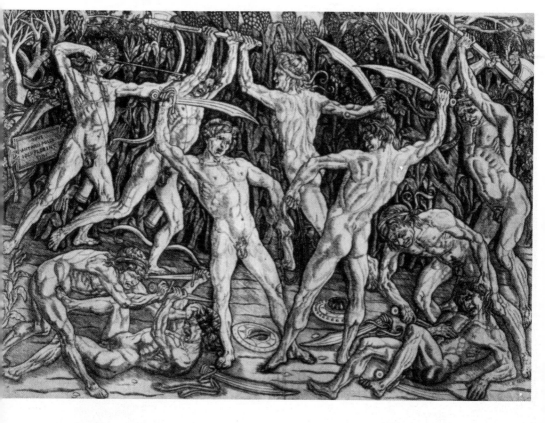

Pollaiuolo's *Battle of Nude Men* (*ca* 1470) shows a knowledge of anatomy gained by dissection. Later, Leonardo da Vinci investigated anatomy for its own sake as in (b) his drawings of the legs of a man and a horse

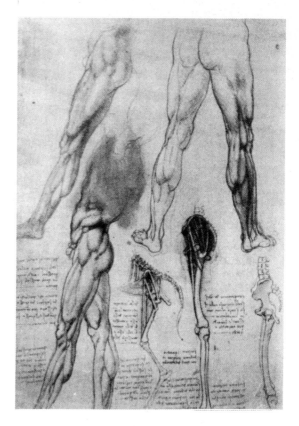

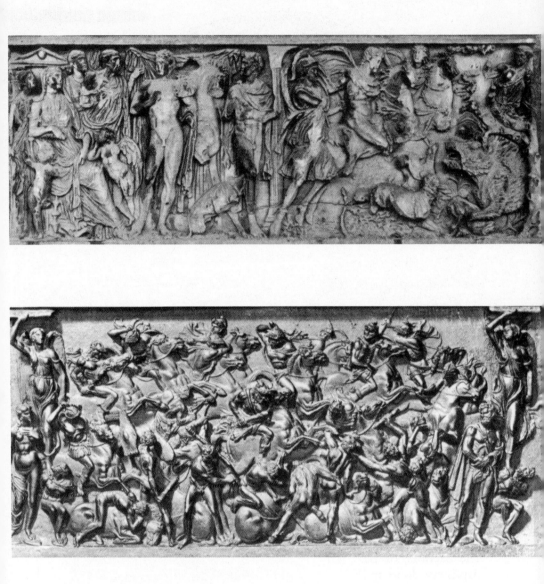

This Roman sarcophagus in Pisa (top), and others like it, supplied
Florentine artists with motifs, including the male nude and winged
putti. Bertoldo's *Battle Scene* shows how the motif of horsemen was
adapted

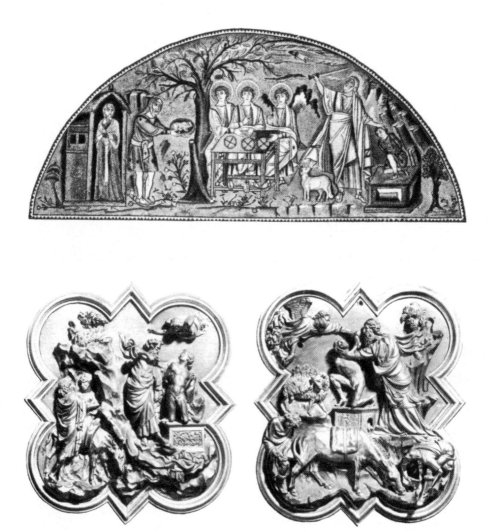

The Sacrifice of Isaac was the subject in a competition for the
Baptistery doors in 1401. In contrast with earlier versions such as
that in S. Vitale, Ravenna (top), the winning panels by Ghiberti
(left) and Brunelleschi drew on classical art

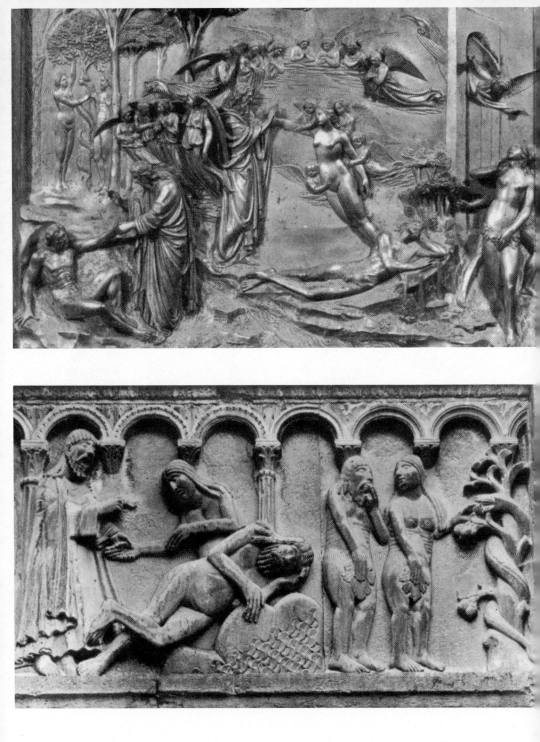

In the Creation of Adam and Eve and the Expulsion (top) Ghiberti
celebrates the beauty of the human body. The traditional rendering
of the body as unlovely and pitiful is seen in a 12th-century Modenese
bas-relief

Government to pay her troops. Cosimo's influential friends in Rome, Venice and Ferrara all made strong pleas for mercy, but Filelfo, an adherent of the Albizzi, wrote a poem urging the death penalty.

Under arrest Cosimo might not touch his property or his stock in the *Monte*, the funded debt. However, he had already salted away several large cash sums. One day he received a visit from a friend of the Gonfalonier of Justice. Cosimo passed this man a slip of paper, asking him to go to the director of the S. Maria Novella hospital, who would give him 1,100 ducats—a ducat was a Venetian coin, containing the same amount of fine gold as the florin; he was to keep 100 for himself and give 1,000 to the Gonfalonier. This and a second bribe to another influential official saved Cosimo's life. He was found guilty but sentenced only to banishment in Venetian territory for ten years. 'They were stupid', Cosimo later remarked, 'for they might have had 10,000 florins or more for allowing me to escape from danger'. On 3 October he was escorted out of Florence by the Porta S. Gallo, one more in the long list of gifted men to suffer from Florence's endemic disease: political faction. With him went his brother Lorenzo, an architect friend, Michelozzo, and many books, including copies of Suetonius and Sallust.

Exiles rarely returned. Dante did not, nor Petrarch's parents. In ten years the sentence would doubtless be extended for a further ten. Poggio sent Cosimo one of those 'consolatory' epistles so exasperating to the unfortunate, reminding him of Scipio Africanus, Cicero and others, all unjustly exiled: 'Fortune has restored you to real liberty.' But, unlike previous exiles, Cosimo had another kind of fortune on his side. Before his arrest he had transferred 15,000 florins to the credit of the Medici branch in Venice, where he was received, he says, 'like an ambassador, not like an exile'.

The departure of their leading banker upset Florence's finances. Not a single citizen, a friend wrote to Cosimo, can supply the government with a pistachio nut. A heavy military defeat at Imola worsened Rinaldo's position, which became further complicated in June, when the Pope, Eugenius IV, was driven from Rome by a stone-throwing mob and sought refuge in Florence. Cosimo happened to be staying in the monastery of S. Giorgio in Venice, where Eugenius had formerly been a friar. Seeing an opportunity of winning the Pope's

friendship, Cosimo commissioned Michelozzo to design a new library for the monastery, and himself paid for its construction.

The element of chance in the Florentine constitution now showed itself dramatically. In September 1434 the ballot purses brought in a Signoria favourable to Cosimo, which immediately authorized his return from exile. Cosimo and his brother left Venice on 29 September with an escort of 300 Venetian soldiers. Rinaldo, who had been absent, hurried back to Florence with 500 troops. For some hours it looked as though they would burn their opponents' houses, seize the Signoria and fight it out with the Medici. But the Pope intervened. He summoned Rinaldo to a meeting. What passed was never revealed, but the Pope wished to return to Rome, for which he needed large credits, and the meaning of the library had not been lost on him. He made it clear that he favoured Cosimo, and Rinaldo returned from the meeting broken in spirit.

The Signoria summoned a *parlamento*, which elected a *balìa* of 350. This *balìa* solemnly revoked the sentence passed on the Medici, and banished Rinaldo with all his family. On 5 October 1434, one year almost to the day after his departure, Cosimo returned to Florence, again by the small Porta S. Gallo. He was invited to dismount at the Signoria and spend the night there as guest of honour. Next day, cheered by large crowds, he paid a visit of thanks to Eugenius, then returned to his own house, opposite the cathedral. An era had ended, a new one was about to begin.

Cosimo was a new kind of statesman. He had never buckled on a breastplate and charged with a lance; he had no royal blood or famous ancestors to justify his influential position. Any power he had came from his extensive banking interests, whereby he could make his city prosperous. He also possessed a new kind of learning. In Ostia, Grottaferrata and the Alban hills, he and Poggio had copied worn and mossy inscriptions among the ruins; he collected Roman coins, cameos and intaglios; he rose early from bed in order to prune his own pear trees and plant his vines: doing so, says his bookseller friend, Vespasiano da Bisticci, 'in imitation of the ancient Romans'. If his power came from banking, it was from the Roman Republic that Cosimo drew his political principles.

From 1434 until his death in 1464 Cosimo was the most influential

man in Florence. During that time he opened banks in Milan, Bruges, London and elsewhere, which greatly increased his wealth and potential power. His friend and ally, Francesco Sforza, later Duke of Milan, constantly urged him to assume full powers. Cosimo could probably have done so, perhaps by becoming Gonfalonier for life. But true to his principles, he remained an ordinary citizen. He held high office often, but not more often than other leading citizens. He was Gonfalonier of Justice in 1435, 1439 and 1445; he served on boards managing foreign affairs and finance. Chiefly he made his influence felt, as the Albizzi had done, by intermittently using the constitutional device of *balie* and short-list elections to the Signoria.

Cosimo marks a shift from the closed to the open society. His moral purpose as a ruler, which was noted in 1456 by Giovanni Argyropoulos, Professor of Greek in Florence, never became repressive. When his severe friend, Archbishop Antonino, proposed a measure forbidding priests to gamble, Cosimo replied, 'Begin by forbidding them loaded dice.' 'I don't believe in government by paternosters,' was another of his sayings. Himself a *novus homo* as Cicero had been, he made it his practice to help any gifted man, whatever his background, to rise politically. To a critic who complained that by exiling Rinaldo's partisans he was emptying Florence, Cosimo replied, 'Seven or eight yards of scarlet will make a new citizen.'

In the past rulers and influential citizens had governed in the interests of this or that family, group of families, or business clique. Cosimo brought to bear a new concept, that of the *patria*. As Camillus and Cicero had worked for the *populus Romanus*, so Cosimo worked not for this or that group, but for all the people of Florence. This explains why he tolerated an opposition. Neri di Gino Capponi was allowed to attack his friendship with Sforza of Milan, Agnolo Acciaiuoli to lash him and his son Piero as *huomini freddi*, 'whom illness and old age have reduced to such cowardice that they avoid anything that might cause them trouble or worry'. Even two generations earlier opposition such as this had been met with imprisonment or bloody vendetta.

Cosimo's concern for the city as a whole also explains his attitude to taxation. It did not escape notice that one of the causes of the fall

of the Roman Republic had been the accumulation of immense private fortunes, which were then used to buy the *plebs*. Anxious to avoid a similar fate, the Florentines in 1427 instituted a *catasto*, which for the first time taxed liquid resources. While giving complete immunity to the poor, it hit the bankers heavily, the tax assessment of the Medici family rising from 14 florins to 397. Not only did Cosimo make no attempt to go back to the old system, but during his régime he paid steadily heavier taxes, as his bank prospered. In 1457, for example, when 82 per cent of Florentine households paid no tax at all, and only three households paid 100 florins or more, Cosimo paid 575 florins, four times as much as his nearest rivals.

The chief difference between the Roman and Florentine republics was that the former had possessed a Senate, with supreme control of foreign policy and taxation. Given Cosimo's respect for the classical model, it is not surprising that four years after coming to power he should establish, by constitutional means, a senate-like body, the *Concilio Maggiore*, to which the Councils delegated their control in matters concerning internal and external security and taxation. The *Concilio Maggiore* was a body of freely elected members. The first lasted from 1438 to 1441, and was followed by a second in 1443, whose members were to remain in office five years. In 1458, when a period of economic stagnation produced a serious challenge to Cosimo's principles, control of taxation and security was returned to the Councils, and the senate-like body took the form of a Council of One Hundred, no longer, however, with sole legislative powers. A Senate continued to be one of the main objectives of Medici policy, and under Lorenzo, as we shall see, was to become a permanent part of the constitution.

In foreign policy, Cosimo the banker naturally favoured peace and as Poggio remarks, he was recalled in 1434 because, 'like the Romans of old, the Florentines desired *pax et otium*,' but it is doubtful whether he would have been able to implement for long a policy which called for sweeping changes in traditional thinking, had he not been able to point, here also, to the classical model. The Roman Republic, in Florentine eyes, had been an age of peace, by contrast with the hated Empire, an age of conquest; what is more, the

Republic had ensured and guaranteed concord throughout Italy. This policy Cosimo was to make his own.

When he came to power, Cosimo found the prospects bleak. He inherited a traditional enemy in the Duke of Milan, Galeazzo's son Filippo, a secretive neurotic, so fat he could not mount a horse and so sensitive about his fatness that he would never have his portrait painted. Terrified of thunder, he had a sound-proof room made in his castle, where he would tremble during storms. While walking in his garden, he would throw off his purple and amethyst clothes and roll naked on the grass in the sun. He would approach a courtier, smile and talk in a friendly way, then dangle a snake under his nose. He married a woman twice his age, but when she had served his political purpose he charged her with adultery and had her executed. Reluctantly he married a second time, but hearing a dog howl on the wedding-night, he would have nothing to do with his bride, and locked her away with spies.

With so eccentric and violent a man, Cosimo realized, there could be little hope of a lasting political settlement. But Duke Filippo had a daughter named Bianca—illegitimate, it is true, but his only child— and the seventeen-year-old Bianca had recently been betrothed to the Duke's energetic *condottiere*, Francesco Sforza. In 1435 this soldier of fortune who might or might not be the next Duke—one could never tell with a man like Filippo—paid a visit to Florence. He had an open, round face, with salient nose and jaw; his receding hair he wore in a rolled curl at the nape. Accessible, bluff and good-natured, he won his soldiers' hearts by remembering the names of their horses. In contrast to the extravagant Viscontis, he ate and drank in moderation, scoffed at horoscopes and practised his father's three golden rules: never make love to another man's wife, never beat a servant, never ride a horse with a hard mouth.

Cosimo quickly took to this energetic soldier with the same simple habits as himself, and recognized in him a key political figure. Sforza had already made himself Lord of the Marches, an eastern border province of strategic importance, and intended to retain it, though this went against Filippo's wishes. If Sforza, menaced by Filippo, turned to Venice for help, the Most Serene Republic, already grown too powerful for Florentine comfort, might well

make herself mistress of Lombardy. Cosimo saw that the best way to avoid this and to ensure that Sforza became next Duke of Milan was to back him with all the credit of the Medici bank.

This he did. The alliance with an upstart despot displeased many Florentines and was much criticized. But it succeeded. In 1450 Sforza made himself Duke of Milan, thus offsetting Venetian power and giving Florence a strong friend to the north. Cosimo was then able to accomplish the ambitious plan for which he had long been working. In 1455 he concluded a series of alliances between Florence, Milan, Venice and Naples, all of which had been intermittently at war since 1400. The signatories agreed to keep the peace for twenty-five years and to stand together against any member state that should commit an aggressive act. Cosimo's Peace of Lodi—the first considered attempt since classical times to preserve peace on a nation-wide basis—was accepted by practically every state of Italy, great or small. Cosimo called the grouping of states the *lega Italica*, and intended it to assume some of the characteristics of a federation. Its partly classical, partly Christian inspiration is preserved in lines which the poet Naldo Naldi attributes to Cosimo:

The temple of Janus will be closed,
Frenzied Mars chained,
Ancient Faith will return and dispense Justice;
Peace, with her purple wreath, will visit the dwellings of Italy,
And the sheep will graze safely in the field.

The gravest threat to Cosimo's peace came as an indirect result of events at the other end of Europe. Bellini's portrait of Mahomet II shows small intelligent eyes under arched brows, a long aquiline nose that almost touched his upper lip, and a great sweep of jaw. The Sultan spoke Turkish, Arabic, Persian and Hebrew, had a working knowledge of geography and history, appreciated painting and wrote poetry in Persian. Intending to found a great Euro-Asian empire, at the age of twenty-three he set siege to Constantinople, a city whose population had dwindled to 42,000 lay people and 18,000 religious. Constantine XI sent for help to Italy, but in that year the leading states were still at war and no help was forthcoming. Mahomet bombarded the walls with sixty heavy guns, the largest being twenty-six feet long with a calibre of forty-eight

inches and firing a cannonball weighing 1,450 pounds. Then he flung in his janissaries. The end is described by a Florentine merchant named Tedardi, who fought with the Greeks and left one of the best eye-witness accounts of the city's fall on 30 May 1453. Constantine rode into the thick of the battle, first throwing off his imperial insignia, so that he might die anonymously. He went down fighting, but his dead body was later identified by a Turk, for he had forgotten to remove his buskins, embroidered in gold with the tell-tale double-headed eagle. While the head of the last Constantine was severed and exposed to jeers on a column of porphyry, Mahomet entered the dusty halls of the Imperial Palace and, deeply moved, was heard to murmur a couplet from Sa'adi:

> Now the spider is chamberlain in Caesar's palace
> And the owl hoots the watch on the towers of Afrasiab.

Italy learned of the disaster with mixed feelings. Florence feared for her alum supplies, Venice for her Empire. Archbishop Antonino, severe as usual, explained that 'the Greeks were exterminated by a just judgment of God'—because they had withdrawn from communion with Rome. But the future Pius II wrote 'My hand is trembling; indignation prevents me from keeping silence, grief from writing coherently. It is shameful to be still alive. Italy, Germany, France and Spain are flourishing and yet (shame on us!) we have allowed Constantinople to fall to the voluptuous Turks.'

When he became Pope, Pius II offered to confirm Mahomet in his new possessions, provided the Sultan offered his head, like Clovis, to the waters of baptism. Mahomet had broad religious views, but not so broad as that. Pius II then announced his intention of launching a great crusade. Florence being now the political leader of Italy, he turned first to that city, asking Florentines to equip two galleys against the Turk, and naming the indulgences they would enjoy in the next world.

Crusade, *sacrum bellum*, had been a recognized feature of Christianity for four and a half centuries, accepted as normal, like the burning of heretics, and practised as recently as 1461 by the terribly-named Bladus Dracula, hospodar of Wallachia and Moldavia, who impaled 20,000 Bulgars regardless of age or sex, an act said to have made even Mahomet shudder. But Cosimo and the Florentines now had

another way of life before their eyes. Neither the Athenians nor the Romans of the Republic had waged religious war: indeed it is doubtful whether they would have understood the meaning of that odd phrase *sacrum bellum*. They provided the Florentines with a lesson in religious tolerance lost to the West since the early days of Christianity. Cosimo replied to Pius, tactfully of course, because he was the Pope's banker: 'When you solemnly speak of our immortal life to come, can any be so dull and leaden not to feel exalted as he reads your words, not to catch a glimpse of the glory of his own immortality?... But with regard to your present plan, most blessed Father, could it be that you, Christ's vicar, are attempting it without the presence within you of Him whose representative you are?'

Cosimo's reply set an example followed by other Italian cities. None save Venice would support the crusade. Doggedly Pius hired a few mercenaries and, already a sick man, set off for the port of Ancona. On the way his suite noticed the mercenaries drifting back, having sold their arms to the Jews of Ancona. They hastily drew the curtains of the Pope's litter, so that he should be spared this final humiliation. A few days later Pius was dead, and Cosimo's peace remained intact.

Cosimo's exceptional services to Florence did not pass unrecognized. For the unprecedentedly long period of thirty years he gave the city, in Tommaso Soderini's words, 'unity and freedom from civil strife', and when he came to die in 1464 the judicial body known as the Ten on Liberty, having incorporated in their *acta* a minute setting forth Cosimo's services, drafted a law giving him the title of *Pater Patriæ*, Father of the State, which had been awarded to Cicero after he foiled a conspiracy against the Senate by the Roman patrician Catiline. Contemporaries were struck by the parallel between Cicero's behaviour and that of Cosimo, who foiled the oligarch Rinaldo in 1434, and again in 1440 when Rinaldo staged a comeback with Milanese help and was decisively defeated by Florentine mercenaries at the Battle of Anghiari. But the fine-sounding epithet, which had been applied to Cosimo by close friends even during his lifetime, was meant also in the larger sense of one who had set the republic on a sure basis. The Ten appointed a young humanist

statesman, Donato Acciaiuoli, to commend the law to the people in a set speech. The law was adopted by acclamation, and Cosimo's tomb duly inscribed *Pater Patriæ*.

Florentines, with their strong sense of family, looked to Cosimo's son Piero to succeed his father in directing policy, just as he succeeded to the Palazzo Medici and control of the family bank. At forty-eight Piero had a handsome, long, full-jowled face, and the thin tight lips of one continually under strain. For whereas Cosimo had enjoyed excellent health, Piero suffered so severely from arthritis and gout that even on short journeys he had to be carried, and he was known as Piero the Gouty. Piero was to play an important part in the development of the arts, but politically his short term of power marks a period of transition. He accepted the succession, foiled a plot by rich citizens to seize the State with the help of Ferrarese troops, continued to apply his father's republican principles, and after only five years as 'first citizen' succumbed to the disease which had for so long held him cripple.

Piero's elder son Lorenzo was then aged twenty: tall, straight, broad-shouldered and muscular, his head despite irregular features attractive by its power. He spent some of his inexhaustible energy riding, hunting and jousting, at which he won a silver helmet. Himself a vigorous creature, he loved race-horses and hunting-dogs. Amusing, witty and open-handed, he made friends as easily as his grandfather had made money. He inherited Piero's taste for the arts and his mother's gift for poetry; these pursuits interested him more than politics. He was not by temperament a politician, and when the leading men of the city and the régime asked him to assume the care of both, on the grounds that 'it is always easier to maintain a power which by its continuance has outlived envy, than to raise a new one which unforeseen causes may overthrow', Lorenzo accepted, he says, with great reluctance: 'solely for the safety of our friends and of our possessions. For it is ill living in Florence for the rich unless they rule the State.'

The Florentines had respected Cosimo and accepted Piero, but for Lorenzo their feelings were warmer. He displayed a natural charm and panache which won their hearts—and they were not easily given to sentiment. Democracies occasionally throw up such

brilliant figures and, when they do, accord them an influence which may on occasion upset the balance within the State.

Lorenzo's life will be considered later: here it is enough to look at his role in the republic. His period of influence coincided with a military threat from Naples and Rome, and with economic decline, partly consequent upon England's policy of keeping her thick, curly Cotswold fleeces at home to manufacture her own cloth. So serious did this decline become that because of their heavy losses, Lorenzo had to close branches of the bank which Cosimo had opened in Milan and Bruges. In times of political and economic crisis a government has to take quick decisions and impose unpopular taxes; hence it must be strong. Lorenzo's way of strengthening the government was to revive Cosimo's concept of a Senate.

In 1480 a *balìa* created a new Council of Seventy, composed of the thirty members of the *balìa*, and of forty citizens of at least forty years of age co-opted by them. The Seventy was to sit for life, and to replace the *Accoppiatori* in carrying out scrutinies of candidates for office and in electing the Signoria from short-lists. Every six months thirty of the Seventy were to elect from among their members new magistracies, the *Otto di Pratica* and the *Dodici Procuratori*, the first responsible for foreign policy, the second for home affairs and spending public money. The Council of Seventy thus became the principal organ of all important decisions, while the Council of One Hundred, which in 1471 had again been given powers to legislate on financial matters, passed more and more laws. It has been calculated that the meetings of the Councils of the People and Commune which completed legislation declined from an annual average of 22·2 during the decade 1470 to 1479, to an annual average of 14·3 during the decade 1480 to 1489. On the other hand, the annual average of the meetings in which the Council of One Hundred passed legislation by its sole authority rose from 5·8 to 8·4 in the same periods.

The trend towards government through one or more senate-like bodies, as in ancient Rome, had been initiated by Cosimo and was now brought to completion under Lorenzo. The Seventy marks a gain in expertise, but a loss in so far as it sheared the older Councils' powers. If Lorenzo proposed it, he did not create it. It was the

Florentines themselves who voted this and other changes constitutionally, recognizing that difficult times demanded prompt and expert decisions.

In 1481 a new law was passed, making taxation progressive. It hit the rich very heavily. Lorenzo's tax assessment soared, becoming proportionately about double that of Cosimo's in 1457, and since the *catasto* was levied three times between December and August 1482, in that period Lorenzo paid to the state 66 per cent of his taxable income. He continued to pay progressive taxation at the heaviest rate for the rest of his life, and this important fact must be taken into account when assessing Lorenzo's political career.

The truth seems to be that there were very real limits to Lorenzo's power, even as a leading member of the Seventy. His personal influence seems never to have become unconstitutional. Very full documentation for the year 1484 shows that Lorenzo influenced the drawing up of the lists of candidates for office, but did not control them. He at no point exceeded his powers as an ordinary citizen. During peace negotiations at the time of the Ferrara war in 1482 he told the Milanese envoys that he had done all he could in trying to persuade the Florentines to accept their master's viewpoint, and that he could not do more 'considering that he is not Signore of Florence, but a citizen', and although he had more authority than he deserved, 'in such a case even he had to be patient and to conform to the will of the majority'. In September 1491 he wrote to the Florentine ambassador in Rome that the 'natural foundation' of his position, as constituted by his popularity in Florence, was much more useful to the Pope than any foundation that was less so. And the law passed a few days after Lorenzo's death granting the succession to his son Piero referred to Lorenzo simply as *vir primarius nostræ civitatis*. That the Medicis' influential position in the State could be terminated by the citizens at any moment was to be made abundantly clear, as we shall see, by the expulsion of Piero in 1494.

The unique achievement of the Medici was that for a period of sixty years they preserved the republic at a time when nearly every other Italian state was subject to tyranny, and such was the popularity of tyrants that the people executed those who stabbed Galeazzo Maria Sforza, hanged the Canedolo at Bologna for trying to deliver

them from the Bentivoglio, cut off Bernardo Nardi's head for trying to restore the republic in Prato; killed and hanged at a brothel door those who had assassinated Biordo dei Michelotti, tyrant of Perugia. The Medici succeeded in preserving the republic because they, and the leading citizens, now had before their eyes historical examples of republicanism actually working, and which provided at certain points guidance for Florence.

The Medicis' own view of themselves clearly emerges from their tombs. This was a period when Italian rulers, even the doges of Venice, perpetuated their names in monumental Gothic tombs, thirty feet high, intricately carved and adorned with up to twenty-two figures, their own towering above the rest, sometimes on horseback waving a sword. Florentines could do this sort of thing if they wished: when it came to burying the young Cardinal of Portugal in San Miniato they made perhaps the most beautiful tomb devised by man, while for John XXIII Cosimo de' Medici had commissioned from Donatello and Michelozzo a fine elaborate tomb with an effigy. But when it came to his own burial arrangements, Cosimo chose a plain tomb without an effigy, such as the Roman Republic had favoured. So did Piero. So did Lorenzo. It was the Medicis' proudest claim that they were ordinary citizens.

The republic which the Medici did so much to preserve had its basis in law, mostly that Roman law which had begun to be rediscovered in the twelfth century. The importance accorded by Roman law to individual rather than family rights and to moveable property as opposed to land, had helped Florence to develop from a feudal to a commercial city, and Roman law remained a powerful guarantee of justice, the equality of citizens, and of private property, including a wife's right to keep her dowry after marriage. Coluccio had been typical of an older age in treating law as something unchanging and divine; his successors such as Poggio saw clearly that law, being different in different cities, was a man-made thing, though always higher than any individual or group, and therefore to be altered only with extreme care. All would have agreed that the main purpose of law in a republic is to ensure order and liberty.

By preserving liberty under law the Medici may be said to have

contributed to all Florence's creative achievements. 'Without liberty', wrote Bruni in 1420, 'no republic can exist, and without it, the wisest men have held, one should not live at all.' In Florence, he goes on, that liberty consists in the free access of every citizen to public offices and honours. 'And it is marvellous to see how powerful this access to public offices, once it is offered to a free people, proves to be in awakening the talents of the citizens.' Bruni is convinced that the remarkable flowering of talent in Florence is directly related to her political constitution.

Liberty's most important form was freedom of speech. Every Florentine was free to think, write and speak as he chose, short of sedition or treason. Cosimo accepted the dedication of Beccadelli's *Hermaphroditus* not from any sympathy with its subject-matter but because he believed in broad-mindedness. This freedom lay at the heart of all Florence's originality. If Donatello wished to depict King David for the first time unclothed, he was free to do so. If Lorenzo's friend Luigi Pulci wished to parody the *Gloria Patri* and the *Pater Noster*, to attribute sudden conversions to the lowest motives, to write that 'the soul enters the body like jam put into a sandwich of bread fresh from the oven', he was free to do so. If Marsilio Ficino suggested that texts from Plato should be read publicly in Florentine churches, no one threw him into prison.

But this is precisely what happened elsewhere, for Florence's freedom of expression was, in Italy at least, unique. In Venice the dreaded Council of Ten could swoop, judge and execute any suspect at any time—all in secret—and even had a listening-post hidden behind the Doge's bed. In Rome persecution could also be severe, as a famous incident will show. A Calabrian-born classical scholar named Piero Sanseverino settled on the Esquiline and took the good old Roman name of Pomponius, to which he added Laetus—'the happy one'. A small man with short curly hair prematurely grey, bright eyes and slightly lame, every morning before sunrise he could be seen shuffling down from the Esquiline, buskins on his legs like an ancient Roman and a lantern in one hand, in order to lecture on history in impeccable Latin, for fear of spoiling which he declined to learn Greek—as good a pretext as any. Pomponius and his friends formed an Academy in order to study classical texts, medals and

inscriptions. They met in the catacombs, discussed Plato's arguments for immortality, celebrated a banquet on 20 April, eve of the anniversary of the founding of Rome, and called Pomponius, as high priest of the antiquarian cult, '*pontifex maximus*,' a title from pagan Rome which had devolved on the popes. In 1468, suspecting a republican plot which did not in fact exist, Paul II arrested the scholars, threw them into the Castel S. Angelo, and had them tortured. The castle resounded with their groans 'like the bull of Phalaris', and one unfortunate Academician, Agostino Campano, died under the *strappado*. The rest were finally acquitted, but the Pope ordered them to be detained in prison during a full year, alleging that he did this to fulfil a vow made when he first arrested them.

The Florentines were proud of their constitution, and knew it to be unique. Certain Flemish towns had evolved rule by members of the merchant guilds, but by 1400 all save Ghent had lost their independence. The Hansa towns of north Germany had also for a time enjoyed burgher rule, but now all were in decline before local princes. In Italy itself any state not under the rule of a tyrant called itself a republic, but the word was improperly used save by Florence. In the 'republic' of Siena, for example, citizenship was strictly hereditary. In Venice the sovereign assembly consisted, from 1319, solely of the sons of those patrician families whose names were written in the Golden Book. All marriages and births were entered by the Heralds' College in this register, which became virtually a studbook ensuring purity of blood. The result was that in Venice, with a population three times as large as Florence's, citizenship was rigorously confined to 200 families.

Florence's broadly-based franchise no one appreciated more than Leonardo Bruni, and he may stand as the type of public-spirited citizen. Born in 1370, the son of an Arezzo grain-dealer, Bruni trained as a lawyer, learned Greek and became a protégé of Coluccio, who found him a post as papal secretary in 1405. He thought of taking orders and accepted a canonry, but in 1412 renounced it in order to marry a certain Tommasa, who brought him the large dowry of 1,100 florins, some compensation for the expensive wedding festivities of which Bruni remarked, 'In one night I have con-

summated my marriage and consumed my patrimony.' He wrote extensively and made many translations, notably of Aristotle's *Ethics* and *Politics*.

Where Poggio was fun-loving and Niccoli in the best sense a dilettante, Bruni's dominant traits were moral earnestness and patriotism. Loving Florence with all the passion of a provincial who has made good, he wanted everyone to be as civic-minded and sober as himself. When his friend Niccoli started living with Benvenuta, who had formerly been the mistress of Niccoli's brother, Bruni threw up his hands: '*O flagitium atrox! detestandam turpitudinem!*' Which should come first, friendship or moral principles? Finally he decided that Niccoli was getting classical studies a bad name, and told his friend what he thought of Malvenuta, as he called her by analogy with the Samnites, who had changed the name of Malventum to Beneventum. Niccoli resented the well-meant homily and their friendship was broken for many years: it was the good-natured Poggio who finally mended it.

Bruni was deeply concerned with the military defence of the republic. To preserve her exceptional privileges Florence had to be strong. Should citizens bear arms themselves, or rely on mercenaries? Such was the debate which lasted many years, costing Bruni and his contemporaries agonies of mind.

During the thirteenth century, in accordance with the medieval division of society into *orantes*, *bellantes* and *laborantes*, Florence had entrusted her military fortunes chiefly to her own noblemen. At Campaldino in 1289 Dante had seen the nobles' cavalry attack win the day against Arezzo, and it was precisely their intolerable arrogance and unruliness after this triumph which led to the enactment of the Ordinances of Justice four years later. Disfranchised, the nobles proved increasingly unreliable, and Florence fell back on citizen soldiers. But these undertrained amateurs proved no match for professional foreigners. As wars increased in length, it became exceedingly expensive to keep large bodies of citizens away from productive work, and the same argument applied to unfranchised labourers. In the fourteenth century Florence solved the problem by employing mercenaries.

The new classical ideal, as embodied in Periclean Athens and

Republican Rome, laid down unmistakably that the defence of their country devolved upon the citizens themselves. Aeschylus fighting at Marathon, Socrates at Potidæa, Cato in the second Punic War—innumerable examples illustrated this truth. But since it was a truth unpalatable to many Florentines, in 1422 Leonardo Bruni wrote a short treatise, *Concerning a Citizen Army*, in order to drive it home. Bruni argued that Florence, like republican Rome, should institute a special class of professional cavalrymen, to be known as *equites* or knights. He complained that barbarians from beyond the Alps had perverted the Roman pattern of knighthood by transforming the order of chivalry into a closed preserve of the nobility. Bruni's knights would be recruited on the basis of personal merit only. Rejecting the legal maxim, enshrined in the Code of Justinian, that the military might not participate in civil affairs, Bruni laid down that knights should be free to hold civil office, though they were to be barred from business. The Florentine knights would be supported, in war, by the whole body of citizens, serving on foot. Such a force, argued Bruni, would fight more effectively and with greater spirit than mercenaries, whose unreliability had become proverbial.

Though Bruni's case for a citizen army was later taken up by Palmieri and Cristoforo Landino, the Medici rejected it, as did the majority of Florentines. The Medici were every inch as patriotic as Bruni, but they disagreed with his methods. Some citizens, following Coluccio, felt that to put weapons into the citizens' hands would make for that very armed faction which throughout the Middle Ages had hampered Florence's development as a free republic. Others pointed out that Florence's military triumphs and territorial expansion from 1380 to 1420 had been achieved by mercenaries. But perhaps the most compelling reason for the rejection of Bruni's case was that Florentines no longer wished to expose themselves to the dangers of war. Though they remained bold thinkers, the old physical boldness was ebbing, atrophied by a hundred years of relying on mercenaries. Two examples from many will make this clear.

In 1436 the Signoria fulfilled a long-standing promise to honour Sir John Hawkwood with a painted monument. This son of an

Essex tanner had been a daring general who took the offensive when-ever he could, but the inscription below Uccello's effigy refers to him as very cautious: '*Ioannes Acutus eques Britannicus dux ætatis suæ cautissimus et rei militaris peritissimus habitus est.*' The explanation is that the words from *dux* onwards come from a classical inscription to Q. Fabius Maximus, nicknamed Cunctator, who really had been cautious to a fault. It is understandable that Florentine humanists should have wished to identify their own general with a well-known figure of the Republic, but so inappropriate a choice as Fabius shows that they too were beginning to overvalue caution. This is confirmed by the second incident. When the Florentine Chancellor Giannozzo Manetti presented insignia of military command to Sigismondo Malatesta on 30 September 1453, he expressly declared that the replacement of the citizen army by mercenaries was a prudent policy designed to protect the citizens from the personal risks of military service.

The consequences of rejecting, in this respect, the classical ideal were not at first very serious. Florence continued to hire *condottieri*, her favourite being Federigo da Montefeltro, lord of Urbino. A lance-blow in a tournament cost Federigo a nicked nose and the loss of his right eye, after which he had himself painted in profile, often reading, full armed, in his library, where the books were bound in scarlet and silver, except the Bible, which had a binding of gold brocade. Federigo chose as his personal emblem both a sword *and* an olive branch, and nothing could better symbolize the bloodless wars of the fifteenth century: manœuvering and shouting and blow-ing of trumpets, but little actual fighting. One of Federigo's sorties, on behalf of Pius II and pronounced by that eloquent prelate to be not only a victory, but 'the righteous vengeance of God', resulted in nothing more than the capture of 20,000 hens, while at Macalo in 1427, 8,000 Milanese troops took part without one being killed. As the Florentine apothecary Landucci wrote in 1478: 'The rule for our Italian soldiers seems to be this: "You pillage there, and we will pillage here; there is no need for us to approach too close to one another." '

As a result, Florence was lulled into a false sense of security. The great republic came to rely on mercenaries, 'unblooded' and

increasingly inept. She ignored the significance of France's decision in 1439 to levy direct taxation in order to support a strong permanent army. When Constantinople fell, it was not Mahomet's giant Wallachian-built gun ironically named Basilica which excited their attention, but Ciriaco d' Ancona's description of a fine equestrian statue of Justinian. So that when the French invasion at last came, Florence was to find herself unprepared in arms and men, as well as in spirit.

If Florence had formed a citizen army, she would doubtless have remained truer than she did to the classical ideal. But the fact that her citizens remained men of peace—this also stemmed from devotion to the classical ideal. Life in a well-ordered republic modelled on classical Rome had taken on a new richness and man a new dignity. Since war destroyed both, it did not really interest the Florentines. They had other more pressing and more generous pursuits.

Man Whole and Complete

THE Florentines put the classical ideal into practice in their own lives no less than in affairs of State. When they first encountered Greeks and Romans in faded ink on wrinkled parchment they found them, by comparison with themselves, 'whole and complete', and they naturally sought to make up their deficiencies in this respect. The process was a gradual one, for the Florentines, being a practical and experimental people, adopted theories only after they had tested them by experience. But steadily, under the influence of the classical ideal, Florentine attitudes changed, and nowhere was the change to have more far-reaching consequences than in their attitude to the body.

If ever a religion made clear that the body, like all created things, is good in itself and remains good so long as it is treated with respect, that religion is Christianity. The second person of the Trinity has a human body. The Word made flesh and blood has redeemed human flesh and blood. By what unholy perversion had it come to pass that, at the beginning of the fifteenth century, Christianity held the body in such abhorrence that fallen man was never represented nude save in certain shameful scenes such as the expulsion from Eden, and S. Bernardino could declare from the pulpit: 'I believe so few are saved among those in the married state that, of a thousand marriages, nine hundred and ninety-nine seem to be marriages of the Devil.'

In the long and complex process which had turned a God-given body into a prison-house of the soul, two factors were of special importance. The first occurred during the collapse of the Roman Empire. Men of sensibility—pagan and Christian alike—turned away from a world of disappointment and disaster. They sought

reassurance and calm in an extra-temporal world of thought. Their needs were satisfied by the neo-Platonist writers of Alexandria, who took out of context certain Oriental features of Plato's thought, swelled them to undue proportion, and amalgamated them with elements from Hinduism. They taught that only mind is perfect, and all matter tainted. Cicero had given publicity to similar views in a minor work, not central to his own thought, entitled *Scipio's Dream*. The body 'fetters', says Cicero there; we come into it by a sort of fall; the body is irrelevant to our nature: 'the mind of each man is the man.' Macrobius, a Roman who lived about A.D. 400, wrote a commentary on *Scipio's Dream* in which he took these ideas even further. For Macrobius, the universe seeps into existence; instead of creation, he sees a series of declensions, diminutions, almost of inconstancies. Only by climbing back from matter to pure mind can man attain his true self.

Many educated Christians adopted these views. They professed a fakir's version of Christ's teaching. The situation might eventually have righted itself had it not been for the second factor. During the barbarian invasions Christian thinking was kept alive in monasteries, by men vowed to celibacy who identified the body with the brute strength, the burnings and torture and carnage which went on outside the monastery walls and kept many monasteries in a state of siege. It was natural for monks to view the body with shame and to debase it at the expense of mind. *Scipio's Dream* became a favourite work and Macrobius a favourite author. Boethius's doctrine of resignation grew out of the same distrust of the body, and of the world.

The view of the body as something evil and shameful hardened during the Dark Ages: the Middle Ages merely codified it and supported it with appropriate snippets, notably St Jerome's statement that no man can serve both a wife and philosophy, and Plato's warning, which Augustine quotes to Petrarch in the *Secretum Meum*: 'Nothing so much hinders our knowledge of the Divine as lust and the burning desire of carnal passion.' Holiness was equated with continence and not eating flesh. Even key New Testament words were twisted out of recognition: in the thirteenth century Cæsarius of Heisterbach defines conversion as leaving the world for the cloister. Petrarch feared sexual passion, feared the body. To his

brother Gherardo he wrote: 'We were begotten in carnal depravity by our father,' while in his letters concerning Laura the key words are 'fear' (of his passion), 'safety', 'hiding-place'. Married laymen tended to regard themselves, and to be regarded by the clergy, as second-rate Christians, for no other reason than that they made love.

When the Florentines turned to the classical world at the beginning of the fifteenth century, they found that the Greeks, far from despising the body, valued it for its strength and beauty; indeed it was by their bodies that they resembled the gods. They prized the body all the more because it would not survive death—Homer likens the dead to bats fluttering and screeching in a cavern—hence the Athenians' perplexity when St Paul preached the Resurrection. They depicted the body in their art with admiration, tenderness and joy. Pindar's odes to victors in the games, countless love poems and drinking songs bore witness to a healthy, unashamed love of the body and bodily pursuits. The Romans had inherited this attitude. They too esteemed the body, its vigour more than its beauty. It was Juvenal of Aquinum who penned the tag *mens sana in corpore sano*. Neither the Romans nor the Greeks attached much value to celibacy. Their most representative men had married and founded families. The Romans in particular esteemed the married state: husband and wife who remained devoted to each other through the years were portrayed in the same roundel on their grave.

The first result of these discoveries was that the Florentines began to take a brighter view of marriage. Leon Battista Alberti devoted much of his chief work, the *Della Famiglia*, to praise of married love, and whereas Boccaccio had criticized Dante for marrying, 'since a wife is a hindrance to studies', Bruni, in his *Life of Dante*, chided Boccaccio for that conclusion: Dante had done well to marry, for the greatest philosophers, such as Socrates, Aristotle, Cicero, Cato, Seneca and Varro, all married and founded families. Not only did the Florentines rehabilitate marriage, they went so far as to suggest that on this point the classical ideal was more in keeping with Christianity than the view presented as Christian for upwards of a thousand years. Married love, according to Alberti, is of all

relationships *religiosissima*, while Lorenzo Valla criticizes priests and nuns for calling themselves 'religious', a name, he declares, which by right also belongs to laymen, single or married.

One typical example illustrates the new attitude in practice. Poggio had been brought up in the traditional view that a married scholar was a contradiction in terms. He considered marriage an irrational act. For a long time he declined to take a wife, though this did not prevent him from begetting numerous children. Finally the influence of his friends, and the examples of antiquity they cited, induced Poggio to accept the responsibilities as well as the pleasures of the flesh. In December 1435 he married Vaggia, daughter of Ghino Menente de' Buondelmonti, an honourable and wealthy Florentine. Poggio was fifty-five, his bride eighteen, and in order to allay his own and his friends' doubts on this difference of age, Poggio wrote a Latin dialogue (with dedicatory epistle to Cosimo) *Concerning Marriage*. Marriage, says Poggio with the slight unction of one newly reformed, is an excellent state, it preserves a man from licentiousness, which is the worst form of slavery, and a husband no longer young has the advantage of full experience, whereby he is able to train his wife to limit her appetites. The marriage turned out well, six children were born and Cosimo gave them a house: later, in 1453, he was to have his friend appointed Chancellor of Florence.

Concomitantly with the rehabilitation of marriage, and largely influenced by it, went a new attitude towards women. There had been something slightly unhealthy about the old attitude. Mainly as the result of Provençal 'courtly love', itself a form of the old neo-Platonic dualism between matter and mind, unattainable women had been idealized, while actual women had never been truly accepted as persons. Dante married Gemma Donati, but it was Beatrice he continued to love, and he gave the name Beatrice to one of his children. Gemma he would not allow to join him in exile, nor does he mention her name in *The Comedy*. Petrarch conceived a lifelong passion for a married woman, the mother of eleven children, with whom he felt himself to be united spiritually. But his passion for Laura did not prevent him from begetting a son on a peasant girl. Not only did he decline to marry the girl but he treated

his son, as the boy grew up, with a hostility friends found hard to forgive.

If the attitude among educated men tended towards spititualized adultery masquerading as communion with God, more mundane creatures treated women with the scorn attaching to objects of shame. Marriage for Sacchetti has no more importance than buying a mare; a woman is treated as a servant, wet-nurse or housekeeper, and can be quickly got rid of. In one of his sermons S. Bernardino has to urge husbands to stop beating their wives when they are pregnant. Cenno Cennini, in his manual on painting, gives the proportions of a man but 'I omit those of a woman, because there is not one of them perfectly proportioned'. According to Paolo da Certaldo, girls should be taught to sew but not to read, 'for only those who plan to enter a convent should know how to read'.

Once again, the Florentines could not fail to be impressed by the respect Greeks and Romans showed for women, and by such examples of educated women as Aspasia, the friend of Pericles, Cornelia, mother of the Gracchi, and Livia, the wife of Augustus, and by the poetesses Corinna and Sappho, not to mention the Sibyls. They encountered lyric poets who praised women's beauty, not as Petrarch and Dante had done, precisely because it was unattainable, but as something good to be enjoyed. They found there a new pleasure in women's beauty and in her accomplishments, and carried this over to their own lives. The process whereby they began to treat women with a new generosity, and allowed them education can be followed in two generations of the Medici family.

Contessina Bardi, who married Cosimo de' Medici in 1414, was the daughter of Giovanni, Count of Vernio. Brought up under the old dispensation, she was taught to read and write but no more. She could handle a pen with difficulty, and usually dictated her letters. Her philosophy was that provided Cosimo and her two sons were well fed, well clothed and performed their religious duties, they would thrive. When they travelled on business, she would ply them with hams, quarters of goat, hares, capons, with warm slippers and lynx-lined coats. She evidently enjoyed good food herself, for she writes with relish of olive oil and especially of pigs. In one letter she tells her son 'to please Cosimo in all things, and see that he wants

for nothing; though they tell me he is quite fat, which is all that matters'. Thrift was her characteristic virtue. 'I have now decided to send you thirty couple of cheeses,' she writes to her son, 'a sack of moulds of cheese and some bad cheeses. Tell Felice to sell the cheese as best he can and the moulds he had better sell to a carpenter who may find them useful. The sack with the pieces is ours, take care of it.' In a postscript she adds: 'Send back our sack and the little sack in which the cheese and the moulds come.'

Contessina's daughter-in-law, Lucrezia Tornabuoni, wife of Piero de' Medici, was also a capable housewife, but she had other interests too. She was a poetess, one of the first since classical times. She wrote a great many religious songs, lauds, and even miracle plays; the *Life of St John the Baptist* and the *Story of Judith* in *ottava rima*, the *Life of Tobias* in *terza rima*. She corresponded with the poet Bernardo Bellincioni, and it was at Lucrezia's suggestion that Luigi Pulci embarked on his highly original satirical epic, *Morgante Maggiore*. In 1460, when Galeazzo Sforza visited the Medici villa at Careggi, Lucrezia entertained him at a concert where Antonio Squarcialupi sang to the lute. 'I do not know', wrote Galeazzo, 'whether Lucan or Dante ever produced anything more beautiful—there were so many references to stories of ancient times, countless mention of Romans, myths, poets and the Muses.' He ends by saying that Lucrezia and the other ladies present all did dances in the Florentine manner: skipping and turning under linked hands.

Lucrezia was anything but a blue-stocking. She suffered from sciatica, which often sent her to take the waters at Bagno a Morba. She took an interest in the baths, bought land and built a large brick bath-house, where the people of Florence could also take the waters. She was a guide and comforter to her son Lorenzo, who turned to her in all his difficulties. Although she addressed Piero in letters as 'Lord and Master mine . . .', she could get her way with him. In 1450 Antonio Strozzi had asked Contessina to influence Cosimo on behalf of his kinsfolk, exiled with Rinaldo degli Albizzi, but she had no success. In 1464 another member of the Strozzi family sought to enlist the sympathies of Lucrezia, and sent her a Christmas present of fine linen, which Lucrezia was known to appreciate. In the following year the Strozzi's banishment was revoked.

By the end of the century emancipation has been carried even further. Alessandra Scala, the daughter of Florence's Chancellor, attended lectures at the Studium and under the guidance of Giovanni Lascaris, Lorenzo de Medici's librarian, learned Greek so well that she was able to recite Sophocles's tragedy *Electra* in the original before a group of friends. To celebrate the occasion Poliziano wrote an epigram praising Alessandra's beauty, her skill in Latin and Greek, in dancing and playing the lyre, to which Alessandra replied with another epigram, also in Greek.

If Alessandras were rare, the average well-to-do Florentine woman of the fifteenth century certainly received a better education and enjoyed a fuller life than her predecessors. She walked out more often, attended dances, had an opportunity of showing off her beauty and accomplishments. Women of all classes were appreciated more by men. Poggio told Niccoli that one day, while he was copying an inscription, two girls watched him, and he let his eyes fall on them with pleasure. Niccoli, who belonged to an older generation, in all seriousness criticized this behaviour. Poggio defended himself: 'Wherever I happen to be transcribing epigraphs I prefer to have beside me two girls with generous curves (*forma liberali*) than a long-horned buffalo or an angry bull.' Whereas citizens of Boccaccio's day had listed in their diaries the amount in gold florins brought by a wife as her dowry, the dates when she bore him children, and the date of her death, a warmer, more personal feeling is evident in fifteenth-century diaries.When he loses his wife, the apothecary Landucci records with deep grief his feelings for her and how during 48 years she had never made him angry. Women had once more become persons, and it came to be seen that this was a more authentically Christian attitude: the risen Hercules had taught the implications of the risen Christ. The Florentines themselves recognized the importance of this development and never ceased to celebrate it in their art. It is above all as a person that woman is depicted by Florentine painters from Filippo Lippi to Leonardo, and by such poets as Poliziano, who writes of woman's beauty joyfully, no longer in an agony of shame; with desire, no longer with renunciation:

Quando la rosa ogni sua foglia spande,
Quand'è più bella, quando è più gradita,
Allora è buona a mettere in ghirlande . . .[1]

Scarcely less important than the new attitude Florentines accorded to women was the new value they attached to versatility. The Greeks, from Odysseus onwards, admired versatility, while the Romans, here as often elsewhere, codified an attitude learned from the Greeks. In his book on architecture, discovered about 1410, Vitruvius lays down a detailed programme of education. The aspiring architect, he says, must receive training in every single branch of knowledge. Cicero and Quintilian demand a similar all-round education of the aspiring orator. These three authorities, and the examples of actual Romans who had put their principles into practice, notably Cicero himself, who was as much at home in the law courts and the Senate as in the sphere of moral and political philosophy, and writers such as Varro, who composed no less than 490 books on subjects ranging from agriculture to linguistics, provided a marked contrast with medieval thinking on the subject. It is true that the Middle Ages had produced a number of encyclopædic works, but so lacking in detail as to make their claims to completeness derisory. In practice medieval thinkers had favoured the concept of one man, one job, and with their passion for systematizing had given this principle a social framework in the guilds. A man decided to be a physician, followed a university course of medicine, received his laurels, and thenceforth practised as a physician. If he wrote books, they were medical books.

But in fifteenth-century Florence this was no longer so. The physician Paolo Toscanelli was to make valuable contributions in the fields of geography and astronomy; another Florentine trained as a physician, who was also a priest—Marsilio Ficino—was to make his mark as a philosopher; Brunelleschi trained as a goldsmith, but was to turn his hand to stage machinery and military engineering, and to win fame as an architect. Vespasiano da Bisticci was a bookseller, but also one of the first writers of biography. Carlo Marsuppini was a scholar who in a single lecture at the Studium managed

[1] When the rose's petals are fully open, When the rose is loveliest and most pleasing, Then is the time to make a garland . . .

to quote from every known Greek and Latin author; but he was also a poet and a Chancellor of Florence. Giannozzo Manetti was a property-owner, so rich that he put his lifetime's total of taxes at 135,000 florins; but he was also a Hebrew scholar who discussed religious questions with Jews on their own terms, and Cosimo's leading ambassador, who arranged a peace-settlement to more than one hundred different wars and disputes, and whose oratorical prowess was such that King Alfonso of Naples listened to him deliver a two-hour Latin speech without noticing a fly on the end of his nose. There had been occasional all-rounders in the past— notably Dante— but in fifteenth-century Florence practically every other citizen proved himself an all-rounder: a 'universal man'. And the result was impressive. By bringing the methods, experience and sometimes the techniques learned in one discipline to bear in another, versatility was to make possible some of Florence's most original achievements.

The new ideals of versatility and of *mens sana in corpore sano* found their most striking expression in Leon Battista Alberti. He was born in 1407, the son of Lorenzo di Benedetto Alberti, a prominent banker exiled by the Albizzi. Leon was illegitimate, a characteristic he shared with Boccaccio, who was the son of a Florentine by a lady of Certaldo, with Filippino Lippi and with Leonardo da Vinci. When Pius II came to Ferrara in 1459, he was received by seven princes, not one of whom was a legitimate son. Illegitimacy at this time carried little if any stigma, as a Florentine joke shows. One man charges another with being illegitimate. 'I am more legitimate than you,' the bastard replies, 'because my father legitimized me. Here are the papers to prove it. Where are yours?' Among Florentines in particular, with their republican traditions and the new emphasis on *virtù* as individual merit, illegitimacy was less a handicap than yet another incentive to the proving of individual worth.

Alberti's portrait shows a lean face, straight nose and large, alert eyes. But he had been born frail and sickly. A sharp wind would bring him down with a cold, a torrid day with fever. Instead of resigning himself to ill-health, he fought against it. He moulded his own body, almost like an artist, toughening himself with mountain climbing and long rides, with jousting and archery, until he became

as strong as any of his contemporaries. 'When a youth, he shone at weapon-practice; with his feet together he would spring over the shoulders of a standing man; he had hardly an equal at jumping with the spear . . . he threw up a silver coin with such force that those who were with him in the cathedral heard it strike the roof.'

Alberti learned Latin at Padua and Greek under Filelfo at Bologna, where he took a degree in law. As fast as they were discovered, he read the old authors, and conceived a longing to realize in his own life the skills they revealed. While still a student he wrote a Latin comedy entitled *Philodoxus*, which he hinted he had copied from a manuscript by Lepidus and was for some years accepted as a genuine work by that author. The intention was less to deceive than to prove himself in literature a 'new Roman'. He fell in love and wrote songs, ballads, sextines, eclogues and sonnets to the ladies of his choice. Having been cheated out of his inheritance by cousins, he had to take a job as papal abbreviator, or writer of briefs. He came to Florence in 1434 with Pope Eugenius and remained there during the 'thirties, in close touch with Cosimo and other leading Florentines.

Alberti taught himself music, 'and his work gained the approval of skilled musicians . . . he loved to play the organ, and was considered one of those most highly skilled in that art'. In 1435, stirred by what he had seen in Florence, he wrote the first treatise on the art of painting. In Rome he set up a diorama which could also be adapted as a planetarium. He made the first scale plan of that city. He tried, with improvised machinery, to raise one of the sunken Roman galleys in Lake Nemi. He frequented cobblers, blacksmiths and shipbuilders, feigning ignorance in order to surprise their secrets. He wrote a book on the duties of a judge, urging that punishment should be used to amend criminals, not to crush them. He wrote books on horse-breeding and on mathematical puzzles, on how to devise cypher, on the way *u* and *v* should be written, and on how an orator should declaim. He exchanged sonnets with the Florentine barber Burchiello, who excelled at burlesque, and tossed off a hundred or so fables. He wrote on sculpture, on statics, and on the secrets of a woman's toilet. 'Tell me,' wrote a contemporary reader in the margin of one of his manuscripts, 'is there anything this man does not know?'

But Alberti was no mere theorist. In all these subjects he had at least considerable practical knowledge, and sometimes he was an expert. To critics who doubted his ability for philosophic work after a life-long political career Cicero replied: 'I have been studying philosophy most earnestly at the very time when I seemed to be doing so least.' This reply became famous in Florence, with its implication that a man's thoughts and theories should grow out of practical experience. In his book on horse-breeding Alberti quoted Columella and Vegetius, but also drew extensively on his own observation. Nor was he a mere dilettante. He was one of the three leading architects of his day, and the best designer of façades. It was Alberti who re-introduced pilasters and half-columns to the front of a building, thus lending it strength. The façade of S. Maria Novella had been unfinished for a hundred years; it was Alberti who added the upper part, including the upturned scrolls to hide the aisle roofs (which set a fashion for 300 years), and strengthening the lower part with classical pilasters. He saw a church as a place not of grim austerity but of joy. He took intense pleasure in the incense-laden air and the singing of the *Kyrie*. Outside there might be winds or frost, but inside it was always spring. 'And if it is true, as people say, that pleasure is to be found in a place where our senses receive all they demand of nature, who will hesitate to call a church a nest of pleasure?'

Alberti believed that man, like a ship, is made for long, exhausting sea voyages, and must drive himself on continually. 'Man is born not to mourn in idleness, but to work at magnificent and large-scale tasks, thereby pleasing and honouring God, and manifesting in himself perfect *virtù*, that is, the fruit of happiness.' Like Valla, he believed that joy and morality intermingle rather in the way of man's soul and body.

In his youth Alberti designed himself an emblem: a winged eye. He chose the eye, because 'nothing is more powerful, more rapid or more worthy'. Under the winged eye ran the motto '*Quid tum*'. Cicero uses the formula '*Quid tum*' as an expression of oratorical suspense, which arouses the listener's expectation, and Alberti evidently intended his motto as an allusion to human versatility. The fact that the eye is winged is of considerable interest in itself, and also

as a symptom of something which made versatility possible: a new conception of time.

The Greeks, with their ebullient vitality, seldom had enough time to do all they wanted to do, and the explanation lies in the fact that at least during their greatest period they did not look forward to personal survival—the ghost of Achilles says that he would rather be the serf of a poor man on earth than rule over all the dead—and they attached a correspondingly higher value to this life, and to the passing moment. The Greeks were followed here by the Romans, whose attitude to time is summed up in Horace's 'Carpe diem'.

The Middle Ages, by contrast, moved to a slow, grave rhythm. Clerics were preoccupied with eternity, while in an agricultural society life was conditioned by the seasons. There could be no question of hurrying the wheat to ripen, or ewes to lamb. Everyone had time on his hands. Louis IX of France, prototype of medieval rulers, every day of the week heard a Requiem Mass and a sung Mass, recited the Office of the Dead, attended vespers and compline.

The Florentines, as a manufacturing and trading people, were already predisposed towards taking time by the forelock. In the Middle Ages the Latin word *horae* had become synonymous with prayers: terce was prayer said at the third hour, nones that said at the ninth. The hour had been divided into four *puncta*, each of ten minutes, each minute being divided into forty 'moments'. But by 1400 it had become customary to divide the hour, as today, into sixty minutes each of sixty seconds, a small but telling sign that the pace had quickened.

However, it was only when the Florentines began to put the classical ideal into practice that time came to be regarded as precious. 'Cosimo', says his protégé Marsilio Ficino, 'was as avaricious and careful of time as Midas of money; he spent his days parsimoniously, carefully counting every hour and avariciously saving every second; he often lamented the loss of hours.' He would spend whole nights without sleep, either working or reading. Whereas his more traditionally minded contemporary, Alfonso of Naples, heard three Masses daily, Cosimo, though a more religious man, had time only

for one. This tendency increased as he grew older. The bookseller Vespasiano da Bisticci tells how Cosimo commissioned him to make a library for the Benedictine abbey known as the Badia. 'It was his wish that it should be finished with all speed possible. Since money was not lacking, I soon engaged forty-five copyists, and in twenty-two months provided 200 volumes.' The ambassador Giannozzo Manetti slept only five hours a night and during his nine years of study in Florence was so averse to wasting time that he did not once cross the Arno during that period. We hear of Brunelleschi, about 1410, making alarm clocks, a device unknown to previous centuries. In spring Alberti sometimes wept before branches laden with blossom and hopes, for he thought of the ceaseless work of nature and of the example it gave to mankind. His fears are understandable, for although the Florentines naturally could not share the classical view of the next world, in every field they had a great deal of ground to make up if they were to rival the achievements of the Greeks and Romans. To that extent they attached an even higher value to time. Every eye had to be winged.

Amid so much concentrated serious work the Florentines evidently required relaxation, and here too classical forms provided an answer to their needs. Humour is conspicuously rare in medieval writing; and the occasional joke is invariably told in the interests of wisdom or edification. Sacchetti, and Boccaccio in the *Decameron*, recount racy tales, but they are diverting rather than funny, and very long-winded. The Florentines found in the pages of Plutarch and Aulus Gellius numerous witty apophthegms, short and to the point, in Macrobius's *Saturnalia* a treasure-house of Roman pleasantries, and in Cicero's *De Oratore* many jokes as well as an analysis of various forms of wit. These provided the basis of a new Florentine humour, short and pithy, as befitted citizens chary of losing time, and its first glimmerings are to be seen in some of the Medicis' rejoinders.

It was Poggio who took the lead in the revival of humour. After more than a thousand years of grave scholarly or practical Latin correspondence, Poggio's letters at last contain a few jokes. In 1416 he visited the spa of Baden, where as an Italian he was much astonished to find ladies taking the medicinal baths unclad, observed by

any interested men, who would toss garlands, crowns of flowers or coins into the water, for which the ladies dived and scrambled. The ladies gave dinner parties actually in the baths, on floating tables, to which men were invited. 'What are these baths meant to cure?' Poggio asks himself drily. 'Doubtless a low birth rate.'

Cicero had analysed the *facetia*, or anecdote, usually licentious; Poggio decided to make a collection of *facetiæ*. Many were collected or concocted, he says, during his years at the Curia, in a common-room which he called the *Bugiale* or workshop of lies: 'here we spared no one, and spoke evil of everything that vexed us.' Some of Poggio's *facetiæ* are unprintably licentious, some, like the originals which inspired them, laugh at human foibles, while not a few poke fun at religious dishonesty, of which Poggio, in common with most of his fellow-citizens, had a particular hatred. The tone of the whole can be gauged from two examples, the first of which Poggio may have heard in England.

During a storm at sea an Irish captain vows that if he and his ship are saved he will offer Our Lady a wax candle as high as the main-mast. 'Couldn't be made with all the wax in Ireland,' one of the crew pipes up. 'Hold your tongue!' says the Irish captain, 'Who's to know that?' The second tells how a certain priest buried his pet dog in consecrated ground. The bishop got to hear of the incident and remonstrated. 'My Lord,' explained the priest, 'if you knew the cunning of this dog, his intelligence was more than human in his lifetime, and especially manifest at his death, for he made a will and, knowing that you were needy, left you 50 golden ducats. Here they are.' The dead dog was allowed to lie.

The Romans had perfected a second form of humour, the satire. This too was adopted with gusto, by Alberti among others, its leading exponent being Francesco Filelfo, the tireless first professor of rhetoric in the Studium. Altogether Filelfo wrote 10,000 lines of satire. Odes, verse, histories, epigrams, speeches—all such works Filelfo would compose for a fee, but this lecturer on morals disappointed Niccolò Niccoli and Cosimo by turning out to be pushing, vain and sometimes also cruel. Asked by a bore to compose an epitaph for the tomb of a young relative, by name Giovanni Vitelli, Filelfo wrote:

Iuppiter omnipotens Vituli miserere Ioannis
Quem mors praeveniens non sinet esse bovem.[1]

Gratuitously spiteful wit was not really to the Florentines' taste any more than was Filelfo's vanity. In 1431 the trustees did not renew his appointment, naming instead his deadly rival, Carlo Marsuppini. After a dispute which almost ended in murder, Filelfo left in a huff and found another patron in Francesco Sforza, for whom he began an epic entitled the *Sforziad*. This poem had the merit of being elastic. If Sforza paid up, inspiration came to Filelfo. If Sforza did not pay, no further verses would be added, for 'genius languishes on poor wine'. If Sforza paid badly, Filelfo would threaten to go off to the Turk and proclaim to the world that Milan was bankrupt.

When Lorenzo Valla wrote his dialogue *Concerning Pleasure*, Filelfo attacked him for daring to be his rival. Poggio joined in against both. Soon a three-sided contest in mud-slinging began, lasting for years. Valla accused Poggio of addiction to wine: not addiction, replied Poggio, but simply the need, when he wrote, to feel 'exhilarated' with best white wine of Candia, Corsica and Genoa. Poggio claimed that Filelfo, who boasted of sound Florentine descent, was really the bastard son of a country priest and a tripe-seller whose husband's hands were so coarse that he used them as a curry-comb in dressing his horses. 'As Hercules traversed the world to benefit mankind by his labours, so you have visited every country and climate to disgust them by your vices.' In a misguided moment Valla spoke of accompanying Alfonso of Naples on campaign, implying that he had seen action. 'That timid little hare', wrote Poggio, 'never saw a naked sword: he dressed up as a kitchen maid and helped the sutlers in the army mess. One day an ass kicked him, whereupon he beat the poor creature to death, then started blubbing, believing himself guilty of parricide.' This somewhat crude abuse was warmly applauded by educated observers, because the tone and much of the language revived yet another literary form from classical times: the invective.

Other aspects of the new Florentine, and some of the dilemmas he

[1] Almighty God, have mercy on John Calf, prevented by early death from becoming a complete ox.

faced, are best followed in the life of Cosimo de' Medici. In 1414, when he brought his bride Contessina to his apartment in the Medici house on the cathedral square, Cosimo doubtless followed the custom described by a social equal, Alberti's uncle: 'Locking the door, I showed her all the things of value: the silver, the tapestries, the fine clothes, the jewels and the places in which they were all kept. For I did not wish any of my precious things to be hidden from my wife. ... Only my account books and papers, and those of my forebears I kept hidden and locked, both then and thereafter, so that she should neither read nor even see them. ...' Later: 'we shut ourselves into our room, and kneeling down prayed God that we might make good use of our wealth ... and live long together in happiness and concord, with many male children, and that He would grant me wealth, friends and honour.' For a Florentine these three things—wealth, friends and honour—were indispensable to the good life, and it will be revealing to follow Cosimo as he pursues all three.

Cosimo made his wealth in small ways, such as letters of credit and exchanging foreign currency in the streets of Florence, and in large ways, by loans to heads of state, and by transferring papal taxes to Rome at a profit. These taxes were sometimes collected by Medici agents, which provided the bank with further profit: in Breslau, for example, where in return for a loan of 1,500 ducats from Cosimo's father, Pope John had appointed Antonio and Leonardo Ricci, relatives of the Medici, as papal tax collectors. Cosimo also made money in Rome by collecting the fees due from any nominee to a bishopric. It was the Medici bank which accepted the bull of nomination, sent it to the appropriate branch, and this branch then delivered the bull on payment of the dues, as much as 20,000 florins. If the dues were not paid, the bull was returned to the Rome branch.

Deposit accounts provided Cosimo with another important source of income. The Medici bank paid an interest rate on deposits of between 8 and 10 per cent. In 1423 the Doge of Venice told his senators that Venetian merchants 'have a capital of ten million gold ducats in use, upon which they make an annual profit of four millions', so by investing the bank's deposits wisely Cosimo could hope to make up to 40 per cent gross profit, and 30 per cent net. The yield in relation to invested capital in fact usually ran between

20 and 30 per cent net. Because of the usury doctrine, Cosimo's bank was not expected to pay interest on deposits made by the papal treasury, but on the other hand it was not allowed to charge any interest on the papal treasury's overdraft, which was to rise in July 1472 to 107,000 cameral florins. To recoup this loss, the Medici overcharged the Pope on the silks and brocades and jewels they supplied.

In 1435 Cosimo drastically reorganized the bank. Breaking his ties with the staid Bardi, he called in as full partners two dynamic 'new men', Francesco Salutati, manager in Rome, and Giovanni d'Amerigo Benci, manager in Geneva. Cosimo and his brother supplied three-quarters of the capital of 25,000 florins, and were to get two-thirds of the profits. The bank now quickly expanded. To existing branches in Rome, Venice and Geneva, Cosimo added others at Ancona in 1436, Bruges in 1439, Pisa in 1442, London in 1446, Avignon in the same year, and Milan in 1452. In 1402 the staff numbered seventeen; in 1470 seventy. Cosimo supervised them closely. In London, for example, Gierozzo had to send all his books occasionally to Florence; he was forbidden to make insurance transactions or to buy more than £500 worth of English wool without special permission.

One of Cosimo's clients, Messer Piero da Noccra, satisfied with an exchange transaction, congratulated him with the Gospel text 'Cosimo, *magna est fides tua*', to which Cosimo replied in Italian, 'Messer Piero, a merchant's treasure is faith, and the more faith he has, the richer he becomes.' Cosimo uses the word *fide*, meaning both fidelity to promises and faith in a given person. In the latter respect he was exceptionally astute. For example, when Tommaso Parentucelli, Bishop of Bologna, asked a loan, Cosimo knew the man only in his capacity of compiler of a library catalogue. But he had noticed his orderly methods and tactful manner, and although the Bishop had no immediate prospect of preferment, Cosimo allowed him unlimited credit. When the Bishop became Pope Nicholas V he rewarded Cosimo by making him his banker, and the jubilee of 1450, alone, was to bring 100,000 ducats into the papal treasury.

'Fidelity' combined with flair made Cosimo a highly successful

banker. Everything he touched seemed to turn to gold. From 1420 to 1435 the bank's profits amounted to 186,382 florins; from 1435 to 1450 they soared to 290,791 florins. But this very success began to trouble Cosimo's conscience. According to its articles of association, the Medici bank was 'to deal in exchange and in merchandise with the help of God and good fortune'. Some ledgers were headed, 'In the name of God and of profit'. But were these not contradictory terms? There was something ambiguous about the whole profession of banker. Usury was still forbidden by Florentine law, and church-men still classified bankers as usurers. It followed that interest was not recoverable at law, and in order to conceal interest charges documents were deliberately couched in ambiguous language that became a fertile breeding ground for expensive litigation.

'Having food and raiment,' St Paul had written to Timothy, 'let us be therewith content. For the love of money is the root of all evil.' That was the principal text on which numerous Councils since 1159 had condemned the *appetitus divitiarum infinitus*. It is right for a man to seek such wealth as is necessary for a livelihood in his station. To seek more—to seek to rise in the world—is not enter-prise but avarice, and avarice is mortal sin. Let banking be left to the Jews, since their Law permits it.

True, the bankers had their own guild, and even their own patron in St Matthew—a customs official—but no matter: in 1419 Cosimo himself had contributed more generously than his fellows towards commissioning a statue of the saint for Orsanmichele. But such reflections and so small a gesture did not set Cosimo's conscience at rest. He was, and evidently knew himself to be, greatly attached to worldly possessions. Asked once why he preferred his villa at Cafag-giolo, among the Apennines, to a more convenient villa at Fiesole, he replied that from Cafaggiolo all the land he could see was his. Unfortunately the classical past which provided support when it came to defending republican principles against ecclesiastical critics on this point offered no help at all. Plato had disapproved of usury, and Aristotle had denounced it with the famous image that money, being a lifeless substance, was not meant to breed. Indeed, in a sense it was that very vitality encouraged by classical models which increased Cosimo's wealth and so made his dilemma more acute.

Though not usually communicative about his business affairs, in 1436 Cosimo decided to take his doubts to the Pope.

Pope Eugenius, by a curious coincidence, was a prime example of the rich and handsome young man choosing poverty for Christ. A Venetian by birth, he had distributed his fortune of 20,000 ducats to the poor and taken the friar's habit. Even as Pope he led an austere life. For long he drank no wine, only water with sugar and a little cinnamon. His particular interest was monastic reform. He favoured the reformed Dominicans—the Observantists—and used to say that, if God would give him grace enough, he would bring all religious under Observantist rule. In January 1436 he had taken the convent of S. Marco from its lax occupants, the Sylvestrines, and given it to a group of Observantists from Fiesole. The church, built in 1299 and adorned with a crucifix by Giotto, was simple and sound, but the conventual buildings had fallen into disrepair. They had become so unsafe that the Dominicans had to build wooden huts, and in these damp, draughty sleeping quarters several friars that winter had fallen ill. When Cosimo confided his scruples to Eugenius, the Pope mentioned this state of affairs, well aware of Cosimo's interest in architecture. Cosimo took the hint and offered to build a new convent. 'I promise', he said, 'to spend 10,000 ducats.'

Cosimo commissioned Michelozzo to design a new group of buildings: chapter hall, dormitory, kitchen, rooms for study; only the old refectory would be retained. There would be a cloister too in the spacious, flowing style of Brunelleschi's new Hospital of the Innocenti. In 1437 building began, and in that year also Niccolò Niccoli died, bequeathing his library of 800 manuscripts, valued at 6,000 florins, to sixteen trustees, including Cosimo. But Niccoli's estate was compromised by heavy debts. Cosimo, who had already made large advances to his friend, offered to pay all the debts in exchange for the right to dispose of the library. He divided the manuscripts into two equal groups, those of interest to religious, those suitable for laymen; the latter he kept for himself and his friends, the former he gave to S. Marco, each inscribed '*Ex hereditate doctissimi viri Nicholai de Nicolis de Florentia*'. This was the first occasion since antiquity on which a layman had endowed a complete library.

During building Cosimo contributed 366 ducats annually towards

the friars' keep. In 1438, when fire damaged the partly completed dormitory, again he came forward with the extra money needed. Monasteries were rarely adorned with paintings because of the expense. But Cosimo did nothing by halves and it was almost certainly he who arranged and paid for one of the friars, Fra Giovanni, known to posterity as Fra Angelico, to paint the convent walls. One cell Cosimo reserved as his own, for occasional hours of retreat, and this Fra Angelico decorated with an *Adoration of the Magi*, those other rich men—the first of many *Adorations* to be painted for the Medici.

By 1444 S. Marco was complete, a most beautiful small-scale building, and also a most paradoxical one. The Pope had not ordered Cosimo to renounce banking; instead, those so-called 'illicit' gains from all over Europe had gone to make this light and airy Dominican convent. Everyone knew it was Cosimo's gift. Conspicuous in the cloister were five red roundels, and Cosimo's patrons, the North African doctor martyrs Cosmas and Damian, figured in two of the paintings. Cosimo had told the Pope he would spend 10,000 ducats; by the time the buildings, library and murals were complete, the furnishing and missals made, he had spent 40,000. 'Only have patience with me, Lord,' he would say, 'and I'll balance our books.'

Cosimo's qualms of conscience did not end with the building of S. Marco, for it so happened that the prior of this convent, who became Archbishop of Florence in 1445, was a traditionalist in his thought and exacting as only saints can be. His name was Antonino, son of Niccolò Pierozzi, a Florentine notary. He was a sickly child who could not play games at school. The master he most admired was Coluccio's opponent, Fra Giovanni Dominici, who made him learn chunks of the Decretals before allowing him to enter the Dominican order at the age of sixteen. He rose rapidly to be novice-master and then prior. Short of stature, he had a gnarled square head, an indrawn toothless mouth and strong pointed jaw. 'All bones and nerves,' his secretary said, and for most of his life he suffered from hernia.

Hearing the rumour of his appointment to the see of Florence, Antonino fled with a friend to the woods of Corneto. When the papal official found him, delivered the brief and asked for the usual tip,

Antonino replied, 'I won't give you a penny for bad news, and worse you could not bring. Besides, we have no money, nothing of value but our capes.' He then took possession of his see on foot, without a cavalcade, furnished his house with a few sticks of furniture and clay dishes, and began a series of much needed reforms. He forbade the red or green fur-lined habits sported by Florentine priests, made them wear sandals instead of ornate shoes, and had their hair cut so that their ears were visible. He made each priest write his name in his breviary, so that he could not sell it. In the countryside he separated priests from their concubines, and, since their Latin was often faulty, insisted that the words of consecration, written on a card, should be kept on the altar. For Lucrezia Tornabuoni, Cosimo's daughter-in-law, and her sister Dianora he wrote, about 1456, a very severe little *Rule of Life*: for example, they were not to accept invitations to weddings, feasts, dances or tournaments unless their absence would be prejudicial to their husbands and family, and they were to take the discipline every Friday of Lent and Advent, and the day before receiving Communion, which should be at least twelve times a year.

But Antonino went further. He attacked classical learning, and poets he abominated, citing St Augustine's remark that they are enemies of truth. Seeing a young married woman pass through the cathedral followed by admirers, he drove her out with a whip of cords. It was his usual practice to extract confessions from suspected priests by torture. Learning that a physician named Giovanni Cani of Montecatini denied the immortality of the soul, he had him arrested and, on 6 May 1450, burned at the stake in his presence outside the cathedral—a blot on Florence's record of tolerance bitterly criticized by the citizens.

Antonino and Cosimo often met and talked. Since Antonino was Apostolic Commissioner in matters of usury for all Tuscany, and engaged in writing (on scraps of waste paper, such was his austerity) a *Summa Moralis*, which would touch on the vexed question of interest, there is little doubt that the conversations of the two men often centred on usury. Cosimo may well have pointed out inconsistencies in the Church's position, illustrated by the following clause in Petrarch's will: 'I bequeath to the said Cathedral of Padua

200 gold ducats for the purchase of some little piece of land wherever it may be done to the best advantage, the income from it to be used for a perpetual anniversary mass for my soul.' Why should income from land be permitted and income from capital condemned? Perhaps also Cosimo argued, as we should today, that a coin is not to be identified with its own fixed gold or silver content; it is an instrument of exchange and because it can help to bring about the production of new things is in fact a *res frugifera*, which the Church denied. Cosimo may also have made the point that all trade then was venture-trading, that is, a merchant sent his goods on consignment without knowing whether or not they would sell: by putting up money for such ventures a banker was sharing in a very real risk. Whatever his arguments, Cosimo must have put them skilfully, for when Antonino came to write the five chapters on usury and money-lending in the section on Avarice, he admitted that the taking of a percentage on bills of exchange could be justified, because of their convenience to travellers and pilgrims; and he admitted also that when money was employed as capital, some form of interest became lawful, to recompense the lender for the use of money which he might have employed on some other profitable enterprise.

From so stern and exacting a figure as Antonino this was a notable victory for Cosimo and also for those of his circle who, in Matteo Palmieri's words, deemed 'riches and abundance to be instruments in the exercise of virtue'. Not that consciences were immediately set at rest. In 1465 Giovanni Strozzi wanted to sell his shares in the *Monte*, or funded debt, at a 9 per cent profit, but he was dissuaded on the grounds that profits made in this way were dishonest. However, the bankers had won their main point and by Lorenzo's day the taking of interest would disturb few if any consciences.

Having achieved riches and a certain peace of mind about the way they were amassed, Cosimo was free to turn to the second ambition of a Florentine citizen: honour. The Florentines' notion of honour differed from that current elsewhere in Italy, with which however it is often confused. The prince's thirst for honour was a form of pride, deriving from the chivalrous ambition of feudal times, clothed now in the garb of the Cæsars. One example from many is Sigismondo Malatesta. The façade of the church of S.

Francesco, which he commissioned Alberti to rebuild in Rimini, is inspired by the Arch of Augustus and inscribed with Sigismondo's name and the date—nothing else; while the interior is blazoned with Sigismondo's emblems, notably the trumpeting elephant, representing Fame, which appears no less than 200 times. The pilasters are interlaced with the letters S and I (for his mistress, the coldly intellectual Isotta degli Atti), and in one of the chapels Sigismondo is depicted as a new star rising into the sky.

In Florence the notion of honour had no such feudal ancestry. Honour was intimately linked with the community. This was an older and more native tradition—Virgil's Aeneas is a hero not in his own interests but in those of the state—and it was confirmed by the Florentines' strong religious sense, which prevented the notion of honour becoming immoderately selfish. In Dante's *Comedy* glory is something that belongs to God: *la gloria di colui che tutto move.* When man aspires to glory, he attains mere vainglory: *Oh vana gloria di l'umane posse.*

Examples of the communal sense of honour are evident in every field. One of the earliest non-religious biographies, that by Filippo Villani, is a collection of short lives of notable Florentines who, by their combined efforts, brought glory to the city. In his work on architecture Alberti praises most the outside of a house, that part of which the whole city can boast, while in the age-old controversy whether a man must have a great *patria* to reach personal greatness, or needs only individual talent, Bruni, following Coluccio, unhesitatingly defended the civic point of view.

It is sometimes said that the new notion of glory derived from the Romans was the driving-force behind the daring achievements of fifteenth-century Italy. But this is not so. The desire to make a name for oneself is a constant in human nature and appears throughout the Middle Ages. The word *gloria* occurs several times in Abélard's *Historia Calamitatum*, written around 1100. When Héloise declines to marry Abélard, her main argument is that marriage will detract from Abélard's *gloria*. Two centuries later Giovanni del Virgilio, discussing Ovid, takes it for granted that one of the poet's chief motives in writing the *Metamorphoses* was a desire for immortal fame. What happened in the fifteenth century was that despots and

princes found in the example of some of the Emperors an excuse
for the wildest extravagances, while in Florence it was the dynamic
classical concepts of *virtus* and *patria* and versatility which drove an
already ambitious people to give of their best in all the newly found
fields of human endeavour.

The most honourable action a Florentine citizen could perform
was to hold high office—and Cosimo, as we have seen, was not
remiss in this respect. But a second way also presented itself. The
Florentines had become aware of the Romans as extensive builders,
particularly Augustus, who boasted with some reason that he had
found Rome brick and left it marble. Cosimo was the first Florentine
to serve the community through buildings. For twenty years he
built unceasingly. He commissioned Brunelleschi to build the church
of S. Lorenzo; he rebuilt the church of S. Spirito in Jerusalem, on
the spot where the Holy Spirit descended on the apostles. He reno-
vated a college for Florentine students in Paris. He rebuilt the Bene-
dictine abbey in Fiesole. For himself he commissioned Michelozzo
to build a villa at Cafaggiolo, and to rebuild Careggi, on the last
southern spur of the Uccellatoio, which Dante claimed had a better
view than the view of Rome from Monte Mario. In 1444 he devised
his most ambitious scheme—a new town house, and asked Brunell-
eschi to draw up plans and a model. Brunelleschi put aside his work
on S. Lorenzo and designed a palace to face the church, evidently
isolated from other houses. 'It was so grand and sumptuous that
Cosimo feared it might arouse people's envy. He set the plan
aside,' and commissioned from Michelozzo a simpler building but
one which nevertheless marks the rebirth of civil architecture.

No citizen had hitherto contributed to the city's adornment on
anything like such a scale. On church and convent buildings alone
Cosimo spent 193,000 florins, more than his father's entire estate.
His buildings were applauded and won him the honour he sought.
One day he told Vespasiano that the great mistake of his life was that
he did not begin to spend his wealth ten years earlier; because
knowing well the disposition of his fellow-citizens, he felt sure that
in fifty years no memory would remain of himself or of his family
save the few buildings he had commissioned.

In the matter of friends—the third possession esteemed by Floren-

tines—Cosimo met with as much success as in the other two, thanks
largely to his warm, homely manner. Here he is, an elderly man,
with ambassadors from Lucca:

> The audience was held in his own house, according to custom,
> and during discussions a small child, his grandson, came up to
> him with some oatsticks and a little knife for Cosimo to make
> him a whistle. Cosimo signified that the discussion was ad-
> journed, devoted himself to the child and made the whistle,
> telling him then to run away and play. The ambassadors were
> somewhat offended. 'Sir Cosimo, we are surprised at your
> behaviour. We have come to you on behalf of our Commune
> to treat of grave matters and you desert us for a child.' With
> a laugh Cosimo flung his arms round their shoulders. 'My
> brothers and lords, are you not fathers too? Don't you love
> your children and grandchildren? You are surprised that I should
> have made that whistle; it's as well that you didn't ask me to
> play it. Because I would have done that too.'

But to win the friendship of a Florentine, least sentimental of
Italians, more than a warm manner was needed. You had to be very
careful not to infringe, or appear to infringe, his political and
commercial rights. Hence Cosimo's sayings: 'A hundred good turns
are forgotten more easily than one bad one', and 'An injury is never
forgiven'. Hence too his concern not to offend with a grandiose
palace. As a result of such tactfulness Cosimo built up a wide range
of friends: politicians and businessmen, artists such as Brunelleschi
and Michelozzo, Donatello and Fra Lippo Lippi, scholars such as
Niccolò Niccoli, Poggio Bracciolini and Leonardo Bruni, one
saint—Antonino—and one *beato*, Ambrogio Traversari, general of the
Camaldoli, who did for Cosimo what he would have done for no
one else: translated all Diogenes Laertius, even the very unedifying
passages that brought a blush to his cheek.

Cosimo, then, achieved in full measure the Florentine's goal of
riches, honour and friends. But what was his ultimate purpose in
amassing these good things? What would happen to them, and to
him? Every generation is troubled by a particular religious problem,
and for Cosimo's it was a surprisingly fundamental one—does the
soul survive death? The question had become a source of anguish

when Florentines came to read Aristotle in the original and found—contrary to their expectations—that 'the master of those who know' provided no proof of personal immortality: he envisaged only the survival of an impersonal intellect, perhaps, as the Averroist university of Padua taught, a collective intellect of all men. This was abhorrent to the Florentines, who valued the individual so highly, and they sought a solution elsewhere.

When he was fifty Cosimo met at the Council of Florence a white-bearded Greek sage of eighty-three, by name Gemistos. This man was the greatest living authority on Plato, and had adopted the surname Pletho, meaning full [of wisdom], because it echoed that of his master. Between Council sessions Gemistos gave a series of lectures, in which he expounded the doctrine of Plato, still imperfectly known in Florence despite translations of some dialogues by Bruni. Cosimo was deeply impressed. In place of Aristotle's curt, authoritarian formulas he encountered a sympathetic, human style which admitted the apparent contradictions of reality, dialogues in the form of a search, where hope alternates with despair, and in Socrates one who expressed the soul's aspiration in Cosimo's own brand of homely, country images. As regards Cosimo's particular anguish, Plato provided a wealth of arguments. In the *Meno* the correct answers of a slave-boy to certain questions in geometry are cited as evidence that knowledge is brought by the soul from a previous existence, and this in turn as evidence for immortality. In the *Phaedo* another argument is used, namely that the soul is simple and lacks the complexity which leads to dissolution. But Plato's most telling argument, as Florentines later developed it, is that God's world possesses perfect order, harmony and economy. Nothing in it is superfluous. Therefore 'the natural appetite of every species directed by universal nature cannot be entirely vain'. Since all men experience a movement of the soul towards God, it follows that this will be satisfied and that the soul will enjoy immortal life.

Twenty years elapsed before Cosimo could realize his ambition of studying Plato thoroughly. In 1459 he adopted a young Florentine Greek scholar named Marsilio Ficino, later giving him a house and a steady income, and commissioning him to translate all Plato into Latin. Cosimo and Ficino would meet either alone or with

friends to discuss Plato, but our glimpses of these talks are tantalisingly few. At one meeting, held in Cosimo's house, the question discussed was whether the laws of the city were themselves part of moral philosophy or merely subject thereto. On a second occasion one member of the group, Pandolfini, found Giovanni Argyropoulos reading Plato's *Meno*. After expounding the dialogue, Argyropoulos took his friend for a walk; they then seated themselves under a laurel in the cloister of S. Maria de' Servi to discuss whether the angel Gabriel had spoken to Mary with a corporeal or incorporeal voice: a question closely related to that of personal survival, and also of practical interest to painters and their patrons.

Though continuing to read Aristotle's *Ethics*, Cosimo turned more and more to Plato for reassurance about metaphysical truths. In the last months of his life he wrote to Ficino: 'Yesterday I came to the villa of Careggi, not to cultivate my fields but my soul. Come to us, Marsilio, as soon as possible. Bring our Plato's book *Concerning the Highest Good* [the *Philebus*]. This, I suppose, you have already translated into Latin as you promised. I desire nothing so much as to know the best road to happiness. Farewell, and do not come without the Orphean lyre', for music set that mood of harmony and yearning on which rested the new argument for immortality.

In the summer of 1464 Cosimo, now in his seventy-sixth year, fell seriously ill. As he lay in bed he would often close his eyes, 'to get used to it', as he explained to Contessina. He had enjoyed a full life, made fuller, as we shall see, by his interest in painting and sculpture. He had brought peace and prosperity, learning and beauty to many lives, including his own. He had truly been a man whole and complete, and he felt some certainty that he was going towards a more perfect completeness. On 26 July Piero wrote: 'It appears to me that he is gradually sinking, and he thinks so himself. On Tuesday evening he would have no one in his room save Mona Contessina and myself. He began to recount all his past life, then he touched upon the government of the city and its trade, and at last he spoke of the management of the private possessions of our family.' His father had made no will, probably because a usurer's testament had no legal validity, and despite the more tolerant attitude towards banking profits Cosimo also deemed it prudent

not to make a will, saying that he would rely on his children's love for each other.

Cosimo died at 10.30 in the evening of 1 August 1464, and was buried without pomp, as he requested, in the church of S. Lorenzo. Piero noted his expenses: 'For wax we paid 43½ lire; for torches, 94 lbs of candles for putting in the church, and 13 small torches to be carried by the priests, in all 190½ lbs, and for sixteen torches of 97 lbs for placing round the body.' There followed a long list of Masses, and of family and friends, each of whom received 10 to 30 *braccia* of cloth for mourning. The women of the family also received black veils and kerchiefs, the exact number being noted down. Man might possess an immortal soul, but this was Florence, and even in grief the record had to be kept straight.

History and Religion

THE Florentines brought to intellectual pursuits the same new needs and interests that had added richness to their personal lives. Their thinking, particularly in the fields of history and religion, was to prove momentous then and is still influential today. It depended, in the first instance, on a quality, rare at the time, that had already won Florence pre-eminence in trade and banking, namely exactness.

The starting-point, once again, was a number of old parchment manuscripts. These were written in crowded characters, sometimes in faded ink, often miscopied by bored scribes—the last word in inexactness. 'We scarcely find one manuscript of Petrarch's and Boccaccio's works', Coluccio complained, 'which does not deviate from the original. They are not texts, but coarse caricatures of texts ... What we have deviates more from the originals than statues from actual men. They have a mouth, but say nothing; or worse, they often say what is false.' The complaint held even truer of old authors. One of Coluccio's correspondents wished to know the ancient name of Città di Castello. The Chancellor could find nothing in Pliny, Solinus, or Mela. Then he remembered that an early bishop of Città di Castello was St Floridus, after whom the cathedral is named. He recalled too that Gregory the Great mentions St Floridus in his *Dialogues*. So he consulted his library which contained two manuscripts of Gregory. They disagreed, so Coluccio went on to examine every manuscript he could lay his hands on—a total of twenty. Such was the degree of textual corruption, these yielded no less than thirteen different readings. Coluccio concluded that *Tyberine* or *Tyferne*, or both together, was the name of the town. Finally he observed that *Tifernum* (the form used in some of the sources) should be spelled with *i*, not *y*, for he recalled having seen

a copy of an ancient inscription in the chapter-house of the cathedral in Città di Castello, describing an inhabitant of the town as *Tifernius*.

Coluccio was the first Florentine to care deeply about the exact spelling of words. 'Make sure', he wrote to his pupil Alidosi, 'that *commune*, which is composed of *munus* and *con*, is written with two *m*'s and not one. Also *communicare*, which plainly derives from *commune*. Likewise *attraho* is made up of *ad* and the verb *traho*, so it must be written with a double *t* and not with one only.' Coluccio and Poggio had some sharp exchanges about the spelling of *mihi* and *nihil*, Coluccio preferring the medieval *michi* and *nichil*, which Poggio declared 'sacrilegious'. It was not the discovery of some long-lost authority which sparked off this interest: when in doubt Coluccio turned to the fifth-century grammarian Priscian, who had been available but neglected throughout the Middle Ages. Simply, a new attitude was abroad: a deep concern for the subject, and hence a concern about every detail of the subject.

For two centuries Italian manuscripts had been copied in an ugly Gothic script, compressed and angular, with words joined together and heavily abbreviated—Petrarch complained that the letters rode 'piggy-back' and tired his eyes. They were also often in places illegible. In order to remedy this situation Coluccio, who was too busy to copy manuscripts himself, called on Poggio Bracciolini, at that time a young man following the notarial course in Florence. Poggio brought to his task a new type of handwriting. Mistakenly believing it to be that of the ancient Romans, he imitated the pure Carolignian script of the eleventh century, before it had decayed into Gothic; his capitals (except his G, the tail of which he extended well below the line) he based on surviving Roman inscriptions he had seen for himself. On such monuments as the arches of Titus, Septimius Severus and Constantine he found his flaring R, and the M with the outside strokes slanting left and right. His use of dots between all words in titles was also imitated from inscriptions. He separated words so that they could be more easily read and abandoned the two-column arrangement of the Gothic period. Chosen by Cosimo de' Medici for all his books and hence given prestige, Poggio's script was to become the basis of modern handwriting. Every time we put pen to paper we are indebted to this Florentine.

But Poggio did more than return to an older tradition. In the interests of accuracy he added greatly to his labour by seldom using abbreviations. He wrote out almost every word in full. And, being a Florentine, he had an eye for beauty. In preparing his parchment for writing, he ruled not only horizontally to keep the lines straight but also vertically, on both left and right, so that all lines might begin and end at the same point. One device used by scribes to fill out a short line was to write an *i* and then to delete it lightly. Disliking this, Poggio spaced his text in such a way as to bring the line naturally to the right margin, thus setting the stage for the 'justification' of the line introduced by the first printers and followed ever since. The result is an easily read, well-proportioned page. A desire for accuracy and a loving regard for the text had produced a work of art.

The printed book was to follow the manuscript book very closely, and still further to increase exactness. Paper-making had spread from China to Europe early in the twelfth century, but printing had not accompanied it, largely because Muslims considered that to reproduce the Koran mechanically would be irreverent. The first printed works in Europe were holy pictures, the earliest dated print being a Virgin Mary made in Brussels in 1418. Then about 1440 Johann Gutenberg, a master of varied skills, including stone-cutting and mirror-polishing, engaged in experiments involving some adaptation of the wine-press and some means of casting separate metal types in matrices formed by engraving metal punches in relief. In 1457 he printed a *Psalter*, the first dated printed book. The sack of Mainz in 1462 dispersed German printers, two of whom, Sweynheym and Pannartz, came to Italy in 1465, setting up their press at the German monastery of Subiaco, where they printed the first book to issue from Italy: the Latin Grammar of Donatus. Some of the German printers' books came to Florence and passed into the hands of a Florentine goldsmith and engraver named Bernardo Cennini. Cennini examined them, deduced how they were made, and decided to produce his own books. He cut his own type, and in the first book to appear from his press, Servius's *Commentary on Virgil's Bucolics*, he printed a pardonably proud claim: 'To the mind of a Florentine nothing is difficult.'

While the Germans cast a thick Gothic type, Cennini and other

Italian printers used more graceful and legible characters. Their Roman founts were based on Poggio's script, while the italic type derived from the cursive script, sprinkled with Gothic, which another early calligrapher, Niccolò Niccoli, had invented for the quick copying of classical manuscripts. Thus the appearance of almost every printed page today derives from the work of these two Florentine friends.

The first edition of a printed book might run to 200 copies. By contrast, of Coluccio's *De Fato*, which circulated in manuscript fairly widely around 1400, only thirteen copies are extant. Moreover, whereas every manuscript had been in many respects unique, printing permitted the diffusion of identical copies. It was now possible to refer to a definite statement on this or that page of a book; the reference made by a scholar in Florence might be checked immediately by a correspondent in Venice, or in Oxford. Poggio, we have seen, had taken thirty-two days to make one copy of Quintilian's *The Training of an Orator*, but now three workmen in three months could produce 200 copies of a printed book. A manuscript Bible had cost ten years' of a priest's income; now a printed Virgil could be bought for a florin. To satisfy the growing demand, Florentine presses, like those of other Italian cities, poured forth Christian and classical works: before the century was out Virgil's works were to be printed 161 times. These books reached a new audience and helped form an even larger class of scholars, who in turn were to carry still further the quest for accuracy.

Printing did not at once replace copying by hand, and Florence continued to produce the best work in this field, sometimes for abroad. Antonio di Mario of Florence wrote three manuscripts for William Gray, Bishop of Ely: selected speeches of Cicero, John Chrysostom's works and John Climacus's *Spiritual Ladder*, both translated by Ambrogio Traversari. Antonio would fill a page at the end of a book by arranging words in patterns, such as a diamond or a triangle, and this persisted in some printed books. As late as 1480 another scribe, Antonio Sinibaldi, claimed poverty in his tax return, saying that since the invention of printing his work hardly kept him in clothes. Yet three-quarters of his extant books were copied after that date.

Exact scholarship, such as Coluccio and Poggio pioneered, was a technique only. It could be, and eventually was, applied in many varied fields. The first in order of time and importance is the field of history.

Who are we? and who are our forebears? the Florentines had asked while Giangaleazzo's cavalry thundered across the Apennines. To find out, they had studied the classical past, but that had given part of the answer only. There remained more recent events, which now seemed doubly dark by comparison with the vivid accounts of Greece and Rome. Bruni claimed that during his youth the history of the past sixty years was less well known than that of the days of Demosthenes or Cicero, and the claim is in no way exaggerated. History before 1400 had been one of the most debased of all intellectual pursuits: a welter of miracles and edifying stories. Here, for example, is a passage dated 1279 from a history of his own times by Salimbene the Franciscan;

Alberto of Cremona was a wine-porter, loving the wine-pot, and living in sin; after whose death, as men said, God wrought many miracles in Cremona, Parma and Reggio . . . Some came from Cremona claiming to have brought relics of this Saint Alberto, namely, the little toe of his right foot; so that all the men of Parma were gathered together, from the least even unto the greatest . . . and they bore that toe to the cathedral church, which is dedicated to the glorious Virgin. When therefore the aforesaid toe had been laid on the high altar, there came the Lord Anselmo di Sanvitale, canon of the cathedral and at one time vicar to the Bishop, and kissed the relic. Whereupon becoming aware of a savour (or rather, a stench) of garlic, he made it known to the other clergy, who themselves also saw that they were both deceived and confounded; for they found in the reliquary nothing but a clove of garlic. And so the men of Parma were despised and mocked.

Christian truth, in short, invariably triumphs, but alas often over the facts as well. The Florentine chronicler Malespini gravely described Catiline's wife hearing Mass in the Fiesole parish church— fifty years before the birth of Christ!—and more sinister errors could creep in when a history was avowedly written by direct revelation,

pure from all taint of earthly documents, the tone being set by an illumination common in medieval manuscripts: a dove speaking inspired words in the ear of a saint. More recently Giovanni Villani had introduced fairly accurate statistics to his chronicle, but with him also it is still the stars, God and Satan that produce events. Of a flood which drowned 300 Florentines in November 1333 Villani comments, 'God pronounced judgment on us for our outrageous sins.'

After the defeat of Giangaleazzo, Leonardo Bruni set out to write a serious documented history of the Florentine people, taking as his chief model Livy but enlivening his pages, in imitation of Thucydides, with imaginary speeches on key issues. For the Roman period he drew on newly available Latin texts; for the middle period, on chronicles; and for his own times, on documents in the Florentine archives.

Bruni begins not with Adam but with the founding of Florence, and limits himself to the one city. Miracle, legend and superstition have disappeared. At the centre of each chapter are living men, forging their own destiny. Events are the outcome of character and, following Cicero, Bruni believes that the events most worth recounting are those implicit with a moral or political lesson. Abandoning the year-by-year chronicle, Bruni writes a continuous narrative and knits it together with a deeply cherished unifying theme: the theme of liberty. The bloodshed of centuries—against the Goths, the Emperor, the Pope, and between Guelf and Ghibelline—now assume unity and meaning as incidents in Florence's single long struggle for liberty.

His new subject-matter and his great theme Bruni matches with a new style, the model, inevitably, being Cicero. It allows Bruni not only to present the facts, but to express his thoughts and feelings about them in the natural way of a man speaking. True, in order to preserve the purity of his Ciceronian Latin, he sometimes omits a distinctive touch: he will describe siege operations and digging of trenches because practised by the Romans, but forgo the pert Florentine custom of running *palii* or horse-races under the walls of a besieged town. Despite such blemishes, the style is up to the subject, and the result is a new kind of history, exact and critical but human.

The importance of Bruni's *History* the Florentines themselves recognized. In 1439 the Commune, proverbial for thrift, exempted Bruni and his children from taxes, 'so that, having immortalized the glory of the Republic, he may have an unending reminder of her citizens' gratitude', and in 1449 they deposited his book in the Signoria, a sort of literary cornerstone of republican Florence. Among the authors it inspired were Poggio, who wrote a history of events from 1450 to the Peace of Lodi in 1455, putting the emphasis on foreign affairs, in which he had more experience than Bruni, and Giovanni Cavalcanti, who wrote his account of events from 1423 to 1440 while serving a term in the Stinche for failing to pay his taxes. A warm admirer of the Medici, Cavalcanti sees history in terms of domestic politics and the clash of men in high office, for which reason he was to become Machiavelli's preferred source. Meanwhile, almost alone, Archbishop Antonino continued the old method of uncritical chronicling, even handing on the hoary chestnut that Joan the Englishwoman became Pope, and giving the length of her reign as two years, five months and six days.

The rise of history is perhaps the single most important intellectual development in fifteenth-century Florence. First and most obviously, it leant new weight to what men did, since their actions would no longer be quite forgotten; and, as Giannozzo Manetti pointed out in 1454, it gave men a new power, for by perpetuating their past they became in a sense masters of time. But of much greater consequence, history gradually replaced formal logic and allegory as the preferred instrument of order in a chaotic world. Allegory had been a special favourite with Dante: in the *Convivio*, for example: 'By "heaven" I mean Science, and by "heavens" the Sciences, because there are three points in which the heavens resemble the Sciences': namely, in their order, number and diffusion of light. Such a method, at best, replaces one abstract term with another. It is static thinking. But as the historical method came more and more to be used, a change gradually took place from static to dynamic thinking. This may be observed in the career of one not a Florentine but who lived for a time in Florence and kept in very close touch with his many friends in the Tuscan capital.

Lorenzo Valla was born in 1407 of Emilian parents living in Rome

and educated by his maternal uncle, an apostolic secretary named Scribani. In appearance he was thick-set, with curly hair, sharp eyes and a hawk nose. He was bold to the point of recklessness and liked nothing better than to attack accepted opinions. While still a youth he made the unheard-of claim that the Spanish-born Quintilian wrote better Latin than Cicero, and when less bookish friends taunted him with being physically impotent, he promptly went to bed with his sister's maid and begot three children in three years. At the age of twenty-four Valla asked Martin V for the place of his uncle, who had just died, and when this was refused left Rome to become professor of eloquence in Pavia. There, according to his enemies Bartolommeo Fazio and Poggio—but this may be invective —he turned his knowledge of Latin style to good account by forging a will, for which he underwent public penance at the order of the bishop. In 1437 he became secretary to King Alfonso of Naples, and in 1448 was appointed papal secretary by the tolerant Tuscan Pope, Nicholas V, a post which he was to hold until his death in 1457.

Valla likes raising ultimate questions. In his dialogue *De summo bono* he asks why beautiful women should not go nude, and why, 'since I have no obligation to die for one citizen, or two, or three and so on *ad infinitum*, I should have an obligation to die for my country, which is the sum of its citizens'. In his *De professione religiosorum* he analyses the vow of poverty and asks whether monks and friars are really poor, since they have sufficient for their needs. 'What greater extravagance than to strip oneself of one's own possessions and then ask for other people's?' Again, is chastity best enforced by a vow? Valla compares monks to Demosthenes, who freed himself from the bad habit of raising his shoulders in the heat of a discourse by practising oratory under a suspended lance which pricked his shoulders should he happen to raise them. Laymen on the other hand he compares to Marius, who underwent a painful operation without having his legs held down. Then Valla asks, Who has the greater merit, Demosthenes or Marius?

Whereas medieval thinkers, eager for universality, had tackled problems by ignoring differences of place and time, fifteenth-century thinkers of whom Valla is representative treat problems—often the same ones—precisely in terms of such differences. 'The historians',

Valla explains, 'show greater gravity, prudence and civil wisdom in their maxims than the philosophers. And to tell the truth, history yields a greater knowledge of nature, customs and other matters. Even in the field of religion Moses and the Evangelists are nothing but historians.' In the hands of Valla philology ceases to be a search for allegorical meanings and becomes history. In his *Elegantiæ latinæ linguæ*, a draft of which he submitted to Leonardo Bruni, Valla shows that the Latin language is not something outside and above time, but has developed like any other human instrument or activity through several historical periods. The best Latin stylists he considers to be Quintilian and Cicero, and as a guide to good Latin he groups examples of their writing. With typical bravado but only slight exaggeration, Valla declared his *Elegantiæ* to be of greater practical use 'than anything written for the past six centuries in the fields of grammar, rhetoric, dialectic, civil law, canon law or semantics'. It became the standard guide to Latin usage as far afield as England.

Because history deals with particulars Valla concerned himself with what his critics termed *res minusculæ*. He feuded with Benedetto Morandi because that scholar doubted whether Lucius and Aruns were the grandsons of Tarquinius Priscus, and with Poggio for writing *illi* instead of *sibi*. Comparing the Vulgate with the Greek New Testament, Valla criticized its translation of 'If the salt loses its savour' (Mat. v, 13) as '*Quod si sal evanuerit*', preferring *desipuerit* as a more exact equivalent of μωρανθῇ. At one point Valla's love of controversy brought him trouble. A Neapolitan friar named Antonio da Bitonto declared from the pulpit that the Apostles' Creed had been composed by the twelve apostles, each contributing one of its twelve articles. Peter said: 'I believe in God the Father', Andrew 'Creator of Heaven and earth', and so on. Valla showed that this could not be so, since dogmatic thinking of that kind only occurred at a later stage of the Church's development. Valla was summoned before the Neapolitan inquisitors and, according to Poggio, condemned to walk through the Dominican convent stripped to the waist, while birch blows were rained on his bare back.

There is paradox here. A study of classical models had led to the revival of history and exact historical method. But these, far from

being unchristian activities, could claim to be Christian disciplines *par excellence*, since Christianity is a religion which attaches unique importance to historical fact. We find the paradox carried a stage further when we consider Valla's most important application of the historical method.

The Pope's claim to the temporal power rested on a document known as the *Donation of Constantine*. This describes in considerable detail how the Emperor Constantine presented Pope Sylvester I with his own diadem, and assigned to the Pope and his successors, the Lateran Palace, Rome itself, and all the provinces of Italy and of the West. Dante had denounced the *Donation* as one of the most disastrous events in history, adding that he considered it invalid, since the Emperor could not alienate, nor the Pope receive, temporal power. Such criticisms fell on deaf ears: the text of the *Donation* was there in the Decretals, in black and white for all to see, and could no more be set aside than those other historical documents, the Gospels or the Patristic works interpreting the Gospels' meaning, on which the Church's whole existence was based.

As part of their temporal power the Popes claimed suzerainty over the Kingdom of Naples. In 1440 yet another quarrel had flared up on this issue between King Alfonso and Pope Eugenius. It was this which interested Valla in the *Donation of Constantine*. He began to study the document and, applying his new critical technique, proceeded to raise the following questions. When precisely did Constantine lead the Pope into the Capitol amid the applause of the Quirites? What bronze or marble monument records this crucial event? Where is the act of acceptance which one would expect to be joined to the *Donation*? Which authors describe an event that changed the face of Europe?

The *Donation* is recorded in an apostil to the Decretals, and this apostil is said to come from the *Gesta Sylvestri*, which Pope Gelasius (492–96) pronounced authentic. True, says Valla, that Gelasius confirmed the authenticity of the *Gesta*, but he did not say that they contained the *Donation*. In fact the *Gesta Sylvestri* are silent on this topic. Even had they mentioned it, that would be worthless evidence, for these *Gesta* are a tissue of legends. They assert that Sylvester baptized Constantine; but in fact Constantine became a Christian

while still a young man, in the lifetime of his father Chlorus and under the pontificate of Melchiades, as many contemporary authors record; as for the story that Sylvester cured Constantine of leprosy, that is just a crude copy of the Biblical story of Naaman and Elias. The *Donation* says the Pope received the provinces of the West but other documents do not bear this out. Melchiades records only *dona immensa et fabricam templi primæ sedis Beati Petri*—extensive gifts and the palace of the Lateran: possessions which are several times mentioned in the registers of Pope Gregory I (590–604).

Turning to the form of the apostil, Valla observed that it provided useless details about ceremony and dress, but forgot to name the chief cities given to the Pope, called Thrace an island and Byzantium Constantinople. It named satraps, who were Persian dignitaries, among the Emperor's councillors. It placed on Constantine's head a crown of gold and jewels, although every schoolboy knew that the emperors wore white fillets. It flagrantly contradicted sacred and secular history as handed down by Eusebius, Eutropius, Melchiades and Jacobus de Voragine. It was proved false by medals of the period. Valla has found one, such medal depicting the Emperor, and on the reverse a cross with the exergue: *Concordia orbis*, a medal therefore minted in Rome, not in the East, and since no coins with the Pope's head had been found, evidently Rome continued to belong to the Empire. Last but not least, the apostil was written in bad Latin. At a period when that master of style, Lactantius, was still alive, the Latin was shapeless, puerile, barbaric: the author imagined that *conculitores*—courtiers—meant houseboys; he used Greek words such as *chlamys* and *phrygium*, German words such as *banna*, and there was a Jewish tone throughout that smacked of the Apocalypse. Valla concluded that the apostil was a crude interpolation by some ignorant monk, some three or four centuries after Constantine.

With the publication of his *De falso credita et ementita Constantini donatione* in 1440 Lorenzo Valla at one stroke demolished a document which had underlain the temporal power since the eighth century, the probable date of its forgery, a document which *inter alia* entitled the Pope to sovereignty of all islands, a document in the name of which Pope Alexander II blessed William the Conqueror's invasion

of England, and Pope Adrian IV presented Henry II with an emerald ring and a bull authorizing him to subdue and rule Ireland 'for the enlargement of the Church's borders'. Yet Valla's motives in writing his treatise were in no sense anti-Christian or even anti-clerical. A practising Christian and later a papal secretary, he was as much concerned to preserve and spread the faith as the Popes themselves, but like the vast majority of his contemporaries, he considered the temporal power an obstacle to this plan.

> Maybe the day will dawn [wrote Valla]—and I hope my treatise will hasten the day—when the Pope will be merely the vicar of Christ, and not of Caesar too; when we will hear no longer the horrible news that the Church is fighting the Church, or the Perugians, or the Bolognese. It is not the Church that fights against Christians, it is the Pope; for the Church can fight only spiritual battles against the spirit of evil. On that day the Pope will be hailed for what he truly is, a holy father, father of all men, father of the Church, and instead of inciting war between Christians will make peace by apostolic censure and his intrinsic majesty.

Valla's treatise did not produce the hoped-for good results, at least in his own century. While the Popes tacitly admitted the truth of his attack, the almost obsessive lesson they drew from their seventy years' captivity in Avignon and the Great Schism was that the Papacy, to be independent, must hold territorial possessions and the money resulting therefrom. Their attachment to the Papal States became more tenacious than ever as the fifteenth century wore on, and now that the *Donation of Constantine* was shown to be a forgery, they claimed that Pippin, King of the Franks, had given Rome and Central Italy to the Popes between 754 and 756. For this claim no written donation existed, and if any such donation had in fact taken place it would have lacked all authority, since Pippin had no just claim on Central Italy, and no right to give it away without consulting the legal holder of imperial power in Constantinople. Even had the full facts been known, they would doubtless have weakened very little the Popes' attachment to their temporal power, including the suzerainty of Naples.

Though it failed in its immediate purpose, the publication of

Valla's treatise is a symbolic moment and was to have very wide repercussions. It freed history from the Church, and indirectly from any kind of obscurantism or tyranny. Henceforward scholars would ask not whether a historical statement was moral, canonical or time-honoured, but simply whether it was true.

The historical method thus proved an ingenious technique for understanding the mind of any past writer. Valla had used it to demolish certain claims; but the same method could also be used constructively. This happened at the Council of Florence, a far-reaching event which calls for treatment at some length.

Since 1054 the Latin and Greek Churches had been in schism. Poor communications over long distances, the language barrier and political rivalry had caused the schism, embittered since by the Crusaders' outrageous sack of Constantinople in 1204. Among present differences, the Greeks faced East when they prayed, and in crossing themselves moved their hand from right to left; they considered fornication a venial not a mortal sin; they used leavened bread for Mass; they objected to the Pope 'wearing on his slippers the cross Christ carried on his shoulders', and they refused his claim to temporal power. But far the most important difference was doctrinal. The Greeks held that the third Person of the Trinity proceeds from the Father only, not—as the Latins believed—from the Father and the Son. Each Church thought the other heretical and spoke of it as Satan's bride.

In 1435 it became advantageous to both sides to seek reconciliation, the Greeks because they needed galleys and archers against the Turkish danger, Pope Eugenius because a Council meeting in Basle without his approval had passed decrees cutting at the financial roots of the papacy and wished to strengthen its authority against him by negotiating with the Eastern Church. Forestalling the Basle Council, Eugenius invited the Greeks to meet him for talks. The Emperor and 700 delegates landed in Venice, noticed with pain the great bronze horses of Lysippus that had once been theirs, and travelled on to Ferrara. Here the ecumenical Council opened in January 1438. It went badly. Ferrara's narrow, provincial atmosphere induced squabbles about precedence, while the bishop declined to have his churches 'polluted' by Mass according to the Greek rite. Also, since

the last such council had met in 869, no one knew the procedure. Ambrogio Traversari hunted for copies of earlier proceedings as far afield as England, where Pietro del Monte promised to obtain in St Albans a codex of the fifth council. After fourteen sessions the two sides were no nearer agreement, while the Pope was five months behind in paying the Greeks' expenses and had run out of money.

Cosimo de' Medici had been following events closely. As a humanist, he would like to meet these men who spoke the language of Homer's gods; as a patriot, he would like the Emperor's 'golden bull' permitting Florence's new fleet of galleys to sail regularly to imperial ports; as a Christian, he sincerely desired union. Cosimo sent his brother Lorenzo to the Pope with an offer of free lodging and a loan of 1,500 florins a month if the Council moved to Florence.

On Sunday, 15 February 1439, the Florentines put on their finest clothes, sounded trumpets and crowded their rooftops to welcome Emperor John Palaeologus. Being both temporal and spiritual ruler, he was in effect another Constantine and viewed by some as a living reproach to the Pope. They were impressed by his strong, handsome bearded face, and even more by his curious white hat, with a brim coming to a long point in front and turned up straight behind, set with a mulberry-sized ruby—it was to figure in many a Tuscan painting. They gave him big wax candles, sixteen boxes of crystallized fruits, marzipan, wine, oats for his horses, but no meat, 'because he was not eating meat'—evidently the Greek Lent had begun—then got down to business.

Full sessions of the Council were held in S. Croce. Here Mark of Ephesus presented the Greek case on the Procession of the Holy Spirit. He based it on a passage in St Basil's book against Eunomius, a heretic who claimed that the third Person of the Trinity is a mere creature. The passage reads: 'The Holy Spirit is ἐξ αὐτοῦ καί οὐχ ἑτέρωθεν—from Him [the Father] and from nowhere else.'

The Western Church's expert in Greek was the Florentine Ambrogio Traversari, a small holy monk of fifty-three, vicar general of the ascetic Camaldolese Order, who ate no meat, and friend of Cosimo, for whose life he had pleaded in 1433. Ambrogio could translate aloud St John Chrysostom on the Epistles of St Paul

quicker than Niccolò Niccoli could write down his words, and had also translated much of St Basil. With Ambrogio's help, the Western spokesman, John of Ragusa, explained Basil's text in the light of another from the same book: the Holy Spirit 'in dignity comes after the Son, for He has His being from Him'. Mark retorted that this was a late addition by the Latins. No, replied John, it is to be found in the manuscript of St Basil's book which Nicholas of Cusa recently brought from Constantinople and which was written at least six centuries ago, therefore long before the present schism. John then asked to see an even older manuscript of St Basil's book which had belonged to Dorotheus of Mytilene. The Greeks sent a secretary of the Bishop of Nicomedia to fetch it. When the secretary saw that the text dangerous for the Greek case (ἔχει τὸ εἶναι ἐκ τοῦ υἱοῦ) was in the manuscript, he decided to scrape it out. While he was fetching a knife, the wind turned a page, and in his haste he scraped out another passage. When the book was produced, it threw the Greeks into turmoil—the Emperor, presiding, had to plead for order—while the bewildered secretary believed the passage had been restored by magic. But when the Emperor suggested sending home for more manuscripts, Cardinal Cesarini rose with the cutting riposte; 'Sire, when you go to war you should take your arms with you, not wait for them in mid-battle.'

Ambrogio next cited two other important authorities in support of the Western Church's teaching: St Maximus the Confessor, and St Epiphanius, a Doctor of the Eastern Church. The Greeks were unable to cite any Doctor of the Church other than Basil and rested their case largely on Scripture and a resolution of the Council of Ephesus in 431 prohibiting additions to their Creed.

After eight stormy sessions the Council could still find no way of reconciling the two sides: the Latins' credal formula 'from the Father and from the Son (ex Patre Filioque)' and the Greeks' time-hallowed phrase 'from the Father through the Son (διὰ τὸν υἱόν)'. But behind the scenes Ambrogio had met a remarkable Greek. Bishop Bessarion, aged thirty-six, was a born mediator, who could pull off anything from a brilliant marriage for his Emperor to a treatise reconciling Plato and Aristotle. He had studied under Gemistos Pletho in the Peloponnese and had there been deeply impressed to

find Frankish lords living peacefully with their Greek Orthodox neighbours. Bessarion had as thorough an understanding of Latin history as Ambrogio had of Greek. The two scholars approached the relevant texts not dialectically but historically. They went behind the actual words to the author's intention, concerned perhaps to refute a particular charge or to counterbalance a heretical tendency. Their conclusion was that in the disputed earliest texts the Greek $\delta\iota\alpha$ (through) was intended to have the meaning of the Latin *ex* (from). Though using different terminology, the Eastern and Western Fathers were really saying the same thing.

This solution, which today seems so reasonable, was then extremely bold, for it involved jettisoning the time-honoured method whereby words and sentences were abstracted from their context and used as weapons in a formalized disputation. The ogre-like preposition which had blocked union for four centuries was now seen to be not an absolute, but a pathetically human attempt to stammer a truth beyond man's power to express adequately. The solution, in short, was both a triumph for the historical approach and a move in the direction of innerness. The Eastern Church agreed to recognize the *Filioque* but was not obliged to incorporate it into its profession of faith. This led to the quick settlement of other points: notably, the Greeks recognized the Pope's supremacy except over existing rights of the Eastern Church, and retained their different ritual.

Ambrogio and Bessarion drafted the decree of union, which the Emperor signed in red ink on 5 July 1439, followed by thirty-two of the Eastern prelates, including Abraham of Susdalia, who signed in Russian characters. On the Latin side there were 117 signatures. Next day the Council met in the cathedral to hear Cardinal Cesarini solemnly promulgate the decree in Latin, and Bessarion in Greek: 'Let the heavens rejoice and the earth exult, for the wall is fallen which divided the Western Church and the Eastern, and peace and concord have returned.'

Eugenius gave the Emperor archers and galleys, the Emperor gave Cosimo the 'golden bull', and Bessarion gave Ambrogio the head of St Gregory Nazianzen and a stick which had belonged to St Joseph. Though die-hard opposition, notably from Mark of Ephesus, and the fall of Constantinople in 1453 were to prevent the

decree of union taking effect in the Eastern Empire, the Council of Florence had succeeded in its momentous task. It had also asserted a generous new principle—unity of faith and diversity of rite—which was to mark Florentine religious thinking for the next two generations and to be developed into an even wider ecumenicism.

Religion played a fundamental part in the life of the average Florentine, more so perhaps than in the lives of his neighbours. One cause may be his deeply religious Etruscan forebears, another the lack of a feudal pattern to direct religious instincts towards worship of the prince. Whereas most other Italian cities began their year, like ancient Rome, on 1 January, Florence began it on 25 March, feast of the Annunciation, when Christ became incarnate (hence the popularity of this subject with Florentine painters). That the Florentine was generous to God could be seen in the size, number and richness of his churches, and to his neighbour in numerous orphanages, hostels and other works of mercy. In religion as elsewhere he tended to be practical and bold. Florentine saints such as Gualberto and the Seven Servites had gone in less for tears and visions than for founding new orders to meet urgent needs or remedy abuses. The Florentine was not superstitious and gave little heed to relics. The toe of S. Alberto would not have interested him. At a time when Louis XI spent up to 13,046 *livres* a year on offerings to shrouds and crosses and holy tears, and even made offerings to St Hubert for the health of his dog '*Chier amy*', nothing more is heard of the finger of John the Baptist bequeathed to Cosimo by John XXIII. The Florentine was, on the whole, glad and reasonable in religion, but beneath his rich scarlet gown lay a strong tendency to simplicity and detachment, which would suddenly break out when his emotions were aroused. The Albigensian heresy had counted many adherents in Florence, and in 1424, after fiery sermons by S. Bernardino, the Florentines lit a bonfire in the Piazza S. Croce, where they burned gambling boards, dice and cards, cosmetics and chignons. Thousands joined in the burning, and an eyewitness described them as in tears and quivering.

The leading religious thinker at this time was Marsilio Ficino, none other than the young Greek scholar chosen by Cosimo to

translate Plato. He was born in 1433, the son of a well-known physician of Figline, in the Arno valley. His mother Alessandra was neurasthenic, deeply religious and subject to visions. She foresaw the accidental suffocation of one of her babies by its nurse, and her husband's fall from a horse. Marsilio was very short—perhaps five feet tall—slim and stoop-shouldered. He had long arms and long graceful hands. His fair curly hair stood up in front; he had a big hooked nose and a small chin, but his expression was sweet. He was very nervous and spoke with a stammer. Alone, he had a tendency to melancholy, but in company became a gay conversationalist. He made friends easily but, according to Corsi, 'was in no way inclined to sexual love'. Like his mother, whom he adored, he had a tendency to visions. Plato would seem to appear to him; once Phœbus handed him the lyre of Orpheus, and Friendship and Virtue gave him advice as though they were real persons. One of the phenomena which most interested him and which he himself experienced was *vacatio mentis*, when the soul frees itself from the body. Ficino names seven conditions which could induce it: sleep, a fainting fit, melancholy, chastity, a well-balanced constitution, solitude and surprise.

Ficino studied medicine in Florence and Bologna. Though he did not practise, he remained interested enough to write works on optics and perspective, and in later life treated friends who happened to suffer from bile. He started reading Plato in his early twenties, to the alarm of Archbishop Antonino, who made him set aside the Greek master until he had first studied St Thomas's *Adversus Gentes* as 'an antidote'. He also became deeply attracted to Epicureanism, and wrote a commentary on Lucretius, which in later life he was to burn. He had always been religious and after a long period of doubt was ordained priest in 1473. He preached often, and continued to seek convincing arguments for religious belief. Lorenzo de' Medici obtained for him the parish church of S. Cristoforo a Novoli, near Peretola—a giant's church, he joked, for tiny Marsilio.

Between 1459 and 1477 Ficino translated the complete works of Plato, and was thus the first man for many centuries to discover the historical Plato. It was an exciting discovery, a philosophic America. Ficino found himself confronted with a closely argued theocentric

system of great power and beauty, attaching the highest importance to love of God and one's neighbour—yet written 350 years before Christ. Ficino's reaction was to treat it not as a stumbling-block to the faith but as a precursory work comparable to the Old Testament—Plato he called 'a Moses speaking Attic Greek'. He set out to harmonize Plato's thought and Christianity in a system of his own.

Ficino's system is summed up in a medal cast for one of his disciples. It depicts the three Graces (a subject known to have been sculpted by Socrates), surrounded by the exergue: Beauty—Love—Joy. Beauty is Ficino's starting-point. The most important single factor about the world is that it is beautiful. Its beauty is an expression of God's beauty, for this world is His poem, His work of art. And, as Florentine painters and sculptors had since the turn of the century been demonstrating with such skill, man too is beautiful, both in body and soul.

Love is the desire of beauty. Man is a loving creature and cannot help loving beauty. Ficino accepts Plato's division of love into heavenly and earthly, but denies that the latter is degrading. 'In reality both are good, since the procreation of children is considered quite as necessary and honourable as the quest for truth:' procreation enables divine beauty and goodness to continue in mortal things. Love is not contemplative as in Plato but active and conative: an agitation of the senses and of the heart that rescues us from selfishness. Man is most easily stirred by bodily beauty, but since bodily pleasures are unsatisfactory, not because they are pleasures but because they do not last, he comes to love beauty of spirit. This Ficino is able to describe as *virtù*, since for him, as for Plato, the beautiful and the good are one and the same. For the spiritual love between two persons described by Plato Ficino coins the term Platonic love. Since all beauty is a reflection of God's beauty and shares in His nature, it follows that in Platonic love we are also partly loving God, which is why Ficino says that in such a relationship there are always at least three partners: two human beings, and God who founds their friendship.

The fruit of love is joy. Ficino's word is *voluptas*—joy of the whole person, for both senses and intellect are satisfied in the rapture of love. But joy is complete only in the next life, where we

experience in God perfect beauty and perfect love. There, as Aristophanes says in the *Symposium*, we realize our never-sleeping desire for a return to our former state of oneness with the Divine.

In Ficino's remarkable system it will be seen that God, for so long Aristotelian and transcendent, again enters the world; a new note of joy is heard, absent since the early years of the Church, when every feast-day had been celebrated as Easter; and the value accorded to love and friendship puts a new emphasis on human relations: other people can lead us to God. All these features are an expression of optimism. Despite melancholy moods Ficino shared the optimism of his city and period; hence his views spread among the Florentines like wildfire.

Ficino gathered a group of friends to meet informally in the house among the pines of Montevecchio given him by Cosimo, the hall of which was decorated with a picture of smiling Democritus, who always saw the cheerful side of things, defying Heraclitus in tears at man's stupidity. Ficino called the house the Academy, after Plato's school, and the name was applied by extension to him and his friends who met there. They included Lorenzo de' Medici, the poet Angelo Poliziano, Cristoforo Landino, who wrote an influential commentary on Dante, as well as statesmen, lawyers and doctors.

The Academy banqueted on Plato's birthday, 7 November. In a prominent place stood a bust of Plato, and guests greeted one another: '*Salus in Platone.*' At one such banquet Plato's *Symposium* was read aloud and discussed, each of the nine guests identifying himself with one of Socrates's actual guests, and Ficino presiding as 'another Plato'. It was a more profound experience than play-acting. The peripatetic antiquary, Ciriaco d'Ancona, expresses well the Academy's intention when describing his own aim. This, he says, is to 'wake the dead', 'to bring glorious things from the dark tomb to light, to live once more among living men'; and this not simply for the sake of reviving 'dead titles', but in order to reveal to his contemporaries their 'own names'. Plato's world, then, was more than a historical spectacle, it was the prototype of civilization, in which later civilizations must find themselves. History for all its riches was not an end, but a key to the present: indeed, Ficino's inscription in

the hall of the Academy repeats that word: 'All things are directed from the good to the good. Rejoice in the present. Do not prize wealth nor seek honours. Flee excess, flee business, and rejoice in the present.'

Encouraged by his success in harmonizing Plato with Christianity, Ficino set himself the far more difficult task of harmonizing Greek, Roman and other religions with the dogmas of the Church. His criterion of truth was invariably orthodox Christianity but he made the generous assumption that behind the rites of every religion lies some measure of that truth, possibly obscured by myth. When the Romans call Vulcan the god of fire, says Ficino, they really mean to apply that name to the concept of fire which, as Plato had shown, is one of the Ideas in the mind of God; the reverence paid to Vulcan is in fact reverence paid to the true God. Ficino was delighted to find the doctrine of the Trinity in certain Zoroastrian oracles, and also in the mysteries of Egyptian religion which Horus Apollo claimed to be revealing in his *Hieroglyphica* (falsely, as we know today).

The kind of thinking involved can best be illustrated from the sphere of art. Filippino Lippi painted two pictures of the same size, known to be companion pieces. One shows a familiar subject, Moses striking water from the rock, the other a very unfamiliar one: the worship of Apis, in which Filippino, following Pliny, has depicted the bull god, risen from the river Nile, prancing in mid-air above his worshippers. The link between the two pictures seems to be this. God spoke to the Egyptians through the annual miracle of their dancing bull just as he spoke to the Jews through the miracle of water springing from the rock, and the two miracles are not unrelated, since, as Philo pointed out, the Jews probably derived their worship of the golden calf from the cult of Apis. The pair of pictures illustrates the belief in Ficino's circle that one religion has passed on truths to another, down to Christianity, and that the Egyptians in celebrating their miraculous bull were, in their own sincere way, worshipping God.

Ficino held that myths such as the love-affair of Mars and Venus and the rape of Deianira imparted moral truths, indeed enriched Christianity by their fresh, piquant treatment of familiar themes: as we shall see, they were to be painted with this in mind. Although

Ficino too often read a causal link into random similarities—he claimed that the cup and the mention of a cock at the death of Socrates were prophetic of events on Holy Thursday—at its best his was a bold and generous use of the historical method in order to discover certain elements common to human thinking about God.

Ficino's note of optimism and search for unity in diversity were continued by his most brilliant disciple, Giovanni Pico, Count of Mirandola and Concordia. Youngest of three sons, Pico was born in 1463 in the family castle of Mirandola in the duchy of Ferrara. Slender and well-built, he possessed striking good looks, notably long curly hair golden in youth. He had an attractive chivalrous nature, and the burning energy of those destined to die young. This drove him to study night and day and to attend no less than four universities before the age of eighteen. Like many devout Christians, including Ficino, he was perturbed by the variety of religions and philosophies which the new learning had revealed. He speaks of 'internal struggles worse than civil wars which only moral philosophy can resolve', and one of his youthful sonnets declares '*Cosa ferma non è sotto la luna*'.

At the age of twenty-one Pico came to Florence, which he found 'an incomparable centre of wisdom and intellectual energy'. He fell under the influence of Ficino and in order to understand all known religions began studying Arabic, Chaldaean, Hebrew and the Cabbala, a book so venerated that no Jew might read it under the age of forty. In 1485 he visited the University of Paris and in the following year, while staying in Arezzo, fell in love with Margherita, the beautiful wife of one Giuliano de' Medici, a tax administrator. 'Blinded by his good looks', Margherita returned Pico's love and the couple decided to elope. Margherita left her house for a walk, and outside the town walls got up behind Pico on his horse. When Giuliano found out, he had the stormbell rung and set off in angry pursuit. With Pico were twenty attendants and two mounted bowmen. A fight took place and several men were killed. Pico received two wounds, but got away to Marciano, where he was arrested and brought before the Ten. Platonic harmony finally prevailed; Pico apologized in a letter for having yielded to temptations 'which

also troubled St Jerome in his pious meditations', and Giuliano took back the wayward Margherita.

Pico rode on to Rome, where in December 1486 he caused a sensation by proclaiming 900 conclusions or theses of a controversial nature, and offering to pay the travelling expenses of anyone wishing to debate them publicly. Pico accepted the Averroist doctrine, denied by Ficino, that men share a common intellect and, basically, cannot disagree, so he went much further in evolving a perennial religion from esoteric sources. His theses ranged from Arabic, Hebrew, Egyptian and classical quotations imparting 'perennial' truths, to certain opinions of his own on subjects from dialectic to mathematics. One asserts that the testimony borne by magic (by which Pico meant the wisdom of the Magi) and Cabbalism to the divinity of Christ is as valid as arguments from philosophy. Another states, 'Whoever profoundly and with his intellect understands the division of the unity of Venus in the trinity of the Graces, of the unity of Fate in the trinity of the Fates, and of the unity of Saturn in the trinity of Jupiter, Neptune and Pluto, will see the right mode of proceeding in Orphic theology', namely, Pico's method of disclosing an underlying truth revealed, stage by stage, in various religions.

If such theses as these were above the heads of the Roman prelates, a third they could understand. It related to Origen, a theologian much admired in Florence for having attempted a synthesis of Greek philosophy and Hebrew scriptures. After his death Origen was condemned by the Church for having maintained several heresies, notably the pre-existence of souls, as taught by Plato, and that all men, and even devils, will finally go to Heaven. Pico championed Origen, claiming that the Greek 'had neither written nor believed the heresies attributed to him; and if he did write them, he did not assert them dogmatically; and if he did assert them dogmatically, he did not commit a mortal sin, because he had erred in good faith; and if he did commit a mortal sin, he repented later; and if he could not go to confession, it was reasonable to believe that God had forgiven so holy a man; and even if the Church had condemned his doctrine, she had not, nor could she, condemn his soul.'

Pope Innocent VIII appointed a group of theologians to decide

what should be done about Pico's theses. They met in March 1487 in the Apostolic Palace near St Peter's. An excerpt from Pico's account reveals his gentle, slightly amused manner, and the way in which historical answers were being sought to religious questions. 'One of them', writes Pico, 'was very insistent that the Church had condemned the soul of Origen. I replied that Greek histories stated that many years after his death his doctrine was condemned, not his soul; and I referred him to the Bishop of Traguria, in whose house I had read a collection of facts, in Greek, about the Councils. "Why do you refer me to the Greeks," said the good Father, "when you know I am completely ignorant of Greek? Let's look at the Latin together. Don't we have a little book of that period which treats these matters very elegantly?" "Let the book be brought," I replied. "But if you propose to set fire to it and burn me as a heretic, I'll leave at once; and to the devil with your book, in which I haven't the least confidence." The priest grew as angry as if I had blasphemed the Trinity. "Don't be cross," I said. 'Have the book fetched, but don't expect me to yield before it's barely opened." The book arrived, and in it we read: "Origen was a famous teacher of incomparably holy life and very high reputation in God's Church." And later: "A great labyrinth has been constructed by many about Samson, Solomon, Trajan and this man Origen, as to whether or not they are saved. The question cannot be answered with certainty, nor can the Church pronounce on it, for these are matters to be left to God alone." So said the dear book. It was wonderful to see the good man grow pale at the last part, and while the authority of the most famous men had failed to impress him, that book made him change his mind.'

Despite this tactical defeat, a majority of the commission found seven of Pico's theses, including the one asserting the probable salvation of Origen, to be heretical, and six more to be dangerous. At this Pico seized his pen and dashed off a defence of the condemned theses. He took his stand on a dictum learned in Ficino's circle: 'It is not intellectual error that makes a man a heretic, but rather malice and perversity of will.' Having finished his *Apologia* in twenty nights, Pico dedicated it to Lorenzo de' Medici, thus singling him out as the champion of intellectual freedom in Italy.

Pope Innocent named two judges to act as inquisitors, with auth-

ority to arrest, imprison, examine and punish Pico. Pico was twenty-four and did not want to be burned. He took to his heels. He thought France would be tolerant, but soon learned his mistake. In January 1488 he was arrested near Lyon and locked up in the royal fortress of Vincennes. Lorenzo, through friends at the French court, procured Pico's freedom and offered him hospitality. Pico arrived in Florence in June 1488, and settled in the villa of Querceto near Fiesole as Lorenzo's guest. He hero-worshipped Lorenzo and decided to stay always. His property in Mirandola together with his third share in the principate he ceded to a nephew for 30,000 gold ducats, and having thus assured his independence, plunged into Old Testament studies with a Jew named Jochanan ben Izchak Alemanno as a prelude to further writing.

Pico's most influential work, his *Oratio de dignitate hominis*, carries to its culmination and supports with syncretist arguments the classical view of active man developed by Bruni, Alberti and others. The book begins: 'In Arabic texts I have read that Abdullah the Saracen, when asked what he considered the most marvellous thing in the world, replied that he could perceive nothing more splendid than man. This agrees with the famous saying of Hermes [Trismegistos]: "O Asclepius, a great miracle is man."' Why a miracle? Because, explains Pico, he alone is able to make his own life. Man's nature is not determined by laws or constrained between fixed limits: he is free to choose and make his own character. He can sink to the level of a brute or rise to be united with God—the choice is his, for 'God the Father endowed him, from birth, with the seeds of every possibility and every life'. And in one of Pico's inspired passages God addresses man with the stirring phrase: 'Masterful moulder and sculptor of yourself.'

Pico's book is the finest expression of those ideals most distinctive of Lorenzo's Florence: freedom, versatility, the active life and love of God through the world's beauty. In the *Hetaplus* Pico was to round off his picture by stating that the world is fulfilled by being understood by man, and by attaining unity in his consciousness. In this sense man is the centre of the world.

Though Pico and Ficino disagreed on some points, both approached the problems of history and religion in a basically

optimistic spirit, and both subscribed to an important belief which Gemistos Pletho had proclaimed during the Council of Florence: in a few years there would, throughout the world, be only one religion, one soul and one mind. When Ficino called for religious peace, in which the reign of the spirit will be perfectly realized, when Pico sought to prove that Plato and Aristotle had the same view of creation, both were working for that 'one soul and one mind'. Both made much of innerness, the communion of all men as spiritual beings. Both made much of prophecy. Both made much of successive revelations of truth. These were conditions favourable to a single world religion. But they were also conditions favourable to a Savonarola.

Discovery

THE CLASSICAL HERITAGE nowhere offered so much new information as in the natural sciences, a province where the Florentines had hitherto achieved little remarkable. There had been few Florentine cosmographers of note, few anatomists or geographers or navigators. But under the impulse of knowledge accumulated by the Greeks, and to a lesser degree by the Romans, the Florentines in all these fields were now to initiate important discoveries, which, unaided, would certainly have taken them several centuries. Indeed, the consequences of their bold thinking were to prove more far-reaching in the natural sciences than in any other field.

Their point of departure—interest in the physical world—was long damped down by so-called Christian taboos. Two incidents mark the course of emancipation, the first involving Petrarch. From his retreat in Vaucluse the shy Florentine cleric could see the peak of Mount Venoux, some 6,000 feet high. Mountains filled the medieval mind with terror and Petrarch would have doubtless never dreamed of exploring it, had he not happened to read in Livy that King Philip of Macedon climbed Mount Hemus, in what is now Bulgaria, in order to discover whether it yielded a view of both the Black Sea and the Adriatic. That sentence stirred the poet's imagination and in 1335, at the age of thirty-one, Petrarch set off with his brother Gherardo, the future Carthusian. On the foothills they met an old shepherd who said they would get nothing for their pains but torn clothes from the rocks and briars. But they kept on and reached the summit.

Petrarch was charmed by the wild beauty and majestic solitude. He sat resting and enjoying the view. He had brought with him a favourite book, St Augustine's *Confessions*, and being a compulsive

reader, presently opened it at random. His eye fell on these words: 'Men go about to marvel at the heights of the mountains, at the huge waves of the sea, at the broad estuaries of the rivers, at the circuits of the ocean, and at the revolutions of the stars, and forsake their own souls.' Petrarch guiltily started up, all his joy of discovery gone. 'I felt that I had seen enough of the mountain, and turned my mind's eye back upon myself; and from that time no one heard me speak till we reached the bottom.' Petrarch never again explored a mountain.

A century passes. In 1435 the Tuscan Aeneas Silvius Piccolomini, later Pius II, landed in Dunbar on shady business for Mother Church, namely to urge King James I of Scotland to make border raids into England, thus easing pressure on France in the Hundred Years War. Piccolomini had read that in northern Scotland barnacle geese were born from the fruit of a riverside tree; this fruit fell into the water, came to life, and turned into birds. He felt sceptical and wanted to test the story. Although very busy and engaged in an affair with a Scots lass, who later bore him a child, he made a special journey in search of barnacle geese. 'But when he got there and made enquiries, eager to witness the marvellous happening, he found it was a lie or, if true, took place still further north, in the Orkneys.' Far from concluding that scepticism had made him unworthy of seeing the hatching, Piccolomini, it is clear from his account, would cheerfully have taken ship for the Orkneys, had time permitted. He did in fact make one small discovery which he records with pardonable pride: in northern Scotland at the winter solstice he found the day to be only four hours long.

In Florence this fresh interest in the physical world, which stemmed naturally from man's new course, was strengthened by the Platonic view that God is not transcendent and aloof, but in some sense present in the world. Nature offers an explanation of God and therefore the study of nature is morally to be encouraged. But it could be studied only by the application of a rigorous method. Uniformity of spelling, precise arrangement of historical facts, the tracing of developments in religion—these achievements, however minor, had prepared the Florentines for their task of getting through a huge accumulation of dross, commentaries, garblings and fancies to what, on any particular scientific point, this or that Greek had actually written.

For their picture of the physical world the Florentines turned to Plato. The philosopher who had proved so helpful in providing a reasoned basis for Christian beliefs was found to provide a no less satisfactory interpretation of the universe. Once again, the starting-point is beauty. Plato insists on the beauty of the universe and he defines that beauty in terms of mathematics. Here Plato is following Pythagoras, who thought of numbers as shapes, as they appear on dice or playing cards. Pythagoras speaks of square numbers, cube numbers, pyramidal numbers, and so on. These were the number of pebbles required to make the shapes in question. Pythagoras presumably thought of the world as atomic, and of bodies as built up of molecules composed of atoms arranged in various shapes. Plato took over and developed his theory, making mathematics the key to an understanding of the universe, which is why, over the door of his Academy, he inscribed the words, 'Let no man enter who knows no geometry.'

On this point, as often elsewhere, Platonic teaching came into sharp conflict with the Aristotelian theory that had long held the stage. Aristotle's physics are qualitative. He considers any object to be composed of certain qualities, such as heat, redness, hardness and so on. Quality and quantity belong to absolutely different categories, so that Aristotle explains a change of intensity in a given quality by positing the loss of one attribute, for example one species of heat, and the acquisition of another. For Plato, on the other hand, a change of quality is to be explained in terms of addition or sub-traction of quantity, that is mathematically.

Respect for mathematics and for numbers generally was of course nothing new in the trading city of Florence. But the sterile form it took in medieval speculative thinking can be seen in the *Vita Nuova*, where Dante aims to prove that the number 9 is intimately connected with the day, the month and the year of Beatrice's death. It so happened that Beatrice had died on 8 June. Dante therefore had recourse to the Syrian and Arabian calendars. He said Beatrice died in the ninth month according to the Syrian reckoning, which corresponds to our sixth month, namely June. As regards the day, Dante said that she died in the first hours of the ninth day of the month according to Arabian usage, whereby the day begins not

at sunrise, as with the Romans and others, but at sunset. He concluded triumphantly that Beatrice was 'a nine, that is to say a miracle, whose root is no other than the marvellous Trinity'.

Since Dante's day two innovations had occurred which predisposed Florentines to follow Plato in making a more serious and fruitful use of number. The first was the widespread introduction, during the fourteenth century, of the mechanical clock, in which the hands translated organic time into mathematical units on a dial. The second was the introduction of perspective, whereby Florentine painters, as we shall see later, represented objects in space according to strict mathematical principles.

While proffering with one hand mathematics as a key to nature, with the other Plato passed to the Florentines a doctrine which, if followed to the letter, would render the key useless. Plato taught that physical phenomena are not in themselves worth studying. They merely serve, like diagrams in geometry, to suggest to us ideal problems which must be solved through reason, not through the senses, which are deceitful. Observation and experiment, then, were ruled out because they could contribute no reliable information. Happily the practical-minded Florentines ignored Plato's teaching on this point, while adopting as a working hypothesis his interpretation of the universe in terms of a simple regular mathematical beauty.

The first to carry out observation on this basis was Paolo Toscanelli. Born in Florence in 1397, the son and grandson of well-to-do physicians, he studied at Padua, learning Greek from Filelfo, and taking a degree in medicine. A private income from two large farms and from iron and copper mines permitted him, on his return to Florence, to devote his life to research in astronomy and geography. A homely man with thick lips, hooked nose and small chin, Toscanelli never married, slept on a plank beside his work-table and followed a vegetarian diet. He was generous and much-liked, his friends including Cosimo and Piero de' Medici, Brunelleschi, to whom he gave free lessons in Greek, and Cardinal Nicholas of Cusa, whom he helped with his mathematical treatises.

The problem that interested Toscanelli was movement of the heavenly bodies in space. Starting from hints in Plato—they are

no more than hints—Toscanelli sought to break down continuous space and movement into mathematical units. To this end he observed and plotted the comets of 1433, 1439, 1456 (Halley's comet), 1457 and that of 1472, which on the fourteenth day attained a size almost as large as the moon, its tail sweeping across a sixth of the sky. Toscanelli represented the sky above Florence on a sheet of paper and marked in pencil the comet's position each night. According to the Aristotelian view comets, having an irregular motion, could not belong to the perfect crystalline spheres, nestling one inside another, of which the universe was composed, and must therefore be sublunary 'vapours'. Although none of his writings have survived, his graphs of comets' paths can have left Toscanelli with little doubt that comets move not below but above the moon. If so, Aristotle's cosmography broke down in part, notably his view that an essential dichotomy exists between an imperfect, corruptible earth and the perfect, incorruptible heavens. Plato denied this dichotomy: for him the universe is a single whole.

As part of his research Toscanelli wished to measure the sun's noon height. The higher he could place the upright of his gnomon, the longer the shadow, and the more accurate would be his calculations. In 1468 he obtained permission to construct a gnomon in the cathedral, using as his upright a column of the lantern of Brunelleschi's dome: it was typical of Florentine broad-mindedness to allow a scientist to conduct experiments in the house of God. Toscanelli installed a brass plate on the cathedral floor near the new sacristy. By measuring the shadow on this plate he was able to calculate the sun's meridian altitude, and thence plot its relation to the earth over the months. One of the discoveries he made was that the equinox fell twenty minutes earlier than would follow from tables based on the Ptolemaic system. This small discovery has an intrinsic and also symbolic importance. It shows a scientist, armed with Platonic hypotheses, finding that his observations disagree with Ptolemy, the accepted authority in the field; and this was to be the pattern of future developments.

When he arrived in Italy in 1496, the young Polish astronomer, Nicolaus Copernicus, learned Greek, came into touch with Platonism at Ferrara, whence it had spread from Florence, and encountered

in Plutarch's *Moralia* the theory of a certain Hicetas, a Syracusan, that the earth moves round the sun, a theory also held by two other Greek scientists, Heracleides and Ecphantus. Now, a prominent feature of Ptolemy's planetary theory had been the huge epicycle in which each planet moves round about its mean position: an unwieldy arrangement posited in order to explain why a planet's speed and distance appear to vary so greatly as seen by an earthbound observer. The epicycle irked Copernicus because it seemed 'averse to the simple regularity to be expected from one best exquisite divine nature'—this, in turn, being not common sense but sophisticated Platonism. The irregularity prompted Copernicus to seek a solution in Hicetas's theory and eventually to claim that the supposed motion of the planet on an epicycle is an illusion produced by transferring to the planet the real annual revolution of the earth about the sun. Copernicus's momentous claim that it is not the sun that revolves round the earth, but the earth that revolves round the sun, was a choice, not a discovery, and the basis of Copernicus's choice—as later those of Kepler and Galileo—was the Platonic cosmology revived in Florence.

Perhaps the chief difficulty under which Florentine scientists laboured in the fifteenth century was that they had inherited a tangled web of fact and fantasy, of science and magic. Astronomy was so closely linked with astrology that the words were interchangeable. As Florence's leading astronomer, Toscanelli was *ipso facto* the leading astrologer, and it was he whom the Signoria deputed to select the most favourable moment for that ominous event, handing the stick of office to the *condottiere* Sigisimondo Malatesta, which marked Florence's commitment to the policy of mercenary troops: the moment Toscanelli chose was 5 p.m. on 29 September 1453. Alberti in his book on architecture says that foundations must be laid at the correct astrological moment. This rule was observed in 1489, when the foundation stone of the Palazzo Strozzi was laid at an auspicious time fixed by three physicians, a bishop and Marsilio Ficino, and it was observed even for churches. The position of the stars as shown in the sacristy of S. Lorenzo corresponded to the heavens in Florence on 9 July 1422, when the high altar was dedicated. On the analogy of the Magi's star comets were held to indicate

imminent change, notably of rulers, an error to which even Tosca-
nelli was not immune, though in old age he changed his views and
denied the influence of comets. The leading theologian of his day,
Pierre d'Ailly, who took a lead in deposing John XXIII and burning
Jerome of Prague, was much attracted by the astrological doctrine
of conjunctions. He remarked a conjunction in 1226 under which the
Franciscan and Dominican orders were founded, as well as the
Tartar Empire; he predicted another momentous conjunction for
the year 1789.

In medicine also astrology held sway. The cranium was held to
come under the influence of the primum mobile, the brain under
the fixed stars, the right eye under the sun, the left under the moon.
Curative baths were believed to lose their virtue in leap years, for
these were dominated by Saturn, which is cold, dry and contrary
to life. If Florence took to its bed in an epidemic of colds, coughs
and fevers, astrologers were consulted, and they would declare that
it was caused by the influence of an unusual conjunction of planets.
This sickness, which kept recurring in hard winters, came gradually
to be known as 'influenza'.

Ficino believed firmly in astrology as yet another link in the unity
of the cosmos. The special attraction he felt for Pico he attributed to
the fact that they had both been born under the planet Saturn in the
sign of Aquarius at an interval of thirty years. Ficino would send
Lorenzo amiable warnings that today and the next day he must
beware of the planets Mars and Saturn, adding, with a generosity
but lack of psychology typical of the man, that he had postponed
warning him until the last moment lest Lorenzo incur or increase
the ills by excessive worry.

This Babylonian structure of zodiacal signs and astrological
houses had exerted a crippling influence on human thought and
conduct for over a thousand years. True, a few voices had been
raised in protest: one was St Augustine's, when he pointed to the
varied fortunes of identical twins; another was Petrarch's. In a
campaign against Pavia in 1359 the astrologer checked the Milanese
attack to await the hours of extreme propitiousness; but when the
hour arrived a month-long drought was broken by torrential rain
that flooded the Milanese camp and forced the siege to be lifted.

Petrarch asked the astrologer what had gone wrong, and received the immortal reply: 'Well, you see, it's hard to predict the weather.'

There could be little progress in the natural sciences until astrology had been swept away. It was Pico della Mirandola, the champion of human freedom, who launched the first sustained attack on a system that claimed to limit that freedom. At first sight the classical model seemed to offer him little help. Fifth-century Athens had been innocent of planetary influence, but the Romans were confirmed astrologers, and one of the texts discovered by Poggio, Manilius's *Astronomica*, expounds at length a system of celestial determinism. But in the Alexandrian writings attributed to Hermes Trismegistos, the *Asclepius* and the *Pimander*, which Ficino had translated in 1463, Pico would have read that while the stars do affect man's body they have no influence over his mind, and this was to become one of the propositions of his *De Astrologia*, a work all the more remarkable in that its author, who had strong mystical tendencies, there takes as his criterion ordinary day-to-day human experience.

In the opening chapters Pico provides examples of astrologers' errors and contradictions. He questions any link between the rising of certain constellations and weather changes, yet accepts as probably learned by experience the belief of sailors that it is dangerous to put to sea on certain days in February, such as the sixth, twelfth and fifteenth. He believes that the hot sun so relaxes the bodies of southerners that it takes away most of their internal heat or drives it to the extremities of the body, producing darkness of skin and leaving fear in the heart: hence they are timid, effeminate and born to servitude. But beyond such physical influences as these Pico refuses to go. He points out that from the sky we receive light and heat; how then can certain stars or planets also produce corruption and death? And if the planets are perfect and unchanging, how can they produce effects opposite to their own nature? Astrologers attribute change on earth to the opposition between the 'hot' sun and the 'cold' moon. How, asks Pico, can light have two diametrically opposite qualities?

In the seventh book Pico develops a more original argument. Why, he asks, do astrologers forecast the future history of a city

from the date when its first stone is laid? Why not from the time it begins to be inhabited or its first government takes office? This line of thought is developed further in the twelfth and final book. Having accepted the Platonist view of nature as mathematical, Pico decides that the chief error underlying astrology is that it judges the workings of the mind as if they too were subject to mathematical laws. But in fact they are not. As Manetti had shown, the new mastery of history made clear that the human mind is master of time, free to move back through the centuries. Nor is it subject to space. In imagination a Florentine could, and frequently did, transfer his thoughts to the wharves of Venice and the newly discovered alummines of Tolfa. So the astrologer's mistake lay not so much in subordinating the higher to the lower as in unjustifiably lending these terms a spatio-temporal meaning.

Pico's systematic attack on astrology has an importance for the freedom and progress of human thought comparable to Valla's attack on the *Donation of Constantine*. It released man from an intricate network of conjunctions and affinities; it gave him back his will in entirety. By freeing man from the stars Pico also freed the stars from man, providing an indispensable basis for the use, by Kepler and Galileo, of purely mathematical methods. And he cleared the way for progress in yet another science, that of medicine.

At the beginning of the fifteenth century Florence had some sixty registered doctors of medicine. Mainly they prescribed simples, cabbage being a favourite panacea. They were held in affectionate distrust. The satirist Stefano Finiguerri speaks of doctors 'unable to find the pulse on a church-tower ringing all its bells', while Poggio expresses the general attitude in a story about Angelo, Bishop of Arezzo, who though seriously ill declined all treatment. One day his doctors sent the Bishop a new medicine, which he emptied into his chamber-pot. Next day they found him better and said how foolish he had been to refuse medicine for so long. 'Your medicines are indeed marvellous,' said Angelo, 'for by merely putting them under my bed I have recovered my health. Had I swallowed them, doubtless I should have become immortal.'

Progress began with the discovery of classical texts hitherto unknown, the most important being eight books *On Medicine* by the

first-century Roman writer Cornelius Celsus, which was published in 1478, one of the first classics to issue from a Florentine press, and the new translations from original Greek texts, freed from Arab garblings and magical overlay, of medical works by Hippocrates and Galen. The garrulous and gullible Pliny's *Natural History* was closely studied, partly because it treats of dyes and painting, and with their admiration of antiquity scholars sought to identify animals, plants and minerals mentioned therein, such as the speciments of gnaphalium and Gallic nard which Collenucio obtained in Germany for his friend Poliziano. Familiarity with actual specimens soon led to a less reverent attitude to the classical authorities. In 1492 a friend of Lorenzo de' Medici, Niccolò Leoniceno, wrote a treatise with a title unthinkable thirty years earlier: *On certain errors in Pliny*. One of the errors was particularly glaring in a city of painters. Pliny declares cinnabar to be a mixture of the blood of a dragon and of an elephant, spilled in mortal combat. Leoniceno pointed out that cinnabar is in fact a mineral (it was well known as the source of vermilion) and in support quoted the second-century Greek physician, Dioscorides. Leoniceno's attack was bookish, but attack it was, and as such symptomatic.

More accurate knowledge led to improved treatment of disease. The scourge of fifteenth-century Italy was gout. To mention only a few, Cosimo de' Medici in later life suffered from gout, Piero was crippled by it, his wife Lucrezia seems to have had gout as well as sciatica, and their son Lorenzo was to die of it. Pius II had to be carried in a litter because of gout; after a youthful attack of the same malady Federigo da Montefeltro drank only apple, cherry or pomegranate juice; while Columbus, shipped home in chains on his third voyage, also suffered from gout. The distinctive feature of gout is a deposit of urates, mainly biurate of sodium, in the tissues of the joints, most often of the big toe, the knee and the fingers. By causing fibrosis of the kidneys, arterio-sclerosis or high blood pressure gout can prove fatal. Though little is known even today about the nature of the underlying error of purine metabolism which causes gout, it has been established that food containing large quantities of nucleoproteins precipitates uric acid and may often lead to the disease. Such a diet is one rich in liver, kidney, brains, game and meat soup,

weak in milks, eggs, fruit and vegetables. Now this was precisely the diet favoured by well-to-do Florentines. One of Lorenzo's favourite dishes was pheasant, which his wife used to send in from the country. Furthermore, in Florence and the surrounding country-side drinking water had to be fetched from a spring, stream or fountain; it was easier and therefore more usual to draw a goblet of red wine from the keg, and red wine again is one of the drinks that often precipitate gout.

Progress in treatment of gout can be glimpsed in the prescriptions of two doctors for Lorenzo's gouty fingers, at one point so stiff they could not grip a pen. A Ferrarese physician, one of the old school, advised Lorenzo to wear a sapphire ring on the third finger of his left hand. 'The pains in the joints will then cease, because that stone has occult virtues, and the specific one of preventing evil humours going to the joints ... Afterwards in the summer, during August, I will find celandine, which is a red stone that grows in the stomach of the swallow. I will send it to Your Magnificence to be tied in a piece of linen and sewn in your shirt under the left breast at the nipple. This will have the same effect as the sapphire.'

In marked contrast with Dr Avogarius's methods were those of Pier Leone of Spoleto, classical scholar, member of the Platonic Academy and a close friend of Lorenzo, who appointed him professor of medicine in Pisa at the then unprecedented salary of 1,000 gold ducats. Pier Leone was the first to study the imperial physician Galen in the original Greek, free from Arab accretions, and there learned the technique of treatment through spa waters favoured in imperial times. He made an analysis of the chief Tuscan mineral waters, and for Lorenzo's gout, as well as his kidney and liver troubles, prescribed baths and drinking of the alum- and iron-rich waters of Bagno al Morbo and of Vignone, where, incidentally St Catherine of Siena had tried scalding herself to have a foretaste of Purgatory. This treatment afforded Lorenzo relief and he was seldom long away from the Tuscan spas.

Study of Galen in the original represented only a limited advance, for some of Galen's premises were faulty: for example, he based his physiology on the four humours and writes as though blood pulsated through the heart's septum by means of minute perforations.

As with Ptolemy in the field of cosmology, it was only through observation that the Florentines were to progress beyond the classical model. Normally advances in observation are made from the treatment of wounds in time of war, but since there was more shouting and flag-waving than bloodshed on Italian battlefields, during the fifteenth century progress came from dissection. The most notable example is the work of the Florentine Antonio Benivieni, a friend of Lorenzo, who dissected corpses of criminals and tried to discover physiological explanations for their persistence in crime, such as poor development of the back of the head, believed to be the seat of memory, or a heart filled with globules from its excessive heat. In the 111 short chapters of Benivieni's posthumously published *De abditis causis* are notes on twenty autopsies, covering cases of intestinal perforation, chronic dysentery, gall-stones, gangrene and obstructive carcinoma of the bladder. These are among the earliest post-mortem studies directed towards finding the internal causes of disease.

But an even more fruitful revolution in anatomy originated with certain Florentine artists. Breaking down the barriers which in the Middle Ages had separated the liberal arts from the mechanical ones, it was the artists who first combined theoretical insight with sensory perception and manual skill. As we shall see later, following classical models, they made the nude the basis of their art, and in order to portray it accurately, from at least 1450 regularly dissected human bodies as part of their training. Donatello's *Anatomy of the Miser's Heart* in Padua is an early work testifying to Florentine interest in the subject; later Antonio Pollaiuolo, who was the first to investigate the action of the muscles by means of dissection, made an engraving of *A Battle of Nude Men*—probably Gauls, who were believed to have fought without clothes or armour—in which he depicts the human body and its muscles more exactly than any medical book of the century. Whereas medical students saw the organs in terms of the misleading texts read by the professor high up on his lectern and which would form the basis of their examination questions, artists approached the body with an unprejudiced eye and more often saw what was actually there.

In the next generation the same technique was carried a stage

further by Leonardo da Vinci, who was born in 1452 near Florence and spent the first thirty years of his life in that city. It was Leonardo's intention and achievement to place art in the service of anatomy. 'You who think you can reveal the figure of man in words, with his limbs arranged in all their different attitudes, banish that idea, for the more minute your description, the more you will confuse the mind of the reader and the more you will lead him away from the knowledge of the thing described. It is necessary therefore for you not only to describe but to represent.' Leonardo dissected thirty males and females of various ages, ten for the study of the veins alone. According to Vasari, 'he made a book of drawings in red crayon, outlined with the pen, of bodies from which he had removed the skin with his own hand and which he sketched with the greatest care. In the same book he drew the entire osseous system, to which were joined all the tendons in order, and the muscular coverings.' Just as a painting of a Madonna would combine the best features observed in several women, so these drawings would combine the details observed in different dissections and were therefore, as Leonardo claimed, more useful to students than attendance at any one dissection.

Leonardo left upwards of 1,550 anatomical drawings, many of marvellous exactitude. He was the first accurately to depict the human embryo, which even in text books of the end of the century takes the form of a miniature adult, and the uterus, which up to that time had been shown as an inverted vessel with rigid walls. Galen had declared the human uterus to be two-horned, as in other mammals; Leonardo showed it to be unilocular. The three cavities or ventricles of the human brain had never been properly represented until Leonardo, borrowing a technique used by bronze sculptors, had the ingenious idea of draining them and then filling them with liquid wax, providing, exactly as in a metal casting, two tiny tubes for the air to escape. When the wax hardened he drew accurate sections of the ventricles. Other new factual observations which Leonardo recorded through draughtsmanship were the moderator band of the right ventricle of the heart and the space in the upper maxilla. It is interesting that on one of the pages of his anatomical drawings Leonardo penned a warning reminiscent of Plato's notice

over the Academy: 'Let no one who is not a mathematician read my work.'

Here was a new kind of art that was also exact knowledge: observations in graphic form that could be instantly grasped. It seems probable that Leonardo's drawings were known to Andreas Vesalius, a Fleming of German origin who studied at Padua. It was Vesalius who first showed that Galen's anatomical pronouncements applied only to animals, and started the study of human anatomy from scratch. In 1543 he was to publish his findings in *De humani corporis fabrica*, a work in which exact engravings of muscles, bones and veins play an integral part. As with cosmology, Florentines had done the revolutionary thinking and sown the seeds of new techniques, which were to produce their main fruit elsewhere in Italy.

In the field of geographical discovery events followed a similar pattern. For centuries geographers had been content with a purely symbolic representation of the earth's surface: a circle divided by a T into three separate areas—Europe, Africa and Asia (which was put at the top out of deference to the Holy Land)—while the spaces between them and around the edge of the circle represented the seas and the all-encircling, all-imprisoning ocean. In fifteenth-century Florence, just as painters rejected the hierarchical for a natural arrangement of figures, so cartographers drew the outlines of countries and continents in scale and as the evidence—classical as well as modern—suggested them to be. Paolo Toscanelli, who on the death of his brother Piero in 1469 seems to have taken charge of a navigational and cartographic business in Pisa, played an active part in the new map-making. He probably had a hand in an elliptical map commissioned by the Medici in 1457—the most advanced representation of the world to date, incorporating the Venetian Niccolò Conti's journeys as far east as Java, which Poggio Bracciolini had published in the fourth book of his *De varietate fortunæ*—and in the great edition of Ptolemy produced before 1458 by the Florentine Pietro del Massaio, which included the twenty-seven Ptolemaic maps plus seven new maps, all distinguished by a new method of representing relief: the highlands being marked off from the lowlands and their surface filled in by solid colour—a prototype of form lines and layer colouring used today.

When he came to draw his own map of the world, Toscanelli discussed the text of Strabo with Gemistos Pletho, and the interior of Asia with slaves born at the source of the Don, Lake Tula. He had a long talk with an Armenian delegate to the Council of Florence who told him of a river in Cathay so extensive that there were almost 200 large towns on its banks, 'everywhere adorned with columns' and possessing bridges of marble. This tied in with Marco Polo's descriptions of Cathay, which were generally considered tales. As a result Toscanelli rejected the geography of Aristotle and the newly discovered Ptolemy in favour of a cosmology which accorded a much larger area to Asia. He developed these views in a letter to a friend at the Portuguese court, Canon Fernão Martins; they were to prove of decisive importance, some years later, in the discovery of America.

About the origins of Cristoforo Colombo, known to posterity as Columbus, there remains much uncertainty, which was fostered in his own lifetime by Columbus himself. Probably he was born in Genoa in 1451, the eldest son of a poor wool-weaver who later opened a wineshop to supplement his earnings. The weavers had their own school and there young Columbus would have learned to read, write and count. At an early age he put to sea and presently rose to command a French man-of-war. In one battle off the Tunisian coast he wished to attack an Aragonese galley, but his tired crew demanded that he return to base. Columbus secretly reversed the polarity of the ship's compass needle, so that his men should believe he was returning to Marseille, then headed straight for the enemy. During another engagement off Cape St Vincent Columbus's ship rammed a Genoese galley laden with Chian mastic, then caught fire and sank. In this battle 1,600 sailors lost their lives but Columbus, clinging to an oar, succeeded in swimming six miles to the Portuguese coast, where he crawled ashore half-dead with exhaustion.

Columbus was then twenty-five, a tall man with blue eyes, ruddy cheeks, aquiline nose and red hair which would turn white by the time he was thirty. His native city had been declining since the fall of Constantinople; it counted few scholars or artists, and if a fine building or painting was wanted a Florentine was called in. Nevertheless, like most Italians of his day, Columbus had been stamped by

the new thinking that had originated in the city on the Arno, and his values resembled those of a Florentine. He would have agreed that *virtù* is manly action, in which a strong will counts for much. He possessed a lively curiosity about natural phenomena, a joyous sense of adventure and a desire to win wealth and recognition. Of the ten books he is known or believed to have owned, one was Plutarch's *Lives of Illustrious Men*. He possessed a strong though by no means complete confidence in his own powers, physical and mental, combined with a deep religious faith: he studied the Bible with the aid of a concordance, he perused the *Summula Confessionis* by Antonino of Florence, a scrupulous man's guide to sins, venial and mortal, and even on shipboard he would recite the Office daily. But in two respects Columbus differed from the average Florentine: he attached great importance to noble titles and coats-of-arms, and he lacked the strong Florentine communal sense, with its concomitant, discipline through criticism: this was to lead Columbus in later life to idiosyncrasies of thought and behaviour.

Probably soon after his shipwreck in Portugal Columbus taught himself Latin. This marks an important stage in his development, for it opened up classical learning. Columbus read Pliny's *Natural History* in an edition compiled by Ficino's disciple Cristoforo Landino, thereby coming into touch with Florentine Platonism, notably with its belief that the world contains secrets about the nature of God which man can discover. The most important classical geographer, Ptolemy, Columbus encountered second-hand in Pius II's *Historia rerum ubique gestarum*, which is largely a condensation of Ptolemy. The book was printed in Venice in 1477 and Columbus probably bought it in that or the following year.

To his late-medieval picture of Asia as a land of gold and jewels and the newly available classical geographers Columbus added a third source of knowledge: his own personal experience. Soon after his shipwreck Columbus took service under the Portuguese flag. He would have had no difficulty in doing so for the Portuguese considered the Genoese highly as navigators, hence their name of 'Genoese needle' for the mariner's compass, and in the next three years he sailed to Galway, perhaps to Iceland and certainly to Guinea. On these voyages he began to notice discrepancies between his

own observations and the classical geography of his scholarly books. For example, Pius II's *Historia* repeats Ptolemy's theory that the earth is divided into five zones, of which only three are habitable. One of the uninhabitable zones Ptolemy places between the Tropic of Cancer and the Equator. When on his voyage to Guinea Columbus arrived in this 'no man's land' he saw with his own eyes Africans very much alive. It became clear to him that Ptolemy could err.

Then there was the question of the Western Ocean (the term Atlantic was reserved for coastal waters near the Atlas mountains). Columbus almost certainly knew nothing about Leif Ericsson's discovery of the Hudson Straits and the Gulf of the St Lawrence in the eleventh century, though these were depicted (as islands) on one contemporary map, the so-called 'Vinland Map', probably drawn in Basle about 1440. But in Iceland he may well have spoken to sailors who knew Greenland, a place mentioned neither by Ptolemy nor by Strabo. Did other islands lie to the west? According to Ptolemy, the answer was No. He declared five-sixths of the globe to be water, and the Western Ocean to be unnavigably vast.

The facts once again seemed to argue differently. On Madeira, after gales blowing from the west, the islanders found thick bamboo washed up on the beach, and seeds of a strange plant: their skin had the colour and texture of a horse-chestnut, and inside was a large air space, which would enable the seed to float long distances: they came in fact from a mimosa-like climber common on Caribbean shores. In Galway Columbus had seen 'two persons hanging on to wreck planks, a man and a woman, a beautiful creature'. Evidently they had Finnish or Lapp features, for Columbus concluded they had come westward from Cathay—northern China—across the Western Ocean.

Columbus was particularly interested by the latter phenomena. Since the capture of Constantinople Europe had to pay more for spices, incense, gems, pearls and other Asiatic luxuries. Men were envisaging a future direct route to the Indies, perhaps through Africa, which was held by many to be part of Asia. With one exception men thought of this route as a route eastward. The exception was Paolo Toscanelli of Florence. The views he had expressed in his letter to Canon Fernão Martins had never been followed up

but they were known to a few, and Columbus heard about them. Doubtless because he had already thought about a westward route himself, Columbus attached importance to them. He felt the need of a theory. Completely sure of himself at the helm of a ship, when it came to cosmology Columbus felt all the doubts of one who has received little formal schooling. Ptolemy's theory, as outlined in the *Historia*, did not tally with what he had seen or with the plans taking shape in his mind. Toscanelli's did. He wanted to know more about it.

Around 1478 Columbus, now aged twenty-seven, wrote a letter to Toscanelli, who was in his eighty-second year. Florence bought Algarve wool and had close commercial links with Portugal, so Columbus was able to entrust his letter to an Italian named Lorenzo Birardi, who would deliver it in Florence. Presently he received Toscanelli's reply.

Paul, the Physician [it began], to Cristobal Colombo, greeting. I perceived your magnificent and great desire to find a way to where the spices grow, and in reply to your letter I send you the copy of another letter which I wrote a long time ago to a friend and favourite of the most serene King of Portugal before the wars of Castile in reply to another which, by direction of His Highness, he wrote to me on the said subject, and I send you another sea chart like the one I sent him, by which you will be satisfied respecting your enquiries . . .

The letter copied by Toscanelli was his letter to Martins dated 24 June 1474. The sea chart is no longer extant, but Toscanelli describes it in his letter to Martins as 'made by my own hands, on which are delineated your coasts and islands, whence you must begin to make your journey westward, and the places at which you should arrive, and how far from the pole or the equinoctial line you ought to keep, and through how much space or over how many miles you should arrive at those most fertile places full of all sorts of spices and jewels. You must not be surprised if I call the parts where the spices are "west", when they usually call them "east", because to those always sailing west, those parts are found by navigation on the under side of the earth. But if by land and by the upper side, they will always be found to the east. The straight lines shown

lengthways on the map indicate the distance from east to west, and those that are drawn across show the spaces from south to north.'

Toscanelli's map may have looked somewhat like this:

By following a westward route, Toscanelli continued, a navigator would arrive at Cathay, ruled over by the Great Khan, a 'country worth seeking by the Latins, not only because great wealth may be obtained from it, gold and silver, all sorts of gems, and spices, which never reach us; but also on account of its learned men, philosophers, and expert astrologers, and by what skill and art so powerful and magnificent a province is governed, as well as how their wars are conducted.'

In his letter to Toscanelli Columbus had mentioned Antilia, an island on which according to tradition a large group of Christians led by seven bishops had taken refuge when the Iberian peninsula was overrun by the Arabs in the eighth century. Yes, replied Toscanelli, Antilia did exist, and lay in the Western Ocean, 2,500 miles from Japan. After further details he ended his letter: 'Many things might perhaps have been declared more exactly, but a diligent thinker will be able to clear up the rest for himself. Farewell, most excellent one.'

This was a generous letter for a famous scholar to write to a young sea-captain he had never met. It encouraged Columbus to write again, enclosing 'things'—probably maps—and stating his burning desire to undertake a voyage westwards as set forth in Toscanelli's letter, to which the Florentine replied that he was delighted, 'for the said voyage is not only possible, but it is true'. So impressed was Columbus that he transcribed the copy of Toscanelli's letter to Martins into the fly-leaf of Pius II's *Historia*.

It was Toscanelli's contention that 130 degrees of sea lay between Europe and the Indies. Columbus reduced this figure by adding to Asia certain of Polo's discoveries, and whereas Toscanelli reckoned a degree on the equator at $62\frac{1}{2}$ nautical miles, which is close to the true figure, Columbus reckoned it at 45. In this way he calculated that Japan lay 2,710 nautical miles from the Canaries—the true direct distance is 10,000 nautical miles—and therefore placed his 'Indies' more or less where America actually is.

Columbus first tried to interest King John II of Portugal in his plan of sailing west in search of gold and spices. When the King declined to provide 'three caravels provisioned for a year', Columbus crossed to Spain and the court of Queen Isabella. The Queen, busy with her Moorish war, referred Columbus's plan to a committee of scholars in Salamanca. After four years' study, the committee reported as follows: it would take not a few weeks, as Columbus claimed, to reach Asia by sea, but three whole years; if Columbus did succeed in finding unknown islands such as the Antipodes (a general term for land on the other side of the globe), contrary winds would prevent him from returning; and anyway it was an error to think that the Antipodes existed, because the greater part of the globe consisted of water, because the inhabitants would be ignorant of the teaching of Christ and His Apostles, so contradicting *Romans* x, 18: 'their sound went into all the earth and their words unto the end of the world', and because St Augustine says so, in the sixteenth chapter of his *City of God*, his point there being that there could not exist men who are not descendants of Adam. The committee's refrain became '*duda sant'Augustin*—St Augustine doubts—'and Columbus's plans were turned down.

Only in 1491 did Columbus's luck change, when the capture of

Granada brought Ferdinand and Isabella victory in the eight centuries' struggle against the Moors. Toscanelli had told Columbus that the 'Great Khan' of Cathay was well-disposed towards Christianity and that the Khan's ancestors had sent to Rome for missionaries, who were dispatched but never arrived. Knowing her to be a zealous Christian, Columbus repeated this to Isabella, and in her new mood of exultation and religious gratitude, it turned the scales. The Queen agreed to back Columbus's expedition, which now had a missionary as well as a commercial character.

Columbus sailed from Palos on 3 August 1492, with Toscanelli's letter copied into the fly-leaf of the *Historia* and doubtless also Toscanelli's map. On 11 October he sighted the island of Guanahani in the Bahamas group, which he took possession of and renamed San Salvador. The mark of the Indies, according to Toscanelli and Marco Polo, was large quantities of gold: in his first letter Toscanelli told Columbus that in Japan 'they roof the temples and palaces with solid gold'. There was no gold on anything like this scale in San Salvador. So without delay Columbus questioned the natives about the places mentioned by Toscanelli: 'I am still resolved to go to the mainland and the city of Guisay [Quinsay] and to deliver the letters of your Highnesses to the Gran Can.' He then set sail for Cuba, believing that that island would be Cipangu—Japan—and there observed natives smoking what afterwards came to be called tobacco, but of gold no more than in San Salvador. Finally he sailed to Hispaniola, where he left thirteen of his men behind with instructions to collect by barter a ton of gold. On 15 March 1493 he arrived back in Spain.

Columbus had set out to discover not a new world but an old one. He felt sure that he had done just that. He believed that he had found a western route to Asia. Ferdinand and Isabella interpreted the voyage in this sense, as later did the Pope. So too did Florence when she received news in late March from one of her government agents that 'some young men in three little caravels had discovered a large inhabited island on the western side of the ocean'. Columbus was to persist in this belief, though each of his three successive voyages provided ample evidence that he was mistaken. It would have been easy for him to modify his view—for example, by accepting

Toscanelli's estimate of a degree on the equator as $62\frac{1}{2}$ nautical miles—and to treat the islands as a new group in the Western Ocean, unrelated to the Indies. Columbus clung to his belief because therein lay his hope of gold. He needed gold in order to justify his commercial promises to Ferdinand and Isabella—his new coat-of-arms as Admiral of the Ocean Sea included gold islands—and also, curiously enough, to implement a new religious purpose. On his later voyages, none of which yielded the hoped-for riches, Columbus re-read his Bible with an eye to gold. He convinced himself that Solomon and David had found their tons of gold in the very lands he was exploring, and that he, a chosen man also—he evolved a cryptic signature: Cristoferens, the Christ-bearer, framed by secret characters—was being guided to King Solomon's mines. With the gold found there he and the Spanish sovereigns would liberate Jerusalem and rebuild the Temple. Then all men—even the subjects of the Great Khan—would come together in one faith and one mind. The unity which Marsilio Ficino had prophesied in Florence Columbus would accomplish with the power of gold.

Perhaps the most curious example of Florentine influence on Columbus concerns the Earthly Paradise. As described by Dante, the fall of Satan into Hell caused part of the earth's substance to leap up heavenward above all the elemental perturbations of the lower atmosphere, thus making itself worthy to become the seat of that human race which was to replace the fallen angels. A steep island, it lay in the southern hemisphere, somewhere in the Great Ocean, and its lower slopes formed Purgatory, where man must climb back, through purgation, to the 'uplifted garden'. During the revival of Dante studies in Columbus's lifetime Florentine scholars had tried roughly to map 'the other world' and had even worked out the dimensions of Dante's Hell in miles.

Coasting the island of Trinidad during his third voyage, Columbus encountered certain puzzling phenomena: powerful currents of fresh water, and a temperate climate in a latitude which, according to Ptolemy, ought to have been torrid. Columbus took a reading of the Pole Star, and a second reading later. He was not very accurate with the quadrant—much less so than Vasco da Gama—and in three places of his journal gives the latitude of the north coast of

Cuba as 42 degrees, a long way from the true figure of 23. Columbus made another error now, and as a result believed the Pole Star's orbit had suddenly grown larger. Here was a third puzzling phenomenon. Brooding over them, and recalling Dante, Columbus now jumped to a series of amazing conclusions. The earth, he decided, was shaped 'not like an apple but like a pear hanging on a tree', its protuberance reaching nearer heaven than the rest of the world. What is more, he had just been sailing over the edge of this cosmic protuberance—sailing uphill; the Pole Star's orbit seemed bigger because he was so much nearer heaven; the Earthly Paradise was Trinidad, crowned appropriately by three hills; and the violent streams of fresh water—actually the Orinoco—were the life-giving waters of Paradise.

Apocalyptic geography continued to play a leading part in Columbus's fourth voyage, for he was now more than ever obsessed with the gold which was to bring about 'the increase and glory of the Christian religion'. Exploring the central American coast from Honduras to the Gulf of Darien he fancied himself in China, in the province of Mago, by which he meant Mangi, Polo's name for South China—not far, therefore, from the Great Khan whom he was destined to lead to the New Jerusalem. One of the last entries in his journal sums up the Admiral's tragic failure to realize his grand designs, a failure which was to cause him to lose the King's favour and spend the rest of his days in hardship: 'The nation of which Pope Pius writes—the Massagetae—has now been found, to judge at least by the situation and other evidence, except the horses, with the saddles and poitrels and bridles of gold.'

Florence, meanwhile, was following Columbus's voyages with the keen interest to be expected of a trading city and an important cartographical centre. On the publication of Columbus's first letter, a Florentine named Giuliano Dati composed a poem from it, which was being sung in the streets in October 1493. Ten years earlier Luigi Pulci had added to his *Morgante* new stanzas predicting the discovery of the Antipodes and asking a typically Florentine question: 'Can man there be saved? The answer is, I don't know.' Toscanelli's successors were drawing maps of Egypt based on the travels of Benedetto Dei and other Florentines in search of new markets for

cloth, showing quite detailed and accurate itineraries as far south as Abyssinia, while a close friend of Lorenzo de' Medici, Francesco Berlinghieri, published a long geographical poem based on Ptolemy accompanied by thirty-one maps, the most accurate of the century.

From this milieu sprang the man who was to show that Columbus had discovered not new islands of Asia but a wholly new continent. Born in 1451 the third son of a notary, Amerigo Vespucci received a classical education and moved in the circles of Lorenzo the Magnificent and Lorenzo's cousin, Lorenzo di Pierfrancesco. He was strikingly handsome and Leonardo made a charcoal drawing of his head. As a young man he went to Spain and, in partnership with another Florentine, Giannetto Berardi, set up business as a provision contractor, first in Seville, then in Cadiz, and as agent for the Medici bank. Amerigo fitted out Columbus's second voyage in 1493, and was described by the Genoese discoverer as 'a very respectable man'. At the age of 48, with commendable initiative, Amerigo decided to give up business and for the first time go to sea. He trained himself as a navigator—he was to become one of the very best of his day— and with a Spaniard named Alonzo de Joheda in command, sailed from Cadiz with four ships on 20 May 1499, bound for the so-called Indies.

Whereas Columbus possessed a remarkable imaginative vision, a power of adapting awkward details to fit what was in effect an erroneous theory, Amerigo possessed a businessman's respect for fact. If he was less imaginative, he was also less impulsive. Moreover, he possessed two advantages denied to the self-taught Columbus: a wide classical education which permitted him to situate a particular problem within its wider context, and a thorough grounding in geographical theory, notably that same Ptolemy who ascribed a smaller area to Asia than did Marco Polo, and a correspondingly longer distance by sea between Spain and China.

Amerigo and his companions duly arrived off South America, at the Gulf of Maracaibo, where their discoveries included a village built on piles, which they named Venezuela, or Little Venice. They explored and mapped the South American coast as far south as Cabo de la Vela. As a student of Ptolemy, Amerigo was already predisposed to doubt that this land formed part of Asia, and such was

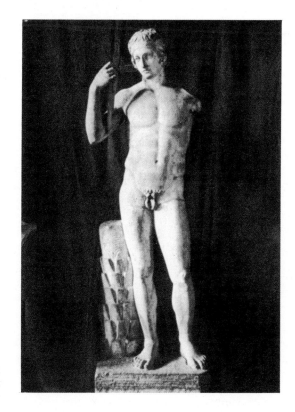

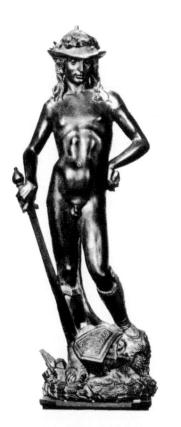

A marble copy of Polyclitus's lost statue, the *Diadumenos* (above), depicting a victorious athlete. Descriptions of this and other bronze statues by Polyclitus influenced Donatello's *David* (left)

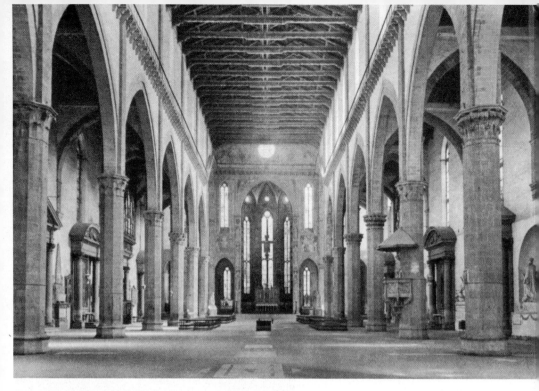

S. Croce (completed 1385) has pointed arches on octagonal columns. Below, S. Lorenzo (nave completed 1469) has round arches on Corinthian columns, features derived from Roman buildings, and its harmony comes from precise mathematical proportions

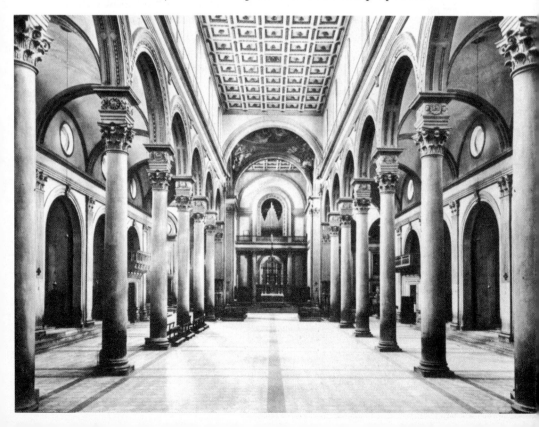

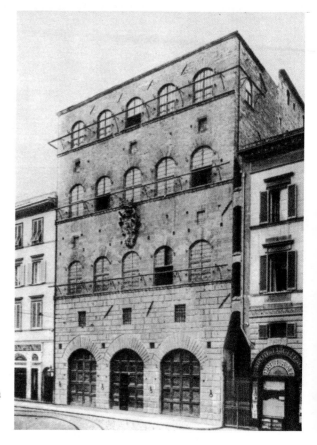

The façade of the 14th-century Palazzo Davanzati is plain and unforthcoming. String-courses that emphasize perspective, a carved cornice and pilasters are among the classical features used in the Palazzo Rucellai (1446–51), (below)

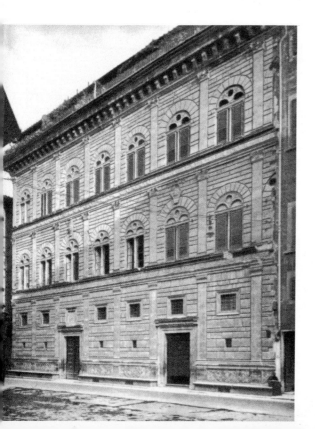

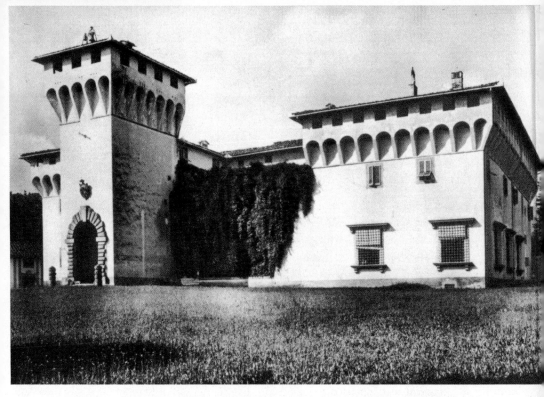

Cosimo de' Medici's villa at Cafaggiolo, remodelled by Michelozzo
in 1451, has a fortress-like character absent in his grandson Lorenzo's
villa at Poggio a Caiano (below), which is notable for its classical
portico and frieze

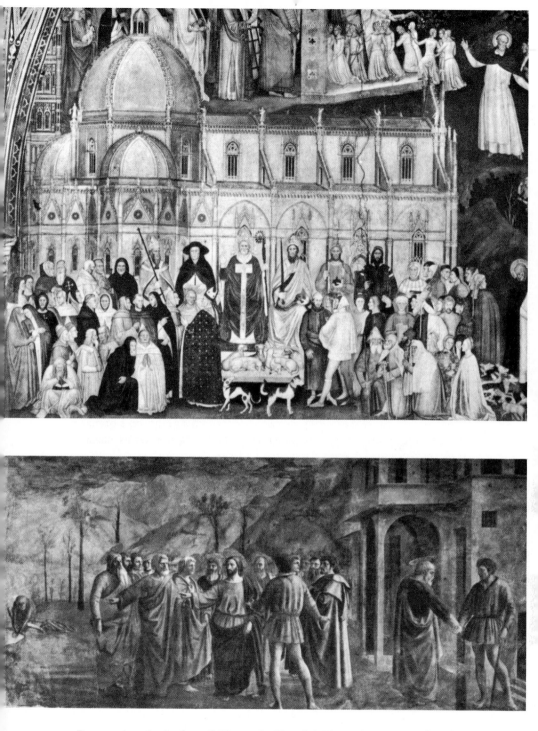

Perspective. In Andrea di Firenze's *Church Militant* (*ca* 1366–8) figures and scenes are depicted in rows, one awkwardly above the other. Below, in *The Tribute Money* (1423–8) Masaccio depicts a group of men in depth according to recently rediscovered laws of perspective

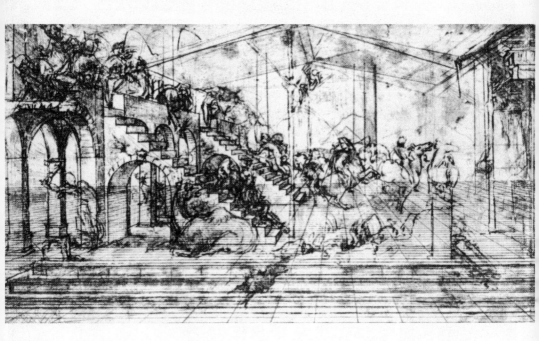

A study for Leonardo da Vinci's *Adoration of the Magi*, in which space
is plotted on a grid system. Opposite, Leonardo's unfinished *Adoration
of the Magi*. Almost lacking in colour, it gains its effect through
perspective and geometrical construction

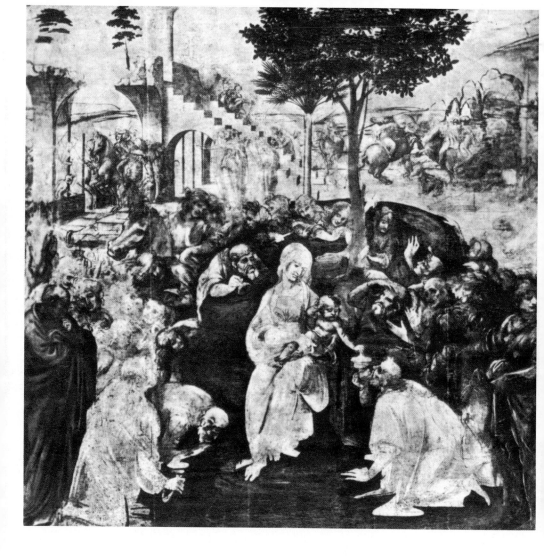

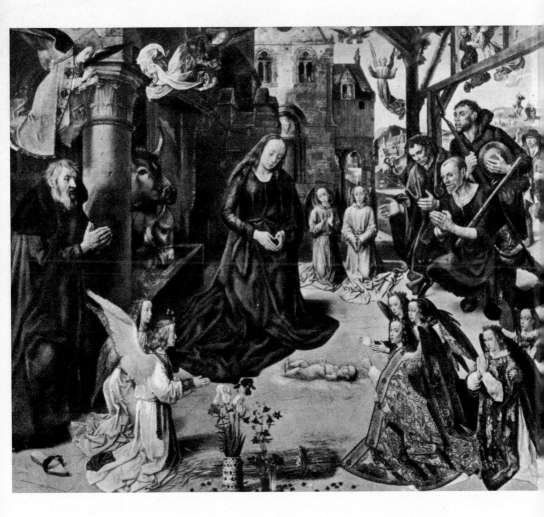

In contrast to Leonardo's picture, *The Adoration of the Shepherds* by
the Fleming, Hugo van der Goes, is brightly coloured and con-
centrates on minute detail at the expense of perspective construction

the extent of coastline they had mapped that Amerigo concluded that he and his companions had reached an unknown continent. This conclusion was confirmed by a second voyage along the coast of Brazil, and a third in which Amerigo explored the east coast of South America from latitude 5 degrees to latitude 50.

These voyages Amerigo recounted in a series of letters, the most important being one describing the third voyage addressed to Lorenzo di Pierfancesco de' Medici. Amerigo's Florentine background reveals itself in his preoccupation with the customs and morals of the natives —subjects which held only an incidental interest for Columbus. He noticed, for example, that certain tribes held property in common. Of others he wrote: 'They live amongst themselves without a king or ruler, each man being his own master, and having as many wives as they please. The children cohabit with the mothers, the brothers with the sisters . . .' Amerigo judged their way of life to be Epicurean, but was under no illusion that they lived in a golden age. 'I have seen', he wrote, 'a man eat his children and his wife.'

In 1504 Amerigo's letter to Lorenzo di Pierfrancesco was printed in Florence under the title *Mundus Novus*. It proved more popular than Columbus's puzzling, deeply tormented letters, was translated into several languages and ran into no less than nine editions before 1507. Amerigo's claim to have reached an unknown continent became widely accepted and rendered every map in existence out of date. The first cartographer to draw a new map fitting recent discoveries into the conventional framework was the Florentine Giovanni Matteo Contarini, whose map was engraved on copper in Florence in 1506.

So far no name had been given to the new land discovered by Columbus and recognized by Amerigo to be a new continent. In 1507 a group of learned priests in the town of St Dié in Lorraine, who had there established a printing press under the auspices of the Duke of Lorraine, published one of Amerigo's letters relating to the new world. Since the Florentine was now well known, they suggested that the new continent should be called after the Latin form of his name. The hint was taken in Waldseemüller's map of 1507, where 'America' appears for the first time. In 1509 America appears as though it were now a well-known denomination in an anonymous

work entitled *Globus Mundi*, printed at Strasbourg, and thereafter won general acceptance. In this way the new continent acquired the name America. Columbia would certainly have been more fitting, but the fact that it is called after a Florentine is a reminder of the importance of Florentine cosmography and cartography, and of the part played in Columbus's voyage by Paolo Toscanelli.

The Rise of the Artist

AT THE BEGINNING of the fifteenth century the visual artist—whether painter or goldsmith, sculptor or architect—played a humble role in Florence. A craftsman strictly controlled by the regulations of his guild, he eked out a living painting baskets and tournament banners, making wedding garments and wickerwork chairs, designing candlesticks and coats-of-arms for chimneys, even constructing stage machinery for the *sacre rappresentazioni* on St John's day, and when occasionally his workshop was awarded a big commission, to paint a Madonna or make a pulpit, in these tasks he was subject to the supervision and conservative tastes of the rich guilds which paid for the work. By the end of the century the artist had freed himself from guild rules and might accept any commission he wished; he had become the intimate friend of leading citizens, his idiosyncrasies were tolerated, he had come to be recognized not only as a skilled technician but as a thinker, a discoverer, an inventor, to such a degree that in his own lifetime Michelangelo was called '*divino*'. How did the change come about and what were its implications for European civilization?

The artist's lowly position dated from the Dark and Middle Ages. Since neither painting, sculpture nor architecture ranked among the seven liberal arts, their practitioners were counted as manual or 'servile' workers. The word 'artist' did not even exist. The architect belonged to the Guild of Masons and Joiners, but the painter did not have a guild of his own: since 1378 he had enrolled in a sub-section of the Guild of Apothecaries and Doctors. True, even within the guild system, certain men of skill contrived to win a reputation: the prime examples are the architect of an important cathedral—the name of the architect of Pisa cathedral is recorded on a stone in the

façade—and a painter of genius such as Giotto. But such exceptions were rare, and even they were bound to work within rigorous conventions and to satisfy the large juries or commissions who controlled ecclesiastical art.

Florence, because of its republican principles, exerted a particularly strict control over artists. Thus in 1366–8, when a revision of Florence's new cathedral was called for, no less than 480 people were asked for their opinion. As late as 1410, in Ghiberti's contract with the Bankers' Guild for a statue of St Matthew, it was stated that the work had to be carried out entirely as the patrons desired, a similar clause figuring in Donatello's contract with the linen-drapers in 1419 for a statue of St Mark. It is not surprising that under such conditions the arts had progressed at a snail's pace. On the other hand, republicanism tends to reduce social barriers, and it was precisely by reducing, and eventually demolishing, the barriers between manual and intellectual labour that the Florentine artist, with help from the classical past and from enlightened patrons, was to succeed in emancipating his talents. The process differed from art to art, and in architecture was the single-handed achievement of one man.

Filippo Brunelleschi was born in 1377, the son of Ser Brunellesco di Lippo Lapi, notary and contractor for mercenary troops. One of his ancestors may have been Diotisalvi, who designed the tower of Pisa. He received a good education, for his father wished him to become a notary or a doctor, but Filippo had a practical turn of mind and showed more interest in modelling and mechanics than in the graces of rhetoric. Being a determined person, he got his way and at the age of twenty-one joined the Guild of Goldsmiths and Sculptors, a sub-section of the Guild of Silk Merchants, and began to earn his living as a goldsmith and jeweller, studying in his leisure hours 'problems of motion and time, and of weights and wheels'. In appearance small and puny, with a blunt, fleshy nose and receding chin, Brunelleschi nevertheless possessed immense energy and unusual independence of mind.

In 1401 Brunelleschi submitted one of two winning panels in a competition for a new pair of Baptistery doors. When the syndics of the Wool Guild wished to award the commission equally to him and the other prize-winner, Lorenzo Ghiberti, Brunelleschi, who did

not believe in collaboration, declined to share the honours. Storming out of the council hall, he announced that he would give up his work as a goldsmith and instead study architecture. Not, however, in the old way, by joining the Guild of Masons, but by himself. Moreover, this being the period of Florence's critical struggle with Giangaleazzo and of unbounded enthusiasm for Cicero's Republic, he would study not in Florence but in Rome.

The decision was unprecedented and on the face of it unpromising. The Middle Ages reversed Augustus's boast that he had found Rome a city of brick and left it one of marble. Temples, mosaics and paintings had been wantonly destroyed, the marble of secular buildings burned for lime. Rome was now a heap of ruins and a few basilicas, its population smaller than Florence's, poor, 'looking like cowherds', subject to malaria. Even within the walls were woods and undergrowth which sheltered foxes and wolves. Hares could sometimes be caught in the streets.

Undaunted, Brunelleschi systematically inspected all the ruins. When he wanted to study a ruin from its base, he hired labourers to excavate. Sometimes he himself would dig and search, helped by his friend Donatello. They would find an occasional coin or cameo, an intaglio of cornelian or chalcedony, and were dubbed by the Romans 'treasure-seekers'. But Brunelleschi was after bigger treasure than this. He wished to discover exactly how the Romans had constructed their colossal buildings. So he measured the thickness of walls, fragments of columns and arches, the size and shapes of bricks, the dovetailing of blocks of marble, writing down all his notes and calculations on strips of parchment cut off when squaring sheets for design in the goldsmith's shop where he covered his expenses by making time-pieces and alarm clocks. The only temple to have escaped destruction was the Pantheon, because it served as a church, and this Brunelleschi inspected closely, climbing on the roof and removing tiles in order to study the ribbing of the shallow cupola. One thing puzzled Brunelleschi—the number of square holes in the large stones used by Roman builders. At last he decided that these holes must have been for the better grip of a machine for moving them. Not knowing what machine the Romans used, he imagined one, and this gave him the idea of the *ulivella*, a kind of

grappling-iron whereby large stones could be lifted by a crane without cords.

For about a dozen years Brunelleschi divided his time between Rome and Florence, studying the ancient shattered stones as eagerly as Poggio a faded speech by Cicero. His eventual aim was to design buildings himself, but in 1417 a project of such importance was mooted that it engrossed his whole attention. One hundred and twenty years earlier, when Dante sat on the city council, Arnolfo di Cambio had designed a new cathedral for Florence. Arnolfo had intended to vault the crossing with a dome, but although the rest of the rose and white marble cathedral had been complete now for two decades, the crossing was still untidily covered with tiles on a temporary wooden frame. The dome had never been built because the diameter of the space to be spanned was so enormous: 138 feet. The only comparable cupolas were those of the Pantheon, built in A.D. 125 and of roughly the same dimension, and of Hagia Sophia in Constantinople, 100 feet across; moreover, in 1347 the dome of Hagia Sophia had partly collapsed, alarming the Florentines, who as a precaution had hastily strengthened the vault of their Baptistery.

The Wool Guild was the body responsible for the cathedral fabric, hence the prominence given to their device, a lamb bearing a banner, but it deputed the problem of covering the crossing to the Guild of Masons and Joiners. In 1417 this Guild held a meeting which Brunelleschi, though not a member, attended. Several solutions were available: a permanent flat roof, or a shallow, tent-like covering similar to that of the Baptistery, or some form of dome, the original plan shirked for so many years. Those members of the Guild who were architects reviewed all the well-known technical difficulties— the vast space to be spanned, and the height at which work would have to start: 120 feet from the ground. Brunelleschi, who had a dry sense of humour, delighted in capping all their difficulties with even greater ones. Among other things, he calmly said it would be necessary to begin the dome even higher than Arnolfo's plan had called for, by raising the octagonal tribune a further thirty feet. At a second meeting Brunelleschi again stressed the difficulties. 'If the cupola were round it would be possible to follow the method the Romans used to vault the Pantheon, but here we have eight sides,

and will need to use tiles, and dovetail the stones.' If he were to be given the job he would find a solution; as it was, he suggested the syndics call in the best architects from Tuscany, Germany and France. Brunelleschi believed that only when the syndics realized the work to be beyond everyone else's powers would they entrust it to him.

The foreign architects duly assembled. One suggested a pumice-stone dome as being less heavy, another proposed that earth should be heaped under the crossing to support the cupola while it was being built. 'Yes,' a wit piped up, 'and mix in some soldi so that people will want to clear it away afterwards.' Only Brunelleschi insisted that no framework, either of wood or of earth, would be needed. He then capped this sensation by a second. Not one cupola but two should be built, with the space of an upright man between: the two walls, being bound together, would provide mutual support. Two cupolas! 'How', asked the experts, 'is that great weight to be supported over such a space, when even Arnolfo's wooden model of a single cupola caved in?' The more Brunelleschi protested that his plan was feasible, the more sceptical they became. Several times he was told to leave the hall, and finally had to be carried out by the ushers. For days he was hooted in the streets, and people pointed: 'There goes the madman.'

A third meeting was called. The syndics wanted Brunelleschi to explain his technique and show them a model, as the foreign architects had done. On this occasion, it is said, Brunelleschi pro-fered his famous challenge. 'Can anyone here', he asked, 'stand an egg upright on a flat piece of marble?' An egg was brought in: the experts tried in turn and failed. Then Brunelleschi took the egg, just flattened the end with a slight blow and stood it upright. 'Oh, we could have done that!' cried the experts. Brunelleschi laughed. 'You'd say just the same about vaulting the cupola if you'd seen my model or plans.' However, Brunelleschi agreed to submit to the syndics a 700-word description of his dome. The syndics did not understand the report, which was highly technical, but what they did understand was Brunelleschi's remarkable confidence. Just as Columbus, in his difficult years at the Spanish court, 'conceived in his heart the most certain confidence to find what he claimed he

would, as if he had this world [of the Indies] locked up in his trunk', so now Brunelleschi 'appeared absolutely confident, repeating the same words all the time so that it seemed certain that he had raised ten cupolas already'. The syndics could not help being impressed, but still they wanted to see an example of this novel method of vaulting without a framework. Brunelleschi was able to satisfy them by vaulting a chapel in the church of S. Jacopo beyond the Arno. The syndics then met and, using the customary method of voting by casting a bean, awarded the commission of building the cathedral dome to Brunelleschi, specifying however that he must build only to a height of twenty-four feet, when his contract would be reviewed.

At once even this guarded decision came in for the bitterest criticism. At a time when there was no shortage of first-class artists, why were the syndics giving so much responsibility to one man? A project of this kind was far too important to be undertaken on the advice of a single individual, and if, as was likely, an accident resulted, the syndics would have to take all the blame. In alarm the syndics met again and reversed their previous decision, appointing Lorenzo Ghiberti, famous now because of his first pair of Baptistery doors, to share the responsibility with Brunelleschi. Both would rank as *provvisori* at 3 florins a month each. This *volte face* so bitterly disappointed Brunelleschi that he thought of running away from Florence, and but for the comfort of his friends Donatello and Luca della Robbia might even, says Vasari, have gone out of his mind. Finally he decided to ride the blow and retaliate in his own good time.

On 30 April 1420 the Works department ordered 120 *braccia* of stone, cut brick-shape, 200 planks of olive-wood, 100 fir-trunks for making platforms, and eight planks of pine-wood. They took a lease of Trassinaia quarry on the hill of Vincigliata, ordering ten gallons of lime and sixty blocks of *macigno* (hard golden-brown stone), to be supplied daily except when it rained. They hired two men to carry the blocks, lending them 100 lire for preliminary expenses. As the blocks began to arrive 223 chisels were sharpened to work them. The Florentines shook their heads: they 'thought Pippo was going to build a city up there, and that Maestro Arnolfo's church would be crushed under it.'

Building was scheduled to start on 7 August 1420. On that day

the eight master-builders were given a treat consisting of bread, melons, a barrel of *vermiglio* wine and a flask of *trebbiano*, costing 3 lire 9 soldi. They were to be paid by the day, at the usual rate of 1 lira 20 soldi. Then they climbed the 400 steps, in flights of five and three, leading up to the top of the tribune, and began to prepare wooden platforms from which the masons could raise the tribune they required thirty feet. At this height, 120 feet from the ground, votive candles down in the chapels looked distant as stars, and the thousands of clustered roof-tops merged as though they were a single ploughed field.

Workers' attendance was marked on two large slabs of plaster, hung conspicuously. To reckon hours of work one Giovanni di Ser Benedetto provided a sand-glass, for which he received 18 soldi. No workman might descend from the cupola during working hours, no wine might be sent up to them unless previously mixed with a third part of water, and anyone breaking this rule was fined 10 lire. When heavy rain stopped work, and there was insufficient employment below, the names of all the masters were put into a bag, and five of them drawn every day. These five and their gangs were employed at stone-cutting and brickwork under shelter. No one might work on the dome during Lenten sermons, because the noise of mallets and chisels would prevent the preacher being heard.

Brunelleschi worked hardest of all. He superintended every detail, going himself to the lime ovens, checking the mixture of lime and sand for the mortar, ensuring that every brick was well baked, every stone sound and cut to size. Consulted about an awkward joint or turning, Brunelleschi would pick up a turnip and in that cut a model of how the job should be done. But his activities extended far beyond usual architectural duties. He invented a new kind of barge to bring Carrara marble for the ribs up the Arno from Pisa. He designed a mechanical hoist for raising heavy blocks with his Roman-style *ulivella* or grappling-iron. For this invention on 18 July 1421 he received 100 florins, and on 20 August an additional 11 florins 584 lire for expenses incurred in making it. These included wheels, pulleys, beams, balances, chains, rope, leather, yokes for the oxen working it, and 14 pails of glue. In 1423 he invented an improved iron hoist, termed a *castello*, for which on 15 April he received 10 florins.

Two years later he was to invent a still stronger hoist, for which Donatello cast a bronze screw-vice.

While Brunelleschi slaved at the dome, the other *provvisore*, Ghiberti, drew his salary and did nothing. Brunelleschi had studied for twelve years to master the techniques required to erect the cupola, and it infuriated one so independent to have to share the credit with Ghiberti the goldsmith. Knowing the syndics of the Wool Guild to be timid and conservative, he believed the only way to secure control of the dome was by some sort of ruse, and in this field it so happened that Brunelleschi was a master. In 1409 he had carried out a ruse so complicated and successful that it became famous in Florentine annals and for long brought him more renown than his architectural achievements.

Brunelleschi's victim was a gullible wood-carver known as Manetto il Grasso. The first scene took place in Grasso's workshop near the Baptistery, where a boy arrived to summon Brunelleschi home: 'Your mother has been taken very ill.' Off hurried Brunelleschi and locked himself in Grasso's house, Grasso's mother being away in the country. That evening Grasso returned home, banged at his locked door and shouted for admission. That was Brunelleschi's cue. Minicking Grasso's voice, he addressed the puzzled wood-carver as Matteo—the name of a debt-ridden fellow-worker—and told him not to pretend to be Grasso. Then the architect made a show of telling Grasso's mother (he mimicked her voice too) how, that afternoon in his shop, a boy had summoned Brunelleschi home to his sick mother. Grasso listened with sinking heart. 'This', he thought, 'must be Grasso inside, for no one else can know that . . . Who then am I?' Off he went in confusion, only to meet Donatello. 'Oh, Matteo, do you want Grasso? He went home some time ago.' Further along the street he fell into the clutches of Brunelleschi's other accomplices, officers of the Board of Commerce. They too hailed him as Matteo, and arrested him for debt. Matteo's brothers, also in on the joke, were called as witnesses, the debt proved from official records, and Grasso clapped into prison. By now Grasso was convinced he really must be Matteo—but who, then, was the man he used to know by that name? The climax came when his brothers paid the debt and Grasso was allowed home. But which was his home? Finally he went

to Matteo's house, where his supposed brothers plied him with food and wine, then put him to bed. Brunelleschi and his friends carried off the sleeping wood-carver in a large basket to his own bed in his own home, and there at last he awoke, once again Grasso.

Brunelleschi's ruse on Ghiberti was to be simpler but no less cunning. The work having successfully reached the trial stage of twenty-four feet, it became necessary to put in place on the double vault the wooden and stone ties which would distribute the weight of the vault as it arched into the centre. At this crucial phase one morning Brunelleschi failed to put in an appearance on the site. Instead, he bandaged his head and took to his bed, and then, groaning all the time, he had sympathisers anxiously warming poultices while he pretended to be suffering from colic. When they heard what was happening, the master-builders who were standing around waiting for their instructions asked Ghiberti what they should do next. He gave an evasive reply: nothing, he said, could be done without Brunelleschi. By the third day of Brunelleschi's supposed illness all work had ground to a halt. Then the syndics of the Wool Guild came to his bedside, begging him to give Ghiberti instructions. 'Lorenzo can do nothing without you.' To which Brunelleschi tartly replied: 'But I could do perfectly well without Lorenzo.'

At last Brunelleschi consented to get out of bed on the understanding that Ghiberti would have no further say in the project. Later, however, the syndics continued to pay Ghiberti his salary and to treat him with the old deference. Determined to finish the matter once and for all, Brunelleschi called a meeting of the syndics and there, in Ghiberti's presence, he made a proposition. 'In case I should ever fall ill again or, which God forbid, in case Lorenzo should, in order to ensure that work is not interrupted, I suggest that, just as your lordships have divided the salary between us, so your should also divide the work.' There were, Brunelleschi went on, two difficult tasks ahead: erection of scaffolding and construction of the ties; let Lorenzo choose one of them. Ghiberti, cornered, reluctantly chose the ties, hoping to copy the technique used in the Baptistery. But he bungled the first tie, whereupon Brunelleschi produced his own plans to the syndics, calling for bricks laid herring-bone fashion, after the method he had discovered

in Rome, and huge oak beams to form a wood-and-iron chain. At last the syndics realized Brunelleschi's superiority. On 27 August 1423 they made him sole overseer and superintendent for life of the entire building, stipulating that nothing was to be done except on his orders. They also paid him an honorarium of 100 florins for the wood-and-iron chain technique, and made him a grant for life of 100 florins a year.

Building now went ahead more smoothly. As the dome rose, workmen received a 25 per cent increase as danger money. By 1432 it was nearing completion, and the full boldness of Brunelleschi's plan became evident to all. Instead of a shallow dome like that of the Pantheon or Hagia Sophia, this was unprecedentedly tall and vast. The height from ground level to the foot of the lantern would be twice the dome's diameter: no less than 270 feet. Other domes, such as those at Pisa and Siena, merely arched over the crossing; this one would draw together the whole vast cathedral. But as praise grew for its architect, so did envy. Brunelleschi's detractors were determined that the last and final stage—the lantern which would hold all together—should be given to another architect. Once again the timid Wool Guild was persuaded to hold a public competition.

Brunelleschi made a wooden model of a lantern decorated with pilaster, scallop shells and scrolls. Many other designs were submitted for the competition, including one by a lady of the Gaddi family, and a second which incorporated details copied from Brunelleschi's work. When it was shown to him Brunelleschi remarked wryly, 'The next model this man makes will be mine.' Nevertheless, Brunelleschi's design looked like being chosen, and his enemies in the Guild of Masons and Joiners sought some way of preventing the architect's new triumph. They recalled that Brunelleschi had been sworn a member of the Silk Merchants' Guild back in 1398, and saw their chance in this. They thought fit to announce that Brunelleschi had intruded himself into their grand project without joining their guild and without paying his annual fees. The consuls of the Masons' Guild opened proceedings and actually succeeded in getting the unhappy Brunelleschi put in prison for unpaid fees.

At stake was the role of the architect: his right to impose his

mind on an entire work regardless of committees and guilds; ultimately, the independence essential to bold, pioneer schemes. Fortunately the Wool Guild considered that their own authority had been infringed by this affront to the architect they were backing. They therefore called a meeting and passed a solemn resolution that Brunelleschi should be released immediately, and all the consuls of the Masons' Guild put in prison—evidently for exceeding their authority. This was done, and Brunelleschi vindicated in just the dramatic way he savoured.

The consuls, as soon as they emerged from prison, began a whispering campaign that Brunelleschi's lantern would smash the whole dome to the ground. 'Not at all,' retorted Brunelleschi, 'the heavier the weight, the better it will hold the cupola together.' Building continued and on the last day of August 1436, after sixteen years' toil, the final stone was laid in place and the great dome closed. The blessing was performed by the Bishop of Fiesole, who climbed the steep stairway within the double vault to reach the top, and on that day priests and canons of the cathedral were invited to a feast, on which Simone di Lorenzo, servant of the Works department, spent 72 lire 12 soldi for wine, bread, meat, fruit, cheese and macaroni, and for the services of trumpeters and pipers.

The belfries of Florence rang peals of joy to welcome the new dome which overtowered them all and seemed rather on a scale with the surrounding mountains. No such dome had been built since A.D. 125, the date of the Pantheon, and even Michelangelo's dome of St Peter's would not surpass this in size. It crowned and unified a composite mass which formerly had tended to sprawl. Leon Battista Alberti said that it was ample enough to hold all the people of Tuscany in its shadow. It became, instead of the Signoria tower, the new landmark and city symbol, to such an extent that Florentines abroad, instead of saying they were homesick, said they were 'sick for the dome'.

Most remarkable of all, the dome had been conceived by one man and executed under his personal direction. It could truly be called Brunelleschi's. The line had first been crossed in 1423, when Brunelleschi was awarded 100 florins as '*inventore . . . della muraglia della maggiore Cupola*'; the word *inventor* had been used of an artist

in the sense of discoverer by Quintilian, but in the Middle Ages it had so lost its original sense that it meant a delator or informer. Now the word was given back its original value, and Brunelleschi was designated a discoverer, one who originated. The new status of the architect was remarked by Toscanelli, Brunelleschi's Greek and geometry master, who asserted that 'architecture is not within the capacity of every craftsman: it demands a mind above the ordinary', a point which Alberti developed in the middle of the century in his *De re aedificatoria*, where he makes a plea for the dignity of the architect, pointing out first that his noble mind and education set him apart from the lowly stonemason and manual worker; secondly, that he answered the new Roman republican ideal in that he served the community by adorning his city, so bringing it honour and fame.

When Brunelleschi died in 1446, a wax model was taken of his face, a tribute usually reserved for saints and patriots, and later in the century his biography was written.

In the fields of sculpture and painting it was the three Medici, Cosimo, Piero and Lorenzo, who, by befriending, encouraging and commissioning, enabled the traditional workshop craftsman to develop into the artist as that word is understood today. That the Medici should have patronized art at all is in itself a most remarkable innovation, since Italy had no tradition of individual lay patronage. True, the Tuscan loves visual beauty and a ploughman will hang the necks of his white oxen with red tassels for the sheer pleasure of the contrasting colours. But the Tuscan is also thrifty and there is a big step from enjoyment of beauty to the employment, often at large expense, of those who make beauty. Before the Medici the typical attitude had been that of Francesco Datini of Prato, a tireless moneymaker who, on returning from business in Avignon, planted a garden, French-style, beside his new house, 'full of oranges, roses and violets and other lovely flowers', only to regret it later as 'a great piece of folly', for it had cost no less than 600 florins: 'I would have been wiser to put the money into a farm.' It is one of their chief claims to fame that the Medici rejected the notion of work as an end in itself and of spending as an evil.

To this change of attitude a passage in Pliny's recently discovered complete *Natural History* certainly contributed, a work which Cosimo admired so much that he commissioned a de-luxe edition. 'King Attalus', says Pliny, 'bid 100 talents for one picture by the Theban painter Aristides; the dictator Cæsar purchased two by Timomachus for 80, the *Medea* and the *Ajax*, to dedicate them in the temple of Venus Genetrix. King Candaules paid its weight in gold for a picture of considerable size by Bularchus representing the downfall of the Magnesians.' A hundred talents was a huge sum, equivalent to 25,000 florins, and the stimulus to modern readers of Pliny's book commensurate.

The origins of Medici patronage are to be found in the collection of antique coins, medals, intaglios and vases which Cosimo began to form in his youth along the lines of one of the very first collections, that of his fastidious friend Niccolò Niccoli. These objects opened Cosimo's eyes to the possibility of non-religious art and later, when he came to build the Palazzo Medici, he adorned the courtyard with eight marble medallions copied from cameos and the reverse sides of medals, some in his own collection. But in his first commissions Cosimo followed a more traditional path. In 1427 he and his brother commissioned Ghiberti to make a shrine for the martyrs Hyacinthus, Nemesius and Protus, whose bodies had been found neglected in the region. Only around 1439 did Cosimo commission Donatello to make for him a life-size bronze statue of *David*, which we shall consider later. It was the first important statue of secular intent to be made in Florence, and the fact that a private individual commissioned it marks it as a parting of the ways.

Classical texts made much of the esteem enjoyed by sculptors such as Phidias and Praxiteles, of painters such as Zeuxis and Apelles, and the fact that even the greatest men sought their friendship. 'The artist Apelles', writes Pliny, 'fell in love with a lady named Pankaste who was Alexander's mistress at the time ... and when Alexander became aware of the state of affairs, he at once handed her over to Apelles with his blessing.' This and many similar passages exalting the artist were not lost on the Florentines. Without going so far as Alexander, Cosimo esteemed Donatello and treated him as a

close personal friend. In hard times, in order that his chisel might not be idle, Cosimo arranged for Donatello to make the bronze pulpits and the sacristy doors in S. Lorenzo, and a bronze head for a Genoese merchant. Yet Donatello was the opposite of easy. This same merchant complained about the price of the head, objecting that since Donatello had finished the work in a month, he would be earning over half a florin a day! Donatello considered himself grossly insulted, threw the head out the window, smashing it, and told the merchant he should be bargaining for beans, not bronzes. The merchant regretted what he had done and promised to pay twice as much if Donatello would do the head again; but even Cosimo's entreaties failed to make Donatello agree. Not that the sculptor set much store by money; what he had he kept in a basket hung by a string from his workshop ceiling, and all his workmen and friends could take what they wanted without asking.

Donatello loved Cosimo so well, says Vasari, that he could understand all he wanted, from the slightest sign, and he never disappointed him. Yet their relationship went much deeper than that of employer and employee. After a long residence in Padua, when the Paduans praised his sculpture to the skies and offered him every kind of affectionate restraint to make him take up citizenship, Donatello decided to return to Florence, 'saying that if he stayed any longer he would forget all he knew because of their flattery, and that he was only too anxious to return to his native land, where he would be constantly criticized', thus spurring him on to better work. Cosimo, being a perfectionist, was certainly among Donatello's serious critics, yet at the same time he wished Donatello to be recognized as the important man he was. One holiday morning he sent the sculptor, who dressed simply, a new suit and a fine new scarlet cloak and hood. Donatello wore the luxurious clothes for a few days, then resumed his usual garb, 'lest people should think he had grown effeminate'. In his old age he received a pension from Cosimo, the first known instance of such help to an artist, and when Cosimo died Donatello continued to be helped by Piero, who gave him a farm at Cafaggiolo. Finding, however, that his role of landlord interfered with his sculpture Donatello asked Piero to take it back; Piero did so and paid him weekly a sum equal to the income from

the farm. Donatello asked to be buried next to Cosimo, a request that was granted: as Vasari says, 'that his body might be near him in death as his spirit had been near him in life'.

Some of Cosimo's protégés were considerably more difficult than Donatello. Filippo Lippi, a Carmelite who threw off the friar's habit at the age of eighteen, was a shameless scrounger. In August 1439 he wrote to the Medici: 'I am one of the poorest *frati* in Florence. God has left me six nieces to be married, all useless and infirm: the little they have, though it is much for them, is I. If you would arrange for me to receive from your house a little corn and wine that you would sell me, it would give me great joy. Set it down to my account, I beg of you with tears in my eyes; for if I should pass on, I leave it to these poor children.' What money he earned or borrowed Filippo seems to have spent on the pretty girls he was for ever chasing. Once when he was painting a picture in Cosimo's house, Cosimo had Filippo locked in so that he wouldn't wander away after girls. But one night his amorous desires drove Filippo to seize a pair of scissors, make a rope from his bed-sheets, and escape through a window to pursue his own pleasures for days on end. When Cosimo found out, he was horrified to think that Filippo might have broken his neck. He searched for him and eventually got him back to his brushes and paints. 'After that he always allowed him to come and go as he liked . . . determined for the future to keep a hold on him by affection and kindness. Being served all the more readily, he used to say that gifted artists were to be treated with respect, not used as hacks.' Cosimo continued to be generous to Filippo. It was he who arranged for the painter to receive commissions in Prato and when Filippo seduced Lucrezia Buti in that town, it was Cosimo who obtained from the Pope a dispensation permitting them to marry.

This friendly understanding is all the more remarkable by comparison with conditions in other circles. In Rome painters were lumped together with carters and grooms, with whom they had to take their meals. When Paolo Uccello was painting the cloister of S. Miniato the abbot fed him largely on cheese. Eventually Paolo grew sick of this and, too shy to protest, ran away. He was pursued and caught by two friars, to whom he explained, 'What with his cheese

pies and his cheese soups, that abbot of yours stuffed me so full of cheese that I'm frightened some carpenter will melt me down for glue. If he'd gone on any more I wouldn't be Paolo Uccello, I'd be pure cheese.' Davide Ghirlandaio went even further. When he and his brother Domenico were served uneatable food in the abbey of Passignano, he rose in a rage, dumped his soup over the friar who had served it, beat him with a long loaf of bread; and when the abbot intervened, turned on him too, 'shouting that the talents of Domenico were worth more than all the hogs of abbots who had ever lived in the monastery'.

This championing of artists by Florence's most prominent citizen naturally raised their status. In his contract for the first Baptistery doors Ghiberti is explicitly described as a wage-earner; but for the second doors he was dispensed from following exactly the programme drawn up by Leonardo Bruni: 'I was allowed a free hand to execute them as seemed good to me.' Because it was now more truly their own, artists began to sign their work. When he completed the second doors in 1452, Ghiberti inscribed them: *Laurentii Ghibertis mira arte fabricatum*, and even included a small bust of himself: bald-headed, with sharp, knowing eyes. When Donatello, some time between 1456 and 1460, cast for Cosimo a bronze group of Judith cutting off the head of Holofernes, he too signed it *Donatelli opus*. As for painters, they began to use the *cartellino*, a panel or label usually painted in *trompe l'oeil* for the purpose of bearing the artist's name and signature. In Italy it appears about 1440 in Filippo Lippi's *Madonna* in the Palazzo Barberini in Rome. Another device was the insertion of the painter's own portrait in the right-hand corner of his compositions, for example, Botticelli's in his *Adoration of the Magi*, commissioned by the Medici about 1476.

Despite his growing reputation, the painter still depended in large measure on his patron. It was the patron who made the all-important choice of subject, and he who supported the painter during the period of work, which might be upwards of a year. On Filippo's *Coronation of the Virgin* an angel points to a kneeling monk with the words, *Iste perfecit opus*; these refer to the donor, not the painter. And at least as late as Piero de' Medici, the patron guided the artist even in details. In 1459 when Piero chose Fra Angelico's

favourite pupil, Benozzo Gozzoli, to decorate the chapel of the Medici Palace with *The Procession of the Magi*, he instructed the artist to fill it with bright colours and rich, courtly dresses along the lines of Gentile da Fabriano's *Adoration of the Magi*. Gozzoli wrote of the quantities of gold and ultramarine he needed, and which he hoped to get at a favourable price if only Piero would advance him money in time. The mural was more like a courtly cavalcade than a Gospel incident, but even so Piero thought certain angels too intrusive.

I have made only one seraph [Gozzoli replied] in a corner among certain clouds; nothing but the tips of his wings is visible, and he is so well hidden and so covered by clouds that he does not make for deformity at all but rather for beauty ... I have made another on the other side of the altar but also hidden in a similar way. Roberto Martegli has seen them and said there is no reason to make a fuss about them. Nevertheless, I'll do as you command; two little clouds will take them away ...

What Cosimo had done for sculpture, Piero did for his preferred art, painting—he took it out of the church. His commissions in this respect to Uccello and Pollaiuolo will be considered later; for the moment it is enough to note that though he commissioned secular subjects, Piero never aped neighbouring courts in their use of art as a means to self-glorification. True, in Gozzoli's mural he had his son Lorenzo portrayed as one of the Magi, and himself in a citizen's high scarlet cap, but this, and a bust of himself by Mino da Fiesole were the limits of his vanity. Federigo da Montefeltro, on the other hand, had his portrait painted over and over again, once by Piero della Francesca riding in a triumphal car, while Borso d'Este not only erected a statue of himself in the main square of Ferrara but covered the walls of the Palazzo Schifanoia with scenes in his own honour: receiving ambassadors, watching horseraces, accepting the gift of a basket of cherries, rewarding a buffoon. All too often the court artist became just another adulatory courtier.

Piero's wife Lucrezia seems to have played a part also in opening new subject-matter to painters. In her poem about Tobias she versified this apocryphal book of the Old Testament and thus popularized in her circle devotion to Raphael. Because he healed Tobit's eyes, Raphael was considered a doctor and hence, like Cosmas and

Damian, specially honoured by the Medici. Since he had accompanied Tobias on a journey to collect a debt, it became usual for rich merchant families, when the son of the house left on a business trip, to commission an *ex voto* painting showing the son as Tobias, accompanied by the angel Raphael: a nice example of the transition from time-honoured religious themes to a subject with both spiritual and secular aspects. Evidently following Lucrezia's poem, a spate of paintings of Tobias and Raphael began to appear around 1470. In one such painting, by a follower of Verrocchio, the roll of paper marked *Ricord.* held by Tobias is no doubt the statement of money due. Raphael's dog, which Lucrezia specifically mentions, is seen dimly at the angel's feet. The dog achieves more prominence in a much stronger and greater treatment of the same subject, that by Pollaiuolo.

The patronage of Cosimo and Piero de' Medici called into being a considerable number of artistic masterpieces. They were of an entirely new character. They had shaken off their devotional or civic origins and treated secular subjects with such power and beauty as to render them of unique and lasting importance. Medieval preachers had been able to point to the skull beneath the pretty face, the worm within the bone, but here, in this statue, or in that painting, beauty was immune from time. The artist conferred a quasi-permanence on ephemeral matter. Moreover, he did this by working not from a medieval pattern-book but from his own sketch-book in which he entered his observations and free inventions. There was a latent danger in this, as Savonarola would soon point out, but for the moment the artistic masterpieces filled men with a sense of elation, and they could not help but influence the thinking of Ficino's Platonic Academy.

Ficino was already well disposed to the artist, for beauty plays a fundamental part in his philosophy; he points out in his commentary on the *Symposium* that the much-admired Socrates was the son of a stone-cutter and well into old age earned his living by his own hands, sculpting stone. Rejecting Plato's doctrine in the *Republic* that the arts are trebly removed from reality, since they depict external objects which are themselves only shadows of perfect truth, Ficino and his circle preferred to emphasize the artistic

quality of Plato's own writings and to adopt a theory put forward by Plotinus, that art born from love can be closer to truth than casual observation or non-artistic experience. This view they expressed in a medal from the school of Bertoldo, showing Mercury working with Eros at arts based on measurement. They held that painters and sculptors, no less than soothsayers and prophets, driven by the same irrational force or *furor*, could succeed in probing the world's mysteries. The artist not the dialectician, the poet not the orator, was the principle of civilization, and as such deserved deep respect.

Lorenzo, himself a poet, accepted and acted on this view. He was the first layman to advance the interest not only of individual artists but of art as such. He sought to revive mosaic-making—Ghirlandaio was one of those who worked in this genre—and called in foreign craftsmen to teach the lost art of carving gems. But the problem to which he gave most attention was the education of future artists. Under the traditional system a boy was apprenticed at eleven or twelve; he could then read and write, but he received no further education during his six years' apprenticeship and for this reason rarely rose above the level of a craftsman, acting on others' orders. In 1488 Lorenzo decided to found a school where promising youths could follow their craft and at the same time pursue liberal and mathematical studies without which, as Ficino says, art is merely conjecture, a plaything of the imagination.

Between his house and S. Marco lay a garden which had once belonged to the Badia of Fiesole and had come into Lorenzo's possession through his wife. This Lorenzo chose as the site of his school and here he set out the now very large Medici collection of antique statues and busts and modern paintings in what was the world's first museum. Within the garden door he set a white statue of the satyr Marsyas, nude and fastened to a tree: just such a statue as had stood in the forum of Rome and was well known from the allusions of Roman poets. He wished to see it balanced by another Marsyas in *pietra rosea*, the torso and head of which had come into his hands. Lorenzo gave them to Verrocchio to restore. 'He completed the work perfectly by adding legs, thighs and arms in red marble. Lorenzo was highly satisfied and placed it facing the other'—an apt

symbol of the continuity between classical and Florentine art which the school was to foster.

As art teacher Lorenzo chose Bertoldo di Giovanni, once a pupil of Donatello, now getting on for seventy. He excelled in the portrayal of stress, struggle and strain which Lorenzo liked, his best work being a bas-relief depicting a *Battle Scene*, in which naked men and Roman horsemen lunge, thrust, wrestle, roll over and fall in a contest which extends them to the uttermost limits of physical endurance. Bertoldo lived in Lorenzo's house; he formed part of Lorenzo's retinue on a trip to take the waters, signed his letters '*vostro ser Bertoldo*', and when he fell ill it was Lorenzo who wrote for the doctor. But Lorenzo himself took a personal interest in the school, and was well qualified to do so, having sufficient practical knowledge of painting, sculpture and architecture to be chosen as an arbitrator in all three fields: the *operai* of S. Jacopo in Pistoia, for example, unable to decide whether to assign the Forteguerri tomb to Verrocchio or to Piero Pallaiuolo, sent the two models to Lorenzo, 'since you have a full understanding of such and all other things'.

Lorenzo next turned to Domenico Ghirlandaio, asking him to recommend any likely boys to become pupils in his school. Ghirlandaio ran a large painting studio and although he could ask 1,000 florins for a set of frescoes (Giotto for the frescoes in the choir of old St Peter's received 500), he was so kind-hearted he would even paint hoops for women's baskets so as not to send them away unsatisfied. Among his apprentices was a boy of thirteen who was learning painting at a salary, over three years, of 24 florins. One day when painting scenes from the life of St John the Baptist in the Tornabuoni chapel of S. Maria Novella—Lorenzo's mother, the donor's sister, appears in one of them—Ghirlandaio left the church on an errand. During his absence the new pupil made a drawing of the scaffolding, trestles, pots of paint, brushes and the apprentices at their tasks. When he returned and saw the drawing, Ghirlandaio exclaimed, 'This boy knows more than I do!'

The boy's name was Michelangelo Buonarroti. He and another apprentice, Francesco Granacci, were generously recommended to Lorenzo by their master, and with other promising boys went to study under Bertoldo in the new school. Michelangelo first worked

on some terra-cotta figures in high relief and did so well that he was given a piece of marble to carve. He began to copy one of the Roman sculptures in the garden, the marble head of a faun. He changed the head slightly, opening the mouth wider to show all the teeth. 'Lorenzo was delighted with it. He said that he did not think a faun as old as that would have such a perfect set of teeth. Michelangelo missed the joke and set to work again. He broke out a tooth and even filed down the gum to make it look shrunken. Lorenzo was much amused.'

Michelangelo was the son of Lodovico di Leonardo Buonarroti, at the time of the boy's birth a magistrate in the Tuscan township of Chiusi and Caprese. Lorenzo sent for Lodovico, whose small income was insufficient to support his big family, and formally arranged to receive the promising young sculptor into his household. Lorenzo was to pay Michelangelo, as salary and so that he could help his father, more than seven times what he had received in Ghirlandaio's studio. Michelangelo was to have a good room in the Palazzo Medici and eat at Lorenzo's table. To make the boy even happier, Lorenzo gave him a violet cloak and appointed his father to a post in the Customs.

Michelangelo remained four years in Lorenzo's household and art school. His training included copying Masaccio's frescoes in the Carmine, and so brilliant were these copies—two have survived—that they excited ill-feeling. One day, while working in the Carmine, Michelangelo was taunted by another pupil in Lorenzo's school, a certain Pietro Torrigiani. Cellini describes Torrigiani as handsome, with beetling brows, very bold and more like a soldier than a sculptor. The taunts led to a quarrel, the quarrel to a fight with fists, during which Torrigiani, who was three years older than his fellow-pupil, flattened Michelangelo's nose, disfiguring him for life. Lorenzo intended to punish Torrigiani, but the young tough fled to Rome. Later he was to work in England, where he made Henry VII's tomb in Westminster Abbey.

'Michelangelo always ate at Lorenzo's table with the sons of the family and other distinguished and noble persons who lived with that lord, and Lorenzo always treated him with great respect.' He became friendly with Poliziano, Ficino and others of the Academy,

from whom he imbibed many of the ideas which were to shape his art, notably Plotinus's allegorical interpretation of the process whereby the form of a statue is extricated from the recalcitrant stone, which Michelangelo was to express in several of his sonnets. 'The best artist', he was to write, 'has not one idea that a piece of marble, still unworked, does not contain within itself.' He learned too, and expressed later, Plato's doctrine, developed by Ficino, that beauty is a way to God: 'Every beauty that is seen on earth recalls to feeling people, more than other things, that fount of pity whence we all come; nor do we have any other sample or fruit of heaven under this earth.' It was in Lorenzo's house that he was taught to respect all those possessed by a force or *furor* higher than themselves, notably prophets and sibyls, whom he would one day blazon over the ceiling of the Sistine Chapel. Finally and most important, in the house of the most versatile Florentine of his day, Michelangelo was encouraged to develop his gifts in several directions: the boy who in Ghirlandaio's studio might have become only a painter here received the training and stimuli which were to make him a master in the fields of bas-relief, sculpture, painting, architecture and poetry.

If it is true, as one reliable source maintains, that Leonardo da Vinci as a young man lived in Lorenzo's household, the same influences may have led him also to versatility and to his conception of the artist as a discoverer of scientific truth. Leonardo was born in 1452 in the village of Vinci near Florence. Perhaps to compensate for his illegitimate birth, he was given no less than five godfathers and five godmothers. About the age of twelve he entered Verrocchio's workshop, where he received the usual apprentice's training: priming boxwood panels with ashes of chicken- or mutton-bones, making brushes from miniver or hog's bristles, grinding the stock colours—seven shades of green, seven of yellow and so on—as described in Cennini's manual. Among Leonardo's earliest notes are recipes for varnish and for mixtures of colours. Since Verrocchio was both sculptor and painter, his pupil may have learned both these arts from him, but there is nothing in the workshop tradition to explain how Leonardo before the age of thirty became proficient on the lyre, in ornithology and the theory of flight—he was already taking notes for a treatise in four parts 'On Birds', which was to

pave the way for his flying-machine—in the design of mills, fulling machines and water-powered engines, and in large-scale engineering —he was the first to propose reducing the Arno to a navigable canal between Pisa and Florence. The most likely explanation is that he moved in Lorenzo's circle and imbibed the teaching of Ficino. One of Ficino's most important aims was to fuse cultural worlds hitherto separate. He wished to abolish the borderline not only between creeds, but between philosophy, religion, all the arts, and science. For example, following Pythagoras and Plato, he linked the harmonies of the lyre with geometry, and geometry with the beauties of painting, and these in turn with beauty of soul and the Godhead. Likewise he perceptively saw that the artist and the scientist are akin in that both make imaginative leaps, both are discoverers.

Archimedes was much esteemed in Lorenzo's circle. Lorenzo commissioned from Lorenzo della Volpaia an astronomical clock nearly five feet high, which marked the risings and conjunctions of planets, because just such a clock had been made by Archimedes, and it may have been Lorenzo who introduced young Leonardo to Plutarch's detailed *Life* of the Syracusan engineer. At all events Leonardo conceived a warm admiration for Archimedes and at one period sought for manuscripts by him. The war that broke out in 1478 between Florence and Naples, coupled with the fact that Archimedes had made war machines during the Roman siege of Syracuse, doubtless turned Leonardo's thoughts to military engineering. He became proficient at designing cannon and invented a chariot with scythes modelled on Boadicea's, as well as machines which owe nothing to classical authors, such as portable bridges, fire-bombs and armoured vehicles. It would have been natural for him to try to interest Lorenzo in building these, but having ended the war with Naples in 1480 Lorenzo was concerned only with maintaining peace. Military inventions held little interest for him or for other Florentine politicians. Finally, either on his own initiative or at Lorenzo's suggestion, Leonardo wrote offering his war machines to the Duke of Milan, and left Florence about 1482.

Whether he was educated in Lorenzo's household or merely in Medici Florence, Leonardo is the culmination of the versatile artist

whose rise took place in the city by the Arno. Supremely confident in himself because he now possessed a philosophy to back up his claims, he used the techniques of one field in order to make progress in others. Outside Florence, however, such a man was little understood. When Leonardo painted the *Last Supper* in Milan, the Dominican prior would have him toiling like one of the labourers hoeing in the garden, never putting down his brush for a moment. When the prior complained that he had spent an entire half-day gazing at his mural without adding a stroke, Leonardo replied in words whose boldness derived from Ficino's thinking: 'Men of genius sometimes accomplish most when they work least.'

'Every painter paints himself.' This perceptive remark was made not by an artist but by a patron, Cosimo de' Medici. Echoed by Poliziano's claim: 'I write not like Cicero but like myself', it recognizes style as the expression of an artist's character, of his individuality. Yet paradoxically it is the 'universal man', such as Alberti, Michelangelo and Leonardo, who possesses most individuality, is most himself. This regard for the artist as an individual, whose style gives him power, authority and a certain claim on the community, may be dated to the years after 1480, when Antonio Manetti, who had already recorded the *burla* or practical joke played on Manetto il Grasso, wrote a *Life* of Brunelleschi running to eighty-five pages, the first complete life of an artist since classical times, and Lorenzo de' Medici began to place in the cathedral of Florence busts of famous artists, notably Giotto, Dante and Antonio Squarcialupi, composer and organist.

Mention has already been made of the communal nature of Florentine civilization, and of the equation of honour with public service. How did the artist as an individual fit into such a picture? It is Alberti, writer and architect, who supplies the answer. A man, he says, is more 'human' in so far as he differs from all others, the most admirable being *l'uomo singolare*. Yet there is no contradiction between the singular man and the community of citizens, since the artist works for the good of others. 'What I write,' says Alberti, 'I write not for myself, but for humanity.' The artist through his particular vision and style is singular, but through his citizenship, through the patron who commissions his work and through criticism by his

fellows, he is saved from petty self-centredness and joins hands with others in the community.

It is important to differentiate between the rise of the individual in Florence and his rise elsewhere in Italy. In Florence the individual was an artist or scientific thinker; elsewhere, more often than not, he took the form of the feudal despot, the flattered lord who set himself apart by his unbridled passions. Such were Niccolò d'Este, who slept with 800 women and murdered his second wife for adultery; Pandolfo Petrucci, tyrant of Siena, whose summer sport was the hurling of boulders from the top of Monte Amiata regardless of who or what might be in the way; and Fondolo of Cremona, who once had an opportunity of pushing Pope John XXIII and the emperor off a high tower, and to the end of his life regretted missing this chance of winning eternal fame.

It was precisely in his attitude to fame that the Florentine at his most individual parted company with the despot and *condottiere*. Since he was working for something beyond himself, whether beauty or truth, he set small store by his own glory and showed a commendable ability to work with others, whenever this did not detract from the work itself. Lorenzo and Poliziano helped Michelangelo; Toscanelli advised Columbus; Manetti, the Rossellinos, the Pollaiuolos, Baldovinetti and Luca della Robbia collaborated in the Cardinal of Portugal's chapel. It was not Amerigo Vespucci but a German who proposed that Amerigo's name should be given to the new continent, and no Florentine wrote his own life in the fifteenth century, save Alberti, whose short work is modest and written in the third person. Cellini's swaggering autobiography belongs to a later and altogether different period, after the fall of Florence, when the artist would again become, as Petrarch had once been, an exile and an egoist. It is a mark of the fifteenth century that the Florentine artist became an individual without outgrowing his strong civic sense or forgetting Ficino's dictum that man proves himself a member of the human race by loving other men as his equals, by being humane.

CHAPTER 9

Sculpture and Architecture

IN 1400, the crucial year of Florence's struggle against Giangaleazzo, plague had swept the city. People had feared a second Black Death, but in fact only a small number died. In the following year, as a thank-offering, the rich Calimala—the Guild of Cloth Merchants—decided to give a pair of decorated gilded bronze doors to the Baptistery. After holding an open competition, the syndics narrowed the field to six: two Florentine goldsmiths and four from elsewhere in Tuscany. They then announced that they would award the commission to whoever produced the best bas-relief of a subject symbolizing Florence's deliverance: the Sacrifice of Isaac. They specified the size of the trial piece, its shape—a medieval quatrefoil—and the number of figures: four humans, one angel, an ass and a ram. Each artist was given a sum of money and told to complete his entry within a year.

The Baptistery was the most beautiful complete building in Florence, its doors were conspicuous, and the commission important, so although held in wartime the competition aroused intense interest. Tuscans had a long tradition of small-scale sculpture, doubtless derived from the Etruscans, whose bronze statues include such masterpieces as the Lateran wolf. But the Florentines had lagged behind and produced nothing to compare with near-by Pisa's twelfth-century cathedral doors and two intricately carved pulpits. For their first pair of Baptistery doors, in 1330, they had been obliged to commission a Pisan artist, Andrea Pisano. Now, in their new mood of patriotism, they looked to the two Florentine entrants, Filippo Brunelleschi and Lorenzo Ghiberti.

How, in the year 1401, did one set about depicting the Sacrifice of Isaac? The answer, in theory, was simple. For four centuries

now mosaicists, goldsmiths, sculptors, painters and illuminators had arranged their figures according to an iconography evolved in the Eastern Empire. It was a European scheme. The mosaics in the Florentine Baptistery had counterparts in Greece, the Pisan pulpit carvings had counterparts on French cathedrals. The scheme allowed of variations and insights but had never seriously been called in question. To depict the Sacrifice of Isaac, therefore, one followed the Byzantine pattern-book, or an earlier work so conceived, such as the mosaics of S. Vitale in Ravenna.

In Florence, however, the answer could no longer be quite as simple as this. Admiration for republican Rome caused the 'new Romans' to look back beyond the medieval pattern-books to the statues and buildings of their model city and spiritual ally. The Calimala's decision to adorn the Baptistery was itself an illustration of this attitude, for Florentines of this period did not know that the Baptistery is an eleventh-century remodelling of a sixth or seventh-century structure; they firmly believed it to be a reconverted temple of Mars built to celebrate the Roman victory over the older Etruscan town of Fiesole, and as such the one surviving relic in Florence of the Roman Republic. Clearly the 'new Romans', in adding doors to this edifice, would be expected to take account of the art of old Rome.

Little such art survived in the region of Florence. Coins and statuettes were occasionally turned up by a plough, but near-by Pisa was richer. Around 1200 Archbishop Ubaldo had brought to Pisa fifty-three ship-loads of earth from Jerusalem so that the Pisans might rest in holy ground, and there in the Campo Santo many had been buried in Roman sarcophagi, of which Pisa possessed a great number. These sarcophagi were richly carved with unclad nymphs representing the soul, centaurs representing the region of Hades, and human figures in action; one or two, notably a figure of Hercules, had caught the eye of Pisan sculptors and been incorporated into Pisan pulpits, though without any conscious attempt to revive classical art. Cortona possessed a fine Roman sarcophagus representing the battle of the Centaurs and Lapithæ: Donatello saw it and described it to Brunelleschi, who felt he must see it too, and set off just as he was, in his hood and mantle and wooden shoes, to walk the sixty miles to

Cortona. Rome also possessed a few classical statues above ground, notably the two Dioscuri of the Quirinal, imitations probably of a Phidian original, and a statue known as the Spinario, showing a youth removing a thorn from his foot.

Scant though these vestiges were, they made abundantly clear one of the main differences between Roman sculpture and medieval pattern-books: the human figure was generally unclad. So when Brunelleschi began to design his panel he decided to depict Isaac in this manner, without the swirling draperies on which artists usually concentrated their skill. He also hit on the idea of copying the Spinario rather than a Byzantine stock-type for the figure of one of Abraham's servants. So sure of himself was Brunelleschi that despite the originality of these features he neither changed nor modified his first design, but modelled rapidly and firmly. Long before the year was out his panel was cast and ready for the judges.

The other Florentine, Lorenzo Ghiberti, was then aged twenty, three years younger than Brunelleschi. He seems to have come from artisan stock and learned the goldsmith's craft from his stepfather, Bartoluccio. He lacked Brunelleschi's solid education and, although familiar with Pliny's *Natural History*, his appreciation of the classical past was primarily visual. He collected antiques and even as a young man loved to counterfeit the dies of antique medals, besides turning out the usual goldsmith's work: ear-rings, fancy buttons and other trinkets. To escape the plague he had gone to work in Rimini, but when Bartoluccio wrote to him about the competition, saying that, if he won, neither of them would need to make another ear-ring, he hurried home. In contrast to the craggy, independent Brunelleschi, Ghiberti was supple and open to suggestion. Under Bartoluccio's direction he produced several models before selecting one from which to work, and he continually sought the advice of friends and even passing strangers.

Ghiberti chose to centre the drama on Abraham's bare blade confronting Isaac's bare flesh. Brunelleschi had also shown Isaac unclad, but his Isaac cringes like one of the damned in a traditional Last Judgment. Ghiberti decided he would follow classical art more closely, and show the human body muscular, proud and beautiful, and he probably took as his model an antique statue of one of Niobe's

children. Thus, after eleven centuries, Ghiberti re-introduced the nude, that is to say an idealized form of the unclad human body, into European art.

Greek athletes raced, jumped, threw the javelin and discus with no covering at all on their bodies. Thus they were portrayed by Greek sculptors, who could claim therefore to be depicting real life. The Romans, shocked by the nakedness of Greek athletes, never adopted this custom themselves. They did depict the nude, but from being an imitation, however stylized, of real life, this form had become merely a convention and by the end of the third century had ceased to interest artists. The spread of Christianity, though not itself responsible for the disappearance of the nude, helped to keep it in abeyance by teaching that the body fetters and imprisons the soul. Christian iconography represented the unclad body in only three scenes: one showing man before the Fall (the Creation of Adam and Eve), and two shameful (the Expulsion from Paradise, and the Last Judgment). Outside these there was no place for the unclad figure, and Florence, a staunchly Christian city, had respected Christian teaching on this point. It was therefore a dramatic moment in the history of art when the thirty-four judges assembled by the Calimala (Cosimo's father among them) set eyes on Ghiberti's panel in its medieval Gothic quatrefoil, and found, as the centre of attraction and essence of the drama, the beautiful figure of a muscular young man.

In any other town of Europe an educated jury would doubtless have been puzzled or angered by Ghiberti's Isaac. Knights, when not fighting, farmed; for them as for peasants the body was a hard-worked instrument that sweats and grunts as it lifts, pulls and heaves, certainly not an object to be portrayed lovingly, while clerics considered it merely an occasion of sin. But this was Florence. The judges were men of wealth and leisure, who associated the body with fine scarlet cloth or shimmering silk. Moreover, victory that year over Giangaleazzo had raised to a new pitch enthusiasm for any and every link with republican Rome. Here was just such a link: a most remarkable one. Here was the kind of art Virgil and Ovid, Cicero and Quintilian knew, admired and described. Patriotism and affection for the classical model got the better of conservative

attitudes, and the judges decided they liked Ghiberti's relief. They also liked Brunelleschi's, doubtless because of its copy of the youth removing a thorn. They could not decide which they liked better, and indeed their indecision is understandable. Certain of Brunelleschi's details, such as his donkey, are superior, but his panel tends to fall into two, whereas Ghiberti's possesses an admirable unity which in part derives from the fact that it was cast, save for the Isaac, as a single whole. In the event the judges offered to divide the commission equally between the two Florentines, and when Brunelleschi declined this arrangement awarded the commission to young Ghiberti, still only a workshop employee.

Twenty-one years Ghiberti spent designing and casting the Baptistery doors, with their 20 scenes from the Life of Christ. Partly as a result of technical progress, he was able to make his figures stand out in greater relief than Andrea Pisano's, so that arms seem really to strike and legs to stride. It was the human body that continued to interest Ghiberti most and at which he excelled. In the Resurrection he depicts Christ's body in such perfection that, as Vasari says, it does seem truly glorified. The finished doors weighed ten tons and because of the gilding cost the Cloth Merchants 22,000 florins. They were judged so far superior to Pisano's doors that these were moved to the south side and Ghiberti commissioned to make a second pair for the conspicuous east entrance, opposite the cathedral. Having vindicated the male nude, in this second pair of doors Ghiberti was to vindicate the female.

Romanesque art had not been kind to Eve. A bronze panel made by Riquinus of Magdeburg in the twelfth century depicts her, and Adam too, with savage harshness, a guilty creature responsible for man's miserable condition. Something of this harshness was carried over to Italian art, where Eve is stocky and unpleasing, with heavy chest and thighs, and short legs. How difficult it was to break this convention is shown by a curious incident described in Ghiberti's *Commentaries*. Towards the middle of the fourteenth century a statue of a female figure supported by a dolphin came to light in Siena. It was evidently a Venus, though the Sienese did not know this, and signed by Lysippus, the Greek sculptor who invented a new canon of beauty calling for long legs and a slender body. The

citizens set up this curious-looking statue as a venerable object on a public fountain in the centre of their town. The Sienese painter Ambrogio Lorenzetti made a drawing of it, but evidently out of curiosity alone and with no intention of learning from it, for there is nothing of Lysippus in Ambrogio's paintings. The statue did not remain long on the fountain. Believing that their esteem for this heathen idol had caused a series of military disasters, in 1357 the Sienese took the Venus down and buried it in Florentine territory in order to bring bad luck to the enemy.

In Pisa, greater tolerance was shown to classical remains. The sculptor Giovanni Pisano and the painter Piero di Puccio were responsive to the nude figures on Roman sarcophagi which met their eyes at every turn in the Campo Santo, but when they came to reproduce them, Giovanni in the Virtue of *Temperance* on the pulpit of Pisa cathedral, and Piero in the *Creation* and *Expulsion of Adam and Eve*, the female nude still possesses Romanesque features: she is stocky, narrow-shouldered and heavy-thighed.

It was Ghiberti, under the influence of the general enthusiasm for the classical past and the new view of the body, who took two immensely important steps. First, he dismissed from his mind the conventional view of Eve and drew directly on a classical model, probably a Roman bas-relief depicting a nereid. Secondly, he treated his subject with a new affection: it is evident that he not only finds Eve's body beautiful but delights in that beauty; indeed Vasari says that Ghiberti intended his Adam and Eve to be the finest figures he had ever done, since they had been the most beautiful creatures made by God. The result is a slim and lovely woman, quite different from previous Eves. She is taller, her shoulders are emphasized more than her hips, so that her body seems to have an upward movement, a lilt, and as it is drawn gently from Adam's rib, almost to soar. Ghiberti's Eve is not more lifelike than Piero di Puccio's, painted about half a century earlier, for it is in the highest degree improbable that either worked from a living model: simply Ghiberti's work more closely resembles the classical nude, which in turn aimed at enhancing and heightening nature.

One of the features of Ghiberti's second pair of doors is that the programme of ten scenes breaks with traditional Byzantine

iconography. Chosen from the Old Testament by Leonardo Bruni, they reflect the Chancellor's ardent community spirit. Instead of or two three figures in a scene there are sometimes upwards of forty, and unusual incidents appear, such as the capture of Jericho and David slaying Goliath, which the Florentines could be expected to interpret in terms of their own city. They were religious scenes with marked political overtones, and this new trend was to pave the way for the next important piece of Florentine sculpture: Donatello's *David*.

Born in 1386, Donatello would have been only seventeen when he accompanied the disappointed Brunelleschi to Rome. What evidently impressed him most on this first, probably short, visit was the uncompromising realism of Roman portrait sculpture, for on his return he made for the west façade of Giotto's campanile a statue of a prophet ten feet high, modelling it closely on one of his friends. The *Zuccone*, as it is called from its gourd-like bald pate, depicts an aged man with blear eyes, cavernous mouth and sloping arms: a work of unflinching realism in which the sculptor aimed at a speaking likeness; indeed, Vasari tells us that Donatello, perfecting the nearly finished statue with chisel and mallet, would repeatedly mutter, 'Speak, damn you, speak!'

Realistic portraiture was only one aspect of the classical past. Brunelleschi had imbibed quite another, and the way he imparted it to his younger friend is revealed in Vasari's story of the crucifix, which, accurate or not in detail, certainly conveys a profound truth about Donatello's development. When he was about twenty-six Donatello made a wooden crucifix for the church of S. Croce, which Brunelleschi criticized. This, he said, is the body of a peasant, not the body of Jesus Christ, which was most delicate and in every part the most perfect human form ever created. 'Get some wood and try to make one for yourself', Donatello retorted. Brunelleschi said nothing but quietly planned one of the grand coups he so enjoyed. For several months he secretly worked on a crucifix of the same size as Donatello's. The medieval crucifix with its harrowing figure of a tormented, bleeding Christ was designed to convert—and indeed often did convert: S. Giovanni Gualberto for one had renounced his plan to kill his brother's murderer while contemplating a crucifix in

S. Miniato. This tradition Brunelleschi rejected, and also Donatello's 'peasant' realism. Instead, he fashioned a Christ according to the canons of ideal beauty found in the classical nude. Having finished the crucifix, he asked Donatello to lunch with him. On their way Brunelleschi bought provisions in the Old Market and asked Donatello to carry them home, saying he would follow in a moment. 'So Donatello went on ahead into the house, and going into the hall he saw, placed in a good light, Filippo's crucifix. He paused to study it and found it so perfect that he was completely overwhelmed and dropped his hands in astonishment; whereupon his apron fell and the eggs, the cheeses, and the rest of the shopping tumbled to the floor and everything was broken into pieces. He was still standing there in amazement, looking as if he had lost his wits', when Filippo came up and laughingly enquired what they were going to have for lunch. Donatello, still overpowered by the beauty of Brunelleschi's Christ, replied that he'd lost his appetite and didn't want any lunch at all.

Though he was to produce many other portrait statues of uncompromising and sometimes stark realism, the incident of Brunelleschi's crucifix revealed to Donatello the possibilities of ideal beauty latent in classical sculpture. The opportunity of realizing these was offered him, probably between 1439 and 1443, by Cosimo de' Medici, who wanted a statue of David for his house—not the wise old king familiar to medieval artists, wearing a crown and praising God on his harp, but the young David who slew Goliath, the boy warrior who had recently come to symbolize for Florentines their own relatively small republic triumphing over larger enemies. In two other respects Cosimo intended his *David* to break with centuries of tradition. It was to conform to the classical model by being freestanding and by being nude.

Donatello had not made a nude statue before. Only Ghiberti among his predecessors had seen the purely formal possibilities of the nude, but Ghiberti had gone to school with the Romans. Donatello, under the influence of the new learning and not least of Cosimo's tastes, went to school with the classical Greeks. Though few Greek or Greek-style statues remained above ground, some he had probably seen on his visits to Rome. They taught him to look on the body not

only with interest (as the Romans had done) but also with intense pleasure, almost with voluptuousness.

Like the Greek sculptors, Donatello enhances nature. His *David* possesses a perfection of physical beauty to be found doubtless in few if any of Donatello's fellow citizens. The muscles and curve of the thigh are lovingly moulded. According to classical writers on art, the statues of Polyclitus were noteworthy because the weight of the body was carried on one foot. Donatello may actually have seen a Roman copy of such a statue, and he certainly knew descriptions of the originals, for he gave his *David* just such a stance: a hallmark, as it were, to prove the statue authentically Greek. But there ends the resemblance between Donatello's work and its classical models. Whereas the Greek nude is a broad-shouldered muscular youth, the *David* has a much narrower waist and narrower shoulders, and his pose is the very opposite of Greek pride: he looks downward, and the suggestion of humility is emphasized by the bent knee and elbows. Although Donatello was reviving classical art, he could not, nor would he have wished to, revive the classical spirit in its entirety. Whereas Greek sculptors had represented the body as self-sufficient, with no hope of personal survival and therefore achieving its godlike quality in this world by purely human means, Donatello could see man only in relation to God. Whereas Greek grace was purely formal and physical, here there is another, religious dimension. Donatello's *David* is not just a conqueror; he is one who knows he has conquered only with God's help.

The *David* is a landmark in the history of civilization. With consummate artistry Donatello shows the body to be the ally, not the prison, of the spirit. More tellingly than the humanists' dialogues, silently, by its mere presence through the century in the courtyard of the Palazzo Medici, this statue was to conquer once and for all the verbal niceties, the clever syllogisms, the volumes of mental abstractions whereby well-meaning but partial thinkers had sought for a thousand years to divide man and limit his powers.

The *David* was also the archetype of several other important patriotic statues. For Cosimo, Donatello made a bronze of *Judith Severing the Head of Holofernes*, and in 1465, after foiling a political plot, Piero de' Medici dedicated and inscribed the *Judith* to 'the

liberty and fortitude bestowed on the republic by the invincible and constant spirit of the citizens'. In 1475, as a symbol of Florence's will to resist papal aggression Lorenzo de' Medici commissioned from Verrocchio a bronze *David* five feet high, which, with a martial inscription, was set up in the Palazzo di Signoria. The last in this series was Michelangelo's towering *David*, commissioned in 1501 during the dark days which were to follow the French invasion: in marked contrast to the works by Donatello and Verrocchio, its giant size is a form of overstatement which here, as so often, disguises a deep-seated lack of confidence.

In the first half of the century the nude had been comparatively static. It was Antonio Pollaiuolo who introduced movement and struggle, notably in his small bronze of *Hercules and Antæus*, in which with superhuman effort the demi-god—yet another symbolic figure of Florence—has succeeded in lifting the giant from the earth whence he draws his strength, and is about to kill him by crushing his ribs. The struggling nude was taken a stage further in Bertoldo's *Battle Scene*, modelled on a Roman sarcophagus, and reached its culmination in an early work by Michelangelo, the genesis of which we are told by Condivi. 'Although not really necessary,' Lorenzo's protégé, the poet and classical scholar Angelo Poliziano, 'constantly urged Michelangelo to study, and during their conversations gave him advice for his work'. One day Poliziano suggested that a good subject for sculpture would be the Battle of Theseus and the Centaurs, and told Michelangelo the story as Ovid relates it in the twelfth book of the *Metamorphoses*. The result was Michelangelo's masterly bas-relief, which draws heavily on Bertoldo's *Battle Scene*, but discards its regularity and easy equilibrium. Here the centaurs unashamedly brawl: each body is twisted, limbs are interlocked at abrupt angles; yet out of this swirl of straining figures emerges a satisfying impression of flowing, circular rhythm, with a suggesion also of something hidden. The figures are like an echoing voice, not wholly unambiguous. This impression is partly inherent in the nature of bas-relief, but Michelangelo evidently valued it, for he was to carry it through to his statues. Twisting or turning, they do not give themselves completely from any one angle, and thus introduce an element hitherto absent from art—a mood of mystery. We shall meet

mystery again in Leonardo's painting, and its source is to be found in the teaching of the Platonic Academy. 'All great truths are cryptic', Pico declared, thinking of the Cabbala, Plato's myths, the Sphinx's riddles and the secret lore of Egypt. Ficino too believed that the highest truths contain an element of mystery, and therefore cannot be stated unambiguously.

This esteem for the cryptic is to be seen in the crucifix which Michelangelo made for the prior of S. Spirito around 1493, his last work before leaving Florence for Bologna. The slim, graceful figure of Christ, carved in the round from poplar, owes its inspiration to classical statuary, but the curious feature is the trilingual inscription. The Hebrew of course runs from right to left, but so too do the Greek and Latin. The explanation is that in 1492 supposed relics of the Holy Cross came to light in S. Croce di Gerusalemme in Rome, and these indicated that the Latin and Greek texts should run just like the Hebrew. Though it is intrinsically improbable that Pilate authorized a Latin text to be written from right to left, the Platonic Academy would have welcomed evidence that the most momentous of all Christian inscriptions took a cryptic form, and doubtless for that reason Michelangelo adopted it.

The classical revival accounts for two other remarkable developments in Florentine sculpture. The first is the equestrian statue, notably Verrocchio's Colleoni monument, the aim here being to rival the *Marcus Aurelius* in Rome and the horses of St Mark's. The Florentines themselves did not erect equestrian statues, which jarred on their republicanism, and Verrocchio's work was commissioned by the Venetian Government, who at the last moment asked a second sculptor to make the figure of Colleoni, leaving the horse to Verrocchio; fortunately the Florentine refused to divide the work, even at the risk of losing the commission altogether, and it was he who made the magnificently scowling figure of the Venetian *condottiere*.

The second development is the portrayal of children. Conspicuously absent during the Middle Ages, children in the form of *putti* abound in classical art and it was these that provided motifs for Florentine artists. The earliest masterpiece depicting children is Luca della Robbia's cathedral choir-loft, made between 1431 and 1438. Clothed in antique tunics, barefooted boys praise the Lord by

singing and dancing, while others sound trumpets and cymbals in illustration of the 150th Psalm: the graceful movement with which some of them toss back their bodies and heads Luca probably derived from classical reliefs celebrating quite another revelry—the rites of Bacchus—but as in Donatello's *David* classical forms and the Christian spirit are perfectly harmonized. Boys for the same reason were also to become a favourite subject with Florentine painters. Christ, formerly shown as a babe—though with a man's face, to signify his intelligence—and John the Baptist as an ascetic prophet in goatskin, both became chubby boys, playing together through countless *sacre conversazioni*.

The two Florentines who excelled at children, Luca della Robbia and Desiderio da Settignano, were also those who succeeded best in the portrayal of women. As a boy, Desiderio worked on the pedestal of Donatello's *David*, making the harpies in marble and the vine leaves and tendrils in bronze. It was the element of grace in Donatello's statue which he brought to his own work. He preferred marble to bronze, and sought subtle, delicate shades of feeling. One senses behind his sculpture a sweet upright character, akin to Pico della Mirandola's, and like Pico he was to die in his thirties. His marble *Portrait of Marietta Strozzi* is in every way a remarkable work. The lady is depicted with head slightly atilt and looking a little to one side; there are dimples at the corners of her sensitive lips, and her eyes hold more than a hint of flirtation and fun. Here, one feels, is a young woman one already knows and would like to know better. Her expression has no precedent among the cold, remote and often supercilious Greek goddesses, or the grave matrons of Rome. In this respect the classical influence came to work indirectly, through literary portraits of individual women which helped the Florentines to notice, develop and finally portray elements in the gentler sex hitherto ignored. For the same reason Desiderio's Madonnas— perhaps the loveliest being the bas-relief of *Madonna and Angels*, now in the Louvre—possess a quality of sweet gentleness absent from the forbidding, queenly Madonnas of Giotto and his followers. It was the terra-cottas of Luca della Robbia, covered in a glaze of tin, litharge and antimony of his own invention, which carried this type of gentle Florentine Madonna to the ends of Europe.

When Brunelleschi stormed out of the council hall of the Opera del Duomo declaring that he would study an art in which Ghiberti could not rival him, Florentine architecture stood hesitant, uncertain of its way. The city's three largest churches had Gothic interiors: pointed arches carried on widely spaced polygonal piers: and one of them, the cathedral, had a Gothic exterior, where pinnacles, lancet windows and statues swathed in flowing drapery clash with the geometrical patterns in rose and green marble. The latest important building in Italy, Milan's vast cathedral, begun in 1386, was Gothic, and would eventually call for 135 spires and 200 external statues. Should Florence continue to follow the Gothic style, either sober or flamboyant, or should she, here as elsewhere, return to her own sources in the classical past?

When Brunelleschi went to Rome in 1402 he would have studied the important fourth-century Roman basilica of St John Lateran, 'mother of all churches', a long, simple, hall-like building, its nave divided by marble Corinthian columns supporting semi-circular arches and a flat roof. The features most different from recent Florentine work were the regularly spaced smooth cylindrical columns and the semi-circular arches. Both, as it happens, were to be found in Florence's Baptistery and eleventh-century church of S. Miniato, which Brunelleschi and later Alberti, even after they had closely inspected classical buildings in Rome, continued to regard as genuinely Roman works, and therefore a thousand years older than they actually were—a mistake similar to Poggio's, when he believed eleventh-century Carolingian script to be Roman. Given the current mood in Florence, the way forward was unmistakable. Brunelleschi would go behind the Gothic to those elements in the Roman style to be found in the Baptistery and S. Miniato.

In 1419, when the Silk Guild commissioned Brunelleschi to build a Foundling Hospital, this is exactly the course he followed. The loggia is supported on slender Corinthian columns, more delicate than those to be found on any building in Rome but reminiscent of those in the Baptistery, and the columns support not pointed but semi-circular arches. Above are windows under shallow pediments, a genuinely Roman motif. The Foundling Hospital is the architectural equivalent of Poggio's adoption of cursive script and Ghiberti's nude

Isaac: the first building to be modelled on classical and what were thought to be classical lines. It was a landmark, and destined to be influential, a similar use of slender Corinthian columns and semi-circular arches being found in Michelozzo's library and cloister at S. Marco and Brunelleschi's own cloister at S. Croce, to mention only religious buildings.

The next development was to prove even more influential. Around 1410 discovery was made of a detailed work on architecture by Vitruvius, a Roman of the first century B.C., and it began to be widely read in the next decade. In the first chapter of the third book Vitruvius makes the following declaration:

> Without symmetry and proportion no temple can have a regular plan; that is, it must have an exact proportion worked out after the fashion of the limbs of a finely-shaped human body. For Nature has so planned the human body that the face from the chin to the top of the forehead and the roots of the hair is a tenth part; also the palm of the hand from the wrist to the top of the middle finger is as much; the head from the chin to the crown, an eighth part . . . In like manner the various parts of temples ought to have dimensions answering suitably to the general sum of their whole magnitude.

So spoke Vitruvius's voice from the tomb, across fourteen centuries. The rule thus formulated was carried a stage further by Vitruvius's next, equally momentous statement: man's body is a model of proportion because with arms or legs extended it fits into those 'perfect' geometrical forms, the square and the circle.

It so happened that Vitruvius's pronouncements dovetailed neatly with Plato's teaching that the structure of reality, and beauty also, are geometrical. They were therefore received with enthusiasm and became the basis of Florentine architecture during the fifteenth century. Proportion, whether in the human body or in a sacred building, came to be considered the distinctive mark of beauty, and a reflection of God's cosmic order: hence the title of Fra Luca Pacioli's architectural treatise, *Divina Proportione*, a work incidentally for which Leonardo illustrated the Vitruvian concept of a man circumscribed by a square and a circle. As for the tangible results of Vitruvius's pronouncements, they first appeared in S. Lorenzo:

in the sacristy, built by Brunelleschi between 1421–9, which is square in plan and covered by a cupola, and later in the church itself, for which Brunelleschi was commissioned to draw up the plans in 1421 but which began to be built only in 1442, when Cosimo de' Medici lent the Commune 40,000 florins, the interest to be spent on this, his parish church.

S. Lorenzo breaks completely with three centuries of church building. The nave is divided by tall Corinthian columns supporting semi-circular arches and a flat roof: so far imitating a Roman basilica. But instead of side chapels projecting awkwardly from the walls, Brunelleschi sets each chapel in an alcove topped by a semi-circular arch, thus unifying the walls and divisions of the nave by means of a single motif: the semi-circle. Vitruvius's circle is found in the aisle windows and his square in the divisions of the ceiling, the flatness of which is an important element in the church, for the eye, drawn upward in Romanesque and Gothic, is here drawn down the nave and finds rest in the proportion of parts to whole. There is no squatness, but neither is there any soaring. Brunelleschi had no intention of making religion more 'human' or man rather than God the centre of the building: simply he rediscovered, through Vitruvius, the satisfaction the eye happens to take in symmetry, the square, the circle, and proportions similar to those of the human body.

Only the transepts of S. Lorenzo fail to partake in the unity of the whole, and this lack Brunelleschi remedied when he designed S. Spirito in 1434. There the arcading extends to the transepts, so forming an internal portico, and proportion plays an even larger role than in S. Lorenzo. The nave is twice as high as it is wide, the ground floor and clerestory are of equal height, the aisles have square bays, again half as wide as they are high. The result is of such harmony and apparent simplicity that henceforth Gothic came to be looked on as impossibly fussy: in Filarete's phrase, blown-up goldsmith's work.

The interiors of the Baptistery and S. Miniato are of white marble inlaid with geometrical patterns of much complexity in dark green marble. It was not good taste alone which led Brunelleschi and Alberti to reject this heavy, not to say overpowering, decoration, which they believed to be Roman. Both Plato and Cicero declared

that the interior of sacred buildings should be chaste, not to distract the eye, and suggested plain white as a suitable colour. This advice was followed, for it allowed the rhythm of the building to assert itself fully. Brunelleschi's walls are white and, in S. Spirito, the columns are of grey stone; he allows neither mural paintings nor statues in the body of the church, only occasional roundels in sober colours in the sacristy, but since the church was well lighted, the interior as a whole was brighter and more attractive than its predecessors. This too was in conformity with the trend to regard Christianity as a joyful religion.

Brunelleschi designed a façade for S. Spirito with four instead of the usual three doors, but neither this nor the façade of S. Lorenzo was built. The probable reason is that the classical model here offered no sure guidance: no common denominator was to be found in the façades, say, of St John Lateran and S. Miniato. Only Alberti succeeded in making excellent façades and it is noteworthy that each of them incorporates a different element from Roman antiquity. S. Francesco in Rimini has as its basis the Roman triumphal arch, S. Maria Novella the half-column and pilaster, S. Andrea in Mantua the massive rectangular piers and barrel vaults to be found in the baths of Caracalla.

Vitruvius referred to the circle as one of the two perfect shapes. For Plato it was the most perfect of all. Ficino regarded the circle as the aptest symbol of God, who, being both immanent and transcendent, is both centre and circumference of the circle. God expresses himself in the cosmos, says Alberti, through circular forms, such as globes, stars and nests of birds. For this reason it seemed that a building devoted to the worship of God should have a circular form. The example of the Romans appeared to bear this out. The Florentines noted that both the Pantheon and Minerva Medica were circular temples, while their own 'temple of Mars', now the Baptistery, though octagonal, had a centralized plan. Brunelleschi had a hankering to erect circular buildings. Besides the sacristy in S. Lorenzo, he built the Pazzi chapel in the form of a squared circle and began another centralized chapel in S. Maria degli Angeli, for lack of money never finished. In 1451 Michelozzo designed a completely round, domed structure for the monks' choir of SS.

Annunziata, but this ambitious scheme was never carried out. Some critics objected that the circular plan had been used chiefly for imperial tombs and was unacceptable in a republic, but the strongest opposition came from the Church. In a circular building, where were the side altars to go? How was the congregation to be disposed? Where was a bishop's throne to be placed, since what was the Gospel side from one direction would be the Epistle side from another? The whole concept of a central altar with the faithful before and behind the celebrant was as unorthodox as Columbus's plan to reach the Indies by a westward route. Though two Florentine architects, Giuliano and Antonio da Sangallo the elder, built centrally planned churches in Prato and Montepulciano, no centrally planned church was ever erected in Florence.

The designs which architects were unable to realize because of ecclesiastical opposition their colleagues depicted in other media. In the sixth scene of the second Baptistery doors, where Jacob sends his sons to buy corn in Egypt, Ghiberti includes a round temple in perspective; in his notebooks Leonardo sketches vast round churches; Francesco di Giorgio of Siena, who was much influenced by Florentine thinking, made drawings and paintings of centralized or circular buildings containing few or no figures, the interest being centred exclusively on these ideal structures which, alas, could never be built; while a number of Florentine painters, notably Perugino and later Raphael in the *Marriage of the Virgin*, depicted the Temple of Jerusalem as a polygon surmounted by a dome and framed by porticoes. In this oblique way the centralized church was vindicated.

When it came to designing private houses, the Florentines received no direct guidance from antiquity and were content to include this or that classical feature as circumstances allowed. In the thirteenth century houses had been quasi-fortresses, with corner tower and battlemented roof; in the fourteenth, tower and battlements disappeared, arched doorways and windows (usually of linen) became larger, but the façade, being virtually unarticulated, lacked character and expression: a good example is the Palazzo Davanzati. The turning-point came in 1444, when Michelozzo was commissioned by Cosimo to design the Palazzo Medici. During Cosimo's exile Michelozzo had sketched the most notable buildings in Venice,

doubtless the Doge's Palace and the latest Gothic palazzi. But it was Vitruvius, not Venice, that influenced him. Like Brunelleschi, he set great store by the square and the circle. The arcaded courtyard of the Palazzo Medici forms a perfect square and is adorned with roundels; the windows and doors giving on to the street are framed by semicircular arches. Heavily rusticated blocks on the ground floor lend an air of solidity befitting a bank, while string courses between the storeys lend interest, depth and unity. But the chief innovation is the finely carved cornice, a direct copy from Roman buildings, which crowns and softens an otherwise severe façade.

The Palazzo Medici marks the rebirth of civil architecture. Here at last was a private house that was also a work of art, as beautiful in its way as many a church and meant to be admired, for it had been built in Florence's newest and broadest street, the Via Larga. Nothing like it had been seen before either in Florence or elsewhere in Europe, save perhaps the Gothic house of finance minister Jacques Coeur in Bourges, a building which by its very sumptuousness had led to its owner's disgrace and ruin. That peril Cosimo had carefully avoided when he turned down Brunelleschi's original plan for a grandiose house standing, like a despot's castle, isolated from its neighbours. It was left to a political timeserver, the greasy, shifting Luca Pitti, to build, on the opposite bank of the Arno, a palace of this kind, the least pleasing of its century.

Cosimo set the fashion. Just as his patronage of painters encouraged Bernardetto de' Medici to adopt and apprentice a farmer's boy with artistic leanings named Andrea del Castagno, so every rich family had to have its palace in the new style. Brunelleschi built for the Pazzi, Giuliano da San Gallo for the Scala and Strozzi. But the best of these town houses was commissioned by Giovanni Rucellai, a cloth merchant who owed his name to the *oricello*, a plant rendering a red dye, and whose son married Cosimo's granddaughter. Rucellai's architect, Alberti, retained semi-circular arches for windows on the first and second storeys but on the ground floor has square windows and rectangular doors. His chief innovation is the placing of pilasters between the windows on all three floors. Their vertical lines offset the horizontal string courses, and each row seems to support the floor above, thus giving an upward thrust to the façade. The effect

is pleasing to the eye, and Alberti's pilasters were to be used in innumerable other façades down to modern times.

So far Florentine borrowings are all from Rome. Greek architecture was to make its influence felt only at the end of the century, though it had been made known to Florence quite early through the agency of a mercurial, happy-go-lucky antiquary named Ciriaco de' Pizzicolli. Born about 1404 in Ancona, Ciriaco started life as a shipping clerk, but the inscriptions and images on Trajan's arch stimulated an interest in antiquities. At nineteen he climbed a ladder in Fano to transcribe the inscription on the arch of Augustus and harangued the citizens on their 'half-buried glories'. At thirty he began a long series of travels in search of antiquities, during which he visited Dalmatia, Greece and the Greek islands, Crete, Cyprus, Asia Minor and Egypt. 'I go to awake the dead', he gaily explained, and for a fair passage would pray to his 'most holy patron, fleet-footed Mercury'. Whenever he found a ruined temple or an inscription he would record it with commendable accuracy for himself and his patrons, who included Cosimo. From Ciriaco's survey alone, it has proved possible to reconstruct the appearance of the temple at Cyzicus in Asia Minor, one of the wonders of antiquity but buried since Ciriaco visited it. From Ciriaco Florence received first-hand knowledge of the Pyramids, which confirmed them in their belief that art should have a strictly geometrical basis, and of the Parthenon, which Ciriaco visited in 1435 and 1437, making a drawing of the west front.

In 1490 Lorenzo de' Medici decided to remodel a country house in a pretty spot some ten miles west of Florence, off the Pistoia road, on a slope of wooded hills, called Poggio a Caiano. The architect he employed was Giuliano da Sangallo, but since the innovations differ in style from Giuliano's other works and Lorenzo had a practical knowledge of architecture, there is reason to think that the villa owes much to Lorenzo's Greek tastes and perhaps also to his own designs. At any rate Lorenzo achieved something which no one before had thought of doing. He made the façade of his country house like a Greek temple, with portico, pediment and frieze. The effect of the columns is to articulate space formerly allowed to disperse against the surrounding trees and hills, and of the pediment

to unify and give the building an upward lift. This adaptation, like Alberti's pilasters, was to have numerous progeny, notably the villas of Palladio.

As villas were remade, so were their grounds. In the pages of Varro and Pliny the Younger Alberti read about, and in 1452 advocated, a new type of garden visually more elaborate and pleasing than its medieval predecessor, which had been a simple enclosure with a lawn, planted with medicinal and pot herbs, sometimes peopled by tame rabbits and kids. The classical garden was linked to the house by loggias or porticos, which provided protection against sun and wind; it was laid out on an axial plan; its paths were bordered with symmetrically planted flowering trees, such as pomegranates and cornelian cherries, garlanded with roses, while box and scented evergreen herbs were cut to form geometrical designs. In accordance with these principles, Lorenzo de' Medici added a double Ionic loggia to Careggi and at Cafaggiolo planted a topiary bower, while Giovanni Rucellai adorned his villa of Quaracchi with figures of box. By the end of the century even flower-beds resembled diagrams in Euclid. Poggio Bracciolini seems to have been the first to place Roman statues in his garden; teased by friends with trying to create a gallery of noble ancestors, he tartly replied that *he* was the noble one for having discovered such marvels. Fountains added a cool note to the new flower gardens, and it was for Careggi that Verrocchio made his bronze fountain statue, *A Boy with a Dolphin*. So in gardens such as these one of the Florentines' sayings about the fifteenth century rang specially true: 'After a long winter, spring.'

Throughout the fifteenth century Florentine architects were building not only beside the Arno but throughout the length and breadth of Italy. In Milan and Genoa, in Rome and Naples the finest buildings were Florentine or of Florentine inspiration. When Pius II remodelled his birth-place as Pienza, he commissioned the Florentine Rossellino to build a palace directly inspired by the Palazzo Rucellai, and when Sixtus IV wanted a chapel in the Vatican which was to bear his name, he commissioned the Florentine Baccio Pontelli. 'Whoever wants to build in Italy today,' wrote Luca Pacioli of Urbino towards the end of the century, 'must soon turn for architects to Florence.' The reason was that, although architects

elsewhere adopted the classical model, only Florentines fully under-stood its presuppositions and worked out its possibilities. Eugenius IV's Palazzo Venezia, for example, looks heavy and asymmetrical compared with its counterparts on the Arno. Florentine buildings possess the solid strength that derives from geometrical principles and a grace that defies analysis but certainly reflects an ingrained idealism.

It was a sound instinct that turned Brunelleschi and his successors away from Gothic. For the Florentine, as Bruni pointed out, dislikes ostentation, while the fussiness of Gothic line had never looked well under the clear, sharp light of Tuscany. The classical model, on the other hand, exactly suited the Florentine temperament. Proportion, symmetry and the impeccable scansion of space were virtues that a sober, orderly people could appreciate and develop sympathetically. And having achieved purity of line, the Florentines with com-mendable restraint refrained from blurring the effect with statues or other decoration. In sculpture they followed the classical model closely, but it is in their buildings perhaps that the Florentines express more faithfully the principles and spirit of antiquity.

The quality of idealism in Florentine architecture and sculpture has been noticed: that quality described in Aristotle's dictum: 'Art completes what nature cannot bring to a finish. The artist gives us knowledge of nature's unrealized ends.' At every turn Tuscans are to be found devising some bold improvement, some new way of perfecting what is already excellent. The daring rose-pink architec-ture which Perugino and Fiorenzo di Lorenzo dreamed up in 1473 for their series of seven panels of the *Life of S. Bernardino* expresses this quality no less than young Leonardo's proposal to the government to raise and place steps under the Baptistery without damaging the fabric, simply in order to bring it into better line with the towering cathedral.

The most interesting and ambitious of these schemes was devised by a Florentine architect known as Filarete, who around 1464 dedi-cated and sent to Piero de' Medici the first treatise devoted solely to town-planning. Rejecting the piecemeal medieval town, with its dark, narrow, winding streets, Filarete describes with a wealth of detail a new and more spacious city conceived as a whole. Its ground plan has the shape of a star. Its centre is a raised piazza 200 yards

long by 100 yards wide, at the eastern end of which stands the cathedral, at the western the ruler's palace. From here sixteen wide perfectly straight avenues radiate to the encircling wall, which has eight gates, and eight towers named after the winds. Each avenue is lined with arcades, and washed clean at intervals by water released from hydrants in the central piazza. All buildings of importance are sited on spacious piazzas. Each is based on a simple geometric shape, and the relation of whole to parts follows definite arithmetical proportions, usually 1:1, 2:3 and 1:2. Churches take the form of a Greek cross, so as to present a regular appearance from whatever angle. Butchers' and fishmongers' shops, for reasons of health, face a canal. The brothel lies near the wine-market, between the tavern and the hot baths.

Filarete's treatise is a brilliant attempt to set a whole city in space. What Brunelleschi had done for the church interior, Filarete does for streets and piazzas. He builds up his city in a succession of spaces, each a clearly defined, self-contained entity. He joins hands also with Toscanelli not only in his approach to space but also in one point of detail: for his ideal city calls for a vast garden to be laid out like a map of the world. As for the sculpture which Brunelleschi and Alberti had turned out of their churches and Cosimo had taken into his palace, Filarete finds a place for this too in his city. Drawing on memories of Hadrian's tomb in Rome, he effectively uses statues of nude human figures to support the arcades on the outside of one of his key buildings, the Temple of Virtù. Though his schemes were centuries in advance of their time and never executed, Filarete can claim to be the first town-planner, the first to design on regular geometrical principles a convenient, clean and spacious city.

Painting

IN THE YEAR 1400 Florence possessed two important series of murals, both of course in churches, which may be taken as examples of the best painting at that time. The *Life of St Benedict* which Spinello Aretino depicted for S. Miniato around 1390 represents the narrative tradition: monks bundled in cassocks and hardly recognizable as living figures go through a series of miracles: here Benedict rescues a monk from drowning, there he resists temptation by rolling himself in briars: sixteen scenes piled one on another without apparent order. A second tradition, the monumental, was represented by Andrea di Firenze's frescoes in the chapter-house of S. Maria Novella, dating from about 1366–8. One wall shows the *Triumph of Wisdom*, issuing from the Holy Spirit to St Thomas Aquinas (at whose feet cower three heresiarchs), thence through fourteen seated figures (the theological sciences and liberal arts), each primly in a niche, accompanied by an historical example. On the opposite wall is an allegory of the *Church Militant and Triumphant*. The Pope and the Emperor are seated in front of the cathedral of Florence (the Emperor a fraction lower than the Pope), each with his stern, unsmiling hierarchy. At their feet lie sheep, symbolizing the faithful, protected from heretic wolves by black and white dogs, the *Domini canes*, while further on Dominican saints defend the ignorant and helpless faithful from sin—one ardent citizen is moved by a sermon to tear out of his book a page pronounced heretical or immoral—before being shepherded into Paradise. Both series of frescoes are impressive by their size and ambitious range, but the figures in them are two-dimensional, stiff, unnatural and seem to stand on tip-toe, while their facial expressions are either blank or stern. They are virtually puppets subservient to

the legend or sermon, and usually there are far too many of them.

The most noticeable characteristic, the two-dimensional appearance, arose from Byzantine artistic principles. The Byzantines had set their mosaics high up, even on the vault, and conceived depth as being in front of the mosaic, not behind it. Their tall tapering saints, when viewed from below, seemed lifelike. But when the Italians applied these principles to scenes low down in the church and in a medium other than mosaic, each row of figures seemed to stand on the heads of the row below. It was obviously unsatisfactory, but no one had thought of a solution. Since the death of Giotto in 1337 his followers had made no significant technical advance and in many respects were producing work far inferior to his. Florentine painting was in full decline.

The classical revival which began in sculpture and then extended to architecture, reached painting last of all, partly because very few classical pictures had survived and none was known to the Florentines. However, the Florentines did have at their disposal a most important classical text. In the seventh book of his work *On Architecture* Vitruvius has the following passage:

Agatharcus, at the time when Aeschylus taught at Athens the rules of tragic poetry, was the first who contrived scenery, upon which subject he left a treatise. This led Democritus and Anaxagoras, who wrote thereon, to explain how the points of sight and distance ought to guide the lines, as in nature, to a centre, so that by means of pictorial deception the real appearances of buildings appear on stage: painted on a flat vertical surface, they seem nevertheless to advance and recede.

It so happens that the exterior of the Baptistery, with its squares of dark green marble inlaid on white receding down two sides, provides a singularly dramatic illustration of Vitruvius's text. Brunelleschi was the first to take note of this. He observed how the parallel lines of dark marble gradually became closer in proportion to distance and, evidently prompted by Agatharcus's example, he made an accurate drawing of the phenomenon, as seen from the centre door of the cathedral, on a thick wooden panel nine inches square. He coloured the drawing and put in the sky with burnished silver, so that it

would reflect actual clouds being carried by the wind. Wishing to increase still further the illusion of three dimensions, he invented a new method of looking at such drawings. He pierced a funnel-shaped hole in his panel, the wider opening at the back. The viewer put his eye to the back of the hole and held a mirror nine inches square at arm's length, facing the picture. What he saw in the mirror was a stereoscopic view of the Baptistery, with the squares of dark green marble receding regularly, and the shops behind.

Brunelleschi's rediscovery of the principles of perspective was to change the artist's conception of space, and so to permit the correction of just those anomalies we have noted. The Byzantines had treated space as something in front of the subject; the Florentines now saw it as something behind. The viewer looks through a window, as it were, at the scene depicted, his gaze being directed right into the picture by means of receding lines or shapes. The painting becomes exactly as Agatharcus had described, the equivalent of a stage drop, creating an illusion of three dimensions.

The first artist to apply this new discovery was Masaccio. Born in 1401, he appears in his self-portrait as a serious, strongly built young man with a Greek nose and curly, tousled fair hair. He was kind and amiable by nature, but gave his whole attention to painting. His real name was Tommaso but because he neglected his clothes people called him Masaccio, or Slovenly Tom. Vasari says that he did not collect debts until actually in want, but the records show that Masaccio was the one usually in debt: even when he had plenty of commissions in hand, he would borrow heavily from assistants in his workshop. Among his early works is a fresco of the Trinity for S. Maria Novella in which perspective is conveyed as Brunelleschi had first discovered it: in terms of architecture. Masaccio set his figures under a barrel-vaulted ceiling divided into square compartments containing rosettes foreshortened and made to recede so skilfully that the surface looks as if it is indented. But the figures themselves are still stock two-dimensional types, and their unconvincingness becomes more glaring against so realistic a background and by comparison with recent advances in sculpture and bas-relief, notably Ghiberti's first Baptistery door. The next stage, clearly, must be the application of perspective to the human figure.

At the age of twenty-two Masaccio received a commission to decorate part of a private chapel in the church of the Carmine from one Felice Brancacci, a silk merchant who had just returned from serving his city as ambassador to the Sultan in Cairo. The subject was to be incidents in the life of St Peter, including the Finding of the Tribute Money, an unemotional scene hitherto rarely depicted. Brancacci belonged to the newly established Board of Maritime Consuls and may have wished to express that the wealth of the State was to be sought on the high seas. Be that as it may, Masaccio's commission came from a well-travelled and therefore broad-minded layman, who chose an original subject and allowed him a remarkably free hand. Masaccio rose to the occasion and produced in *The Tribute Money* the most influential of all Florentine paintings. His aim was to apply perspective to a small group of figures without the aid of architectural framework, and he achieved this by conceiving the group as a section of a cylinder. Because the eye is accustomed to 'read' an oval as really a distant round, it projects on to the group the dimension of space required by the artist. By means of shading he made the apostles' eyes appear firmly set beneath the brow, and by means of foreshortening set their feet solidly on the ground, not as hitherto on tip-toe. As a result Masaccio's figures possess weight and volume, and therefore a new authority. They are the visual equivalents of Coluccio's 'new Romans'. Poor Masaccio died in unknown circumstances at the age of twenty-seven, but his style was to endure, a fusion of the narrative and monumental traditions into a new and convincing realism, and it was to be studied by succeeding generations, including, as we have seen, Michelangelo. Moreover, the principles of Masaccio's style were incorporated into an influential treatise on the art of painting written in 1435 by his admirer Alberti: one of the points on which Alberti most insists is that figures should be depicted in the round and set in perspective.

The next painter to study the problems arising from Brunelleschi's demonstration of perspective was Paolo Doni, nicknamed Uccello. Born in Florence about 1397, at the age of ten he was already an apprentice in Ghiberti's workshop, where his tasks included polishing the Baptistery doors. A shy, solitary man, he had a great fondness for animals and, being too poor to keep pets, he filled his house

with pictures of cats, dogs, lions, snakes and of birds, his love for which earned him his nickname. Even stronger was his passion for geometry and the puzzles of perspective. He studied Euclid with the mathematician Giovanni Manetti, and despite the disapproval of his friend Donatello, who claimed that he was neglecting the known for the unknown, devoted much of his life to the task of depicting complex objects in space, such as heraldic crowns with their hoops and points, and solid bodies showing seventy-two faces like diamonds, with shavings twisted round sticks on every facet. He would shut himself in his house for months at a time and stay up all night trying to work out vanishing points. When his wife called him to come to bed he would say, 'Oh, what a lovely thing this perspective is.'

In 1436 Uccello painted for the cathedral a fresco monument of Sir John Hawkwood on horseback. It is a carefully thought-out attempt to conceive the horse in terms of geometrical shapes. Sir John's clover-leaf kneepiece sets the pattern of linked circles to which the horse's arched neck, haunches and raised right leg correspond. Cennini in the early years of the fifteenth century had declared that animals, unlike man, lack regular proportions; Uccello is implicitly denying that proposition. Vasari was quick to point out that Uccello's horse is moving its legs on one side only, something which horses cannot do without falling, but he failed to notice the reason for this slip: Uccello is primarily concerned to apply geometrical principles to a new and difficult subject.

Uccello continued to experiment on these and similar lines. In order to assert dramatically the importance of shape, in certain paintings for S. Miniato he made the fields blue, the cities red, and the buildings in various colours as he felt inclined. Commissioned, some time after 1447, to paint *The Flood* in the Green Cloister of S. Maria Novella, he chose to depict Noah's ark not as the usual houseboat, but pyramid-shaped. The pyramid had come into vogue through Ciriaco's first-hand account, and was considered a perfect form, like the square and circle, whose depiction in space presented Uccello with just those formidable difficulties he enjoyed. Again, Uccello overlooks an obvious fact, namely that a pyramid-shaped ark would have immediately capsized and sunk, but then the Florentines, with

a few notable exceptions, were not a sea-faring people and one of their expressions for death was 'entering the great sea'. Uccello's pyramidal ark was shown open, with ranges of perches in the upper part for birds, which he depicted in perspective, as they fly away in their various families.

In 1456 Uccello received from Piero de' Medici a commission to paint, in three panels, a historic Florentine victory over the Sienese, the *Rout of San Romano*. Piero's commission was something of a land-mark in patronage, for large wall paintings of a secular subject were still rare, and Uccello's were destined not for a public building but for the newly built Palazzo Medici. Like Donatello's *David*, the sub-ject had political overtones but Uccello treated it as a problem in perspective. He chooses to foreshorten objects of appalling com-plexity: wind-swept plumed helmets, a heraldic breast-plate marked like a backgammon board, a horse lying belly-upwards on the ground, another horse kicking its hind hooves high in the air. Amid this confusion only the gold roundels and oblongs on the horses' trappings and the lines of the long lances stand out clearly, so that the battle becomes a contest of geometrical figures. The *Rout of San Romano* hung in Lorenzo de' Medici's bedroom and doubtless helped to form his taste for scenes of strain and struggle, but the panels are less successful than another painting by Uccello: *A Hunt*, which may be accounted his masterpiece, since it perfectly realizes his gifts as a painter of animals and as a mathematician working out the laws of perspective. Red-coated horsemen and nimble hounds pursue an unseen quarry from both sides of the picture into the depths of a dark forest. The two lines of figures recede like the sides of a pyramid towards a vanishing-point near the centre of the picture, but the geometrical pattern is here implicit and restrained. The work which most resembles it, Pisanello's *Vision of St Eustace*, makes no use of the newly discovered rules of perspective and is for that reason less compelling, and also one might add less mysterious, for in his *Hunt* Uccello suggests space continuing indefinitely, something no artist had ever done before.

'Uccello', says Vasari, 'discovered a method and rule for standing his figures firmly on the plane of the floor while foreshortening them bit by bit, and making them recede and diminish in proportion.'

This and related passages in Vasari's *Life* suggest that Uccello's method or rule was a mathematical formula and, if so, it corresponds closely to experiments carried out by a second mathematician-painter, Piero della Francesca. The son of a cobbler, Piero was born between 1410 and 1420 in the Tuscan town of Borgo San Sepolcro, and until the age of fifteen applied himself to mathematics. He kept up his interest in the subject all his life and wrote two mathematical treatises, one on painting perspective, the other on the five regular bodies. When quite young he came to Florence, where he learned his craft and helped Domenico Veneziano in decorating S. Egidio. Piero's proud figures, with their straight, defiant mouths, were evidently too severe to please Piero de' Medici, for he never employed the great innovator in Florence and it was left to the Duke of Urbino, a tougher character, to become Piero's principal patron, both as mathematician and painter.

In a folder of drawings now in Parma Library Piero plotted a series of cross-sections through the human head preparatory to exact perspective construction. On one page a head is shown in profile, and vertical lines are drawn from key-points on the head to similar points in a section viewed from above and a second section viewed from below. Radii are then drawn from numbered points on the circumference of each section to a centre. The drawings leave no doubt that Piero believed he had found a mathematical rule governing the foreshortening of the human head. The hypothesis underlying his search and drawings, like that underlying the work of Uccello, Toscanelli and Ficino, was Plato's teaching that mathematics is the key to the cosmos.

Piero carried the implications of this hypothesis a stage further. Whereas in his *San Romano* Uccello had depicted circles and oblongs triumphing over the chaos of reality, Piero depicts reality itself in terms of certain regular geometrical bodies. In the background to his *Finding of the Cross* he represents the buildings of Jerusalem as cubes and cones, and in *The Baptism of Christ* the tree-trunk as a cylinder. Formerly solidity and the articulation of space had been achieved by artificial means, as in Andrea del Castagno's vigorous *Last Supper*, where six square panels of marble impart an air of foredestiny to the Apostles' various attitudes, and in Domenico Veneziano's

S. Lucia Altarpiece, where an architectural framework lends the saints authority, but Piero finds these qualities, much more effectively, in nature itself. The tree in his *Baptism* articulates space as effectively as any arch, and imparts strength even to the human figures, which the spectator unconsciously invests with the same solid form as the tree.

As though this were not achievement enough, Piero also played a pioneer role in introducing credible landscape to art. In the 88th chapter of his manual on painting, somewhat misleadingly entitled 'How to draw a mountain well from nature', Cennini writes: 'If you wish to draw mountains well, so that they appear natural, procure some large stones, rocky and not polished, and draw from these, giving them lights and shades as the same rule guides you.' This advice had been followed by Piero's predecessors, notably Fra Angelico, and quite effective it proved for desert scenes, but it did not please Piero, who as a painter of portraits demanded, like Donatello, a convincing realism. In his *Baptism* Piero reproduces faithfully bushes, trees, patches of sand, donkey tracks, a winding river and distant hills that are recognizably Tuscan. No longer a mere decorative background, landscape has become an exact representation of spaces and masses. It is also subject to the same law of perspective as buildings and the human figure. Even so, it did not altogether satisfy the Tuscan liking for order, regularity and unity. Piero found a solution to the difficulty in his *Portrait of Battista Sforza*, Federigo of Urbino's wife. He gives the duchess a sleeve of flowered brocade, the regular pattern of which is echoed in the quilted fields, the trees and groves; even certain broad tapering leaves on the brocade pattern are matched by distant battlements. The effect is to identify a creature with his or her habitat, to root human nature in the earth, and most satisfying it is both to the eye and the mind. This exact treatment of landscape was to be continued by Alessio Baldovinetti, who unwinds the Arno like a ribbon across the Tuscan hills; by Antonio Pollaiuolo, who through the use of oils is able to convey distance with even greater convincingness; and by Leonardo da Vinci, who by means of *sfumato* is able to melt distant mountains into the sky, and so achieves the most complete unity of all.

Leonardo, like Uccello and Piero, was to consider geometry the

marrow of painting, and all his major works have a firm geometrical basis. But he made several important innovations, chief of which is the rendering of effects through contrasts of light and shade. As a youth he painted a shield with a fire-breathing dragon and set it on an easel with the window partly shaded and a single ray of light falling on the dragon, so effective an illusion that Leonardo's father took the dragon for a living creature. But in his serious paintings Leonardo reserved darkness for caves, as in the two versions of *The Virgin of the Rocks*, and light for spiritual goodness, and here he seems to be applying ideas learned in Lorenzo's circle. One of Plato's preferred images is the contrast between light and darkness as symbols of wisdom or goodness and ignorance or evil, while his myth of the cave in the fifth book of *The Republic* compares the life of sense-perception to a puppet-show seen in shadow on a cave wall.

During his early years in Florence Leonardo undertook one major extant work, an *Adoration of the Magi*, commissioned in 1481 by the monks of S. Donato. This subject had become popular owing to the interpretation placed on it by the Platonic Academy. The Magi's arrival in Bethlehem symbolized the convergence of Jewish revelation and the astral wisdom of Chaldaea, which, according to Ficino, have an underlying concordance with Christianity. The Academy, with its ecumenical aims, could claim to be working for a new and similar Epiphany, and Leonardo's painting is therefore not only a record of a historical event but also a form of prophecy.

Traditionally, the Magi were rendered in sumptuous, richly coloured robes, and sometimes one wore a pointed hat with the brim turned sharply up behind, similar to the hat worn at the Council of Florence by Emperor John Palaeologus. Leonardo disdains these obvious effects and renders the scene through contrasts of light and darkness. As he bends humbly before the Christ-child, the eyes of the aged king are dazzled with light; the golden glow that had formed the background of Byzantine pictures now radiates from the holy figures themselves. As for the position of the Magi, and of sixty-three other persons who crowd the panel, they appear to be grouped at random. All seem to gather 'naturally' round the Mother and Child. But Leonardo's study in perspective for the *Adoration* shows with what careful artistry this apparently 'natural' effect is

achieved. He divides the ground into rectilinear segments and marks each building like graph paper, so that the position of the buildings and figures in space will be mathematically correct and impart to the picture its solid geometrical basis: a triangle inscribed in the arc of a circle, with four verticals to furnish stability.

Leonardo left the *Adoration* far from finished. His contract called for completion in thirty months, but many of the figures remain shadowy and almost no colour has been put in. Two factors may well have played a part in this. First, the Academy attached supreme importance to the initial stages of any work of art, the inspired sketch which the artist executes under the influence of what Plato terms the 'divine fury'. It is then that the painter or poet experiences the exquisite moment of rapture which Landino likens to Ganymede being seized by Jupiter in the form of an eagle, a moment comparable to the ecstasy of the mystic, the prophet and the lover. The later stages, because they do not call for inspiration, were held in correspondingly low esteem by the Academy. The second factor is related to the first. In 1479, two years before Leonardo began his *Adoration*, a Flemish *Adoration of the Shepherds* arrived for the church of S. Egidio, having been commissioned from Hugo van der Goes by Tommaso Portinari, director of the Medici Bank's Bruges branch. The picture created a sensation, because every feature of foreground and background, from the ears of wheat to the shepherds on the distant hill, was painted colourfully and in meticulous detail. Though some Florentine artists, notably Domenico Ghirlandaio and Filippino Lippi, admired and on occasion imitated van der Goes's descriptive style, the leading artistic thinkers found it lacking in intellectual marrow. Michelangelo complained that Flemish art possesses 'neither symmetry nor proportion'—in other words, no firm geometrical basis—'. . . it aims at rendering minutely many things at the same time, of which a single one would have sufficed to call forth a man's whole application.' This opinion Leonardo evidently shared, for in his *Trattato* he expressly warns against compositions that are too 'finished', that paralyse the movement of the mind. At any rate, in the *Adoration* his rejection of the descriptive style is total and, one may feel, justified, for the result admirably enhances the mystery— in a Christian sense—of what is taking place.

Mystery in a more general sense, whether of style or subject, was, as we have seen, a quality much esteemed by the Academy. In a passage of his *Apologia* Pico points to sphinxes carved on Egyptian temples as an example of how 'mystical dogmas are to be kept from the profanation of the uninitiated by the devious knots of riddles'. In Leonardo's *Virgin of the Rocks*, probably conceived in Florence though painted in Milan, the angel crouches in the posture of a sphinx, pointing at the child Jesus. The angel here has a dual role: guardian of mysteries but also representative of Egyptian, forerunner of Christian, wisdom. Pico's reference to knots is interesting, for Leonardo is known to have spent a great deal of time making patterns out of series of knots, one of which contained in the centre the words: *Leonardus Vinci Academia:* further evidence of that predilection for the complex, the enigmatic and the mysterious which appears also in Leonardo's mirror-writing and, most notably of all, in his introduction to Western painting of the smile.

The smile had been one of the distinctive features of certain Etruscan bronzes, before disappearing with the Roman conquest in the third century B.C. From time to time Etruscan works were turned up by ploughshares, and an Etruscan red-figure vase-painting provided the subject of Antonio Pollaiuolo's fresco of dancing nudes in the Torre del Gallo. Perhaps some gay Etruscan funeral bronze was Leonardo's source for the smile, though it is equally possible that he drew on a Gothic smiling Virgin. At any rate, the form he gave it is all his own. Just as he will draw a finger pointing at something outside the picture, for ever unknown to the viewer, so Leonardo imparts to the smile an obliqueness whereby the person smiling appears to respond to some secret, also for ever unknown to the viewer. When the subject is a secular one, as in the portraits of Cecilia Gallerani and Mona Lisa, the combination of mystery, beauty and timelessness can induce in the spectator an overwhelming impression of enchantment: the door is then opened to aestheticism and art as a substitute for religion.

But this lies in the future. During the fifteenth century Florentine painters depicted preponderantly religious and moral subjects with techniques learned from classical texts, the most important, as we have seen, being Vitruvius's statements about perspective and pro-

portion, and Plato's belief that mathematics is the key to the cosmos. But Florentines also borrowed directly and repeatedly from classical works of art, even in their religious paintings. Michelangelo's round painting of the *Holy Family*, commissioned for the wedding of Agnolo Doni and Maddalena Strozzi, borrows from one of the roundels in the Medici palace courtyard, themselves enlargements of Roman gems: a Faun supports the young Dionysius with arm raised behind his back in just such a gesture as Michelangelo lends to Mary. In a quite different but no less inspired mood Filippino Lippi, when called to depict Egyptian revellers in *Worship of the bull-god Apis*, took as his model maenads and dancers from a Bacchic relief, adding three turbans and a horn as used by Roman legionaries.

By such borrowings Florentines enriched their art with new themes and gestures. Their example was imitated, with very different results, by painters elsewhere in Italy, and a glance at one of them may throw light on the distinctiveness of Florentine painting. Andrea Mantegna, who was born near Vicenza about 1431 and studied in Padua under Francesco Squarcione, introduced into his painting inscribed arches, columns, Roman helmets, corselets, buskins and swords; banners, trophies, temple ornaments, mantles and togas. Mantegna went to much trouble to make them authentic. He belonged to a club of antiquaries and a letter dated 1464 describes him sailing with fellow-members along the west shore of Lake Garda to copy Roman inscriptions in a temple of Diana. Mantegna's arches in the St James frescoes bear authentic Roman inscriptions, whereas a Roman arch in a Florentine painting will not necessarily do so: for example, in Botticelli's *Punishment of Korah, Dathan and Abiron*, the arch bears a moral message referring to Aaron's priestly vocation. Mantegna's painstaking authenticity is admirable in itself, but on many of his pictures it lies heavily. All too often one senses an archæologist, even a pedant, and a keener interest in the correct fluting of a column than in the bone structure of the human figure.

Again, the disciplined legions were an essential element of Roman power and Mantegna does well to depict them, but more than once they betray his own harsh temperament, and he seems to exult in a world shuddering under the tread of Roman soldiery. In short,

Mantegna, admirable painter though he is, finds in the classical world confirmation of his own dark view of human nature, whereas the Florentines find there only life-enhancing qualities: joy, beauty and energy. These are the hall-marks of their painting whenever they served Florentine patrons. Outside Florence they could go astray, as for example Paolo Uccello, when commissioned by Federigo of Urbino to paint the legend of the *Profanation of the Host*, a crude, anti-Semitic story of blasphemy and bloodshed which reflects the tastes of one whose job in life was making war. By contrast, Piero de' Medici's agent in Flanders turned down the offer of some fine tapestries precisely because they included scenes of dead bodies. No Florentine could have imagined the *Pietà* painted by Cosimo Tura of Ferrara, where Christ and his weeping mother are watched ironically from a tree by a baboon, or the lovely drawing of the *Annunciation* by the foremost Venetian of his day, Jacopo Bellini, where the three small figures are almost lost in a palace of maze-like intricacy, like Venetians themselves in their police state. In Tuscan painting the mood is positive and man is never at the mercy of his surroundings: even geometry is used to enlarge, not restrict, his freedom and *virtus*.

During the first six decades of the fifteenth century Florentine painters had been concerned with perspective; in the last four they were to be concerned with what may be termed perspective in time. Instead of tackling problems in geometry, they tackle problems in history and myth. They people their pictures with figures from the classical past, with gods and goddesses, with demi-gods, heroes and nymphs. Yet the two perspectives are not unrelated: both are forms of a single quest for truth.

Florentine interest in such subjects was prompted by a Roman work on painting entitled the *Imagines* by Flavius Philostratus, a third-century native of Lemnos, and by the surviving part of another book with the same title by Philostratus the Younger, his grandson. Both list and describe many subjects of actual classical paintings. Some did not appeal to Florentine taste and were therefore ignored: for example, the sufferings of Philoctetes, Hercules and the pigmies, Pasiphae's love for the bull. Others, such as a fairly detailed des-

cription of centaur families, including female centaurs nursing their young, were unsuitable as main subjects but appear in a subordinate role: for instance, as bas-reliefs in one of Botticelli's pictures. The most important subject listed in the two *Imagines* is Hercules accomplishing his Labours or other exploits. Philostratus the Younger gives a detailed description of a picture representing the demi-god crushing Antæus: 'pressing his forearm against the pit of Antæus's stomach, which is now flabby and gasping, he squeezes out his breath and slays him by forcing the points of his ribs into his liver'—which Antonio Pollaiuolo seems to have drawn on for his bronze of that subject, while another exploit specifically mentioned is the rescue of Deianira. The Florentines were impressed by these lists and descriptions: Hercules, as we shall see, was to become one of the main themes of their painting, and precisely in those scenes described by the Philostrati.

Other subjects known to have been depicted in antiquity were the *Aphrodite Anadyomene*, the masterpiece of the Greek painter Apelles which Augustus brought to Rome, and the *Calumny* of Apelles, presented to one of the Pharaohs and described in a passage by Lucian. Both subjects were to be adopted by Botticelli, the latter in curious circumstances. Botticelli did not know Lucian's original Greek. He came to the description in the pages of Alberti's *Treatise on Painting*, in which this most far-seeing of Florentines lays down that a painter (who must be well versed in geometry) should aim to give an accurate, three-dimensional representation of the visible world, and then, somewhat paradoxically, goes on to describe suitable subjects, all drawn from classical literature. Not once does Alberti mention a Christian theme, though in 1435 scarcely a single picture of a pagan subject had yet been painted. One of the subjects he lists is the *Calumny* of Apelles, which, according to Lucian represents the conviction and punishment of an innocent victim belatedly vindicated by Repentance and Truth. Lucian is silent as to the appearance of Truth, but describes Repentance as 'weeping and full of shame'. When he came to translate this passage or to transcribe Guarino of Verona's Latin translation, Alberti reversed the situation by saying 'after Repentance, there appeared a young girl, shamefaced and bashful, named Truth': '*pudica et verecunda*.' By

shifting the epithet '*pudica*' to Truth, Alberti evidently imagined Truth as a naked figure akin to Venus Pudica, a type often portrayed by classical sculptors. When Bernardo Rucellai came to Lucian's text around 1493, he actually embodied Alberti's image of Truth in his Italian translation, describing her as '*nuda e pura*', and in this form she appears in Botticelli's picture, perhaps the most authentically classical of all his works, yet in one respect more classical than the classics.

The decision by fervently Christian painters to depict classical deities and demi-gods, notably Venus, Mars and Hercules, is surprising at first sight but appears less so when viewed in context. The classical gods never completely died, even during the Middle Ages. They survived, however, in odd guise. Some were identified with the planets to which they gave their names: on Giotto's campanile Jupiter is shown as a monk, holding chalice and cross, because the planet Jupiter influences the western Christian nations, just as Saturn influences the Indies. Others survived because an edifying interpretation was put upon their deeds: Ceres looking for Proserpina symbolized the Church looking for souls astray. Hercules, as a loose symbol of courage, figured on the Florentine Signoria's official seal. In either form lack of imaginative sympathy and of the historical sense resulted in distortion: a mid-fourteenth century French manuscript shows Hercules brandishing his club, but he is dressed like a knight for the Hundred Years' War in chain-mail, breastplate, shoulderpieces, gauntlets and greaves.

What happened in Florence during the later fifteenth century was that the gods were depicted authentically and restored to their classical setting. The first stage occurred about 1460, when Piero de' Medici commissioned Antonio Pollaiuolo to paint for his house three *Labours of Hercules* larger than life—the rending of the jaws of the Nemean lion, the crushing of Antæus, and the slaying of the Hydra—and to do so from classical sources, literary and visual. As a result, Hercules slips free of his medieval armour to trust in the strength of his semi-divine body, each muscle of which Pollaiuolo renders with the accuracy of one who has himself performed many dissections. Pollaiuolo has investigated and understood the Greeks' notion of a demi-god possessing superhuman strength, and because he in his way is as confident as Hercules he dares to do what

no medieval artist had dared, to depict a pagan demi-god in a classical setting, to turn, undiluted, the classical stream into the course of European painting. True, his Hercules has a secondary meaning for the Florentines, as a figure of their republic, but this symbolism is relegated to the background, and if the Arno appears in one of the three pictures, it in no way disturbs the classical spirit.

The next metamorphosis of a classical god took place under the influence of the Platonic Academy. At a banquet offered by Lorenzo to a visitor in 1469 the discussion of virtue ended with an evocation of Hercules, now become a 'moral' hero, a symbol of reason at grips with vice, who finally climbs Mount Oeta, like the soul at the end of life, in order to attain immortality. Mythology has turned into moral philosophy, of a more sophisticated kind than that current in Martianus Capella's *Nuptiæ* and the medieval commentaries thereon. But this is still not the final stage. According to Marsilio Ficino: 'The form of the first planet we call the god Saturn, of the second Jupiter, and so on. Likewise the idea of fire we call the god Vulcan, of the air Jupiter and Juno, of the sea Neptune, and of the earth Pluto.' Ficino was saying in effect that what the Greeks and Romans called gods and goddesses were merely aspects of the true God, aspects, however, which could provide Christians with valuable insights. This line of thought was amplified by another member of the Academy, Cristoforo Landino, in his annotated edition of Dante's *Comedy*, published in 1481 and printed in no less than ten editions before the end of the century. Dante, he said, was looking in fables and pagan history for the manifestation of a kind of pagan mystery which completes the Christian mystery and must finally agree with it. Landino, and Lorenzo's circle generally, regarded Hercules, Venus and Mars not as idols or inventions now superseded, but as meaningful expressions of eternal truths. These truths had found their highest expression in Christianity, but the earlier figures still retained their validity, some because of their beauty, others because the myths in which they took part conveyed profound truths about the human predicament.

Two paintings by Antonio Pollaiuolo embody a fairly simple stage of this attitude to mythology, which was to reach its highest and most complex form with Botticelli. The subject of the first

painting is the *Rape of Deianira*. Deianira was the lovely daughter of
the god Dionysus by Queen Althæa; she drove a chariot and prac-
tised the art of war. Hercules won her by overthrowing his rival, the
bull-shaped Achelous. After three years of marriage, one day at a
feast Hercules grew angry with the boy Eunomus, who was told
to pour water on his hands and clumsily splashed his legs. Hercules
struck Eunomus so hard that he accidentally killed him. Though for-
given by the boy's family, Hercules decided to pay the due penalty
of exile and went away with Deianira. They came to the river
Evenus, then in full flood, where the centaur Nessus, claiming that
he was the gods' authorized ferryman, offered, for a small sum, to
carry Deianira across the water while Hercules swam. Hercules
agreed, paid Nessus the fare, threw his club and bow over the river
and plunged in. Nessus, however, instead of keeping to his bargain,
galloped off in the opposite direction with Deianira in his arms;
then threw her to the ground and tried to violate her. She screamed
for help, and Hercules, quickly recovering his bow, took careful aim
and pierced Nessus through the breast from half a mile away. The
dying centaur called out to Deianira to take his blood with her, as
it was a sure means of preserving the love of Hercules. The sequel
to this was a double tragedy. Deianira, whom Hercules had asked
for a priestly garment, sent him a robe she had steeped in the blood
of Nessus. The blood contained poison and as soon as Hercules put
on the robe it corroded his flesh. Deianira, on seeing what she had
done, hanged herself, while the dying Hercules ascended Mount
Oeta, raised a pile of wood, on which he placed himself, and ordered
it to be set on fire. When the pile was burning, a cloud came down
from heaven, and amid peals of thunder carried him to Olympus,
where he was honoured with immortality.

Such was the story told by Apollodorus, Ovid and Diodorus
Siculus, and part of which, the rape, had been depicted by Roman
painters. Pollaiuolo, in representing the scene, abridges it, so that
Nessus is shot in mid-flight. This allows him to model Nessus and
Deianira on those scenes of centaurs carrying off nymphs which
adorn sarcophagi in the Campo Santo of Pisa. The symbolism of
his painting also derives in part from the symbolism of the sarcophagi.
Deianira stands for the passionate part of the soul, Hercules for

manly virtue, Nessus for the bestial in man. Hercules errs in allowing Deianira out of his control and although he here retrieves his mistake, later both will pay with their lives. Hercules, however, is to be carried up to Olympus, where he will marry the daughter of the goddess Hera, and this symbolizes the soul's ultimate bliss in Paradise.

The subject of Pollaiuolo's second mythological painting, *Apollo and Daphne*, is again one of the minor classical stories. The god Apollo falls in love with Daphne, a mountain nymph, daughter of the river Peneus in Thessaly, and priestess of Mother Earth. After pursuing the unwilling girl over hill and dale, at last he overtakes her. At the very moment when Apollo's arms encircle her waist, Daphne cries out to Mother Earth, who spirits her away to Crete, leaving in her place a laurel tree, and from the leaves of this tree Apollo makes a wreath to console himself. The myth may originally have been devised to explain the Hellenic capture of Tempe, where the goddess Daphoene was worshipped by a college of laurel-chewing Maenads, the suppression of the college and the transfer to the Pythoness at Apollo's Delphic shrine of the practice of chewing laurel-leaves in order to induce trance. But the Greeks and Romans of classical times were indifferent to the myth's ætiological purpose, if any, and treated it as a touching, dramatic story, nothing more.

Pollaiuolo, in his painting, shows Daphne at the moment of metamorphosis: Apollo is clasping her waist, and her arms, raised partly in a last effort to escape, partly in supplication of Mother Earth, have already become branches of a laurel tree. What can this picture have meant to fifteenth-century Florentines? Two things, it would seem. From the point of view of Daphne the priestess, her deliverance is an answer to prayer, and as such a pagan prefiguring of a fundamental Christian doctrine. From the point of view of Apollo, god of prophecy, song and music, leader of the Muses, his love is thwarted but not fruitless, since he is left with the laurel, symbol of poetry, with which he binds his brow. In this sense the picture conveys Marsilio Ficino's dictum that love is the basis and inspiration of all the arts, and conveys it in a form that touches us as mere argument never could.

As the Academy developed its own highly individual and sophisticated æsthetics, it became desirable not only to reproduce but also

to adapt classical myth in order to emphasize this or that favourite point. Sometimes virtually a new myth was created, difficult of decipherment. An example is seen in a picture by Luca Signorelli, who arrived in Florence from Cortona during the 1480's in order to study the works of Florentine masters. According to Vasari, he painted two pictures for Lorenzo de' Medici, one a Madonna with prophets; prophecy, as we have seen, being much in vogue in Florence. The second Vasari describes as 'nude figures of the gods', and more than that we are not told. If the painting known as *The Court of Pan* is the painting described by Vasari, its subject is un-precedented and nothing like it again appears in Signorelli's work: it was almost certainly suggested by Lorenzo or one of his circle, just as Poliziano suggested to Michelangelo the *Battle of the Centaurs*. At the centre of the life-size canvas sits a goat-legged figure who is clearly the god Pan. His eyes are fixed longingly on a female figure, doubtless a nymph or goddess, who in turn gazes at a young reclining male. Both are making music on long reed pipes, while another young male dances before Pan and also plays a pipe. An older man seeks to turn Pan's loving gaze in the direction of an aged man leaning on a stick and watching the scene sadly. In the background are two female figures, one of them seated, hanging her head, her eyes downcast.

First, the choice of Pan as a subject. During the first half of the 'eighties a hostile Pope, the bad faith of the King of Naples, ceaseless rivalry between the Italian states and intermittent war had disgusted Lorenzo and his circle with political life, from which they sought an escape in rural pleasures and the writing of eclogues based on Theocritus and Virgil, some in celebration of Pan, the god of flocks and shepherds who prefers to live in Arcadia rather than among the Olympians. From his fondness for hunting, music and pretty girls Lorenzo was sometimes addressed as Pan, perhaps jokingly at first and certainly in no adulatory spirit, for Pan differs from the towering Olympians: he has an easy-going, fun-loving nature and is the only god to have died in our time. Whereas classical artists depict Pan as an ugly, pug-nosed and bearded creature, Signorelli, depicts him as a well-built man and, following Servius's commentary on Virgil's second eclogue, horned with the crescent moon. If not

simply conforming to Florentine taste, which rejected the monstrous, Signorelli doubtless wished to stress the link between Pan and Lorenzo.

Marriage trays and chests were occasionally decorated with nude figures of Venus, but Signorelli's is probably the first painting since classical times—certainly one of the first—to show a nude female other than Eve. But the nudity of the figures, far from being caprice or invention, follows strictly from a passage in Ovid's *Fasti*. Hercules and Omphale, says Ovid, spent one night in a grotto, and before going to sleep on separate couches it amused them to change clothes. Pan, smitten with love for Omphale, crept into the grotto and found what he thought was Omphale's couch, because the sleeper was clad in silk. With trembling hands he untucked the bed-clothes from the bottom of the bed and began to wriggle in, but Hercules awoke and, drawing up one foot, kicked the intruder across the grotto. Lights were brought and Hercules and Omphale laughed until they cried to see Pan sprawled in a corner, rubbing his bruises. Since then Pan has detested clothes and summons his votaries naked to his rites.

It is from another of Ovid's poems, the *Metamorphoses*, that Signorelli derives the key elements of his picture. Pan fell in love, says Ovid, with a chaste Arcadian nymph named Syrinx. He pursued her a long day's journey from Mount Lycaeum to the river Ladon and here, in response to her own prayer, she was changed into a reed. Since he could not distinguish her from among all the rest, Pan cut several reeds at random, and made them into the first musical instrument, the pan-pipe. So far the myth resembles that of Apollo and Daphne, but it has deeper overtones. Originally Pan had possessed the art of prophecy, but one day Apollo wheedled it from him. In pursuing Syrinx Pan is also pursuing prophetic power, for this is an attribute belonging to nymphs of spring and stream, and one they convey to those who drink of their waters.

All these elements combine in Signorelli's picture. The nude female holding a reed pipe is clearly Syrinx in her dual aspect as nymph and reed. Pan, symbolizing Lorenzo, gazes at her with the longing of unfulfilled love, while Syrinx has eyes only for the reclining figure, evidently the river god Ladon, with whom as a reed she is now merged. The nude dancer playing the reed flute

represents Pan in his other aspect, as master of music, song and in-spired poetry, those arts which derive from unfulfilled love. The seated Pan is too forlorn to heed the flute and its hopeful message, but the figure beside him, by indicating the aged man, is calling his attention to the passing of time, something which Pan, being mortal, can well realize. The apt text seems to be Lorenzo's own poem, *Apollo and Pan*, where Pan pleads with Syrinx to recall to him the poetry of the gods: '*ninfa, ricorda a me che versi foro cantati dalli dei.*' In his left hand Pan holds the pipe which owes its origin to the meta-morphosis of Syrinx. The picture's message, then, would seem to be this. Since life is short, let Pan—or Lorenzo—cease to pine for his lost nymph. Let him rather play his pipe, sing and dance, for through his love he has rediscovered prophecy, that is, God-given inspiration. The picture's original title is unknown, but it might well be called *An Allegory of Inspiration*.

The painting of myth was to find its supreme exponent in Alessandro Botticelli. He was born in Florence in 1444 or the begin-ning of 1445, the youngest of a tanner's seven children, and received a slightly better education than most painters of his day, for at thirteen, according to a tax-return, he was still at his books, and in poor health. He trained as a painter under Filippo Lippi. The self-portrait in his *Adoration* of 1475 shows a good-looking man, with a long, sensitive face, big, deep-set eyes, sensuous lips and rather heavy jaw. He became famous in his lifetime but spent money freely, and in later life was to become hard up. Few painters have been so sen-sitive to feminine beauty, but Botticelli, it seems, was shy with women. One day a prominent citizen, Tommaso Soderini, urged him to take a wife, and Botticelli replied by recounting a dream he had had. 'I dreamed I had married, and that caused me so much pain that I woke up. I was so frightened of dreaming the same dream again that I spent the whole night walking round Florence like a madman, so as not to sleep.' Soderini concluded that 'this was not the soil to plant a vine'.

Botticelli had an inquiring and deeply religious turn of mind. He was a student of Dante and made a series of drawings to illustrate the *Comedy*. Like Brunelleschi and Leonardo, he felt the need to play tricks as a relief from tension, and the two described by Vasari are

both of a religious character. On the first occasion, for a joke, he denounced a friend to the parish priest as an Epicurean, one who denied the immortality of the soul. Another time, when a pupil of his had painted a *Madonna and Angels*, Botticelli made eight red paper hats like Florentine citizens' caps and stuck them with wax on the angels' heads, mystifying his pupil, who thought he had painted them like that in a moment of aberration. The majority of Botticelli's early works are of religious subjects and reveal deep piety, particularly the Madonnas. In 1481 he was summoned to Rome to decorate the Sistine Chapel with Biblical scenes and a very dull series of Popes. He might well have continued to paint in this vein had he not at the age of thirty-seven come into Lorenzo's circle. Probably for Lorenzo, he painted the portraits of Giuliano and of Clarice; and in or about 1482 he decorated Lorenzo's villa of Spedaletti, near Volterra, with 'an image of Vulcan, with nude figures hammering out lightning for Jupiter'. These would have been male figures. Botticelli's later transition to painting the female nude probably occurred in Lorenzo's circle, independently of Signorelli. Because of his mastery of line Botticelli was known as 'Apelles' or 'another Apelles', just as Ficino was known as 'another Plato', and he took his cue from what was known of the Greek painter. Now in the passage of Pliny's *Natural History* already mentioned it is expressly stated that Apelles falls in love with Pankaste while portraying her, at Alexander's request, in the nude. It seems likely that this incident provided the necessary stimulus to Botticelli and his patrons.

What is certain is that Lorenzo's circle turned Botticelli from sad Madonnas to classical gods and goddesses. For Lorenzo he painted *Pallas and the Centaur*, as well as a life-size *Pallas* which has not survived the *festa* it apparently served to decorate, while his three masterpieces in this vein, all of them depicting Venus, were painted for close connections of Lorenzo's: one for a member of the Vespucci family and two for his second cousin who was also his ward and later became his political opponent: Lorenzo di Pierfrancesco de' Medici.

Venus had survived during the Middle Ages by being identified with the planet of that name. A figure personifying Venus, the Third Heaven, rode in Florentine carnival processions, and Filarete

wished his ideal city founded on 15 April 1460, 'with Venus in the ascendant', for her influence engenders joy and grace. With the rediscovery of Lucretius, Venus had also come to be considered the great generative and pacifying force in nature, alone capable of neutralizing the destructive principle symbolized by Mars, and since, according to Statius, the union of Venus and Mars results in universal harmony, she is often invoked by Ficino and the Academy as a symbol of concord.

The astrological, cosmic and metaphysical aspects of the goddess are all present in Botticelli's *Mars and Venus*. Wearing a long white dress braided with fillets of golden embroidery, Venus reclines at length on the grass, while opposite her lies Mars, asleep. Sporting baby satyrs creep into Mars's breastplate and try to shoulder his lance. These conform to a description by Lucian of an actual Greek painting. Botticelli is aiming at authenticity but also, as a typical peace-loving Florentine, he is poking gentle fun at martial pursuits. The unusual position in which he places Mars and Venus is an attempt to achieve another kind of truth. According to Ficino, 'Venus, when in conjunction with Mars, in opposition to him, or watching from sextile or trine aspect, as we say, often checks his malignance . . .' Now Botticelli represents Mars and Venus precisely in one of these positions—in trine, that is, at an angle of about 120 degrees. Accuracy on this point mattered, because Ficino considers that 'a work of art represents the invisible face of the astral powers, and so becomes a talisman with occult radiance'. He speaks of the efficacy of an image of Venus, clad in yellow or white and carrying fruit or flowers, executed 'at the hour of Venus, under her ascendant in the first aspect of the Scales, the Fishes or the Bull'. Such a talisman, thought Ficino, by giving visible form to the planet it represents—the planet itself being one of the expressions of God's omnipotence—could ensure bodily harmony and happiness. It would have been quite in the spirit of the times if Botticelli had begun or completed his *Mars and Venus* at the correct astrological moment—the foundation stone of the Palazzo Strozzi was laid 'as the sun came over the hills' on an auspicious day in the strong sign of the Lion—but whether or not he did so, the picture certainly possessed for Botticelli's contemporaries an astrological significance in addition to its other

meanings, and this would have ensured it a warm welcome in Lorenzo's circle, who considered that a good painting should embody truths of several different kinds and possess a cryptic or mysterious quality.

Ficino, always seeking to merge one concept in another, somewhat confusingly speaks of Venus now as Humanity, now as Love and Charity, now as the mother of Grace, Beauty and Faith. In a passage of Plotinus's *Enneads* which Ficino translated and made his own, it is written: 'If the soul is the mother of Love, then Venus is identical with the soul, and Amor [Cupid] is the soul's energy.' In yet another passage Ficino says that there are actually two Venuses, not one, in the soul: 'The heavenly Venus, by its own intelligence, tries to reproduce in itself the most exact beauty of the divine; the natural, by the fertility of the divine seeds, tries to prepare in earthly matter the beauty divinely conceived in itself.' Like Lucretius's Venus Genetrix, natural Venus gives life and shape to the things in nature and thereby makes Heavenly Beauty accessible to men.

Natural Venus in this sense would seem to be the central figure of Botticelli's *Primavera*, though doubtless other aspects of the goddess were also in his mind. Above hovers her son Cupid, blindfolded and about to fire an arrow. To the left are her companions, or daughters, the Three Graces. Whatever their names may be—Ficino calls them Grace, Beauty and Faith, Pico Beauty, Love and Joy— the Graces signify the trinitarian principle at work in the universe. Further left is Mercury, revealer and interpreter of hermetic truth and also, as a planetary influence, protector and defender of the Christian faith. On the extreme right a figure who may be Zephyr, the wind of spring, pursues and catches a nymph. As Zephyr touches her, flowers come out of her mouth, and she is transformed into Flora, the herald of spring—yet another example of that merging of one thing with another which marks the Academy's aims and peculiar logic.

The immediate subject of Botticelli's picture is indeed Spring, the season of love. Venus is with child, a warm wind stirs flowers to life, the Graces dance joyfully, and one of them, touched by Cupid, turns in the direction of Mercury. But this conception of

spring is the reverse of pagan. Venus extends her right hand to modulate the Graces' dance, and Mercury is not just a handsome youth, but the revealer of truth. He is touching barely visible clouds lightly with his staff in order to reveal the mysteries beyond, symbolized by imperishable golden apples. The deeper subject of the *Primavera* is this: while spring stirs the world to beauty, Venus uses love to turn the human heart to truths divine.

The groups divide easily into three, in accordance with neoPlatonic teaching that all unity has a triple aspect. There are nine figures altogether, for the same reason that nine guests dined at the Academy, this triple trinity being considered a perfect number. As in his *Mars and Venus*, Botticelli has tried to paint in the way he believes the Romans painted. He makes his Graces tall in accordance with the poet Claudian's description, 'Jove's tall daughters', and clothes them in the loose transparent garments described by Horace and Seneca— *solutaque ac perlucida veste*. Their form owes much to classical statues of Venus, the rhythm of their dance to classical reliefs. But in vain did Botticelli seek authenticity. Neither the Romans nor the Greeks would have understood the implications of the *Primavera*. For them Aphrodite, or Venus, was a goddess who actually existed, whereas Botticelli could only imagine that she existed. Lacking the definiteness of actuality, she has become a subject for 'higher meaning', a unique complex synthesis of Plato, classical myth and a tolerant kind of Christianity.

The fact is that in such paintings as the *Primavera*, for all their borrowings, Botticelli reveals himself as an inventor, one of the greatest in fifteenth-century Florence. He discovers new subjects for painting and depicts them with all the fervour formerly reserved for strictly devotional works of art. Though not himself a secular painter, he opens to secular art man's deepest emotions and highest aspirations, and this amounts to a change not of degree but of kind. He proves the power of style to confer a more than human value on earthly objects, and thereby not only the nymph of spring, but man himself undergoes a metamorphosis.

Perhaps a decade after the *Primavera* Botticelli painted for the same patron, Lorenzo di Pierfrancesco de' Medici, the *Birth of Venus*. In an unfinished poem written in 1475 to celebrate a tournament

given by Lorenzo de' Medici's brother, Giuliano, Poliziano had described how Venus is born in the stormy Aegean and driven ashore by winds, where she is welcomed by three nymphs, who enfold her in a starry cloak. Poliziano drew on a passage in the Homeric hymns which had also been used by Pliny. The poem provided Botticelli with a literary basis for his painting, and the desired classical authenticity. But there is much more to it than that.

It is necessary first to recall certain facts familiar to the Florentines. They knew well the writings of the early Fathers, who were so bold in pointing to pagan anticipations of Christianity. As analogies to the sonship of Christ Justin, in the second century, does not hesitate to cite Mercury, 'who you [pagans] say is the angelic word of God', and Perseus, whom Zeus had begotten on Danaë in a shower of gold. Venus too could provide analogies of a similar sort, particularly if Ficino's distinction were observed between her two aspects: the heavenly and the natural. Furthermore, the Florentines knew that even apparently unedifying scenes were amenable to a Christian interpretation. The drunkenness of Noah, for example, which Uccello and Ghiberti depicted and Lorenzo de' Medici put into verse: Noah's stumbling and nakedness are a figure of Christ, helpless at the Passion and stripped of his garments while, later, the covering of Noah's nakedness by Shem and Japheth symbolizes conversion, a return to right living.

It was well known to the Florentines that Venus's symbol is the dove. Classical reliefs of Venus with the dove above her head had almost certainly been found, for Filarete describes a relief of this kind in his ideal city: 'Venus was nude and very beautiful. On her head she had a garland of myrtle with a dove above it.' Such a work would immediately have evoked the only rendering of a dove in New Testament iconography: the one above the head of Christ in the Baptism. One final point has to be recalled. Another of Venus's symbols, the scallop shell, had been represented on Roman gravestones, and later on Christian gravestones, where the symbol of the rising goddess becomes the symbol of the rising soul. Thence the scallop shell had become a recognized feature of Christian painting: Botticelli's master, Filippo Lippi, introduces it in an alcove behind Mary's head in a *Madonna and Child*, and Botticelli himself uses

the scallop shell above Mary's throne in the altar-piece of S. Barnaba. In both works, it is not just an ornament but a precise Christian symbol of spiritual birth.

Against such a background as this Botticelli painted his *Birth of Venus*. The goddess stands on the edge of an upturned scallop shell. To the left two winged zephyrs scatter flowers and blow the goddess and her shell to land. Venus is about to step ashore, where, beside orange trees, a nymph waits ready to clothe her in a flowered mantle.

The disposition closely resembles that in a Baptism of Christ: a central nude or nearly nude figure against a background of water, angels to the left, an attendant to the right, holding garments. But the resemblance is more than formal. Zephyrs happen to be the nearest classical equivalent of angels; and here they are so closely linked as to merge into one, making altogether a trinity of figures. The scallop shell, Venus's symbol but also a Christian motif, confirms that the picture is a meeting-point of two worlds.

The picture shows natural, sea-born Venus rising from the water, as Christ had once risen from the Jordan, and being given a garment to clothe her nakedness, as formerly Noah was clothed by his sons, under the influence of zephyrs, the classical equivalent of angels. Once clothed, the goddess will assume a new role, that of heavenly Venus. Her expression is wistful because she is at a turning-point. Natural love, purified, is about to become Christian love, *eros* to become *agape*.

If this interpretation is near the mark, in addition to its assured position as a supreme work of art the *Birth of Venus* also illustrates the ideal of Florentine civilization: the setting of what was best in the classical world within a Christian framework, the amalgamation with Christianity of the highest pagan beliefs about love. If the faces of his Venuses are almost interchangeable with those of his Madonnas, that is because Botticelli was painting in the belief that love purified, whatever its religious context, could lead men to truth. It is a generous belief; it puts its trust in the spirit, not in the letter, and perhaps it is over-optimistic about the behaviour of love left to itself: Botticelli might have been shocked to learn of the actual dark rites performed for the original Venus, Astarte. Yet like all generous beliefs,

this one was capable of abuse, and the paradox of the *Birth of Venus* is that when Savonarola came to attack it and to demand the destruction of Venus altogether, he travestied, without realizing it, that trust in the spirit which Botticelli's picture so beautifully celebrates.

CHAPTER II

Magnificent Lorenzo

FOR ALL THEIR EXCELLENCE, the fine arts in Florence were means to an end, not an end in themselves as we, in retrospect, tend to see them. They formed only one part—though an important part, given the Florentines' visual sense—of a whole way of life. They conveyed truths, recalled ideals and sometimes stirred citizens to patriotic action. But it is in the lives of individual men that the secret of Florentine civilization is to be found, and its value judged. Of these the most brilliant, in the second half of the century, was that of Lorenzo de' Medici.

The eldest child of Piero de' Medici and Lucrezia Tornabuoni was born on the first day of January, 1449. We first hear of him at the age of six, dressed in French-style clothes by his father, who admired the finery of northern courts, in order to visit Duke Jean of Anjou, then residing in Florence: 'The Duke received him with delight, as if he had been a little Frenchman fresh from France ... But Lorenzo's serious deportment, so unlike the French character, revealed his individuality.' The serious boy was educated at home by Gentile Becchi, later ambassador to France and a fine speaker, of whom Charles VIII punned: *'Je n'ai jamais entendu meilleur bec'*: it was doubtless from him that Lorenzo learned to speak and write with clarity, force and grace. At ten he was quickly learning the verses Becchi set him and then teaching them to his five-year-old brother Giuliano. At thirteen he could read—and, says Becchi, enjoy—the fables of Ovid and an easy universal history by Justinus. He went on to Italian literature under Cristoforo Landino, Greek under Argyropoulos, and Platonic philosophy under Ficino, receiving in short the best classical education then available. Nor was religion neglected. His pious mother, to whom he was devoted, sent him to meetings

of the confraternity of S. Paolo, where he kept vigil before feast-days and distributed alms to the poor.

This son of an invalid father and delicate mother possessed a splendid physique. Lorenzo had broad shoulders, strong muscles and a deep athlete's chest. Vigour is written all over his head. Its best points are thick dark hair and dark intelligent eyes. His jaw jutted forward, his underlip tended to protrude, and he had a long flattened nose that lacked all sense of smell, a loss that Lorenzo gaily shrugged off, saying that he was grateful to nature, since unpleasant smells were commoner than pleasant ones.

With this powerful body went an exceptional zest for the purely physical side of life. Lorenzo enjoyed playing *calcio* and *pallone*, he enjoyed hunting. At the age of nineteen he gave a tournament in Piazza S. Croce and says modestly: 'Although I was not a great fighter, nor even a very strong hitter, I won the prize, a helmet of inlaid silver, crested with a figure of Mars.' He loved horses and he loved hunting-dogs, filling one whole stanza of a poem with the names of his favourites. He seems to have possessed that purely physical attraction—a mixture of strength and trustingness—to which animals respond. We are told that his racehorse, Morello, was so attached to him that it showed signs of illness when he did not feed it with his own hand, and testified its joy at his approach by stamping and loud neighing.

Lorenzo possessed what Ficino calls a 'naturally joyful nature'. Riding with friends the thirty miles to S. Miniato al Tedesco, Lorenzo sang the whole distance and, it appears, kept everyone in good spirits. At carnival he took a lead in the dancing, masquerading, horse-play and singing of bawdy songs. He composed some prodigiously bawdy ones himself, giving a double meaning to various familiar handicrafts, such as beating copper, grafting vines and baking sweet cakes. For Lorenzo had a strong earthy streak; he enjoyed riotous drinking sessions and down to earth joking. One day he saw a student with a squint returning from a university lecture. Turning to his companions, Lorenzo remarked that this was surely the best scholar in the class. Why? Because he could read two pages of a book simultaneously. Another time, at an inn, when he and Matteo Franco were poured a flask of palpably new wine, which

the inn-keeper asserted was very old: 'Yes, it's attained second child-hood.' In *La Nencia di Barberino* Lorenzo recaptures a jolly bucolic spirit lost since Theocritus and can smile at those very love poems which, in another mood, he could pour forth with tearful sincerity: Nencia has skin pale as a tallow candle, her teeth are whiter than a horse's, her glance can pierce a wall, she dances like a nanny-goat and spins round like a mill-wheel. Nor was Lorenzo above playing practical jokes. One evening when a troublesome parasitical doctor named Maestro Manente had drunk too much, Lorenzo arranged for him to be carried off by two men in disguise, shut up in the country and given out for dead. Later, when the supposed dead man knocked at the door, his wife took him for a ghost and would not let him in.

At table Lorenzo and his friends would suggest to Luigi Pulci new jokes for his burlesque poem, the *Morgante Maggiore*, and Pulci is doubtless echoing the table-talk when he pokes fun at Marsilio Ficino: rising to God on the wings of intelligence and love, ragout, eels, kidneys, tripe, perry, well-cooked *migliaccio*, tart, which is the mother of tartlet, and liver, which comes single, double or triple. In another canto there is a dig at Pico. The episode of Margutte, Pulci says, is very esoteric: it was found in Egypt in an ancient Persian manuscript by a certain 'Alfamenonne'; it was translated successively into Arabic, Chaldaean, Sorian, Greek, Hebrew and Latin. Here at last it is in Italian. Pulci then produces a slapstick episode about an atheist giant.

If Lorenzo liked to joke and fool, at heart he was a serious person, just as he is described in his seventh year. He had inherited from his mother a poet's sensibility, but whereas Lucrezia had been stirred only by religion, her homely son responded to a vast range of beauty, including women, classical myths, streams and woods, a day's falconry, or a winter scene, when the bay, the myrtle and the prickly juniper shine among the bare trees. He wrote good poetry on all these themes and also several deeply felt religious poems called lauds, which were hymns sung to popular, even dance tunes, before a picture of the Madonna on Saturday night. Lorenzo was in two minds whether to write in the cultivated language, classical Latin, or in Italian. Finally he chose the latter. He pointed out that because the

vernacular was 'common' to all Italy, that did not detract from its dignity. What mattered in a language was that it should be copious and suited to express the writer's meaning. Italian, he said, might still be in its adolescence, but constant use would bring it to greater perfection. Lorenzo's choice of the vernacular was partly an expression of traditional Medici sympathy with the *popolo minuto*, and its consequences were also partly political. Lorenzo in poetry, Matteo Palmieri and others in prose, enriched the vernacular with words and phrasing from classical Latin and purified its style until the Italian of Tuscany became generally recognized as the best medium of communication then available. By the end of the century even some non-Florentine ambassadors were writing their despatches in Tuscan. One of the main changes in this virtually new language was an increase in abstract words derived from Latin, as in the opening lines of a fine prayer by Lorenzo:

> *O venerando, immense, eterno Lume,*
> *il quale in te medesimo te vedi,*
> *e luce ciò che luce nel tuo Nume!*[1]

Through most of Lorenzo's poems run classical allusions. In one of his sonnets to Ginevra de' Benci (the lady who sat to Leonardo) a reference to Lot's wife is strengthened by another to Orpheus and Eurydice, while even his pæan in praise of wine, the *Simposio*, has classical overtones in its title and a fine classical simile:

> *e come Anteo le sue forze reprende*
> *cadendo in terra, come si favella,*
> *la sete mia dal ber sete prende.*[2]

Some of his circle thought Lorenzo a greater poet than Dante and Petrarch because, being a Platonist, he had a deeper insight into the nature of love and reality generally. This was carrying friendship too far. Lorenzo's chief work, his sonnets, are too abstract in conception and language, too idealistic indeed, to be great poetry, while the *Simposio* and carnival songs, endearing and funny though they are, remain minor verse.

[1] O venerable, immense, eternal Light, who seest Thyself in thine own being, and lighteth the splendour that shines in thy Godhead!

[2] And just as in the story Antæus by falling to the ground regains his strength, so I, the more I drink, the thirstier become.

More important than his poetry is the poetical outlook Lorenzo brought to Florence. He had an exceptional capacity for imagining, in any field, the ideal and the perfect. Quite early on he seems to have decided that he wanted to make something fine of his life, to make it, as it were, a well-wrought poem. This was a reasonable ambition because Lorenzo possessed a strong will: it is typical of the man that he preferred writing sonnets precisely because that form gave him most difficulty.

To start with, Lorenzo undertook an impressive range of activities. If we consider only his private life, he found time to run the largest international bank in Europe, to manage four country estates and a town house, to plant botanical gardens at Careggi and mulberry trees at Poggio, to raise a herd of cows which supplied Florence with the cheese formerly imported from Lombardy, to breed racehorses for the *palio*. He looked after his children's education, as a member of the confraternity of Magi carried out charitable work in his parish, read the dialogues of Plato, and added to the Medici collection choice objects of exceptional grace of line: Roman sardonyx vases, a cup with lid of mauve and violet amethyst, a tenth-century Byzantine agate chalice, and a Sassanid beaker in dark sardonyx. He played the lyre, accompanying his own songs on that instrument, and probably also the organ. He possessed a theoretical and practical knowledge of architecture. 'In both private and public buildings', wrote Filippo Redditi, 'we all make use of his inventions and his harmonies. For he has adorned and perfected the theory of architecture with the highest reasons of geometry, so that he takes no mean place among the illustrious geometers of our age.' 'Many majestic structures' were built according to Lorenzo's advice. In his new palazzo Filippo Strozzi planned shops for letting on the ground floor; it was Lorenzo who persuaded Filippo to forget about the shops and the extra income, and to build instead an imposing rusticated façade. In 1491 when a new competition was held for the façade of Florence cathedral Lorenzo submitted one of the twenty-nine entries, which included designs by Verrocchio and Botticelli.

If Lorenzo represents the flowering of the classical ideal of versatility, there is a new panache about what he does which reflects his own self-confidence. Lorenzo felt none of Cosimo's guilt about

ursury and less inferiority towards the past. Whereas Cosimo, we are told, humbly had the name of Nero engraved on one of his antique intaglios, believing that it might once have belonged to that emperor, Lorenzo incised his antique vases with his own name: LAUR. MED. The awareness of a turning-point may be dated to mid-century, when Giannozzo Manetti wrote a little book called *De dignitate et excellentia hominis*, in which he declares that Florentine works such as Brunelleschi's cupola are in no way inferior to Roman temples or even the Pyramids, and Benedetto Accolti, Chancellor of Florence, in his *De præstantia virorum sui ævi* declared that contemporary Florentines, making use of classical wisdom, have equalled and even surpassed the Greeks and Romans. Not all took such an optimistic view, but Lorenzo did, hence his confidence and exhilaration.

But was so much activity a good thing? Lorenzo loved Nature's peace and responded when his friends Ficino and Landino praised the contemplative life. He too longed to discover God quietly in beauty. Yet here he was being trained up by his crippled father to replace him in politics and business, already at seventeen being sent on an embassy to Pisa and Venice. Time and again in his verse Lorenzo returns to his dilemma: 'If amid riches, honour and pleasure I seek Thee, Lord, the more I look the less I find Thee . . . Thou hast planted in my breast a longing for Thee, yet still I fly Thee, never see Thy face.'

Another tension lay in the nature of Lorenzo's vision of the classical past. Where Coluccio had met stern sober citizens like Cicero, where Piero had found gold coins and finely cut intaglios, Lorenzo discovered the gods and goddesses, the nymphs of wood and stream. These innocent happy creatures haunted his imagination and skip through his verse. The highly intelligent Lorenzo longed to get away from money-making and exchange rates to the sort of mindless happiness Bacchus had enjoyed with his wife Ariadne. And so he exhorts himself: '*Chi vuol esser lieto, sia: di doman non c'è certezza.* —Let all be happy who will, None can predict tomorrow.'

Wishing his gifted son to make a marriage useful to Florence, Piero's eye fell on Clarice Orsini, who belonged to one of the two dominant families of Rome, and whose maternal uncle was a cardinal. Lucrezia, sent to inspect Clarice, found her shy and pretty but was

disappointed that she did not have the blonde hair so esteemed in Florence. Clarice's hair was reddish and she had a round face. 'Her bosom I could not see, but it seemed to me of good proportions.' The wedding took place in June 1469 with pageantry, feasting for 1,000 guests and the gift of fifty rings, the value of each being carefully noted down. Clarice was to bear Lorenzo ten children, of whom three boys and four girls would survive infancy, but of the marriage itself Lorenzo's words three years after the ceremony are eloquent enough: 'I, Lorenzo, took to wife Clarice, daughter of Signor Jacopo, or rather she was given to me.'

Clarice's portrait by Botticelli shows a lady with dull eyes, stoop-shouldered, almost limp, wearing a plain brown dress and no jewellery. The shyness Lucrezia noted in her seems rather to have been a form of vanity. She belonged to the old feudal world of castles, quarterings and religious narrowness. Literature and the arts, which Lorenzo could discuss with his mother, were closed worlds to her. She disapproved of Lorenzo's gay humanist friends and of his decision, presently, to resist Pope Sixtus. When her sons reached boyhood, she insisted that they learn not classical Latin but Church Latin from the Psalter, and when their tutor, Poliziano, protested, dismissed him and showed him the door, though Lorenzo promptly arranged for his return to the household if not to his tutorial duties. The climate of Florence suited her no more than its values and she often chose to winter in Rome. The marriage, in short, was neither close nor happy.

Lorenzo had a great capacity for love. His conversation was seasoned with 'the salt of the sea from which Venus arose', and he lived in a circle preoccupied by one idea: perfect love as described by Plato which, in Lorenzo's words, is the surest guarantee of a good life, since all things base and ugly necessarily displease one who is in love. Lorenzo wrote forty-one love sonnets, making much of his pangs and 'slavery', but these were purely literary: in real life his passions were much too strong for a Platonic relationship. First, he had an affair with a young married Florentine lady named Lucrezia Donati. After Lucrezia's death and that of Clarice also, in 1488, Lorenzo fell in love with another Florentine lady, Bartolomea de' Nasi, wife of Donato Benci. He would ride out to spend the night

with her in her villa, returning to Florence before morning. Enemies charged that his ardent love-making to Bartolomea wore him out and shortened his life.

If Lorenzo was unsuited to Platonic love, he made an ideal friend in the Platonic sense. Whenever we hear of Lorenzo, he is in company. His closest friends were poets, artists, and the philosophers Pico della Mirandola and Marsilio Ficino. They discussed, usually in the country, such questions as the nature of happiness, the merits of the active and contemplative lives, the meaning of classical myths; they read poems and discussed newly discovered texts. A comradeship was formed based on learning and the arts, as warm in its way as the old stern comradeship of arms in the Dark Ages. Lorenzo treated his friends with easy informality—at the table there was no set seating and each took his place according to the time of arrival— and won their lasting affection. Some perhaps had reason to flatter in their tributes, but the voice of a non-Florentine, Pico, rings true in the dedication of his *Apologia*: 'Words are too cold to express the warmth of my gratitude—the love, fidelity and respect which your long-tried kindnesses have excited in my breast.'

Friendship went hand in hand with patronage. Already at seventeen Lorenzo was expressing his admiration for Pisistratus of Athens for having rewarded anyone who brought him lines by Homer—'he thus gave perpetual life to Homer, and covered himself in immortal glory and brilliant splendour'. Four years later Lorenzo discovered a youth of sixteen from Montepulciano lodging with his uncle in a poor street on the other side of the Arno, his coat in tatters, toes coming through his shoes, but on his table the first book of the *Iliad* translated into Latin hexameters. Lorenzo read the translation, found it brilliant, and took its precocious author to live in the Palazzo Medici, later giving him a villa of his own. Under the name of Poliziano he became the best poet of his day.

For Poliziano and Pico Lorenzo bought or commissioned a copy of any book they wanted and once said that he would gladly pawn his furniture to get them books. In order to help the Academy, who called Lorenzo 'our patron', he procured manuscripts ranging from mathematical works by Archimedes and Hero of Alexandria to Proclus's commentary on Plato's *Cratylus*; he sent Giovanni Lascaris

to the East, notably to Mt Athos, to bring back 200 Greek manu-
scripts, of which eighty were unknown in Italy, and towards the
end of his life in one year he spent 30,000 florins on research of this
nature. Others who benefited from Lorenzo's financial support
were the three Pulci brothers—all poets—the geographer Francesco
Berlinghieri, Pier Leone the physician, not to mention Michelangelo
whom, we are told, Lorenzo treated 'with respect', though the sculp-
tor was less than half his age. Drama also Lorenzo encouraged. In
1476 he arranged for Giorgio Vespucci's pupils to perform Terence's
Andria in the Palazzo Medici, and he even wrote a play himself,
San Giovanni e Paolo, performed in 1489 with Lorenzo's son in the
cast of thirty-two characters and music by Lorenzo's friend, the
Flemish organist Arrigo Isaac, a play into which with typical zest
Lorenzo packs a banquet, a miraculous cure of leprosy, two con-
versions, several political coups, a military harangue, three appari-
tions, two battles and a perceptive portrait of Julian the Apostate.
Lorenzo was fascinated by Julian, for he too felt the pull both of
Hercules and the pale Galilean. Lorenzo also gave pageants with a
strong dramatic element, the most famous being the *Triumph of
Aemilius Paulus* as described by Plutarch. The pageant is known
from an engraving, and Lorenzo's designer evidently drew on an
authentic relief, such as the Triumph of Titus on the Arch of Titus
in Rome.

Lorenzo's most lasting contribution in the field of patronage was
the re-establishment of a university in Pisa. At the age of twenty-three,
only a year after Cennini had started his printing press, Lorenzo
grasped the chief implications of Gutenberg's discovery: a new
demand for learning and its growing international character. He
proposed to move the faculties of science from Florence to Pisa, to
enlarge them and to establish them as virtually a new university—
the old one had for two centuries ceased to function. Pisa had plenty
of empty houses and, an important port, was easy of access to Ger-
mans, Frenchmen, Englishmen and others. Lorenzo's proposal met
with stiff opposition, for there was a tendency to consider Florence
the only city in Tuscany, and Pisa a conquered no longer prosperous
rival, to be kept down. But Lorenzo got his way, and on 19 Decem-
ber 1472 a decree of the Signoria established the university, with effect

from November 1473. Lorenzo sent his son to study there, and its alumni were to include Galileo.

In 1471 Lorenzo found a notebook containing the sums disbursed by his grandfather and father for charities, taxes, building and patronage. In 37 years they had spent what Lorenzo calls the 'incredible' total of 663,755 florins. 'But I don't regret it', he adds in his *Ricordi*. 'Although many a man would prefer to have part of that money in his purse, I consider it well spent, since it has brought great honour to our State.' This was a generous reaction considering that Florence in Lorenzo's day was no longer the city of easy profits where Cosimo had amassed a fortune. She had passed her economic zenith. The loss of Constantinople and the growth of the English cloth trade had reduced her markets. Moreover, England, France, Germany and other northern countries were required to make increasingly heavy payments to Rome for the now luxurious court of cardinals and Pope; these disturbed the balance of international trade, and meant less foreign exchange for the purchase of Florentine woollen and silk goods. The result was that Lorenzo had less money to spend on patronage than the earlier Medici. Where Cosimo ran up a dozen buildings, Lorenzo could afford only three: a monastery in San Gallo, a villa in Arezzo, and another at Poggio a Caiano.

Yet it was to Lorenzo that the Florentines gave the name Magnificent. The background to the title, unthinkable a century earlier, was the new meaning attached to *virtù*. If a man possessed *virtù*, he owed it to his own efforts and so deserved higher consideration than before. This is reflected in the titles of books—Pico's *On the Dignity of Man*, Manetti's *On the Dignity and Excellence of Man*—and also in day-to-day affairs, where the words 'noble', 'great', 'honourable' and so on were applied not only to superiors but to equals, and even to their intentions: Toscanelli speaks of Columbus's 'magnificent and great desire' to find a westerly route to the Indies. For humanists 'magnificence' also had a precise meaning. Aristotle in his *Ethics* describes it as a virtue, concerned with the appropriate spending of large sums. Like all virtues, he says, magnificence is a form of moderation, lying between extravagance and shabbiness.

In private letters correspondents usually addressed senior partners in the Medici Bank as '*magnifico major mio*', Cosimo and Piero had

sometimes been addressed in the third person as '*La Magnificenza Vostra*', and when he succeeded as head of the bank, Lorenzo was addressed in the same way. The epithet spread to daily speech because in its primary sense it fitted Lorenzo's character. There was an undeniable lavishness about the man's tireless energy, his gaiety, his attitude to friendship, and to public life. When it came to entertaining heads of State or mounting a carnival pageant, he could be counted on not to spare the brocade and gold leaf or the flasks of old Greek wine. Magnificence indeed was directly related to service of the city: hence the acknowledgement on Ficino's *Plotinus*: '*Magnifico sumptu Laurentii patriæ servatoris.*' Lorenzo's magnificence, however, never amounted to mere superabundance of wealth: it was in Aristotle's sense stylish and appropriate spending of limited resources, and might well entail mortgaging two or three hundred acres. Hence it commands a certain respect, as it did among the Florentines, when they spoke admiringly of '*magnifico Lorenzo*'.

It is time to turn to Lorenzo the statesman. When Piero died in 1469, and the dominant group of 700 citizens invited Lorenzo to continue his father's role, Lorenzo accepted 'reluctantly', explaining that only so could he preserve the family fortune. Economic motives certainly played a part in his decision, but there is more to it than that. Lorenzo at heart was a poet. His favourite occupations were to discuss Plato and Theocritus with a few intimates amid the cypresses, to write verse, to feel himself reborn into the past and to recreate the past in the present. But he knew that a life spent like that would be wholly selfish. He even went so far as to pronounce it unnatural, 'contrary to our best parent, Nature'. In a famous controversy in the Academy about the active and contemplative lives Lorenzo showed himself the heir of Bruni and Alberti by unreservedly choosing the active, because, as he says, only the politically active man can contribute to his neighbours' welfare. So although he felt temperamentally unsuited to it, Lorenzo accepted a political role in 1469. Continually he told his friends that he could stand Italian politics no longer, that he would retire to the country and study, but for twenty-three years he was to remain Florence's leading politician.

Lorenzo announced his programme, which was really the Medici programme conceived poetically, during a tournament of 1469. He wore a silk scarf embroidered with fresh and withered roses, inscribed in pearls 'Le tems revient'—a translation into the language of chivalry of Dante's 'secol si rinova', in turn a paraphrase of Virgil's fourth eclogue. In that poem, written about forty years before the Incarnation, Virgil foretells the birth of a miraculous baby, which would mark the opening of a new age of the world, a golden age corresponding to the idyllic first beginnings, where there would be no more suffering or bloodshed. The child when grown was to become a god and rule the world in perfect peace. By evoking this, Lorenzo was pledging himself to give Florence a golden age free from war, and therefore amenable to intellectual and artistic pursuits. Indeed, Lorenzo's chief claim to be associated with the splendour of Florence in the 'seventies and 'eighties lies first and foremost in what he achieved as a politician.

At first his task proved fairly easy. He spent much of his time working in administrative committees and writing, in his quick italic script, upwards of a dozen letters a day to Florentine ambassadors and foreign princes. By firmness and tact he guaranteed order at home and the city's interests abroad. Then in 1471 a new Pope came to power and Lorenzo found himself faced with an enemy possessing a character at least as strong as his own.

Sixtus IV was born Francesco della Rovere, of a poor Ligurian family. After a lonely childhood he was educated, at his uncle's expense, by the Franciscans, an order which he later joined, rising to become General. Theology was Rovere's chosen subject and he made his name with a treatise declaring—in opposition to the Dominicans—that Christ's blood shed during his Passion was not, as it lay upon the ground, worthy of adoration, since it was separated from his body. At the conclave of 1471 Rovere was attended by his handsome young nephew Piero Riario who, when he saw that the cardinals were undecided, made bargains with the most influential: Vote for my uncle and you will have the preferments you desire. Rovere was speedily elected.

In appearance the new Pope was burly. He had a big head, with cold, stern eyes, double chin, hollow cheeks, toothless mouth and

curiously small unobtrusive nose, like the nose-piece of a helmet. The skin on his hands was tight and dry. Though he sold off his predecessor's collection of coins, cameos and classical busts, he was not averse to humanism: he paid for translations and added to the Vatican Library. He did much for the city of Rome, building a bridge over the Tiber, and paving the streets with tiles. He also built the Cappella Sistina. But what interested him most was power for his family. Perhaps as a result of his lowly birth and impoverished childhood, he wished to see the Rovere coat of arms, a sturdy acorn-bearing oak tree, everywhere exalted. The Papacy was now richer (thanks to clever Florentine bankers) and stronger than at any time for 250 years. All opposition in the form of conciliarism had been crushed; there was no longer any check to temporal ambitions, fired by the now vividly available example of the Roman Caesars. Sixtus was the first Pope to behave like any other Italian monarch, the first to make of the institution of the Papacy the vehicle of his dynastic aggrandizement.

He began four months after his election by raising to the cardinal-ate two of his nephews: Giuliano della Rovere, later Pope Julius II, aged twenty-eight, and Piero Riario, aged twenty-five. He made Giuliano Archbishop of Avignon and of Bologna, Bishop of Laus-anne, Coutances and Viviers—later, also, of Ostia and Velletri—as well as Abbot of Monantola and Grottaferrata. The handsome Piero fared even better. Sixtus gave him the bishoprics of Treviso, Seni-gaglia, Mende and Spalato, the patriarchate of Constantinople, the abbey of St Ambrose in Milan and the very rich archbishopric of Florence. Transformed overnight from a mendicant friar into a Crœsus with revenues of 60,000 gold ducats a year, Piero plunged into the wildest excesses. He bought up vast quantities of gold and silver plate, hangings, carpets and thoroughbred horses. He appeared in clothes stiff with gold, surrounded by 500 attendants in scarlet and silk liveries. For his mistress he ordered dresses covered in pearls, for his friends extravagant banquets. One which he gave in 1473 for the daughter of the King of Naples consisted of forty-four dishes: stags roasted whole in their skins, goats, hares, calves, herons, pea-cocks with their feathers, even a bear with a staff in its clenched jaws; ten ships made of sugar laden with sugared almonds which, in allusion

to the Pope's arms, were shaped like acorns; and finally Venus appeared, drawn in a chariot by swans.

Two years of this were enough to exhaust Piero. He died in 1474, leaving debts of 60,000 ducats. But his removal merely enabled two other nephews—laymen, these—to rise in the Pope's affections. The first, Giovanni della Rovere, Sixtus made Prefect of Rome and lord of Senigaglia in the Marches, and of Mondovi in Piedmont. For the second, Piero's brother Girolamo, Sixtus had even higher ambitions. He intended to buy or subdue those towns in the Romagna which over the centuries had shaken free of the temporal power, and there to found for Girolamo a new State.

The Florentines' trade route with Venice lay through Romagna. They could not afford to see this vital area fall into the hands of one man, nor did they like the idea of so serious a disturbance of the balance of power on which, since Cosimo's Treaty of Lodi, the peace of Italy had rested. In May 1473 Lorenzo negotiated an agreement with Galeazzo Sforza, Duke of Milan, whereby Galeazzo was to sell to Florence for 100,000 florins the strategic town of Imola, commanding the road from Bologna to Rimini, and hence communications between Rome and Sixtus's projected new State. Sixtus got wind of the agreement, charged Galeazzo with hostile intentions, and ordered him to cancel the sale. Galeazzo, a throwback to Visconti craftiness, decided to bargain. The upshot was that he agreed to sell Imola to Sixtus for 40,000 ducats, provided that a marriage took place between Girolamo Riario, for whom the town was being bought, and his own illegitimate daughter Caterina. This meant that Milan as well as Rome would be guaranteeing the formation of a new State: an intolerable situation for Florence. So when Sixtus turned to Lorenzo, in his capacity as papal banker, for a loan of 40,000 ducats in order to pay Galeazzo, Lorenzo made difficulties. Sixtus replied by dismissing Lorenzo and appointing in his place a rival Florentine, Francesco de' Pazzi.

With Francesco's money Girolamo Riario in due course took possession of Imola against its people's wishes (one day they were to revolt and slit his throat). But Imola alone did not satisfy Girolamo. He wished to extend his frontiers. Aware that the Medici would oppose him, especially if his uncle the Pope should die, Girolamo

hatched a plot for the assassination of Lorenzo and his brother Giuliano. He found accomplices in the new papal banker, Francesco de' Pazzi, a tiny restless man with political ambitions, and Francesco Salviati, a political opponent of Lorenzo's whom the Pope had named Archbishop of Pisa without the usual consent of the Signoria and whom Lorenzo had succeeded in keeping out of his archbishopric and consequently without his stipend for three years. With their chosen assassin, an army captain named Giovan Battista da Montesecco, the conspirators hurried to Rome in order to get Sixtus's explicit approval for what they described simply as the overthrow of the government in Florence. After a preliminary discussion Girolamo asked Sixtus to pardon in advance any man forced to commit murder.

'Fool!' retorted the Pope, 'I tell you I will have no man killed; what I desire is a new government. To you, Giovan Battista, I repeat that I wish the regime in Florence changed and Lorenzo overthrown. He is an evil, undutiful man who defies us. With Lorenzo gone we can deal as we choose with the Republic, and that will be most convenient.'

Girolamo and the Archbishop were still unsatisfied. 'Then your Holiness is content that we should take every means to bring this about?'

'Go and do what you will—but no bloodshed.'

The Archbishop tried again. 'Holy Father,' he asked, 'are you content that we steer this boat? We will guide it well.'

'I am. But see to it that the honour of the Holy See and of Count Girolamo does not suffer.' He then gave the conspirators his blessing and promised them the support of an armed troop, or anything else they needed.

The conspirators needed a decoy, innocent-seeming and important enough to warrant attentive hospitality from the Medici. They found him in the Pope's grand-nephew, Raffaello Riario, seventeen years old, whom Sixtus had just created a cardinal to fill the place of Piero, giver of Lucullan banquets. A student of the University of Pisa, Cardinal Raffaello was to go to Florence in the third week of April 1478, accompanied by Archbishop Francesco Salviati.

Shortly after noon on Sunday, 26 April, Cardinal Raffaello

changed his dress at the Palazzo Medici and, as he came downstairs, met his host, Lorenzo. Lorenzo had already heard Mass, but said he would accompany his guest to a second Mass in the cathedral. He was wearing a brocade waistcoat. Archbishop Francesco excused himself from going with them: he wished, he said, to visit his aged mother. Lorenzo and the Cardinal set off for the cathedral, where they were presently joined by Lorenzo's younger brother, Giuliano. Montesecco, who had refused to kill 'where God would see me', had been replaced by four other assassins of the Pazzi faction: one, Antonio Maffei, was a priest.

There were no chairs in the wide nave, and the congregation moved about during the long ceremony, Lorenzo himself in the choir. The celebrant read the Epistle and Gospel, proceeded to the Offertory, then to the Canon. The sanctuary bell announced the consecration of the bread, then the elevation of the Host. This was the signal. As the congregation reverently bowed their heads before the body of Christ, the assassins struck. While one pair rushed on Giuliano, Maffei and his accomplice struck at Lorenzo. A dagger blade, aimed at Lorenzo's throat, missed its mark but wounded him in the neck. Lorenzo pulled off his cloak, wrapped it round his left arm for a shield, drew his sword and sprang into the choir. Blood dripping down his brocade waistcoat and followed by friends, he ran under della Robbia's singing children into the new sacristy. There he ordered the doors locked: they were heavy bronze doors by Michelozzo and della Robbia. While Lorenzo stood painting for breath a friend, Antonio Ridolfi, fearing the daggers were poisoned, put his lips to Lorenzo's wound and sucked it clean. 'Giuliano—is he safe?' Lorenzo kept asking. No one knew. People were dashing about in the cathedral, shouting so loudly some believed the roof was falling in. Lorenzo and his friends were on tenterhooks, thinking the Pazzi had seized control and would force the sacristy doors. Suddenly sharp knocks were heard, and voices: 'We're friends, kinsmen. Come out, Lorenzo, before the enemy breaks in.' Suspecting a trick, Lorenzo and his group shouted back: 'Enemies or friends? Is Giuliano safe?' No answer. Then Sigismondo della Stufa, a friend of Lorenzo since boyhood, climbed the ladders into della Robbia's choir-loft, and saw the body of Giuliano lying in the nave. It had

been pierced by nineteen dagger strokes: in fact Francesco de' Pazzi had stabbed again and again with such fury that he had wounded his own thigh. Giuliano's companion, Francesco Nori, also lay dead in a pool of blood. But Sigismondo recognized the men below as friends, and shouted to Lorenzo to come out.

Meanwhile, when he heard the cathedral bells pealing for the Elevation, Archbishop Francesco, far from visiting his aged mother, went straight to the battlemented Palazzo della Signoria, more fortress than palace, escorted by Perugian roughs disguised as his suite. He informed the Gonfalonier of Justice, Cesare Petrucci, that Pope Sixtus had bestowed an appointment on Petrucci's son, the credentials of which he had come to deliver. But he spoke with such hesitation, changing colour and at times turning towards the door, as if giving a signal, that Petrucci grew suspicious and suddenly rushed out to call the guards. The Archbishop ran for the gate. Petrucci ran after him. On the way he met Giacopo Poggio, one of the Archbishop's men, whom he seized by the hair and threw to the floor. On taking office he had fitted a new gate which locked at a touch, so that the Archbishop and his men, retreating, found themselves shut in. Seizing any weapon they could find, even iron meatspits from the kitchen, Petrucci, with other magistrates and their servants, rushed on the conspirators, overpowered them, and tied them up.

Meanwhile, Jacopo de' Pazzi rode through the streets with armed men, shouting 'Long live the people! Long live freedom!' only to be driven off with the Medici cry, 'Palle, palle! and death to the traitors!' Lorenzo returned to his house, where the Florentines shouted to see him. He made a speech, calling for calm and a fair trial for the presumed assassins. But the Florentines were horrified and grieved by this murder in their cathedral. They had loved the handsome Giuliano, only twenty-five years old, and were wild to avenge his death. Seizing the assassins and the Archbishop, they hanged them from the windows of the Signoria—though Lorenzo managed to save the guiltless young Cardinal Raffaello. The Government decreed that the name of Pazzi be deleted from the registers, and those who still bore it must adopt another. The Canto dei Pazzi was renamed, and the Pazzi dolphins everywhere obliterated.

But in Florence sooner or later everything, even murder, even the Black Death, turned to art. It was customary to paint the portraits of criminals on the façade of the Palazzo del Podestà, and Lorenzo commissioned Botticelli to depict there the Pazzi, the Archbishop and the rest of his brother's murderers; later Leonardo made a savagely realistic drawing of one of them, Bernardo Bandini, whose epitaph—'I was another Judas, a traitor, a murderer in church'— Lorenzo himself composed, while Antonio Pollaiuolo designed two commemorative medals: one of Giuliano inscribed *Luctus Publicus*, the other of Lorenzo, *Salus Publica*.

Sixtus, far from keeping quiet about a plot he himself had backed, now launched into a violent personal attack on Lorenzo. Lorenzo, he claimed, was the guilty one, guilty of the blood of Archbishop Francesco and other clerics, who technically should have been handed over to a Church court. Lorenzo, he said, must come to Rome and make public amends. When Lorenzo declined to do so, Sixtus excommunicated him and laid Florence under an interdict, citing the example of 'our predecessor of good memory, Pope Boniface VIII', whom Dante had committed to Hell for similar use of spiritual authority for temporal ends. It was part of a general hardening of the Pope's attitude—in November this year he would institute the Spanish Inquisition and later appoint Torquemada Grand Inquisitor. Finally Sixtus issued an ultimatum to the Florentine Government: Hand over Lorenzo to me or suffer the consequences. The Florentines, devoted to Lorenzo as never before to any leader, rejected the demand scornfully. Sixtus then declared war on Florence and compelled his nominal vassal, King Ferrante of Naples, to do the same. In July Papal and Neapolitan troops invaded the Chiana valley.

Lorenzo was appointed one of the Ten of War. He chose Ercole d'Este, Duke of Ferrara, to command Florentine troops and sought an ally in Louis XI, for whom in the past he had done several small favours, such as providing a watch-dog to guard the bedroom of this most suspicious of kings. 'I well know, and God is my witness,' Lorenzo wrote to Louis, 'that I have committed no crime against the Pope, save that I am alive, and having been protected by the grace of Almighty God have not allowed myself to be murdered.

This is my sin, for this alone I have been excommunicated.' But the spider king was too busy mastering powerful nobles and putting them in iron cages to heed a call from abroad. All he did was to invite Sixtus to hold a Council at which the peace of Italy would be discussed, an invitation that Sixtus coolly ignored.

The war dragged into its second year. Lorenzo prosecuted it with his usual vigour, despite plague, which forced him to send Clarice and the children to the country, and the inevitable heavy losses to Florentine trade and banking. Ercole d'Este won a victory on the shores of Trasimeno but failed to follow it up. Thereafter everything went wrong. On 15 November 1479 Landucci noted in his diary: 'The Duke of Calabria captured Colle di Val d'Elsa. He had besieged it for about seven months, and the mortars had been fired at it a thousand and twenty-four times.' This strategic town lay only thirty miles from Florence. Something would have to be done, and done quickly. The Duke of Calabria had already hinted that Lorenzo must come to Naples and negotiate with his father Ferrante. It would be dangerous to leave Florence, where Sixtus might well achieve his aim of a revolution, but Lorenzo decided to take the risk. On his own initiative he arranged for Neapolitan galleys to fetch himself and his suite. Then, raising 60,000 florins by mortgaging Cafaggiolo and farms in the Mugello, he embarked at Livorno and on the afternoon of 18 December 1479 sailed into Naples.

King Ferrante was a pudgy-faced man of forty-eight. He had been educated by a Borgia in all the niceties of dissimulation and Commines said of him: 'No one ever understood either the man or his real thoughts.' He liked falconry and on one visit to Rome his hawks destroyed every kite in the Campagna. Towards his unruly barons he behaved in much the same spirit, and he had the reputation of being the astutest politician in Italy. He received Lorenzo with the honours due to a head of State and even praised his dashing appearance with a quotation from Claudian: *Vicit præsentia famam*. Lorenzo went some way towards justifying the compliment by purchasing the freedom of 100 galley slaves, to each of whom he gave 10 florins and a new suit of green cloth. This was the sort of flourish expected of *il Magnifico* and the Neapolitans applauded.

In the talks that followed Lorenzo found himself at a marked dis-

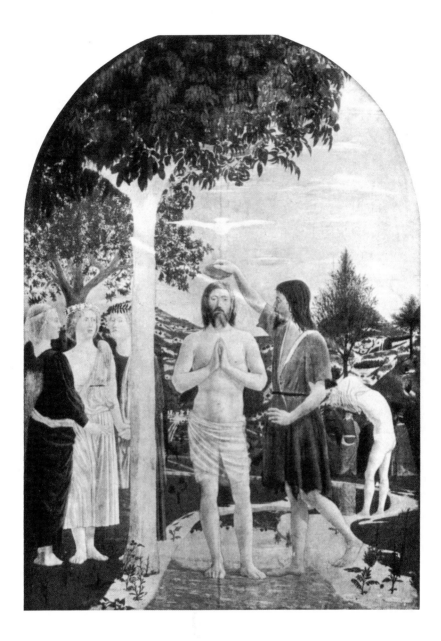

Piero della Francesca's *Baptism of Christ*, one of the first Tuscan
paintings accurately to depict landscape

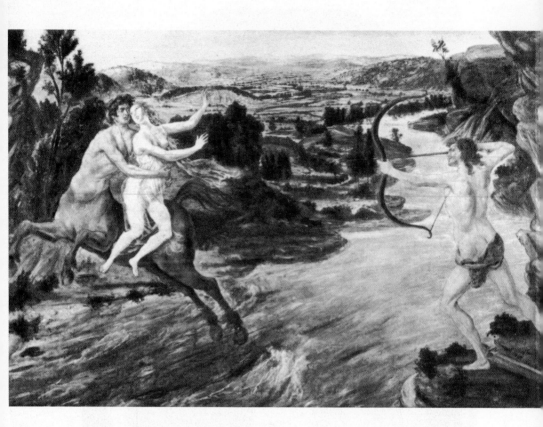

Pollaiuolo was one of the first artists convincingly to depict movement and energetic action, as in *The Rape of Deianira*. Bold brush-strokes—an innovation at that time—suggest the river's turbulent surface

Apollo and Daphne, by Pollaiuolo. Daphne's gratified expression
points the moral of the picture: that prayer is being answered

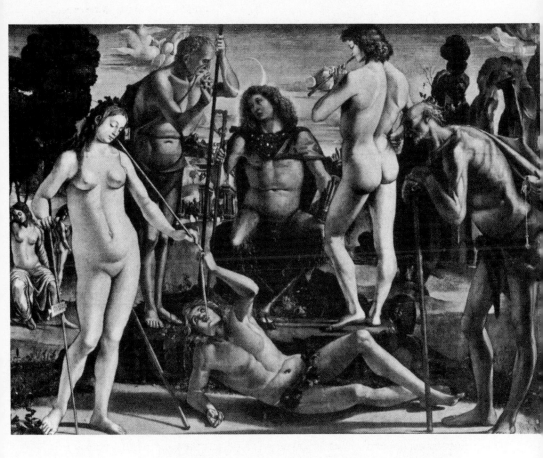

Signorelli's *Court of Pan*, a complex allegorical painting. Goat-legged
Pan gazes at the nymph Syrinx, who, rejecting his love, turns towards
the reclining river-god Ladon

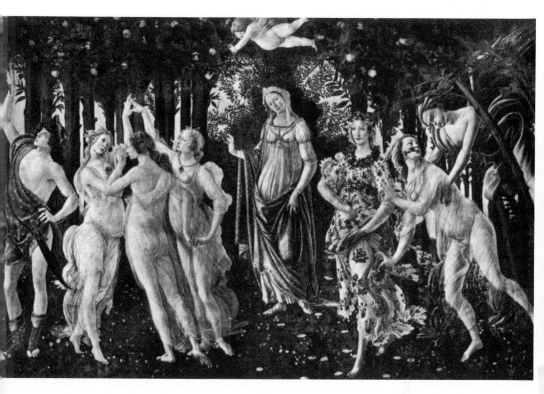

Botticelli's *Primavera* is an allegory of springtime love. Flora scatters flowers on the earth; Venus, who is with child, symbolizes fruitfulness to come. The three Graces, smitten by Cupid, dance towards Mercury, whose raised caduceus indicates heavenly mysteries, symbolized by imperishable golden apples

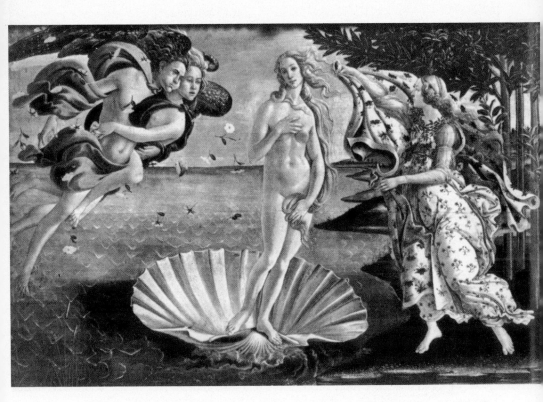

Botticelli's *Birth of Venus* shows the goddess being driven ashore by two winds, and greeted by a florally clad attendant. The scallop shell was a familiar Christian symbol of spiritual birth. The subject was probably suggested by descriptions of Apelles's *Aphrodite Anadyomene*, one of the most famous pictures of antiquity

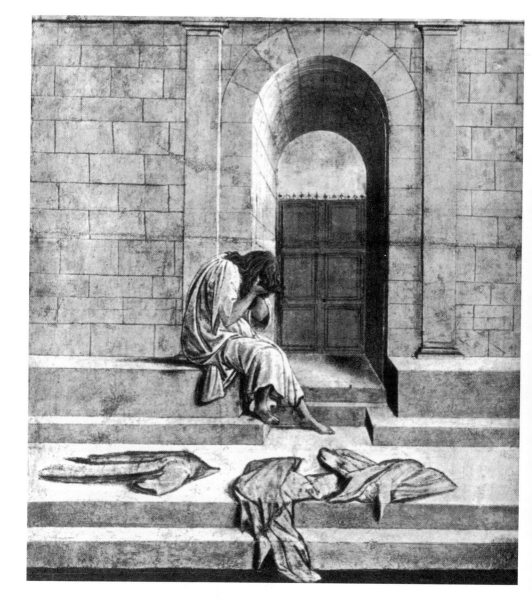

Botticelli's *La Derelitta* has an Old Testament subject. Queen Vashti, deposed by her husband Ahasuerus, sits stripped of her finery and excluded from the palace. The picture expresses the despair in Florence after the French invasion

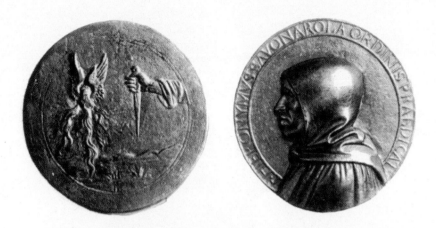

Medals depicting Savonarola and the dagger which he saw in a vision suspended over Florence. Below, Botticelli's *Magdalen at the foot of the Cross* shows flaming brands being hurled down from heaven, while shields protect Florence

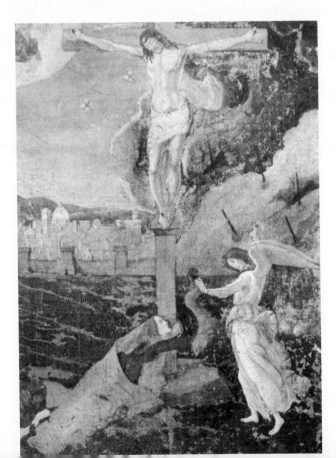

advantage. He could argue that the Papacy was neither a consistent nor a trustworthy ally, and point to a seven years' civil war in which Pope Calixtus III had embroiled Ferrante. Since then, however, Ferrante's son Giovanni had been raised to the purple, that memorable banquet of 44 dishes and Venus drawn by swans had been given by the Pope's nephew for Ferrante's daughter, and in 1472 Sixtus had waived the tribute due from Naples—8,000 ounces of gold—insisting only on a well-caparisoned white palfrey and certain 'services', such as the present war on Florence. In military terms Lorenzo was even more at a disadvantage. Florence's armed forces, as opposed to mercenaries, numbered only 150 men, no match in skill for the Neapolitan barons, newly mustered by Ferrante in his Order of the Ermine. The latest news was that the Genoese had captured one of Florence's key fortress towns, Sarzana, commanding her north–south communications. It was all most depressing. As a Florentine in Lorenzo's suite put it: 'He seemed to be two men, not one. During the day he was the embodiment of easy grace, happiness and the utmost confidence, but at night he grieved sorely about his own ill-fortune and that of Florence, repeatedly saying that he did not give a fig for his own life but was grieved how to save his country in such peril.'

One hope presented itself. Ferrante fancied the new learning. He had scholars from the north lecturing at Naples University and he supported poets. True, his court poet, Pontano, wrote in praise of dissimulation, claiming that St Francis of Assisi had practised this art because he once put hunters on the wrong track of a hare he had hidden in his cloak, while another Neapolitan poet, Cariteo, thought fit to sonnetize his beloved under the name Luna: Luna is not the moon, but a bright, living sun; the face of Luna is the sun of his moon; if Luna were to die, there would be in the sky two suns and two moons, and so on. What mattered to Lorenzo was less the quality of such poetry than Ferrante's interest in it and in the new learning generally. The King's values were not wholly medieval and feudal. Instead of citing some grandfather or great-uncle who had acquired a few hundred more fields and a dozen castles by wielding the battle-axe, he might be prepared to take a longer view, to compare the present with the distant past, and to look at those

numerous figures from a thousand years of Greek and Roman history who now possessed the double attraction of novelty and antiquity.

This was the method Lorenzo employed. Himself a firm believer in the ways of peace, he pointed out to Ferrante numerous Greek and Roman rulers, from Pericles to Augustus, who had won fame not through war but through peace. Historically, said Lorenzo, Italy was a whole, and the welfare of all its people should take first place with a ruler. Any king or statesman worth his salt should turn enemies into friends and even allies. Lorenzo's line of argument seems to have been that war belonged with Gothic architecture, Byzantine painting and scholastic Latin, to be rejected by educated men. Doubtless he backed it up by enumerating the material advantages to Ferrante of peace.

Lorenzo happened to have a close friend in Naples. Count Diomede Carafa, aged seventy-two, loved antiques and the arts generally; he wrote the first book on courtiership. Lorenzo had done the older man many favours—looking after his friends when they visited Florence, protecting the interests of a Neapolitan Jew—and had given him a bronze head of a horse from the third century B.C., one of the most beautiful antiques then known, for which in a warm letter Diomede thanked Lorenzo 'an infinite number of times'. It seems likely that Diomede, as Ferrante's chief political adviser, now gave practical form to his gratitude by supporting Lorenzo's novel arguments for peace. Anyway, either alone or with Diomede's help, Lorenzo gradually won round Ferrante. The Neapolitan king agreed in principle to make peace. Florence of course would have to make a large money payment, as she always did in such circumstances. But when it came to signing an actual treaty the crafty Ferrante kept delaying. After nine weeks in Naples, Lorenzo decided to try bluff. He could not, he declared, absent himself any longer from Florence. He must return at once. With a brief goodbye, he set his fast horse on the road north. This unexpected departure precipitated a decision. Ferrante sent off a long letter asking Lorenzo to return and when the Florentine ignored this, quickly drew up the promised peace treaty, signed it, and sent it after Lorenzo by special courier. Ferrante agreed to restore, at his discretion, all places captured during the war, while

Lorenzo promised to free a number of Pazzi partisans held prisoner and also, for a limited period, to pay a sum of money to the Duke of Calabria. From Lorenzo's point of view the treaty was a considerable personal coup because not only did it end the present war, it joined the two States in a defensive alliance, so rendering future war unlikely.

The Florentines regarded the treaty equal to a victory gained on the battlefield, and welcomed Lorenzo home with wild rejoicing. The price of corn fell and trade picked up. But some grumbled. In May 1480 Luca Landucci wrote sarcastically: 'At this time the Duke of Calabria was sent a sum of 30,000 florins, on several occasions . . . We Florentines have the wise custom of giving money to everyone who does us an injury, and who destroys and pillages our territory. This is not a solitary example; it will always be the same: anyone who wants money from the Florentines has only to do them an injury.' There was an element of truth in this, but Landucci forgot that war could cost Florence up to a million florins a year.

Sixtus, deprived of his chief ally and alarmed by the Turks' capture of Otranto in December 1480, was obliged to make peace with Lorenzo. But after the rout of the Turks in 1481 the Pope renewed his dynastic ambitions. In order to gain more territory for his nephew Girolamo, known from his growing power as the 'arch-pope', Sixtus joined with Venice this time in a wholly unjustified war on Ferrara. Though Florence was not directly threatened, Lorenzo had come to see that peace in Italy depended upon a balance of power. If Sixtus defeated Ferrara, he would turn next on Milan, Venice, or Tuscany. So Lorenzo and Ferrante of Naples sent troops to help Ferrara. This was a fresh approach to Italy's political problems, and it worked. After only seven months' hostilities Lorenzo took the initiative and concluded peace. Furthermore, he created a league along the lines of Cosimo's Treaty of Lodi, whereby Florence, Naples and Milan were each to guarantee the others' territories.

Hardly had Lorenzo secured this new pact when Sixtus again broke the peace. On the pretext that Venice had declined to join the pact, but in fact in order to win for Girolamo the towns of Cervia and Ravenna, he plunged the league into war against Venice. He even pronounced a bull of excommunication against the Serene

Republic and promised in advance a plenary indulgence to anyone who killed a Venetian. Again it was Lorenzo who took the initiative in making peace. He convinced Naples and Ferrara of the futility of the war and brought them to the conference table. In August 1484 peace was signed and the bombards silenced. Ferrara lost all her recent gains beyond the Po, and the Pope's nephew got neither Cervia nor Ravenna. When ambassadors told him the terms, Sixtus rounded on them angrily: 'You bring back conditions of peace suited to the vanquished, not to the victor . . . This peace I can neither approve nor sanction.' Next day, 12 August 1484, Pope Sixtus died, broken it was believed by this set-back to his ambitions. He was not regretted. His apartments were immediately plundered and his master of ceremonies, Johann Burchard, in preparing the Pope's body for burial, made a revealing mistake: he forgot that this arch-nepotist had been a Franciscan and buried him not in the austere brown Franciscan habit but in full pontificals. Only later did he remember and, punctilious as only a German can be, constantly recurred to his stupid blunder, one which could never be rectified.

Lorenzo immediately had to face a new threat to peace from Sixtus's successor, Innocent VIII, a kindly Genoese, neither very intelligent nor very strong-willed. Lorenzo's agent called him 'a rabbit': he did have the eyes and nose of a rabbit, and to a certain extent the malleability. Innocent at once fell under the influence of Cardinal Giuliano della Rovere, who had secured his election: he who later sat to Michelangelo, and when the sculptor suggested portraying him with a book in his hand, replied, 'No, give me a sword, for I am no scholar.' Cardinal Giuliano played on Innocent's ingrained hostility to the Aragonese kings to such a point that in 1485 the Pope declared war on Ferrante of Naples.

Despite opposition from Guelph diehards, Lorenzo decided to honour his recent alliance with Naples, but at the same time began an intensive diplomatic effort to secure peace. In August 1486 he did succeed in making peace, then set out to win Innocent from Cardinal Giuliano's control. His chance came in 1487. A *condottiere* named Boccolino Guzzoni seized the town of Osimo in the Marches and threatened to hand over the whole region to the Turk. Innocent sent Giuliano to capture Osimo, but the warrior cardinal failed and

asked to be recalled. Lorenzo then stepped in and, after some clever bargaining, induced Boccolino to give up Osimo to the Pope for a mere 8,000 ducats. Innocent was delighted and impressed. His relationship with Lorenzo ripened into friendship, and in 1487 Lorenzo married his daughter Maddalena to the Pope's son, Francesco Cibo.

Henceforward Lorenzo controlled the Pope's foreign policy. He was close enough to Innocent to write him letters in this vein: 'Your Holiness can rest assured that even as St Francis by reason of his stigmata felt the pain of Christ's wounds, so do I feel every pain and ill suffered by your Holiness in my own person, and am thereby much oppressed.' He constantly urged the weaker man on, and one of his phrases is typical of Lorenzo's whole philosophy: 'A Pope is what he wills to be.' Innocent still hankered after territorial expansion in Naples, and on three separate occasions Lorenzo had to restrain him from war. That made seven occasions in all when Lorenzo brought peace to the great powers of Italy. He had become Italy's recognized peace-maker. Perugia, Castello, Bologna and Faenza all resorted to him as an umpire in case of faction or a protector in case of aggression.

'It is perfectly known all over Italy what influence you have with the Pope and that the Florentine ambassador *quodammodo* governs at Rome.' So Vettori, Florentine envoy in Naples, to Lorenzo in 1490. Lorenzo had become a European figure. Requests poured in to the *Seigneur Laurenz* from Anne de Beaujeu and her husband Pierre de Bourbon, from the Duchess Blanche of Savoy, from the King of Portugal. In 1488 the Sultan of Egypt sought Lorenzo's favour with eleven sable skins, porcelain vases, sweets and a giraffe, which Piero di Cosimo promptly painted. In return Lorenzo consolidated and publicized the *pax Florentina* in a novel way: by sending artists to work abroad: Giuliano da San Gallo to Naples, Antonio Pollaiuolo to Rome, Andrea Sansovino to Lisbon, and so on.

For the moment Lorenzo had the Pope under control, but what would happen when Innocent died—and when he himself died? Gout and worsening arthritis had taught Lorenzo to think ahead, and for a decade he had been pursuing a design centred on his second son Giovanni, a naturally pious boy who had entered the Church. Lorenzo procured for him many benefices, starting with the abbey

of Passignano when Giovanni was aged nine. Lorenzo's design culminated on 10 March 1492 in the Abbey of Fiesole, when Giovanni, aged seventeen, was consecrated a Cardinal of the Holy Roman Catholic Church, not only, said Lorenzo, 'the youngest of living cardinals, but the youngest that has ever existed'.

Florence rejoiced, Lorenzo exulted and magnificence for once became immoderate. The barber who renewed the Cardinal's tonsure received for a few minutes' work 150 ducats, his assistants who held the basin and poured the water 50 ducats each. In the evening two elephants took part in a procession to the Palazzo Medici, one garlanded with the seven cardinal virtues. In a farewell letter to his son upon his departure for Rome, Lorenzo summed up his hopes for the Church:

> You know how important are the position and example of a
> Cardinal, and that the world would be far better if the Cardinals
> were what they ought to be, for then there would always be a
> good Pope, from whom emanates, one may say, peace for all
> Christians. Make every effort therefore to be this; if others had
> done so we might hope for universal good.

Lorenzo advised Giovanni to get up early in the morning—excellent for the health and it allowed time for planning one's day— and asked him to give what help he could to Florence and the house of Medici: 'you will doubtless find a way to save, as the proverb puts it, both the goat and the cabbages, always keeping steadfastly to your above-mentioned duty of setting the interests of the Church above everything else'.

'Peace for all Christians . . . the interests of the Church'—Lorenzo's words have the ring of sincerity. Ambitious he was for his family, certainly, but because he believed their values could preserve order in Italy. Giovanni was in fact to lead an exemplary life throughout his cardinalate and to work for peace. Very soon he would realize Lorenzo's ultimate ambition: in 1513, at the age of thirty-eight, he was to become the first Florentine Pope, taking the name Leo X. But these events happened too late to save Florence.

On the day Giovanni left for Rome Lorenzo was so ill with rheumatic fever that people thought he was dying, and to calm their fears he had to show himself at his bedroom window. Later that

March he moved to his villa of Careggi. There he discussed literature and philosophy with Poliziano, Ficino and Pico della Mirandola. He planned, he said, to devote the rest of his life to study with them, far from bustling Florence. 'The citizens won't let you', Poliziano protested. Lorenzo replied that his son Piero would take his place, adding that he promised to be the best of the Medici. As his illness grew worse, it was Piero, now aged twenty, who nursed him. According to Poliziano, 'the one beautiful sight among all this grief was that the father, not to increase his son's sadness by his own, put on a brave face whenever Piero entered the room, and for his sake held back his tears.'

In the city anxiously waiting for news portents occurred. On 5 April the two lions kept at the Signoria as symbols of liberty sprang at each other and fought so fiercely that both were killed. That night out of a cloudless sky lightning struck the lantern of Brunelleschi's dome and split it almost in half. Lorenzo asked on which side the shattered marble had fallen and said, 'Alas! I shall die, because it fell towards my house.'

On the seventh Lorenzo made his confession and received Communion. He asked to see Pico and enquired about the library which, with his help and money, Pico was building up. 'I do wish I had lived to see it complete.' By the eighth he had become very weak and only partly conscious. 'The Passion was read and he showed that he understood by moving his lips, or raising his tired eyes, or sometimes moving his fingers. Gazing at a silver crucifix inlaid with precious stones and kissing it from time to time, he died.' He was forty-three years old.

'Oh that my head were waters', wrote Poliziano, 'and my eyes a fountain of tears, that I might weep day and night!' Lorenzo's friend and physician, Pier Leone, who had firmly expected his recovery, went out of his mind and drowned himself in a near-by well. Luca Landucci wrote: 'This man was reputed the most glorious, the richest, the most exalted, and the most famous. Everyone said that he ruled Italy, and truly he was a wise man; he succeeded in everything. He has made not only his house but our whole town illustrious.' Nearest the mark were the words of King Ferrante: 'This man lived long enough for his own glory, but too short a time for Italy. God

grant that now he is dead men may not attempt what they dared not do while he was alive.'

Lorenzo's body was carried by members of the Confraternity of the Magi from S. Marco to the old sacristy of S. Lorenzo, where it was laid to rest by the side of his brother Giuliano under the simple sarcophagus fashioned by Verrocchio for Cosimo and Piero. Five days after his death the Councils passed the following motion by 483 votes out of 546: 'He always subordinated his personal interest to the well-being of the community: he never shirked danger nor sacrifices for the good of the State and for its freedom; to that end he dedicated himself wholeheartedly, assuring order in the republic with excellent laws.'

How much did Lorenzo achieve for Florence? When Domenico Ghirlandaio completed his *Life of St John the Baptist* in S. Maria Novella, he dated it proudly: 'In the year 1490, during which this most beautiful city, famous for its victories, arts and buildings, enjoyed great prosperity, health and peace.' 'Victories' was hyperbole for Florence's recapture of Sarzana, and prosperity no longer expressed economic growth, but on the whole Ghirlandaio's jubilation was justified. Two years later in a letter to a Dutch priest, Paul of Middelburg, Ficino went even further and claimed that Florence was now 'the city of the Golden Age'. This, as we have seen, meant an age of peace, with its attendant benefits. Ficino's claim is justified and it is Lorenzo who must take the credit, since it was he who brought Florence through a long dangerous war aimed at ending her independence, he who secured peace for Italy, and preserved it through judicious use of the balance of power.

In other fields also Lorenzo's achievements are as solid as they are undeniable. He did much to aid the economy, notably by securing a contract for working the Elba iron mines. He made Florence the intellectual and artistic centre of Europe. He encouraged a generous attitude to non-Christian religions. In his own phenomenally active life he combined both the spirit of *Carpe diem* and that of the *Stabat Mater*. He embodied his own deep conviction that man must realize himself to the full if he is to serve others well.

Lorenzo succeeded; perhaps from Florence's point of view he

succeeded too well. His activity on every front wedded to a natural charm made his influence well-nigh irresistible. That influence, it has to be said, was benevolent. For example, in 1487 a fiery Franciscan named Bernardino da Feltre came to Florence and preached a course of anti-Semitic Lenten sermons—no Christian, he said, should go for medical treatment to a Jewish doctor. So violent were his sermons that they led to Jew-baiting. It was Lorenzo who energetically intervened and arranged that Bernardino should pack his bags and leave. On the other hand, there exists a letter from the son of Cennini the goldsmith humbly apologizing to Lorenzo because for once the vote in the Wool Guild went against his patron's wish. It is a distressing symptom. It is distressing also that after the Pazzi plot Lorenzo decided to take a bodyguard of ten men with staves. However advisable the bodyguard may have been, one would like Lorenzo better without it.

Later, enemies of the Medici were to accuse Lorenzo of having made himself tyrant. The charge, like that other charge of embezzling *Monte* funds, is not borne out by modern research. The creation of the Seventy certainly increased Lorenzo's influence, but never to a point even bordering on tyranny. The truth seems to lie in Lorenzo's character, in the fact that he was not by temperament a politician. He liked to act man to man, on a personal basis, not through the slow calculating alignment and interaction of groups. There is a sense in which Lorenzo developed his talents to an undesirable degree, so that he loomed too large on the Florentine scene. By becoming altogether too magnificent as a person he exercised in the city a kind of involuntary tyranny. Guidance by one determined man was doubtless necessary for Florence's survival, but as always it weakened the organization of the State. It left the Florentines smaller, too willing to listen to the most brilliant speaker, whoever he might be, and their habit of communal decision seriously impaired. Well might Florence weep at Lorenzo's death, for the city had become a dwelling swept and garnished, ready for seven devils to enter.

A Friar with Lightning

AFTER Lorenzo's death the most powerful man in Florence was not a Florentine at all but a Dominican friar from the north. The friar's grandfather, Michele Savonarola, a physician of Paduan birth, had made the family name as an expert on spa-waters; he also wrote a curious little treatise on *aqua ardens*, claiming alcohol to be the fifth essence and telling of noted men who lived to a ripe age by imbibing it generously. Michele Savonarola became court physician in Ferrara at a salary of 400 gold ducats, a post which his son held after him. His grandson was born in Ferrara in 1452 and christened Girolamo—evidently someone in the family found congenial this most violent of the Fathers. Girolamo grew up to be a pale, highly strung boy. His was not a happy nature, nor was it brightened by his early days in the shadow of the Duke's castle, with its massed square towers, wide moats and dungeons crowded with political prisoners. Out of school he strummed sad music on his lyre and wrote a murky little poem called *The Ruin of the World*. He fell in love with the illegitimate daughter of a Florentine exile, but this girl informed him that no Strozzi might stoop to an alliance with a Savonarola. To the sensitive Girolamo the rejection doubtless came as a painful blow. He became even gloomier and decided he was disgusted with 'the great wretchedness of the world, the sins of men, lecheries, adulteries, theft, pride, idolatry, cruel blasphemies.'

On May Day 1474 Girolamo happened to be in Faenza, on a pleasure trip. Entering by chance the church of S. Agostino, in which a friar of that order was preaching, he was suddenly struck by a phrase, not of the preacher, but from *Genesis*: 'Egredere de terra tua! Get thee out of thy country, and from thy kindred, and from thy father's house.' This call impressed itself on Girolamo's mind and

gave him no rest. On the festival of St George's Day, a year later, while all Ferrara was celebrating, he slipped away to Bologna and entered the friary of S. Domenico, asking to become the friars' drudge.

Next day from his cell Savonarola wrote to his father, the court physician: 'Over and over I sang that tearful line: *Heu fuge crudeles terras, fuge litus avarum*—Alas, flee the cruel lands, flee the shores of the greedy [*Aen.* III, 44] ... I could not endure the corruption of the Italian people.' Later he was to explain that he had longed for quiet and freedom, particularly freedom from taking a wife.

During his first year in religion Savonarola found that the clergy too could be corrupt and wrote another disabused poem, this one entitled *The Ruin of the Church*. He remained seven years in Bologna, acquiring a thorough knowledge of Scripture and Aquinas, then for a short time became novice-master at S. Marco in Florence, before being sent up and down Italy to give sermons and retreats. Pico heard him and was so impressed by his fervour that he persuaded Lorenzo de' Medici to have the Dominican appointed to S. Marco as a preacher.

Savonarola arrived in Florence in the summer of 1489. Now aged thirty-seven, he was a rather short, slender man, with deeply-lined brow, hooked nose and prominent lips. What struck people most were his burning grey-green eyes under bushy dark eyebrows. His gestures in the pulpit were vehement, but the hands that made them were long, thin and translucent. He wore patched clothes, always, however, clean. He ate sparingly. His bed was a wooden frame laid across trestles, a palliasse and a single blanket. Everything about him suggested a very holy man.

The Dominican from Ferrara found a far more complex situation than had met other strangers, such as St Catherine of Siena and S. Bernardino, who had come to Florence preaching repentance. Florence had evolved virtually a new civilization, of whose achievements she was justifiably proud. Ficino compared his own revival of Platonic philosophy to the rebirth of grammar, poetry, rhetoric, painting, sculpture, architecture, music and astronomy which had been accomplished in the city. An age of light after darkness, spring after winter, restoration, renovation and rebirth—these were some

of the boasts Florentines made. More than a rebirth of the past, it was a rebirth into the past. After visiting Filarete's ideal city, Lodovico Gonzaga is made to say: 'My Lord, I seem to see again the noble buildings that were once in Rome and those that we read were in Egypt. *Mi pare rinascere a vedere questi cosi degni hedificii:* It seems to me that I have been reborn on seeing those noble buildings . . .' In a similar vein Botticelli sought to become another Apelles, Ficino another Plato. Such a bridging of time is an imaginative, even poetic experience which brings intense pleasure, for the spirit, released from the limiting present, has an awareness of eternity. This pleasure the Florentines had tasted to the full.

It is often said that Savonarola misunderstood the Florentines, that he was a grisly, unintelligent relic of the Middle Ages, who flayed them with Old Testament imagery. This is not so. Savonarola grasped with keen perception what educated Florentines were doing and thinking. He believed it to be dangerous and misguided, and he wished to replace their system with one of his own, equally logical. What Savonarola did was to oppose the classical revival with a religious revival, the glory of Athens and republican Rome with the Rome of the Apostles and early martyrs. Man should be reborn not into the classical spirit but into the spirit of the early Church. What was that spirit? Simplicity, and purity of morals, the former being a condition of the latter. And so, over against the new complications of living and thinking, Savonarola propounded the need for simplicity.

First, in economics. The hocus-pocus of interest-taking was wrong. Everyone should do an honest job of work and be content with a sufficiency. 'Your palaces are built with the blood of widows and orphans.' Money should not be invested in luxuries, even if these provided work for craftsmen, but given to the poor. Gambling, card games, fine dress and cosmetics should be abolished, likewise the *palio* races on the feast of St John, and the money given to the destitute.

The scramble for material possessions meant that not even priests had time for God. 'In the early Church the chalices were made of wood and the prelates of gold, while today the chalices are of gold and the prelates of wood.' Church art too had lost its simplicity.

'Young men go about saying, "There is the Magdalen and there St John," and all because the paintings in the church are modelled on them. This is a bad thing that makes you greatly undervalue the things of God. You fill your churches with your own vanities. Do you imagine that the Virgin Mary went about dressed as she is depicted? I tell you she went about dressed as a poor person, simply, and so veiled that her face could hardly be seen. So with St Elizabeth. You would do well to blot out pictures so unsuitably painted. You make the Virgin Mary look like a harlot.'

Sumptuousness led to effeminacy and hence, Savonarola believed, to sodomy. Florence dealt with this practice through its 'Office for the Investigation of Nocturnal Traffic and Monasteries', which acted on anonymous denunciations put into a *tamburo* or drum-shaped box in the Palazzo della Signoria. Under such a system charges were naturally commoner than convictions: Leonardo, for instance, had the misfortune to be charged, and so did Botticelli, but both were acquitted. There may have been under Lorenzo a slight increase in homosexuality—and in prostitution—because the high cost of houses and marriage festivities in a society where money had become scarce meant that men married later or not at all. Savonarola, however, took luxury not poverty to be the cause, and he wanted the practice stamped out. The usual fine was 50 florins; quite inadequate, said Savonarola. He demanded that sodomites be mercilessly stoned and burned alive.

Having thus rid themselves of luxury and its consequences, let the Florentines simplify their political system. Savonarola had spent his formative years under the despotic Este regime and tended to see the Medici in terms of the tyrants of Ferrara. He disapproved of the Medici, and also of the rule of the Ottimati, or wealthier guilds. 'I believe that the best constitution is that of the Venetians. You should copy it, but leaving out the features that are unsuited and unnatural to us, such as the office of Doge.' Like S. Bernardino, Savonarola favoured the most static and conservative system then in existence, believing that it would 'favour virtue' and obviate the scramble for high office. Cosimo, he claimed, had been wrong in his tag that States are not ruled by paternosters.

When it came to philosophy Savonarola showed a keener under-

standing of Florentine ways than he did in the matter of politics. There had from the first been shock as well as joy in meeting the classical past at close quarters. One example will illustrate this. Leonardo Bruni retold an incident he had found in the Greek historian Appian. It concerns King Seleucus of Syria, whose son Antiochus falls violently in love with his father's beautiful young second wife. Antiochus controls his passion, but falls sick and longs to die. Seleucus calls the doctor. 'Your son's disease is love,' he tells Seleucus, 'but a love that is hopeless.' The doctor only dares to hint at the lady in question, but Seleucus understands. Instead of storming into a rage and pulling out daggers, he gives his wife to Antiochus, who promptly recovers and all three live happily after. Bruni then compares Seleucus with a well-known figure in Italian history, Tancred of Naples. Tancred had a beautiful daughter named Ghismonda, of whom he was jealously possessive. When a Neapolitan noble started courting the girl, Tancred had the suitor strangled, whereupon Ghismonda died of grief. Bruni concludes that 'in humanity and kindness of heart the ancient Greeks were far in advance of Christians.' This had been the shock. One consequence was that a principle other than Christianity had to be found as a yardstick against which to measure moral behaviour. Lorenzo Valla, in a famous dialogue, had proposed pleasure—all virtuous action, he claimed, springs from man's natural tendency towards pleasure, while Ficino held that behind love, and hence virtue, lay a response to beauty. But whatever the answer proposed, most Florentines agreed that Christianity could no longer claim a privileged position but must justify its moral code on rational grounds.

Savonarola believed this development to be extremely dangerous. Simple Gospel truths were being obscured by researches into comparative religion. Before he came to Florence 'this pulpit was occupied by Aristotle and Plato. In Lent a snatch from the Gospels was followed by long philosophical arguments. By Ovid, too. Ovid's *Metamorphoses*. A good writer, you say. I reply: *Ovidio fabuloso, Ovidio pazzo*—Ovid romances, Ovid's mad.' 'Someone informs me, "I decline to believe unless I verify my beliefs by the light of nature." He might as well say, "I want to become blind in order to see." Your eyes will open if you lead a good life, and a good life depends on faith.'

Plato and the rest may have seemed to lead virtuous lives, but they lacked the supernatural light of faith, and so were not good through and through. 'Plato, Aristotle and the other philosophers are fast in Hell. Any old woman knows more about the faith than Plato.'

'Socrates, you say, gazed on the beauty of his young friends in order to find beauty of soul. But I would not advise you to follow his example, or to admire divine beauty in a pretty woman. That is tempting God.' To the gap between nature and grace corresponded another gap between pagan wisdom and Revelation, which it was equally perilous to try to bridge. A woodcut of the time shows seven sages, dressed variously in togas and turbans, listening docilely to Savonarola, who is surmounted by a dove. He alone has the truth.

How far were Savonarola's charges true? Had Florence forsaken Christ? From her printing presses poured not only classical texts but lives of saints, sermons and works on theology. She had more con- fraternities to look after the sick and miserable than any other city: a new one had just been founded in S. Giovanni Decollato, whose members, wearing black garments and hoods, comforted condemned criminals on the way to execution. In the period 1325-65 forty-five per cent of Florentine children had been given the name of a saint; In 1365-1400 66 per cent; in 1475-87 the number rose to 75 per cent. As for love of beauty, it derived from the Florentines' keen visual sense and seldom amounted to a craving for luxury. Indeed, it had given Florence its finest convents and churches.

'You fill your churches with your own vanities', thundered Savonarola. 'Vanity' and 'vanities' were often on his lips, and later when he consigned to the flames playing cards, books of verse and works of art, he called this a 'burning of vanities'. 'Vanity' in this sense savours of Manicheism: indeed it occurs only three times in the Old Testament outside *Ecclesiastes*, and in the New Testament not at all. Why were most human pursuits vanities? Because they took time from religion. The argument between Savonarola and the Florentines about simplicity became in the last analysis an argument about time. It is no accident that Lorenzo in his poems constantly recurs to time, the passing of time, and the misery of losing even a moment of time. He was trying to crowd into a single lifetime the rebirth of the past and also his duties as a Christian. He succeeded,

indeed the very pace at which he lived contributed to his success. Most of his friends succeeded too. They led intensely active lives without thereby ceasing to be good Christians, indeed it is note-worthy that the vagabond-poet Luigi Pulci, to whom as an un-believer the Church denied Christian burial, was precisely the man in Lorenzo's circle with most time on his hands.

'All things are clean to the clean,' Coluccio had argued against Dominici à propos pagan books, and the Florentines might in justice have made some such reply now. They did not, and for this there are three main reasons. First, they had adopted the new learning and their new way of life so rapidly that they had had no time to prepare a reasoned defence of either. Secondly, there lurked in every Florentine a strong tendency to simplicity and detachment. This had been repressed by the new joy in living, in other people and in things, but it was bound to assert itself as soon as a suitable occasion arose. The third factor was Savonarola's power as a preacher. In sermons lasting about an hour and a half—short for that period—he inter-wove arguments from Aquinas and quotations from Scripture with practical admonitions in every field. The tone was intensely serious. Very rarely came a moment of wry humour: ' "But Father, I am not evil, as you claim. I am good, I go to confession once a year." I'm glad to hear you are good, but be sure you don't confess to Fra Bonino or Fra Dolcino. Go to Fra Giusto, and hide him nothing.' At the core of almost every sermon lay the easily understood theme of simplicity. 'God renewed his Church and the whole world through simple people, through fishermen; so he will do now.' And the burning eyes seemed to pierce every soul present.

In 1492 Savonarola's sermons took on an apocalyptic tone. He announced that he had seen in the sky a hand bearing a dagger. The dagger was inscribed 'Gladius Domini super terram cito et velociter'. Suddenly the dagger turned down over the city of Florence; the sky darkened; swords, flaming arrows and brands rained down; thunder-claps roared; and all the world fell a prey to war, famine and pes-tilence. So vividly did the friar describe these events that his audience seemed to see them actually happening.

Flashes of lightning dominated Savonarola's next vision, the most important of all, which he imparted on Good Friday. A black cross

rose from the city of Rome, and, reaching the heavens, stretched its arms over the whole earth. On the cross was written '*Crux iræ Dei*'. Amid flashes of lightning the sky turned dense black, thunder pealed, there came a storm of wind and hail. From the centre of Jerusalem rose another cross, golden this time, shedding its rays over the whole world, and on this was written, '*Crux misericordiæ Dei*', and all the nations flocked to adore it.

Should the people of Italy fail to adore this golden cross, thundered Savonarola, woe betide them. What would the penalty be? Invasion from the north. Foreign princes would sweep into Italy: 'barbers armed with gigantic razors', they would bring distress upon Florence 'like a salad of borage, bitter in the mouth; they would carry out reforms like a mill grinding out the flour of wisdom'. He likened the coming invasion to a flood: all who would escape it must take refuge in 'a mystical Ark'.

These sermons met with phenomenal success. Lightning and thunder seemed to strike from the pulpit. Many in the congregation, even the stenographer transcribing the friar's words, broke down and wept. Another century was nearing its end, the reassuring figure of Lorenzo had gone, and for those who had learned from Ficino the value of prophecy here was prophecy on the grand scale. When Savonarola charged Florence with having become through the classical revival an unchristian city, thousands believed him. They ranged from simple men like Luca Landucci, the apothecary-grocer, to Ficino, Pico della Mirandola, Poliziano, Botticelli and Michelangelo, who sixty years later was to tell his biographer that he could still hear Savonarola's voice ringing in his ears. One and all felt the deep atavistic appeal of a renunciatory religion, and showed it in a deeply emotional way, hence the nickname given them by tougher citizens: *Piagnoni* or Snivellers.

Their response was speedy and extreme, a swing in the opposite direction as pronounced as the old one for Cicero and Plato. Botticelli stopped painting nudes and mythological scenes, Girolamo Benivieni exchanged Platonist verse for Christian hymns. Pico decided to join the Dominicans but was to die before he did so, in 1494: Savonarola said he had a vision of Pico burning in Purgatory for his negligent delay. Others more than made up for this: 250

joined the Dominicans, and a new house had to be bought opposite S. Marco, to which it was connected by a tunnel under the street. Savonarola organized squads of altar boys to enter houses and seize playing cards from gamblers, and at Carnival, instead of halting citizens with sticks and demanding money for sweets and masks, these boys sang hymns of repentance. The boys of Florence, the angel-faced boys whom artists had turned into sporting *putti*, now had their hair cut short, above the ears, and became an image of the simple life. 'The Church will be scourged, it will be speedily regenerated, and all this will come to pass quickly.' As Savonarola won a following, he clarified his prophecy. The scourging would be administered by invading armies led by a new Cyrus, and in the resultant disorder a few holy men would regenerate the Church. The centre of regeneration would be Florence. Not Rome, because Rome had become hopelessly corrupt. In his most terrifying vision it was from Rome that the black cross of God's wrath arose.

Rome had indeed sunk very low. In 1483, when the body of the rich Cardinal d'Estouteville was being taken for burial, the friars of S. Maria Maggiore, who were Dominicans, quarrelled with the Augustinians about the gold brocade cloak in which the body was wrapped. A fight ensued, with fists, torches and swords, and when the procession arrived at S. Agostino, the Cardinal's body was bare; cloak, mitre, rings—all had disappeared. In 1489 Domenico Gentile of Viterbo confessed to having forged some fifty apostolic letters or bulls, by washing out part of the writing on a discarded letter, reconditioning the paper with flour and writing in the required dispensation; the forgery fetching up to 2,000 ducats a bull. Domenico and his accomplices were hanged, but most criminals, even murderers, bought their way free. When Cardinal Borgia, then vice-chancellor and later Pope, was asked why justice was not done in Rome he replied, 'The Lord requires not the death of a sinner, but rather that he may pay and live.'

Sixtus IV had authorized brothels, and even made money from them: 60,000 *jules* a year. In 1490 there were 6,800 prostitutes out of a population of under 100,000. Elsewhere they were shunned as *peccatrici*—Savonarola called them 'pieces of meat with eyes'—but in Rome they were beginning to be received into educated society.

Despite useful achievements in scholarship and humanism, the moral tone of the Curia was low. There came a point when Cardinal Ardicino della Porta could stand it no longer. He slipped away secretly one night during 1491, intending to enter a Camaldolese monastery in Tuscany and, as Lorenzo put it, 'to make a new life and practise another kind of religion'. But he was intercepted by an envoy of the Pope and brought back to Rome.

Brunelleschi had once boasted to Pope Eugenius—it was Archimedes's boast originally—that, given a fixed point in space, he would move the world. Savonarola's fixed point for moving the Church was Florence. Here he could freely castigate the abuses which no Pope would allow to be denounced in his own diocese. Here he could hope to reform all Italy. For it is part of Savonarola's attraction that he looked beyond the present corruption and imminent scourging. He believed that Florence would become a new Jerusalem, an example of the good life to all. This is what he called the Triumph of Faith. Botticelli depicted it in a woodcut: Christ on the Cross, flanked to the left by Jerusalem, to the right by Rome and Florence, and in the foreground men eagerly stripping to bathe in the stream of blood that flows from the Cross.

Soon after his arrival in Florence the friar with the burning eyes had predicted three imminent deaths, those of Lorenzo, of Pope Innocent, and of King Ferrante. Lorenzo had died in April 1492, Innocent followed in July, and two years later Ferrante—a vigorous sixty-three—unexpectedly joined them. One other of Savonarola's solemn prophecies remained to be fullfilled: the chastisement of Italy at the hands of foreign invaders: the 'barbers with giant razors'.

CHAPTER 13

Invasion

LOUIS XI had increased the area of France by one-fifth, so that it was now thirty times as large as Tuscany, but his long reign, which ended in 1483, and the century generally, count among the most melancholy in French annals. The mood after the Hundred Years' War resembled that in Florence immediately after the Black Death. 'I have always tears in my eye, I wish for nothing but to die', wrote the poet Deschamps. Chastellain, chronicler of Burgundy, which in 1477 became a French province, describes himself as 'a man of sadness, born in an eclipse of darkness, and thick fogs of lamentation', while his successor, Olivier de La Marche, chose for his device the complaint, '*tant a souffert La Marche*'. The fervent faith and mysticism of the Middle Ages had ebbed, leaving one obsessive image, the grisly skeleton to be found in countless *danses macabres* and *memento moris*, while French noblemen remained virtually untouched by the new classical learning, and its belief that a man might fulfil himself otherwise than through war.

Louis's son, Charles, had been born with a small, puny body, and reared away from court on very few lessons and much hunting, jousting and tennis. This strengthened his muscles and will but left his mind dreamy. The only Latin he learned was his father's favourite tag, *Qui nescit dissimulare, nescit regnare*—The first rule for a king is to hide his feelings—and he was allowed to steep his imagination in romances about paladins and feats of arms. There were few deeds of Roland's which he did not know by heart.

In 1492, the year of Lorenzo's death, Charles celebrated his twenty-second birthday and his ninth year as King. He was an ugly young man, with myopic eyes, a big hooked nose, thick lips, and a straggly reddish beard. His head shook with a nervous tic, and his body was

so small that he had to be lifted into his stirrups. He spoke seldom, and then in a mumble; his hands trembled to such a degree that his signature was an unreadable sprawl. But he had ambitions and a will. In 1491 after a whirlwind three days' courtship he had persuaded Anne, the young Duchess of Brittany, to renounce her engagement to Maximilian of Austria and to marry him instead. Charles gained a pretty, intelligent wife, France the province of Brittany, and when a son was born in due course Charles called the boy, revealingly, Charles-Orland, after his hero. Then he looked round for more adventure.

His father, by crushing the house of Anjou between 1477 and 1481, had gained for the French crown the Angevin claim to the kingdom of Naples. It was a fairly good claim, the Counts of Anjou having ruled Naples for almost 200 years, from 1266 to 1442. Off and on since then many an Italian ruler, even Cosimo de' Medici on one occasion, finding himself in desperate need of an ally, had urged first the house of Anjou, and later Louis XI, to exercise their rights in Naples, and also of course to lend help in the particular crisis. Louis XI had never responded, and it became almost a standing joke in Italy that the French would never do so.

In 1493 the ruler of Milan, Lodovico il Moro, found himself in an awkward situation. He himself was a usurper, and his nephew, Gian Galeazzo, the rightful ruler, had obtained a promise of troops from his father-in-law, Ferrante of Naples, in order to regain the dukedom. Lodovico, a timid man though, like all the later Sforzas, a crafty politician, did not relish facing Ferrante's armies alone. He therefore invited Charles to assert the French claim on Naples.

The French court almost to a man dismissed Lodovico's invitation as quite impracticable, but not so Charles. The kingdom of Naples carried with it the title of King of Jerusalem, and Charles saw himself waging a crusading war through Italy to the Holy Land. He found support for this bold plan in Francesco da Paola, a saintly Calabrian hermit whom Lorenzo had sent to comfort the dying Louis and who had remained in France to establish his order of Minims. Francesco, who had belonged to the strong pro-French party in Naples and there denounced Ferrante's cruelties, believed Charles's rule would benefit that miserable and backward country.

It so happened that on 25 January 1494 King Ferrante died. Charles formally advanced his claim to the throne of Naples, called his army to the colours and, that summer, marched at its head to Lyon, where he solemnly assumed the titles of King of Naples and Jerusalem. Having received, by way of Lodovico, an indispensable loan from the Genoese Bank of the Sauli—100,000 francs at 14 per cent—on 8 September Charles crossed the Alps and next day reached Asti, where he and his advance-guard were welcomed by Lodovico. The French army numbered 31,500 men, ten times larger than the usual Italian army. Twelve days later in Florence Savonarola mounted the pulpit and cried out in prophecy: 'Ecce ego adducam aquas super terram!—Behold I shall unloose waters over the earth!' Pico della Mirandola, listening, said he felt a cold shiver run through him, and his hair stand on end.

The Florentine man in the street had a soft corner in his heart for France. He believed that Charlemagne had rebuilt his city after its alleged destruction by Totila, and tended to see the French in terms of the heroes of his favourite stories, Charlemagne and Orlando, as a nation of fair-minded knights whose role wherever they might be was the preservation of justice and liberty. The educated Florentine took a different view. He realized that France had become a powerful nation state, that French values were different from Florentine, and potentially hostile. The *Morgante Maggiore*, which Pulci wrote with the active encouragement of Lorenzo and his mother, is a prolonged study of chivalry in action, in which admiration is outweighed by amused scepticism. The hero, Morgante, is a giant who uses a big bell-clapper as a club, knocks back a buffalo or a camel for dinner, and picks his teeth with a pine-tree: Pulci uses him to show that the whole idea of gaining one's ends by force is mistaken and ultimately ineffective. In short, responsible Florentines, while sensing the danger from France, did not truly believe in chivalrous values and could work up little enthusiasm for the sword and battle-axe, let alone cannon and bombards. There existed, moreover, a third group, a small opposition party, who actually favoured the French, by whose help they hoped to secure power, and as soon as Charles crossed the Alps the party's leader, Lorenzo's envious and litigious cousin, Lorenzo di Pierfrancesco de' Medici, rode north to join the French King.

In these circumstances the safety of Florence depended on her new ruler, Lorenzo's son Piero. This young man of twenty-two looked like Botticelli: tall oval-faced, with regular features, curly fair hair falling to his broad shoulders, he improvised verses, read Greek and Latin, rode like the wind. As a boy nothing had been too good for him. Aged five, he wrote to his grandmother: 'Please send me some figs, for I like them. I mean those red ones, and some peaches with stones, and other things you know I like, sweets and cakes and other little things, as you think best. We are at Trebbio with Madonna Ginevra, who spoils us.' Aged seven, to Lorenzo: 'Please send us a bloodhound, the best that can be found.' A month later: 'I haven't had that pony you promised me, and because of that everyone makes fun of me.' The pony, we can be sure, was promptly dispatched. One winter he even got Michelangelo to make him a statue of snow. As a result, Piero had grown up to be almost the antithesis of Charles: highly educated but somewhat immature, tending to get his way by charm rather than by action.

Lorenzo seems to have left his son clear instructions: in the event of French intervention in Italy, Florence must stand firm with her allies, Naples and Rome. These instructions Piero followed only obliquely. In the autumn of 1493 when Charles had invited him to declare openly for the French, Piero declined, arguing that this would throw the Pope into the arms of Naples: better, he said, for Florence to remain neutral. This declaration of neutrality, even if only a move to gain time, naturally alarmed Florence's Italian allies, so that when the French invasion had become imminent and Piero, with commendable energy, set about trying to form a united front, both Naples and Rome showed understandable suspicion. Moreover, like Piero, both the Pope and the Neapolitan king faced strong pro-French parties in their own domains, which rendered difficult the expedition of a strong army up the peninsula. Both expected Florence, as the northernmost state of the three, to face the brunt of the French army alone.

When Charles crossed the Alps, a letter from the Florentine ambassador in Milan describing the strength of the French forces added to the sense of doom which Savonarola had already created. Again Piero showed commendable vigour. He demanded military credits,

only to be attacked by one of the twelve procurators, Lorenzo Lensi, who said that resisting the French would ruin Florence. He then began strengthening the fortresses of Sarzana and Pietrasanta, believing like all in Florence that the French army would wait until spring before crossing the Apennines. But by mid-October the French had begun to move down the peninsula in two corps: the first, headed by the Duc de Montpensier, into the Romagna, putting to flight a small Neapolitan force; the second, led by the King, through Pontremoli and Fivizzano, which was captured and mercilessly sacked, into Tuscany. On 26 October Piero, who had sent his brother-in-law Paolo Orsini to Sarzana with reinforcements, rode to take command in Pietrasanta. There he learned that the French had by-passed Sarzana and were advancing on Pisa. He realized that it was now too late to stop the French reaching Florence. But instead of returning home for instructions from the Signoria, he asked for a safe-conduct to the French King's camp.

The two young men met at San Stefano on 31 October. It was an odd situation. Charles called his invasion simply 'the Enterprise'. He and Florence were not at war, yet he needed the Tuscan fortresses to secure his rear. Piero for his part knew the full weakness of Florentine morale and that no help would arrive from the Pope or Naples. It came to him that he might repeat his father's personal triumph with Ferrante, and so he threw himself at the feet of the French King. This action Charles interpreted as a sign not of friendship but of contemptible weakness, and he coldly made known what he wanted: Sarzana, Sarzanella, Librafatta, Pietrasanta, Pisa and Livorno for the duration of the Enterprise, and a loan of 200,000 ducats. The demands were outrageous and Charles never dreamed they would be accepted. They were merely a prelude to bargaining. But Piero, although he had no official powers from the Signoria, decided on a dramatic gesture of complete self-surrender which would, he hoped, win for himself and his people the friendship of Charles. He agreed to the demands, every one of them, there and then, exactly as they stood. He made no protest, no quibble. Charles and his Court were amazed. Their silken white banners were inscribed '*Voluntas Dei*' and '*Missi a Deo*'. Now they really began to believe their own slogans, for Piero's behaviour seemed to them nothing less than a miracle.

Piero returned to Florence on 8 November and next morning went to the Palazzo della Signoria with an armed bodyguard to give an account of his meeting with Charles. The Florentines were angry with their 'schoolboy leader'—Piero found the main gate shut and was told that he alone would be admitted by a side door. Piero replied by a gesture of contempt. Some of the magistrates came down and after a hot argument again shut the gate in Piero's face. They then summoned the people by ringing the *Vacca*. Some cried to Piero, 'Go away; don't disturb the Signoria'; some hissed, others threw stones. Again Piero did not know what to do. He stood threateningly with drawn sword, but did not attack. Finally his attendants hurried him back to his house. Cardinal Giovanni raised the old magic cry of '*Palle, palle*', but this time no one responded, and Giovanni returned home to kneel at his window with clasped hands, praying Heaven for mercy—Landucci glimpsed him there and felt a stab of pity. The people's mood continued generally threatening. They were angry at Piero's high-handed behaviour. Later that day all three Medici brothers fled the city, the Cardinal disguised as a Franciscan friar, to seek refuge, as Cosimo had once done, in Venice. The Florentines sacked their palace and set a price on the heads of Piero and Giovanni.

By expelling the Medici the Florentines were expressing their disapproval of Piero's ill-advised methods, not of his capitulation. They did not dream of resisting the French. Savonarola, now the most influential figure, twice went as ambassador to Charles, hailing him as an instrument of the Lord, 'sent to relieve the woes of Italy, as for many years I have foretold'. In a movement of abasement scarcely less extreme than Piero's he begged mercy for the Florentine people who, if they had sinned against Charles, had done so mistakenly. Any resistance the French had met, he said, was all Piero's fault.

Charles named 17 November as the date of his entry into the *gran villa*, as he called Florence, and sent his quartermasters ahead, chalk in hand, to mark the best houses as billets. Shocked and stunned, in the week that remained before the King's entry the Florentines tried to make sense of those two startling events: the arrival of the French and the expulsion of the Medici. Gradually an

explanation was evolved by the anti-Medicean party. Charles had been sent by God to Naples and Jerusalem. Florence was a city of peace and Piero had betrayed the city's peaceful traditions by trying to resist Charles. Charles was now entering the city in order to confirm the city's freedom from Piero. He was a liberator and must be welcomed as a liberator. And so great panels were set up announcing in gold letters 'Peace and Restoration of Liberty', a medal was cast for Charles inscribed *Victoriam Pax Sequitur*, with an image of Victory, whose chariot is led by a man holding an olive branch, while Botticelli's pupil, Filippino Lippi, was commissioned to construct, with all the resources of Florentine art, an elaborate *Trionfo della Pace*. Even defeat was turned into something beautiful.

On the fourteenth, while bells rang peals of joy from a hundred churches, Charles's soldiers paraded through the streets of Florence, and the Florentines, crowding windows and roofs, saw for the first time the army to which they had surrendered. First came bass drummers and fifers, followed by seven sergeants abreast carrying gleaming halberds: one Florentine, unfamiliar with modern arms, described these as 'long burnished steel bill-hooks', while to others they must have seemed to be in terrible reality Savonarola's 'giant razors'. A whole troop of German mercenaries armed in this way was followed by cross-bowmen, Scottish archers, more drummers, and musketeers led by a Herculean figure carrying a pike on a young undressed oak tree. Then came the Swiss, the pikemen, the King's own company of halberdiers, the cavalry, the ears of their chargers clipped, the gentlemen lancers, mounted crossbowmen and archers of the royal guard in fours. Altogether 12,000 soldiers, and this was only a third part of the total French expedition, military and naval. The Florentines had never seen anything like it before. Savonarola must surely be right—this was the hand of God.

Charles, in gilt armour and a cloak of cloth of gold, on his head a white cap surmounted by a crown, received from the Priors the keys of the city. At sunset he reached the Cathedral and amid wild cheers dismounted. 'When we saw him on foot,' says Landucci, 'he lost a little of his prestige, for he was indeed a very small man.' None the less, after Mass, as Charles rode to lodge in the Palazzo Medici, the people cheered as loudly as ever and shouted '*Viva*

Francia!' 'Never had there been such happiness, nor such honour given sincerely and without adulation; we put in him all our hopes of peace and quiet.' Peace was the key word.

On the twenty-fifth a treaty, drafted by Florentines, was ready for signing, and this provided the occasion for one brave act. In the presence of Charles and Florentine notables an official read the document aloud. It was pretty fulsome. Charlemagne had restored the fabric of Florence, devastated by the Goths, but Charles VIII, because he had restored Florentine liberty, deserved to be called Greater and Greatest, *Major et Maximus.* Florence left in the King's hands for the duration of the Enterprise the fortresses he had already occupied, and would pay him 120,000 ducats. When this figure was read out, Charles, who had previously agreed with the Signoria on 150,000, rose to his feet. Trumpeters, he threatened, would call his men to arms. The French courtiers made similar threats. Piero di Gino Capponi, a former ambassador in France, turned red when he heard them and, angrily seizing the treaty, tore it into small pieces. 'If you sound your trumpets,' he cried, 'we will ring our bells, and the whole city will fly to arms.' Others said likewise; then Piero stalked out of the room. 'Ah! Capponi, Capponi, you are a bad capon', said Charles, but that day he signed the treaty with the indemnity left at 120,000 ducats.

Eleven days Charles and the French army remained in Florence. They had intimated that they would pay all their expenses, but when it came to a settlement 'they paid for the horns and ate the ox'. However, 'not one of them used an unsuitable word to a woman'. Incidents were few and accounted for ten men killed in all.

As the French marched south to Rome Savonarola, his prophecy fulfilled, found himself more powerful than ever. He persuaded the people to fast three days in the week on bread and water, and two more on bread and wine: one consequence was that the butchers suffered and had to be given a special tax reduction. Savonarola purged S. Marco of its illuminated books, its gold and silver crucifixes. In Lent his boy recruits raided houses and requisitioned playing cards, dice, harps, lutes, scent, looking-glasses and carnival masks. The Great Reform, that was to spread through Italy and across the world, had now begun. Soon Charles would sail for Constantinople;

the Turks would be conquered or converted, and all men would be brothers under the sign of the triumphant Cross.

The French army reached Rome, which fell with no more resistance than Florence. Only one man might stop the French now—Alfonso, the new King of Naples and the best soldier in Italy. But Alfonso panicked. He thought he saw the ghosts of barons he had put to death. The ghost of Ferrante appeared three nights in a row to Alfonso's surgeon, warning that resistance was useless, the royal line being doomed because of its abominable deeds. On 23 January 1495 Alfonso abdicated. Wailing that he heard the thud of the French troops, that the very trees and stones cried 'France', he fled with his treasure and wine to the Olivetan monastery of Mazara in Sicily.

Charles continued south as easily as on a peacetime parade. Cavalrymen dispensed with the iron spurs of battle, wearing instead light wooden pegs inserted between the heel and upper of their boots, such as mule-drivers used. This prompted the Spanish Pope to say: 'The French came into Italy with wooden spurs, carrying in their hands chalk to mark their billets.' On 22 February Charles entered Naples to cheers and the peal of bells: the people, they told him, had awaited his coming as eagerly as the Jews the Messiah.

Charles's original intention had been to secure an Adriatic port, and there embark on crusade. But as spring came, the city of the sirens exerted its old spell. 'An earthly paradise, though without Adam and Eve,' wrote one of Charles's court. Eve, however, soon appeared in the person of Leonora di Marzano, wife of a Neapolitan nobleman. Strikingly pretty and also a daring horsewoman, she enchanted the French King. Other dark-eyed Neapolitans granted their favours to Charles, who had their portraits painted in a special album. His troops too relished the fruits of victory, the soft climate, the sweet wine. And the mood grew: This is the promised land— why go further?

Meanwhile, Italians in the north drew belatedly together. Lodovico now regretted having called in the French, since the Duc d'Orléans had crossed the Alps also, and he had as good a claim on the dukedom of Milan as Charles on Naples. On 31 March 1495 Lodovico, the Pope, the Venetian Republic, Maximilian, and Ferdinand of Spain concluded a Holy League for the expulsion of the

French from Naples. Charles realized the danger but it was not until 20 May that he could bring himself to forsake the siren city. Leaving a strong garrison to hold Naples, he began the long march home.

In July the French army, numbering 9,500 men, was winding across the Apennines, accompanied by 5,000 mules loaded with gold, plunder, the royal insignia and Charles's album of pretty women. In the plain below waited Francesco Gonzaga, Marquis of Mantua, a small, tough, blackbearded professional soldier at the head of 30,000 fresh troops, determined to wipe out ten months of shame with a crushing victory. Despite the favourable odds Francesco disliked the idea of a pitched battle and devised what, on paper, looked a clever plan. As the French filed along the narrow road on the left bank of the River Taro, the Stradioti, light scimitar-bearing cavalry recruited in Dalmatia, were to pin down the vanguard of 350 heavily armed knights and 3,000 Swiss infantry, while Francesco and his best *condottiere*, Bernardino Fortebraccio, raced upstream, forded the Taro and attacked the main French force from the flank.

Francesco left out of account one vital factor—heavy rain had fallen in the past few days. When he rode upstream, he found the River Taro in spate and too deep to cross. He rode to a shallower ford and crossed there, only to find an unexpected obstacle: a deep canal with steep, slimy banks of clay which fed water to a near-by mill. At this point, while Italian horsemen floundered and slithered on the clay slopes, the French attacked. The Dalmatian cavalry, after a first successful charge, had spied the gold-bearing mules and galloped away to loot.

The battle of Fornovo lasted only fifteen minutes, but it was the bloodiest Italy had known for 200 years. Men hacked at one another with swords, pikes and halberds; horses reared up and plunged in the constricted space, as though in a battle scene by Bertoldo. The Italians broke and turned. For a further forty-five minutes the French pursued and killed them. At the end of that time 4,000 dead were left on the battlefield, two-thirds of them Italian. Charles quickly reached Asti and crossed the Alps. Nobody pursued him.

Francesco Gonzaga maintained in the teeth of the facts that he, not Charles, had won the battle: he even got Mantegna to paint a

Madonna of Victory, with himself in full armour, and struck a gold medal: *Ob restitutam Italiæ libertatem*. No one was taken in. Italians recognized the defeat for what it was: one of these decisive moments when the soul of a nation, being tested, fails. Abroad, pulses quickened. It was obvious now that any power that wished could invade Italy and get away with it.

Florence had not joined the Holy League: she still clung to her alliance with France. But her main concern was moral regeneration. Savonarola's fierce sermons and even his increasingly bold demands —he urged citizens to make interest-free loans to the Commune— swelled the ranks of *masticapaternostri* (prayer-mumblers), as scoffers called them. Among those who entered S. Marco were Giorgio Vespucci, uncle of the navigator, and six brothers of the Strozzi family. Now more than ever they wanted to make Florence 'a new Jerusalem', which would set the world an example of good living.

With this in mind, during Carnival 1497, instead of drinking and ribaldry, Savonarola arranged a procession of children carrying a statue of the Child Jesus by Donatello, one hand raised in blessing, the other holding the nails and crown of thorns. But he did not stop at this. On Shrove Tuesday he exhorted Florentines to erect in the middle of the Piazza della Signoria a pyramid of wood nearly sixty feet high, having eight faces with fifteen steps on each face. Here they piled their 'vanities'. 'On the first step valuable foreign tapestries, full of immodest figures; above these, on the second step, were many images and portraits of beautiful women, Florentine and others, made by the most excellent artists, painters and sculptors'—Botticelli among them. Higher up were stacked ivory and alabaster chessboards, playing cards, musical instruments, and books of music; chignons of hair, scent, looking-glasses, books of poetry, both Latin and Italian; copies of Boccaccio, Petrarch and the *Morgante Maggiore*. 'The value of the works was such that a Venetian merchant offered 20,000 *scudi* for them; when this became known an effigy was made of him and placed on top of the pile, in a chair, as the prince of those vanities.'

A man with a blazing torch set fire to faggots inside the pyramid and flames began to crackle round the vanities. In what was called

the Festival of the Higher Folly, three groups formed a circle round the fire: elderly men on the outside, in the middle young men, in the innermost ring Dominican friars and boys dressed as angels. Their heads wreathed with leaves, they danced round the flames, chanting a song composed by one of Lorenzo's friends, Girolamo Benivieni: 'Three ounces of hope, three of faith, six of love and two of tears: put them all in the fire of fear.'

The beauty of Florence, the civilization she had created—going up in smoke. Why did the Government allow it? The answer is that Savonarola to all intents and purposes had now become the Government. It was his sermon in July 1495 attacking the system of *parlamento* which secured the law abolishing *parlamenti* the following month, and in October, when Piero de' Medici made an unsuccessful attempt to return, Savonarola, crucifix in hand, openly and loudly counselled the citizens to put to death all who sought to re-establish the Medici. From now on, he insisted, Florence would be ruled by paternosters. The Government would favour virtue, but in the Christian not the classical sense. Virtue consisted in renunciation, simplicity, suffering. So the Florentines struck a new silver coin: on one side the Florentine lily, on the other a cross, and the words *Jesus Christus Rex Noster*. Florence's new ruler was Christ—as Savonarola saw him.

Like Columbus, Savonarola had a sense of divine mission based on prophetic interpretation of Scripture; he was haunted by the *Quattrocento* nearing its end and looked forward to a golden age in the new century, one of simplicity not of civilized living, when all unbelievers would enter the one true fold. It was precisely on this point that Savonarola gained his strongest grip. With their long ecumenical tradition, expressed in the Council of 1439 and the books of Ficino, many educated Florentines believed that the friar's spiritual brand of Christianity would facilitate union with other religions. In one of his poems Giovanni Nesi, a friend of Pico and Ficino, salutes the new age when Moslems would enter the one true fold and Rome would be destroyed: always this fundamental belief that the one great obstacle was Rome.

The ruler now in Rome was a Spaniard. In the conclave of 1492 Roderigo Borgia, after thirty-six years in the Curia the wealthiest

cardinal, had promised lucrative posts to those who gave him their vote and, as Burchard puts it, 'immediately after his election, distributed his goods to the poor': to this cardinal a palace and castles, to that a bishopric and a cellarful of wine. He was fat, bald, with a receding chin, and subject to fainting fits, but 'he drew women as a magnet draws iron'. He had six children, for whom he sought political power. One bore the revealing name of Cesare. He himself took the name of Alexander, not after a saint, but after Alexander the Great.

This Spanish Pope had a shrewd sense of politics. He had taken a leading part in forming the Holy League against Charles. He saw that Italy must unite if she were to save herself from foreign invaders, and that Savonarola's pro-French sermons constituted a threat to unity, and a temptation to the French to return. Early in 1496 he tried to win over the friar, offering him a cardinal's hat if he would change the tone of his sermons. 'Give me another kind of red hat,' was Savonarola's defiant answer, 'one red with blood.'

In 1493 Savonarola had secured independent status for the Tuscan Dominicans. Alexander wished again to bring them under control of the Roman congregation, for this would make it possible to post Savonarola away from Florence. Savonarola rejected any idea of a change of status. Simultaneously he stepped up his prophecies, and these prophecies, he claimed, came directly from God. Now this was something no Pope could tolerate, since the Holy Spirit spoke through one man only, St Peter's successor in Rome. Alexander warned Savonarola about his prophecies. But the friar continued more violently than ever. Finally, on 18 June 1497, the Pope published a Brief in which he charged the Dominican with preaching dangerous doctrines and with disobeying him regarding the independent status of the Tuscan congregation: on these grounds he excommunicated Florence's hero.

The effect on Savonarola can be easily imagined. He found himself cut off from the Church he longed to reform, forbidden to say Mass, forbidden to preach. In this long summer of darkness, he prayed intensely, made a retreat and struggled with his conscience. Genuinely he longed for reform. Could others achieve what he was forbidden to do? A Council, for example? He began to doubt it. 'A Council

would have to make its own reformers. It would have to punish all the evil clergy, and perhaps there would be left none who were deposed.' As for Alexander's excommunication—was it binding? The Council of Constance had laid down that if excommunication was unjust it had no validity. No one more than Savonarola believed in the justice of his own cause. And so, during six months' silence and prayer, he groped for a way forward.

On Christmas Day 1497 Savonarola made his choice. That morning in the Church of S. Marco he celebrated Mass three times, thus openly challenging the Pope, whose excommunication he declared unjust and invalid. In a sermon in February Savonarola explained his defiance: 'When the agent withdraws himself from God, he is no longer an instrument; he is a broken iron. You will ask how I am to know when the agent fails. I answer: compare his commands with the root of all wisdom, namely good living and charity: if they are contrary thereto the instrument is a broken iron, and you are no longer bound to obey.'

This of course was an old claim. John Huss and Jerome of Prague, to mention only two, had declared before him that provided they acted in a perfect spirit of charity, they could disregard the letter of the law. Savonarola had already done so on one significant point. In direct contradiction to the Church's ruling he permitted married women to enter convents, and even to separate from their husbands, against the wishes of the latter. Theologically, Savonarola was treading dangerous ground. The Church's teaching on these matters was clear and St Catherine of Siena had once put it in writing to the Signoria of Florence: even were the Pope a devil incarnate, he ought to be obeyed in obedience to God, whose vice-gerent he is. St Thomas Aquinas, foreseeing just such a dilemma as Savonarola's, had prescribed not resistance but prayer. Well might Savonarola quote Peter's words to the high priest: 'God has more right to be obeyed than men'; history proved unerringly that the touchstone of sanctity is obedience to those in lawful authority. Be a man as holy as St Francis, as soon as he set himself up against his spiritual superiors his holiness turned to pride.

The citizens of Florence sensed this, and when the Pope threatened them with an interdict, and its consequence, economic sanctions,

they asked Savonarola to stop preaching. The Dominican had no choice now but to bow to the wishes of his supporters, and on 18 March he preached a farewell sermon, lashing the Church as a protector of whores, and its power as hellish and Satanic. Then the thunderbolts ceased and in the calm that followed political issues again became dominant. Charles had broken his promise to hand back Pisa and the Florentines, despite a long siege, had failed to recover the town. The loss of Pisa had followed directly from Savonarola's prophetic utterances and political advice. By what right, his enemies began to ask, did he set himself up as divinely inspired? The Franciscans in particular challenged the Dominican to produce some visible sign from God. Savonarola had always claimed to be one of those prophets like Jonah and John the Evangelist who rely on the bare word, not on wonders. But one of his colleagues, Fra Domenico da Pescia, volunteered to prove his belief in Savonarola by undergoing an ordeal by fire.

The Franciscans associated Savonarola and a third Dominican in this misguided offer, and on 7 April Florentines flocked to the Piazza della Signoria, expecting to get a final answer that would set their minds at rest. Faggots soaked in oil and pine resin had been laid on a platform seventy-five feet long, with a path three feet wide down the centre, for Savonarola and his two colleagues to walk. The whole idea of ordeal by fire was retrograde, and the procedure uncertain. After prolonged discussion Fra Domenico insisted on carrying a crucifix and, when this was agreed, changed his mind and insisted on carrying the Blessed Sacrament. The magistrates decided that that would be sacrilege and forbade it. Fra Domenico refused to enter the flames without the Blessed Sacrament. Then rain began to fall, damping the faggots, and the magistrates called the ordeal off.

The Florentines had worked themselves into a state that only a miracle could satisfy. Disappointed and angry, they believed that Savonarola had shirked the ordeal and turned against him with all the sudden unpredictable violence of mob emotion. They hated him now, hated him for losing them Pisa, for getting them into trouble with the Pope, for making them, under what now seemed false pretences, burn the beautiful things of Florence. Next day, Palm

Sunday, a crowd stormed S. Marco with clubs and swords. They killed those friars who offered resistance and seized Savonarola, whose arrest the magistrates meanwhile ordered. He was thrown into that same tiny prison, the *Alberghettino*, where Cosimo de' Medici had once been held.

Put to torture by the *strappado*, Savonarola confessed to all the enormities his examiners proposed. His prophecies had been based on what six Dominican spies learned in the confessional. He had fraudulently usurped the name and office of a prophet, hence for twenty years he had been living in mortal sin and to avoid sacrilege deliberately omitted the words of consecration during all the Masses of that long period. One item in his confession typifies the pettiness of the examiners who concocted it. On a certain day Savonarola had prophesied an attempted poisoning. Then, it was charged, he ordered the convent cook not to touch gifts of fish on a coming fast day, while secretly arranging for the delivery of a fine lamprey containing poison. At dinner he reminded the friars of his prophecy and, falling on his knees, begged God to protect His servants. Then he had the convent cat brought in and offered it a piece of the poisoned lamprey. Soon after eating the lamprey the cat died. This had lifted to new heights Savonarola's prestige as a prophet.

To forty-two pages of deceptions such as this the wretched Savonarola confessed under torture. 'When I heard this confession read out', says Landucci, 'I stood in stupor and amazement. My soul was grieved to see so grand an edifice fall to the ground because it was built on the sorry foundation of a lie.' As most of the friar's followers melted away, the Pope's Spanish commissioner arrived in Florence. 'Make me a good fire,' he said, 'I've brought sentence with me.' Savonarola was found guilty of heresy, schism and disrespect for the Holy See, and handed over to the secular arm. On 23 May 1498, with an iron collar round his neck, he was hanged in the Piazza della Signoria. In the last terrible Festival of the Higher Folly, a fire was lit and his body consigned to the flames. Then his ashes were thrown into the Arno.

The ashes of Florentine hopes could not so easily be cast away. In a little over four years Florence had experienced three profound catastrophes. First, Charles and the French army had shown her the

new nation state in action, her own greatly reduced status in the order of things, and her probable powerlessness to remain a free and independent State. Secondly, in burning her 'vanities' she had turned her back on the great classical civilization built up so laboriously over the century. She had done so in the hope of reforming the Church, but that hope had been shattered in a third and final catastrophe, the failure and death of Savonarola. Some like Ficino had come to consider the friar anti-Christ, others like the poet Benivieni believed him to have been at heart a holy man, but all recognized a fundamental failure to impose on the Church the Florentine ideal of Christianity.

As the flames died in the Piazza della Signoria, it became clear to the Florentines that their golden age was over. Silence fell on the numbed city as it awaited the century's end, the final closing of the shadow. Michelangelo had left in 1494, Pico died in the same year, Pollaiuolo in 1498, Ficino a year later. Only Sandro Botticelli was left with the courage and gifts to express if he could the profound sadness in the people's soul.

Botticelli had been a devoted follower of Savonarola and renounced the painting of nudes because the friar condemned such works. He had suffered profoundly from Savonarola's confession, trial and death, and sought to understand them. At eight in the evening of 2 November 1499, he happened to be at home with a visitor: Doffo Spini, one of the men who had examined Savonarola. Tell me the plain truth, the painter said to Doffo. What wrong did Savonarola do to deserve so infamous a death?

'Sandro, do you really want the truth?' said Doffo. 'We never found any sin in him, either mortal or venial.'

'Then why did you sentence him?'

'I didn't. It was Benozzo Federighi [one of the seventeen commissioners who conducted Savonarola's civil trial]. If the prophet and his colleagues hadn't been put to death, if they'd been sent back to S. Marco, the people would have rushed on us and cut us to pieces. It was either their lives or ours.'

Botticelli then realized the truth behind the official lies: that his beloved Dominican preacher, misguided perhaps in his decision to defy the Pope, had been innocent of fraud and perfectly sincere in all

his claims. Florence's political defeat, with all that it entailed, and the moral defeat in the unjust death of Savonarola fused into a single tragedy. How could he express that tragedy? European painting offered no precedents, for Botticelli, good Florentine that he was, refused to see the fate of his city in terms of traditional martyrdoms: an all too easy solution whereby present misery is offset by future happiness. He was concerned with the present only, with the terrible fate of generous ideals. Once again it was the classical past which provided a suitable equivalent, in two episodes from early Roman history. The first tells how Sextus, son of Tarquinius Superbus, King of Rome, ravishes his cousin's wife, Lucretia. As soon as Sextus has departed, Lucretia sends for her husband and father, tells them what has happened, enjoins them to avenge her dishonour, then stabs herself to death. This Botticelli painted as *The Rape of Lucretia*. A remarkable change has taken place since *The Birth of Venus*. Spring has yielded to winter, the wide expanse of sea and countryside to constricting buildings, nude or nearly nude figures to those plain and simply clothed, the vertical flowing lines of birth to the recumbent horizontal figure of the dead Lucretia.

Even more harrowing is the second episode, which Botticelli painted as *The Story of Virginia*. Virginia, a centurion's daughter, is engaged to be married to a tribune of the people. Her beauty excites the lust of the decemvir Appius Claudius, who instigates one of his clients to seize the girl and claim her as his slave. Virginia's father, arriving just as Claudius has assigned the girl to his client, snatches up a butcher's knife from a near-by stall and plunges it into his daughter's breast, exclaiming 'There is no way but this to keep you free.' In his painting of the story Botticelli again centres attention on the recumbent figure of the dead girl, conveying a mood of outrage and hopelessness, while the two pictures together reveal the same intense vision: Florence as a fair and innocent young girl who fell in love with all that was finest in life, who went trustingly into the world to pursue her love, and the world defeated her.

Both Lucretia and Virginia were later avenged, but Botticelli avoids any hint of this and clearly did not see any likely avenger for Florence. Indeed for what was probably his next picture he chose a subject from the Old Testament where again a tyrannical action is

perpetrated, but this time without redress. King Ahasuerus wishes Vashti, his queen, to attend a certain magnificent feast; she declines, whereupon Ahasuerus deposes her. In Botticelli's painting of the scene, known as *La Derelitta*, Queen Vashti becomes a symbol of 'inner', spiritual Christianity, dishonoured none knows why. Seated in torn garments, weeping and bowed with grief between a locked gate and an empty tomb, she is perhaps the most poignant figure ever painted in Florence.

Not everyone in the doomed city showed Botticelli's pathos and restraint. Horror, panic and anger were more usual reactions. One Florentine woodcut, based on a sermon by Savonarola, is a throwback to medieval fears long cast out from Florence though still the rule in France: it depicts a loathsome skeleton swinging a scythe through a field of corpses and ruins. Pico's friend, Girolamo Benivieni, sent shivers through the Florentines with poems about the imminent Last Judgment, and this mood reached its peak in a series of frescoes depicting the End of the World, the Judgment and related scenes, which Signorelli began in Orvieto Cathedral about 1499. Again, the subject is retrograde. It had been central to the Florentine achievement to think of Christianity in more generous terms than that of punishment—until Savonarola came. But the treatment is new and almost unbearably terrible, for on the one hand Signorelli celebrates the human form, on the other he shows what can happen to it at the hands of devils who are no longer monsters but believable hairy men with muscles like tough mercenary troops and brutal expressions. Adding an apocalyptic note in key with the date, he shows anti-Christ preaching, and anti-Christ is none other than Savonarola.

Botticelli did not paint a Judgment. His spirit was a soaring one, and he did not think in those terms. But at the turn of the century he too underwent an apocalyptic mood. In the wake of the French withdrawal the Pope's ruthlessly cruel son, Cesare Borgia, was achieving Girolamo Riario's dreams under Sixtus IV: carving out for himself with the sword a State in central Italy. Botticelli saw Cesare if not as anti-Christ at least as a devil, and his *Nativity*, painted under the influence of Savonarola's prophecies, carries what is probably a reference to Cesare: 'This picture, at the end of the year 1500,

in the troubles of Italy, I, Alessandro, painted during . . . the loosing of the devil for three and a half years: then he shall be chained according to the 12th [chapter of the *Apocalypse*], and we shall see him trodden down as in this picture.' The incident of the devil, however, plays only a small part in the painting, which centres on the nativity, symbolic here of the Church's renewal, and on peace in the shape of six figures grouped like those Botticelli had watched during the burning of vanities: three young Florentines in long robes crowned with olive, who carry olive branches and exchange a kiss of peace with three angels.

But Cesare Borgia was not trodden down. He continued his path of destruction. Joining forces with a new French army of invasion, during 1501 he laid siege to Capua in the name of his father the Pope. On 24 July he entered the town, which had been betrayed to him, and in cold blood massacred 5,000 of its inhabitants. It was probably the cruellest deed ever perpetrated in the land of Italy, and every year on that day the bells of Capua Cathedral have tolled. The effect on all those Florentines who still longed for a holy Church and peace can well be imagined. Botticelli undertook no further important commissions. Prematurely old, he hobbled about the city with the help of sticks. He had no money, partly because Florence had fallen into serious economic difficulties: as early as 1495 the Banker's Guild had dwindled to the point where offices could not be filled or records kept. And still the expected heavenly justice did not appear. No one arose to avenge Lucretia and Virginia. Botticelli's sense of loss had grown to the point where classical imagery could no longer convey it. He seemed to be reliving another Golgotha, and it was this vision which demanded to be expressed. His powers were failing, but he took up his brush to depict in one last cumulative painting the whole series of tragedies: humiliation by the French, the prophecies and failure of Savonarola, a militant Papacy, above all the sense that his golden city was doomed. *Magdalen at the foot of the Cross* is the supreme expression of Florence's agony just after the turn of the century. On the right stands an angel holding a rod and what appears to be a young fox. In the sky a number of shields blazoned with the Cross fall from heaven towards a bank of angry clouds, in which are a number of devils who hurl flaming brands upon the earth. The

shields have evidently been sent by the Almighty as a defence against the brands. But as the brands fall they ignite everything in a general conflagration, which approaches the walls of Florence on the left of the picture, while Mary Magdalen, prostrate, embraces the upright of the Cross in a movement of love and horror and despair.

CHAPTER 14

Aftermath

THE ACTUAL FALL of Florence came quickly. In the thirty years after 1494 Italy was invaded by two more French kings, by Austrians, Germans, Swiss, Flemings and Hungarians. Finally it was Spanish power, backed by gold discovered in the wake of Columbus and Vespucci, that decisively crushed Florence. In 1529 the Prince of Orange laid siege to the city with 40,000 mainly Spanish troops and heavy artillery. Florence had at last mustered a citizen militia, numbering 14,000, but having no suitable general, entrusted them to a Perugian, who refused to march against so powerful an enemy. Michelangelo strengthened the walls and, in a revealing incident, tried—in vain—to protect the beautiful belfry of S. Miniato against Spanish gunfire by hanging its walls with mattresses. In August 1530 Florence fell, immediately lost her independence, and had to accept the first of a long line of Dukes nominated by the Emperor Charles V. Thereafter until the nineteenth century Florence was to remain a vassal State, first of Spain, then of Austria. Her decline, which had begun in 1494, became even more pronounced, for the basis of all her achievements had been freedom.

The single most important cause of Florence's fall—already implicit in the capitulation of 1494—was the rise of the nation states, whereby Florence found herself reduced to a second-rate power. This occurrence lay beyond Florence's control: it was, in the language of the day, the working of Fortune. There were also, of course, subsidiary causes. If the Florentines had lived up to the classical ideal in so far as it obliged citizens to undergo military service and defend their own city, they might have warded off the invaders for a time and in so doing rallied the other powers of Italy. Again, if they had not been carried away by Savonarola's prophecies, and his equation

of Christianity with humility and suffering, they might have remained true to their duties as free and responsible men. But it has to be remembered that the Florentines had developed their civilization with exceptional rapidity, so that there were bound to be some faults in the structure.

It is one of the saddest symptoms of Florence's decline that after the turn of the century Florentines refused to face up to these facts. In a sweeping rejection of the past comparable to Plato's denunciation of the Periclean age after Athens's defeat by Sparta, Francesco Guicciardini (though in later life he was to revise his opinion) laid the blame for Florence's fall on Lorenzo de' Medici, a tyrant, he claimed, who had undermined the city's will to resist. The whole concept of living as 'new Romans' had been mistaken. 'To do as the Romans did, we would need to have a city in like circumstances as theirs. To attempt it with means so inferior as ours is to require of the ass the fleetness of the horse.' Guicciardini sounds a new note of fatalism which would have shocked Coluccio and Bruni: 'All cities, states and governments are mortal, since either by nature or accident everything in this world must some time have an end.'

Florence's sense of loss and powerlessness after 1494 found their embodiment in Niccolò Machiavelli. A lawyer's son, Machiavelli had grown up during the age of Lorenzo and was aged twenty-five when the French marched in. Shocked by Florence's collapse, he set himself to organize a citizen army similar to Bruni's, but failed. He served on diplomatic and other missions but constantly withdrew. His salary, he claimed, was insufficient; more probably, he disliked working as a subordinate. He tried to win real political power, but his sarcastic smile, aloof arrogance and poor understanding of men were against him. When the Medici returned in 1512 he was dismissed from office and had to retire to his small country property, dividing his time between snaring thrushes and dicing at the local inn. In the evening he dressed up in his best clothes and entered his study in order to commune with the great men of the past, and from these communings produced two important political works, each of which, however, embodies substantially different views, in this reflecting not only the author's edgy frustration but Florence's as well.

In the *Discourses upon Livy* Machiavelli praises the Roman Republic

as an example of an effective state united by the public spirit of its citizens. In scope and energetic argument it is the most brilliant of those defences of republican principles which had originated in the *Quattrocento*. But these principles, like the fine clothes Machiavelli wore when composing them, were not suitable to everyday life. Machiavelli believed that every so often, and never more than in his own lifetime, a republic needs a strong, ruthless leader, and this view he develops in *The Prince*.

Machiavelli analyses the quip that Charles VIII conquered Italy with a piece of chalk. 'Because of our sins', said Savonarola. Yes, but not the sins Savonarola thought, rather the sins of relying on mercenary troops and the weak fibre of Italian generals. Machiavelli calls for a dictator in the Roman sense who will have the strength to save Italy. 'Men must be either pampered or crushed.' Savonarola failed because he was unarmed, and so 'had no way of . . . forcing the incredulous to believe'. 'If a prince wants to maintain his rule he must learn how not to be virtuous . . . Generosity results in a prince being despised and hated . . . It is far better to be feared than loved if you cannot be both.' A prince must imitate both the fox and the lion. He must make a show of religion. He must know how to be 'a great liar and deceiver'. And the model prince, the paradigm whom Machiavelli dares to hold up to the Florentine people, is none other than that ruthless cut-throat, Pope Alexander's son, Cesare Borgia.

The Prince is the work of a man with an obsession. Where Savonarola had been a fanatic of religion, Machiavelli is a fanatic of power. Everything is made subordinate to military power. 'Since where there are good arms, good laws inevitably follow, I shall not discuss laws but give my attention to arms.' 'Look at the duels and the military skirmishes, how the Italians are superior in strength, in skill, in inventiveness; but when it is a matter of armies, they do not compare. All this is because of the weakness of the leaders.' It was not. Machiavelli had a better understanding of Alexander and Agathocles and Hiero of Syracuse than of his own people; he failed to see that Cesare Borgia was more Spanish than Italian, and that for a Florentine to imitate such a tyrant would be not only psychologically monstrous but also, after so long a republican tradition,

an impossible reversal of history. He failed also to understand the all-important part played by religion in Florence's achievements. The lesson he drew from 1494 was the necessity of losing one's soul in order to save one's city. But then the city would no longer have been worth saving.

A guilty rejection such as this of the very values underlying former greatness is one of the marks of a civilization in full decline, and though painful to dwell upon, such symptoms as Machiavelli's *Prince* and—final betrayal—his equation of *virtù* with ruthless military prowess, serve to illustrate by contrast the healthiness and distinction of the age which had passed. The Florentines had lost confidence in themselves. They believed that something irreplaceable had perished in their city. They were right. But it had not wholly perished. The civilization which the Florentines had created, the work of Bruni and Brunelleschi, of Toscanelli and Leonardo, of Botticelli, the magnificent Lorenzo and so many others, was too true to man's profoundest aspirations to die completely. It had not perished, simply been removed elsewhere.

At the very climax of Florence's tragedy, Charles VIII and his court had been experiencing the joy and wonder of discovery. They had stared unbelievingly at such buildings as the Medici palace, which Commynes described as 'the finest house of a citizen or merchant that I have ever seen', and the Florentine-designed Castel Capuano, where Charles lodged in Naples. They visited churches, marvelled at Italian sculpture, 'and also I have found most excellent *painters*,' Charles excitedly wrote to Pierre de Bourbon on 28 March 1495. 'I shall send you some to make the most beautiful ceilings imaginable. The ceilings of Baux, Lyon and other places in France cannot compare with these in beauty and richness.' Charles took back to Amboise twenty-one artists and fine craftsmen. They included three architects, a landscape gardener, goldsmiths, a maker of marquetry, a builder of organs and a ladies' dressmaker. He shipped home manuscripts, tapestries, pictures and marbles weighing thirty-four tons. He engaged Lorenzo's librarian, Giovanni Lascaris, to establish the serious study of Greek in France: one of his pupils, Budé, was to found the Collège de France, an important centre of humanist studies. Charles's court poet had started on the Italian campaign ignorant of classical

allusions, but by the time Fornovo was fought he was hailing the French king as '*vray filz de Mars, successeur de César, compaignon de Pompée, hardy comme Hector*'.

Valla, Pico and Ficino became influential authors at the Sorbonne, while the Florentine concept of versatility was embodied by Rabelais—not without a debt to *Morgante*—in Gargantua, who wants to learn *all* languages, read *all* the great books (headed by Plutarch and Plato) and assimilate *all* the useful sciences. Italian brought new life to the metrical jugglery which passed for poetry in Paris. The new and more generous religious ideals evolved in Florence replaced relic-hunting and the buying of indulgences. 'This miserable world' had been a common phrase with Commynes, but by the turn of the century France was already set on a brighter course, summed up by an inscription which Louis de Ronsard placed over the doorway of his manor-house after rebuilding it in Italian style: *Voluptati et Gratiis*.

Nor did the English lag behind. If the term Renaissance is specially appropriate to Florence because of the fourteen hundred years of darkness and twilight separating her achievements from their nearest model, for England too the metaphor Renaissance is apt, because England was renewed by an even richer inheritance: not only the classical past, but what Florence and other Italian cities had made of it. Once described by Poggio as 'Sarmatians and Scythians', 'their libraries full of foolishness', and caring little for literature, Englishmen now eagerly sought Florentine learning and values. As early as 1486 Lorenzo de' Medici had invited Thomas Linacre, a Kentish man and a Fellow of All Souls, to share his son Piero's lessons for a year, under Poliziano and Demetrio Chalcondylas. On his way home Linacre piled up a rough altar of stones on the last Alpine pass, dedicating it gratefully to his '*sancta mater studiorum*'. Linacre translated Galen into a Latin finer, according to Erasmus, than Galen's original Greek, became tutor to the Prince of Wales and taught the Greek he had learned from Poliziano to Thomas More. More conceived a deep admiration for Pico della Mirandola, as a young man translated a biography of Pico into English, and took the layman-scholar who would have liked to be a friar as a pattern for his own life.

It was chiefly by way of Florence that Englishmen approached classical antiquity. Under Poliziano William Grocyn perfected his Greek before establishing Greek studies at Oxford. Under the influence of Pico and Ficino John Colet turned from Aquinas and the scholastics to an inner, more personal Christianity; under the influence of Valla he introduced to England the historical method of interpreting Scripture; under the influence of Florentine educational ideas he endowed St Paul's School for teaching the humanities, including Greek, specifying that it was to be governed by 'married men', not ecclesiastics. Among the English poets who owe a debt to Florentine Platonism are the Earl of Surrey and Sir Thomas Wyatt, who visited Florence in 1527 and took Petrarch as his model when he wrote the first sonnets in English. Spenser's blending of Christian imagery and classical mythology in *The Faery Queen* is close to Botticelli, while his two *Hymnes in honour of Love and Beautie* are the versification of ideas taken from Plato's *Symposium* read in the light of Ficino's commentary.

In the field of art Tuscans exerted an equally strong influence. Antonio Toto and Bartolomeo Penni painted frescoes at Hampton Court, which was decorated by the sculptors Giovanni da Maiano and Benedetto da Rovezzano. The latter designed a magnificent marble tomb for Wolsey, later used as a resting place for Nelson, while Pietro Torrigiani, who had been a pupil in Lorenzo's art school, brought to his tomb of Henry VII two gilded *putti* straight from the classical world, their joyful bodies aglint with the sunshine of Florence and attesting—as the inscription has it—'the gifts of benign Nature'.

With the new love of the classical past went a taste for the Italian present, which embodied so much of that past. It was a Florentine refugee, Michelangelo Florio, who wrote the book from which blunt English courtiers learned to speak 'soft Tuscan'. Gardens, masks, fencing, dress—all had to be Italian. Henry VII sent at various times to Florence to purchase gold cloth, as well as silks, while embroidered gloves, muffs, fans and hair-washes were all imported. It soon became the fashion for Englishmen to finish their education by travelling in Italy, and it was then that a change of attitude set in. The Italians, subject to foreign domination and profoundly demoral-

ized, had become cringing and cunning; they indulged in sharp practices, in rapier thrusts in the dark and poison. 'O Italy, academy of manslaughter,' wrote Nashe, 'the sporting place of murder, the apothecary shop of all nations! How many kinds of weapons hast thou invented for malice!' All these currents are met in William Shakespeare. A classically-educated poet who loved the classics, Shakespeare gave six of his plays Greek backgrounds, while six treat of Roman history; but equally he sets seven plays in the Italy of his own day; and if he shows respect for individual Italians such as Romeo and Cassio, a Florentine and 'a great arithmetician', his suspicions are evident too in the subtle scheming of Iago.

The Renaissance in England, unlike such later movements as the Gothic revival and the Romantic revival, extended to almost every phase of intellectual and artistic life, and beyond these to the very notion of man himself. It is this which links the Florentine and English Renaissances, and indeed the most important of Florence's immediate legacies to England was the 'complete man' in a form embodying both Christian and humanist strains: that is, the idea of a gentleman, in the sense of a well-educated, versatile, responsible citizen.

Leon Battista Alberti and Lorenzo de' Medici have some claim to be called the first gentlemen in this sense, and certainly the concept of a man realizing to the full his *virtù* regardless of birth originated in Florence, though it was a Mantuan, Baldassare Castiglione, who put the ideal into words, in slightly softened form, in *Il Cortigiano*, written between 1508 and 1516, and translated by Hoby in 1561. Castiglione's courtier, or gentleman, is skilled in the arts of self-defence but would rather make his point with an epigram than with the rapier. He is good at riding, running, swimming, but with physical grace he combines those intellectual graces so long the preserve of clerics. He can give an edge to an otherwise dull experience by citing an apt classical parallel. He can make witty conversation and, if need be, lead an embassy abroad. He has a strong sense of beauty and his philosophy is Ficino's Platonism. He can draw and play the lyre. Because he sees God in created things, his attitude to life has a strong cast of idealism.

The word gentleman is now out of favour, being held to smack of

snobbery or effeteness, but it did not have these overtones originally or even during most of the four centuries in which it has been an English ideal. Thomas More, Walter Raleigh, Philip Sidney, were all gentlemen in Castiglione's sense: indeed Sidney, who was termed 'a perfect Castilio', seldom went far without *The Courtier* in his pocket. Although Castiglione, attached to a ducal court, had given his gentleman an aristocratic tinge, its original republican Florentine form always found champions in England, such as William Segar at the time of Queen Elizabeth: 'I say that the true nobility of man is virtue, and that he is truly noble that is virtuous, be he born of high or low parents.' For it was above all a type of egalitarian Christian man that Florence had evolved, not without faults, but positive in outlook, eager to learn and discover, eager to add to a world which he found beautiful. As Florence declined, this creation was to flourish elsewhere, beyond the Alps, in France, the Low Countries and Germany, but especially perhaps in England, and later in the countries overseas which took their birth from England.

APPENDICES
SOURCES AND NOTES
TABLE OF DATES
INDEX

APPENDIX A

The Context of the Florentine Renaissance

Was there an earlier Renaissance?

In 1924 Charles Haskins of Harvard published *Studies in the History of Medieval Science*, a collection of papers describing works of Greek science which reached the West in translation mainly during the twelfth century. Most were translations from the Arabic made in Toledo: works by Galen and Hippocrates, Euclid's *Elements* (though Euclid's thought had never been lost to the West), Aristotle's natural philosophy, and Ptolemy's astronomical treatise, the *Almagest*. Some were translations from the Greek, made mainly in Sicily: the *Data*, *Optica* and *Catoptrica* of Euclid, the *De motu* of Proclus, and the *Pneumatica* of Hero of Alexandria.

The number of translations was small, and Haskins comments unfavourably on their quality. 'At their best the Arabic versions were one remove further from the original and had passed through the refracting medium of a wholly different kind of language, while at their worst they were made in haste and with the aid of ignorant interpreters working through the Spanish vernacular.' 'The twelfth century was closely, even painfully literal, in a way that is apt to suggest the stumbling and conscientious schoolboy. Every Greek word had to be represented by a Latin equivalent, even to μεν and δε'. Many Greek terms were simply transliterated because their meaning could not be discovered. 'The Sicilian scholar's knowledge of Greek was not reflected in Greek dictionaries or in any permanent improvement in lexicography; indeed the Greek of the etymologists grows worse rather than better as the Middle Ages wear on. When, about 1200, the learned Pisan canonist Hugutio, professor at Bologna and bishop of Ferrara, compiles his *Derivationes*, he takes his Greek etymologies chiefly from his predecessors, the Lombard Papias (1053) and the Englishman Osbern, both likewise ignorant of Greek; yet Hugutio was the standard lexicographer of the later Middle Ages and was by Petrarch bracketed with Priscian as the chief of grammarians. The *Grecismus* of Evrard de Béthune (1212), a favourite grammar in its time, is notable chiefly for its ignorance of Greek.'

It is quite plain from Haskins's own evidence that these translations enjoyed a very limited circulation and exerted little or no influence on contemporary thought. Of Chartres, a centre of Platonic studies, Haskins says: 'With the decline of humanism in the second half of the twelfth century its fall was rapid, so that Chartres

never became a centre of the new science.' In England, the natural philosophy and metaphysics of Aristotle 'were cited in part but little utilized' by Alexander Neckham, one of the leading translators, while with the writings of Alfred the Englishman 'the movement passed from its mathematical and astronomical phase to that which occupied itself primarily with natural philosophy and metaphysics, and we are thus brought into the philosophical currents of the thirteenth century.' A list of text books drawn up probably by Alexander Neckham in 1190—'an unofficial enumeration of the books then in use in the schools of Paris'—does not mention Ptolemy's *Almagest*, though translations of this were made in Sicily around 1160, and in Spain in 1175. A little later Michael Scot translated Aristotle's *Historia animalium* from the Arabic—not without numerous errors, as Haskins points out, which were repeated by Albertus Magnus in using it—but Scot's own most important work, the *De secretis naturae*, is a retrograde list of prognostications from dreams, complexions, and the different parts of the body.

Haskins's book made a valuable contribution to the study of intellectual currents in the twelfth century. Though he speaks occasionally of a 'scientific renaissance', his main picture is of a short-lived and abortive attempt by a few isolated translators to introduce classical science to the curriculum of the new universities, ending in 'the decline of the classics before the triumph of the scholastic logic'.

In 1927 Haskins published a second book, entitled *The Renaissance of the Twelfth Century*. The conclusions of the earlier book were combined with other signs of intellectual activity, notably the founding of universities and the growth of urban life. But again the picture is one of a strictly limited and abortive revival. Haskins's arguments are less convincing than in the *Studies*, and he does not seem to have been altogether happy about his title, for he made clear that he was in no way denying the existence of the Renaissance in its usual, later significance.

Stirred by the title of Haskins's book rather than by its content, medievalists soon began to stake claims for the 'Carolingian Renaissance', the 'Thirteenth-Century Renaissance', and so on (their views are summarized in W. K. Ferguson's *The Renaissance in Historical Thought*). In all these a grain or two of truth was magnified out of all proportion. True that Charlemagne summoned the scholar Alcuin to his court, but it has to be remembered that the same Charlemagne kept a slate under his pillow in a vain attempt to teach himself to write. True that the thirteenth century came to know Aristotle's natural philosophy in translations direct from the Greek, but the test of this and any age surely lies in its representative individuals. Albertus Magnus made a few original observations in his scientific works, but to quote Dr Richard Hunt, 'it is a long step from making observations to the formulation of a theoretical basis of experimentation, and the climate, where authorities counted for so much, did not favour it.' St Francis of Assisi and Frederick II are others cited by medievalists who would date the Renaissance to the thirteenth century. It is enough to point out that St Francis specifically renounced all human learning and forbade his friars to possess books, while Frederick II's

much-vaunted scientific method could take the form of feeding two of his men an excellent dinner, sending one to sleep and the other to hunt, and in the evening causing both to be disembowelled in his presence, in order that he might discover which had digested better.

For about a decade after the publication of Haskins's book much was heard from medieval scholars who disapproved of Burckhardt's periodization and wished to obliterate the distinction between Middle Ages and Renaissance. Then the catch-phrases died down and it became possible to evaluate the various arguments on their merits. Some historians still accept Haskins's view. Professor Trevor-Roper in *The Rise of Christian Europe* is one of those who would share out among earlier periods the achievements of the fifteenth and early sixteenth centuries. Other historians reject Haskins's view. They argue that the Italian Renaissance, being unique in scale, character and influence, alone deserves the famous epithet. One is reminded of recent litigation about 'Spanish champagne'. Myself, I reject Haskins's term, 'Twelfth-century Renaissance', just as I would reject an attempt to dilute the Athenian achievement by referring to Egyptian temples, monumental sculpture and applied geometry, though these clearly left their mark on Athens, or to dilute the Age of Discovery by referring to John of Monte Corvino's journey to Peking, and the fact that he had Biblical pictures printed there in 1306 for the instruction of the ignorant.

In support of my view I would cite three authorities. George Sarton, the historian of science, had originally subscribed to Haskins's thesis but in 1953 abandoned it. Writing in that year and defining the Renaissance as the period from 1350 to 1600, he declared: 'In the field of science, the novelties were gigantic, revolutionary . . . The Renaissance scientists introduced not a "new look" but a new being.' A second scholar, Hans Baron, the historian of civic humanism, accepts Vasari's statement that, beginning about 1400, the whole trend of cultural life in Italy changed, turning back to the pure traditions of antiquity, and forward to a new realistic observation of man and the world. Finally, the distinguished art historian Erwin Panofsky, writing in 1962, accepts in uncompromising terms Burckhardt's distinction between the Middle Ages and Renaissance: 'it is impossible to abandon the proposition that something really decisive—to use the biological term, a "mutational change"—did happen'.

For my part I am convinced that a Renaissance did take place in Italy during the fifteenth and sixteenth centuries, and that to apply the word to any part of the early Middle Ages is misleading, not only because the achievements were on such a minor scale but because the protagonists then lacked that sense of 'starting anew' which so marked the later period. Indeed, one of the strongest but least used arguments in favour of the traditional time-limits is that the Italian Renaissance was the first age to define and name itself.

Dating

In dating the Italian Renaissance much turns on the position accorded to Petrarch. Burckhardt, defining the Renaissance largely in terms of the rise of the individual and the 'discovery of man', treated Petrarch as a Renaissance figure. Because I take a different view of events I exclude Petrarch, but even on Burckhardt's definition I think that the hermit of Vaucluse should be excluded. Interested in himself and his own emotions Petrarch certainly was, but his whole attitude to life—his sighs of self-castigation—is at the opposite pole from those tyrants and *condottieri* whom Burckhardt takes as the type of Renaissance individual. It is true that Petrarch's attitude to antiquity was very influential indeed, but there remains a big gap between his view of humanism, and that of the *Quattrocento*. To cite only one example, Petrarch wrote a handbook for travellers in Egypt, though he had never been to that country, indeed no further east than Naples. How different from Ciriaco d'Ancona and Florentine merchant-adventurers such as Benedetto Dei in the next century. 'I happily forget those among whom an evil fate has forced me to live,' Petrarch writes in one letter, 'and employ all my strength of mind to flee the moderns and seek the ancients.' It is above all this aloof approach that makes him in my opinion a precursor of the Renaissance, not a protagonist.

I have chosen to describe events mainly between 1400 and 1500, and these dates require an explanation. Obviously all human activity forms a continuum, and no period is born parthenogenetically. Equally obviously, a historian has to select. If it is to be viable, a period should, I believe, satisfy three conditions. It should possess an organic unity, with a natural beginning and end; its limits should correspond to those recognized by observers at the time or immediately afterwards; and it should be marked by a spiritual unity, a concord of tone. The fifteenth century in Florence meets all three requirements. The invasion of Giangaleazzo in 1400 culminating in the successful resistance of 1402 inaugurated a period of stable republicanism and bold thinking which lasted until the French invasion and the burning of Savonarola in 1498. As for the second point, the Florentines themselves thought of the *Quattrocento* as a whole. When the Calimala commissioned splendid gilded bronze Baptistery doors in the winter of 1400-1, the occasion might be an escape from plague, but the driving force was the new hope which came with a new century. Dante, for instance, had set his vision in 1300, and it was in that year that Villani conceived his plan of writing his history of Florence. Men in those times still looked on each century as in many ways a self-contained unity, so that in the 'nineties it was no accident that fears and doubts should redouble, igniting the pyramid of vanities and ushering in a twilight of the gods. That same Guicciardini who in his youth had judged Lorenzo harshly, writing after a lifetime of war and humiliation, looked back on the *Quattrocento* as Florence's period of peace and greatness. As for spiritual unity, this is particularly sharply defined, and is well illustrated by the contrasting cynicism and despair which

descended on Florence almost as soon as the century ended. Machiavelli in *Mandragola* criticizes the Church with all the bitterness which comes from knowing that abuses are now past remedy, while in his *History of Florence* he discards the old social sense for an emphasis on personal fame, the one straw to clutch at in a floundering State. Thus, the murder of Galeazzo Maria Sforza in 1476 happens to be well documented, and we know it to have been motivated by republican ideals, but Machiavelli ascribes it solely to thirst for fame. When he cannot squeeze Leonardo Bruni and Poggio Bracciolini into the category he most prizes, that of ruthless climbers, he says they 'erred greatly and showed that they understood little the ambition of men and the desire to perpetuate a name'. Perhaps the best known example of this shift from social responsibility to personal ambition verging at times on insanity is the *Autobiography* of Benvenuto Cellini (begun in 1558).

I am not of course suggesting that with the turn of the century the Renaissance came to an end in Florence. But it did assume a quite different form, and the old powerful soaring ideas turned either abroad or, within Italy, to other cities, of which by far the most important was Rome.

The Florentine Renaissance and Italy

Burckhardt treated the Renaissance in Italy as a whole. He made little or no distinction between what took place in the republic of Florence and what took place under the rule of tyrants. Yet such a distinction is essential to an understanding of all but the most general points. Whatever outward trappings they may share, the free citizen remains fundamentally different from the tyrant, and any attempt to place, say, Cosimo de' Medici and Sigismondo Malatesta in the same category of 'individuals' will cause only confusion. I believe that it was the confusion so engendered that led Burckhardt to overemphasize Renaissance man's subjective side and his willingness to act outside the main body of opinion. This in turn led him to view the Renaissance as an unfulfilled or pre-Reformation. Such a view, which came naturally to a German-speaking Swiss writing in the mid-nineteenth century, now appears the most dated thing about his great pioneer work. If Burckhardt had been right, the Florentines, instead of hanging and burning Savonarola, would have supported his demands for reform against the Pope, just as they had supported Lorenzo on a temporal issue in 1478.

I believe that it is legitimate to speak of an Italian Renaissance provided we differentiate between those men who enjoyed political freedom and those who did not, and provided we recognize that Florence was the power-house which generated far and away the largest number of influential ideas. Florence led the way, Italy followed. Thus, we find educational, political and moral problems being discussed at Ferrara, but chiefly in terms evolved by Coluccio and Bruni, Poggio and Alberti, while the Platonism of Isabella d'Este's circle in Mantua stems directly from the translations first of Bruni, then of Ficino. When Sigismondo wished to hold a

debate with learned Jews of Rimini, it was to Giannozzo Manetti that he turned, because the Florentine could speak to the Jews in their own tongue, just as in a different field Antonello, when painting his *Virgin Annunciate*, drew on the geometrical notions evolved in Florence. As Lionello Venturi puts it: 'The new Renaissance style emerged in northern Italy a generation later than in Florence, and as the direct result of work done on the spot by Tuscan artists: Paolo Uccello, Filippo Lippi, Piero della Francesca, Andrea del Castagno, and, above all, Donatello.' What is true in painting holds true in nearly the whole range of intellectual life. Every important Italian city had its Renaissance, but the Florentine, because it was the most complete and the most influential, has a special claim to be considered representative of the whole.

APPENDIX B

The whereabouts of works of art mentioned in the text or reproduced as illustrations

Andrea del Castagno	*Last Supper*	S. Apollonia, Florence
Andrea di Firenze	*Church Militant and Triumphant*	Spanish chapel, S. Maria Novella
Fra Angelico	*Adoration of the Magi*	Convent of S. Marco
Antonello da Messina	*Virgin Annunciate*	Palermo Museum
Gentile Bellini	*Sultan Mahomet II*	National Gallery, London
Jacopo Bellini	*Annunciation*	Louvre
Bertoldo	*Battle Scene*	Bargello, Florence
Botticelli	*Adoration of the Magi*	Uffizi
	Altarpiece of S. Barnaba	Uffizi
	Birth of Venus	Uffizi
	Calumny of Apelles	Uffizi
	La Derelitta	Pallavicini Collection, Rome
	Magdalen at the foot of the Cross	Fogg Museum, Cambridge, Mass.
	Mars and Venus	National Gallery, London
	Nativity	National Gallery, London
	Pallas and the Centaur	Uffizi
	Portrait of a Lady, believed to be Clarice de' Medici	Pitti
	Primavera	Uffizi
	Punishment of Korah, Dathan and Abiron	Sistine Chapel, Rome
	Rape of Lucretia	Gardner Museum, Boston
	Story of Virginia	Acc. Carrara, Bergamo
Brunelleschi	*Crucifix*	S. Maria Novella
	Sacrifice of Isaac	Bargello
Bernardo Ciuffagni and Nanni di Barolo	*Joshua ('Poggio Bracciolini')*	Duomo, Florence
Desiderio da Settignano	*Madonna and angels (bas-relief)*	Louvre
	Marietta Strozzi	Staatliche Museen, Berlin

315

Domenico Veneziano	*S. Lucia Altarpiece*	Uffizi
Donatello	*Anatomy of the Miser's Heart*	S. Antonio, Padua
	Crucifix	S. Croce
	David	Bargello
	Judith severing the head of Holofernes	Piazza della Signoria
	Portrait bust of a lady, believed to be Contessina de' Medici	Bargello
	Zuccone	Museo dell' Opera del Duomo, Florence
(with Michelozzo)	Tomb of John XXIII	Baptistery, Florence
Gentile da Fabriano	*Adoration of the Magi*	Uffizi
Ghiberti	*Creation of Adam and Eve, and the Expulsion*	West door, Baptistery
	Sacrifice of Isaac	Bargello
	Self-portrait	West door, Baptistery
Ghirlandaio	*Life of St John the Baptist*	S. Maria Novella
van der Goes	*Adoration of the Shepherds*	Uffizi
Gozzoli	*Procession of the Magi*	Chapel, Palazzo Medici
Filippino Lippi	*Moses striking water from the rock*	National Gallery, London
	Worship of the bull-god Apis	National Gallery, London
Filippo Lippi	*Coronation of the Virgin*	Accademia, Florence
	Madonna and Child	National Gallery, Washington
Leonardo da Vinci	*Adoration of the Magi*	Uffizi
	Drawing for the *Adoration*	Uffizi
	Drawings of legs	Windsor Library (no. 12625)
	Last Supper	S. Maria delle Grazie, Milan
	Mona Lisa	Louvre
	Portrait of Cecilia Gallerani	Czartoryski Gallery, Cracow
	Virgin of the Rocks	Louvre
Mantegna	*Madonna della Vittoria*	Louvre
	St James frescoes	Church of the Eremitani, Padua (damaged)
Masaccio	*Life of St Peter*	Church of the Carmine, Florence

	Trinity	S. Maria Novella
Michelangelo	Battle of the Centaurs	Casa Buonarroti, Florence
	Copies from Masaccio	Graphische Sammlung, Munich; Albertina, Vienna
	Crucifix	Casa Buonarroti, Florence
	Holy Family	Uffizi
Mino da Fiesole	Piero de' Medici	Bargello
Perugino	Marriage of the Virgin	Caen Museum
Perugino and Fiorenzo di Lorenzo	Life of S. Bernardino	Pinacoteca Vannucci, Perugia
Piero della Francesca	Baptism of Christ	National Gallery, London
	Battista Sforza	Uffizi
	Federigo da Montefeltro in triumph	Uffizi
	Finding of the Cross	S. Francesco, Arezzo
	Perspective drawings	Library, Parma
Piero di Puccio	Creation and Expulsion of Adam and Eve	Campo Santo, Pisa
Pisanello	Vision of St Eustace	National Gallery, London
Giovanni Pisano	Temperance	Pisa Cathedral
Antonio Pollaiuolo	Apollo and Daphne	National Gallery, London
	Battle of Nude Men	Uffizi
	Dancing Nudes	Torre del Gallo, Florence
	Hercules and Antaeus	Bargello
	Labours of Hercules	Uffizi
	Rape of Deianira	Jarves Collection, New Haven
	Tobias and the Angel	Galleria Sabauda, Turin
Polyclitus (after)	Diadumenos	British Museum
Raphael	Marriage of the Virgin	Brera, Milan
Riquinus of Magdeburg	Adam and Eve	Novgorod Cathedral
Luca della Robbia	Choir loft	Museo dell' Opera del Duomo, Florence
A. and B. Rossellino	Cardinal of Portugal's tomb	S. Miniato, Florence
Bernardo Rossellino	Leonardo Bruni's tomb	S. Croce, Florence
Sassetta	Marriage of St Francis with Poverty	Musée Condé, Chantilly
Signorelli	Court of Pan (Allegory of Inspiration)	Formerly in Berlin: destroyed
	Last Judgment	Duomo, Orvieto

Spinello Aretino	*Life of St Benedict*	S. Miniato, Florence
Pietro Torrigiani	Tomb of Henry VII	Westminster Abbey
Cosimo Tura	*Pietà*	Museo Civico, Venice
Uccello	*The Flood*	Chiostro verde, S. Maria Novella
	A Hunt	Ashmolean Museum, Oxford
	Monument to Sir John Hawkwood	Duomo, Florence
	Profanation of the Host	Ducal Palace, Urbino
	Rout of San Romano	Uffizi, National Gallery, London, and Louvre
Verrocchio	*Boy with a Dolphin*	Palazzo Vecchio
	Cosimo de' Medici	Staatliche Museen, Berlin
	David	Bargello
	Lorenzo de' Medici	National Gallery, Washington
	Monument to Colleoni	Venice
Verrocchio (follower of)	*Tobias and the Angel*	National Gallery, London
Wiligelmo	*Adam and Eve*	Modena Cathedral

Sources and Notes

LIST OF ABBREVIATIONS

ASI	*Archivio storico italiano*
BN	Biblioteca Nazionale, Florence
Fabroni	Angelo Fabroni, *Magni Cosmi Medicei Vita* (Pisa 1784)
Ficino	Marsilio Ficino, *Opera Omnia* (Basel 1576)
JWCI	*Journal of the Warburg and Courtauld Institutes*
Landucci	Luca Landucci, *Diario fiorentino da 1450 al 1516*, ed. I del Badia (Florence 1883)
MAP	Mediceo avanti il Principato, Archivio di Stato, Florence
Prediche	Girolamo Savonarola, *Prediche*, ed. G. Baccini (Florence 1889)
Ross	*Lives of the Early Medici as told in their Correspondence*, ed. Janet Ross (London 1910)
Strozzi	Alessandra negli Strozzi, *Lettere di una gentildonna fiorentina*, ed. C. Guasti (Florence 1877)
Tagebuch	Agnolo Poliziano, *Das Tagebuch des Polizian*, ed. Wesselski (Jena 1929)
Vespasiano	Vespasiano da Bisticci, *Vite di uomini illustri*, ed. P. D'Ancona and E. Aeschlimann (Milan 1951)

Preface (pp. 15-16)

The eighteenth-century origin of the word 'Renaissance': B. L. Ullman, *Studies in the Italian Renaissance* (Rome 1955), p. 24. Michelet gave the title *Renaissance* to the seventh volume of his *Histoire de France*, published in 1855, and characterized the period as a discovery of the world and a discovery of man. Five years later Jacob Burckhardt published his pioneer work, *Die Kultur der Renaissance in Italien*, in which he developed with a wealth of detail Michelet's two salient characteristics.

Chapter 1: The City and its Citizens (pp. 17-34)

General sources: *Cronica di Giovanni Villani*, ed. F. Dragomanni (Florence 1844-5); *Cronica di Matteo Villani*, ed. F. Dragomanni (Florence 1846); *Cronica domestica di*

Messer Donato Velluti, ed. I. del Badia and G. Volpi (Florence 1914). Modern works: F. Schevill, *History of Florence* (New York 1936); F. T. Perrens, *Histoire de Florence* (Paris 1877–90).

The Florentines' comment on the visit of John of Vicenza is given by Salimbene under the year 1233.

The textile trade depended on circulating capital, not fixed capital. Looms usually belonged to the workers, who depended upon wages advanced by the employer, who also furnished the materials and assumed the risk of finding a market. A weaver of brocades about 1460 could earn 130 florins a year, more than twice the salary of a cashier of the Medici Bank. R. de Roover, *The Rise and Decline of the Medici Bank* (Cambridge, Mass. 1963), p. 7.

The description of alum-making as well as details of commercial practice are taken from Pegolotti's text book (*ca* 1342): *La pratica della mercatura*, ed. A. Evans (Cambridge, Mass. 1936).

The development of treadle-mills and silk-twisting mills: R. Patterson, 'Spinning and Weaving' in *A History of Technology*, ed. C. Singer, etc. (Oxford 1957), vol. III, pp. 151–81.

On his death-bed in 1423 the Venetian Doge Tommaso Mocenigo said: '*Firenze annualmente inviava a Venezia 16,000 pezze di panno che poi venivano trasportate, su imbarcazioni venete, in Barberia, in Egitto, Siria, Cipro, Romania, a Candia, Morea ed anche in Istria . . .*' S. Romanin, *Storia documentata di Venezia* (Venice 1855), IV, p. 94.

The usurer's death: Filippo degli Agazzari, *Gli Assempri* (Siena 1922), pp. 51–4.

According to F. Schevill, *op. cit.*, the commune was not a survival of the Roman municipality, but something new which arose about the eleventh century, when the *boni homines* adopted the sonorous title of 'consuls'. By the twelfth century the consuls were usually twelve in number.

In 1965 a computer at the University of Pisa calculated that the word which occurs most often in Dante's *Comedy* is *occhio* and its plural (213 times), followed by *terra* (136 times).

The population of Florence: Professor Nicolai Rubinstein expresses the opinion (in a letter to the author) that the population of Florence c. 1434 was 'not much in excess of 50,000 (however, it may have grown in the course of the century)'. Beloch estimates it at 70,000 towards the end of the fifteenth century. See also E. Fiumi, '*La demografia fiorentina nelle pagine di Giovanni Villani*,' ASI cviii (1950).

Contessina was portrayed by Donatello, according to Vasari, and I take the bust in the Bargello to be this work. There can of course be no certainty about this identification, or about the subject of Botticelli's portrait of a lady in the Pitti, which, because it tallies so well with Lucrezia's description, I take to be Lorenzo's wife.

The characteristics of the various nationalities of slaves: Strozzi, p. 475; difficulties with Cateruccia, Strozzi, p. 104.

Block-printing on cloth—a recent invention—and the process for decorating linen for children's frocks and church hangings are described by C. Cennini, *Il libro dell'Arte*, ch. 173.

Women's trains: Bernardino da Siena, *Le prediche volgari*, ed. Bianchi (Siena 1888), III, p. 211.

Difficulty of enforcing sumptuary laws: Novella cxxxvii. F. Sacchetti, *Il Trecentonovelle*, ed. V. Pernicone (Florence 1946), p. 304.

Chapter 2: A Turning-point (pp. 35–47)

There were glimmerings of humanism elsewhere in Italy before the time of Petrarch, Boccaccio and Coluccio, but they were scattered and sporadic. In Verona Giovanni de Matociis (*fl.* 1306–20) proved that the Elder and Younger Pliny were two persons, not one as supposed in the Middle Ages. In Padua, Albertino Mussato, a notary (1262–1329), wrote a Senecan tragedy in Latin verse, *Ecerinis*, for which he was crowned with laurel in 1315, while in Naples, King Robert I (1309–43) commissioned translations into Latin of various treatises by Galen and Hippocrates, and secured the crowning of Petrarch. Cf. R. Weiss, *The Spread of Italian Humanism* (London 1964).

The idea of a literary biography as an end in itself was of course unknown in the Middle Ages. The life of Ovid, as of any poet, was considered by the commentator only so far as it helped to elucidate the causes determining the origin of the poem, the matter of which it was composed, its intention, the useful lessons to be learned from it, its title, and, finally, to what part of philosophy it should be ascribed. Fausto Ghisalberti, 'Medieval Biographies of Ovid', in *JWCI IX* (1946).

The medieval view of Cicero, Petrarch's discovery in 1345 of the *Letters to Atticus* and his shocked horror, which took the form of a letter full of accusation to the shade of Cicero in Hades, and the very different attitude of Coluccio, the soldier's son and responsible statesman, to Cicero's *Epistolae Familiares* are discussed fully by Hans Baron, 'Cicero and the Roman Civic Spirit in the Middle Ages and Early Renaissance', in *Bulletin of the John Rylands Library* xxii (1938).

St Jerome's '*non posse simul uxori et philosophiae servire*', which he ascribes to Cicero, occurs in his *Adversus Iovianum* I, 48.

For Coluccio, the edition of his *Epistolario*, ed. F. Novati (Rome 1891), and B. L. Ullman, *The Humanism of Coluccio Salutati* (Padua 1963).

Coluccio's letter on the active life is addressed to Pellegrino Zambeccari. *Epist.* II, pp. 303–7.

Coluccio's arguments for reading 'secular' books are to be found in his correspondence, especially in a letter to the Bolognese chancellor Giuliano Zonarini, who had called Virgil a lying prophet and dissuaded a friend from reading him (*Epist.* I, pp. 298*ff*) and, fairly presented by Dominici, in the highly important *Lucula noctis. Iohannis Dominici Lucula noctis*, ed. E. Hunt (Notre Dame 1940).

The *Lucula Noctis* is full of scraps of classical learning taken out of context from Christian authors: for example, in ch. xi: '*Veneris stellam pandit Varro mutatam in celo magnitudine, colore, figura, cum cursu, alludentem stationi solis sub Iosue, retrogressui sub Ezechia, et stelle Magorum, libro xxi°, capitulo octavo [Civitas Dei]*. This passage, incidentally, is typical of Dominici's cumbersome style.

For the war with Giangaleazzo I have mainly followed two contemporary chroniclers: Goro Dati, *Istoria di Firenze* (Florence 1735) and Giovanni Sercambi, *Le Cronache* (Rome 1887–92), and a recent work: E. R. Chamberlin, *The Count of Virtue* (London 1965).

Coluccio's manifesto at the beginning of war is printed in N. Valeri, *L'Italia nell'età dei principati* (Verona 1949), pp. 258–9.

English military tactics: F. Villani, *Cronica* xi, 81.

Giangaleazzo's propaganda is quoted and discussed by Hans Baron, *The Crisis of the Early Italian Renaissance* (Princeton 1955), pp. 29–30.

The forged letter: R. Volterrano, *Commentarii urbani* (Basel 1544).

Coluccio's temporary reversal in the *De Tyranno* of his usual political views is discussed by Baron, *op. cit.*, ch. 7.

'To be conquered . . .' G. Dati, *op. cit.*, p. 69.

Chapter 3: The Classical Ideal (pp. 48–60)

For Niccolò Niccoli, Vespasiano; the Life by Giannozzo Manetti; and Lorenzo di Marco de' Benvenuti, *Oratio in Niccolaum Nicholum*. His career and those of contemporary scholars, including Poggio, are analysed in L. Martines, *The Social World of the Florentine Humanists 1390–1460* (London 1963).

Niccoli's mistress: Bruni, *Epistolae*, *V*, 4. In Mehus's edition (Florence 1741), pp. 17–25.

The discovery of classical texts: R. Sabbadini, *Le scoperte dei codici latini e greci ne' secoli XIV e XV* (Florence 1905–14) and J. E. Sandys, *A History of Classical Scholarship* (Cambridge 1908–21), vol. 2.

Having heard that a complete codex of Pliny's *Natural History* existed at Lübeck, Niccoli, at a distance of three weeks' journey, paid agents to track it down and, through a kinsman of Cosimo, bought it for a hundred Rhenish ducats. It was to prove one of the half-dozen most influential books of the *Quattrocento*.

Boccaccio's visit to Monte Cassino is described by Benvenuto da Imola in his *Commentary on the Divine Comedy*, Paradiso xxii, 74.

The finding of Quintilian: Poggio, *Epist.* I, v.

The amount of copying was prodigious. 'Fifteenth-century manuscripts of the Latin classics are probably more numerous than those of all previous centuries taken together.' P. O. Kristeller, *Renaissance Thought* (New York 1961), p. 152.

The first fifty-three chapters of Plato's *Timaeus* had been translated and

commented upon by Chalcidius in the fourth century. Aristippus had translated the *Meno* and *Phaedo* about 1156 in Sicily, but these versions were little known.

Renovation of the Florentine Studium: C. Gutkind, *Cosimo de' Medici* (Oxford 1938) pp. 229–31.

The key texts for the development of civic humanism in Florence are Bruni's *Dialogi ad Petrum Histrum*, his *Laudatio*, and his correspondence, and the correspondence of Poggio. In interpreting them I have found most useful E. Garin, *L'umanesimo italiano* (Bari 1952) and H. Baron, *The Crisis of the Early Italian Renaissance* (Princeton 1955). Both underestimate the effects of Ockhamism, which, by discrediting speculative theology and metaphysics, paved the way for the rise of ethics, an interest in just those problems that could in principle be verified by actual examples from the past. It had become obvious from Coluccio's *De nobilitate legum et medicinae* how unsatisfactory and inconclusive were his metaphysical (mainly Franciscan) arguments for the primacy of the will.

Coluccio defined *humanitas* as moral learning: '*humanitatis, hoc est eruditionis moralis.*' *Epist.* III, p. 517. Bruni's definitions are wider: '*idcirco est liberalis, quod liberos homines facit*' and '*quae propterea humanitatis studia nuncupantur, quod hominem perficiant atque exornent.*' *Epist.* VI, 6.

A more precise definition of the humanities is that composed by Nicholas V in his youth for Cosimo de' Medici's library: '*de studiis autem humanitatis quantum ad grammaticam, rhetoricam, historicam et poeticam spectat ac moralem.*' Quoted by P. O. Kristeller, *op. cit.*, p. 159.

The anecdote concerning Piero de' Pazzi is given by Vespasiano, 'Life of Niccolò Niccoli'.

Dante's description of Faith, the key virtue, occurs in *Paradiso*, xxiv, 90. In early Tuscan *virtù* sometimes meant power of effectiveness, for example, of precious stones.

Fortitude was one of the first lessons drawn from Roman behaviour, as in Petrarch's letter à propos the death of Paolo Annibaldeschi. *Var.* 32.

The burning of Jerome: Poggio, *Opera* (Basel 1538), pp. 301–5.

Chapter 4: The Republic and the Medici (pp. 61–84)

The most notable of the early Medici, Salvestro di Messer Alamanno, played a prominent role in the Ciompi revolution of 1378. G. A. Brucker, *Florentine Politics and Society 1343–1378* (Princeton 1962), pp. 363–6.

The library of Giovanni di Bicci (and that of Cosimo, which included many classical works) are attested by an inventory made in 1418. F. Antal, *Florentine Painting and its Social Background* (London 1948), p. 115.

The career of Cosimo de' Medici: Vespasiano; Fabroni; C. Gutkind, *Cosimo de' Medici* (Oxford 1938).

SOURCES AND NOTES

'*Cosimo di qualche huomo pronto et accorto soleva dire che egli haveva il cervello in danari contanti.*' *Tagebuch* no. 268.

The Medici lent Cardinal Baldassare Cossa 4250 florins as early as 1404. The receipt dated 25 October is in the Archivio di Stato, MAP filza 139, n. 110. The purchase of Maddalena: Fabroni II, pp. 214–15.

The new attitude of Cosimo's circle to money: H. Baron, 'Franciscan Poverty and Civic Wealth in Humanistic Thought', *Speculum*, xiii (1938).

For the working of the Florentine constitution I am indebted to N. Rubinstein, *The Government of Florence under the Medici 1434–1494* (Oxford 1966).

My estimate of the number of citizens, based on a population in 1434 of 50,000, follows from the figures given by Rubinstein. In 1484, when the population had swelled probably to 60,000, there were at least 8,000 citizens (p. 214). But only about 3,000 qualified as candidates eligible for the three highest offices (p. 62, n. 3).

Niccolò da Uzano put the case against Cosimo: '*Le opere di Cosimo che ce lo fanno sospetto, sono, perchè egli serve de' suoi danari ciascuno, e non solamente i privati ma il pubblico, e non solo i Fiorentini ma i condottieri . . .*' Machiavelli, *Istorie Fiorentine*, bk. iv, in *Opere* (Florence 1873), I, p. 205.

Even under *balìe* republican safeguards were enforced. Family representation for the elected members of the *balìe* of 1438, 1444 and 1452 was kept at the lowest possible level of one per family. N. Rubinstein, *op. cit.*, p. 85.

Giovanni Argyropoulos, appointed in 1456 to the Chair of Greek, was the first to praise Cosimo consistently as a learned and virtuous Aristotelian ruler whose task of ruling has a moral rather than a practical purpose. Alison M. Brown, 'The Humanist Portrait of Cosimo de' Medici, Pater Patriae', in JWCI xxiv (1961).

Cosimo's remark to Archbishop Antonino on gambling priests: *Tagebuch*, no. 2.

Cosimo's political restraint: '*El non se pò governare un populo como se governa un particulare signore.*' This outburst by Florence's first citizen is quoted by Nicodemo to Francesco Sforza, dated 13 June 1462. N. Rubinstein, *op. cit.*, p. 129.

The tax system under the Medici is fully discussed by R. de Roover, *op. cit.*, pp. 21–31.

The lines from Naldo Naldi: *Elegarium libri III* (Leipzig 1934), p. 49, quoted by E. H. Gombrich, 'Renaissance and Golden Age', in JWCI xxiv (1961).

Cosimo's letter to Pius II, declining to equip two galleys for the Crusade, dates from November 1463. Fabroni II, p. 243; in Ross, p. 66.

In rhetorical humanist writings Cosimo and his brother were being discussed as Patres Patriae twenty-four years before this title was formally bestowed on Cosimo. The implications of the title were expounded by Pliny, an author familiar to Florentine humanists:'*Salve primus omnium parens patriae appellate, primus in toga triumphum linguaeque lauream merite, et facundiae Latinarumque litterarum parens atque, ut dictator Caesar hostis quondam tuus de te scripsit, omnium triumphorum laurea adepte maiorem, quanto plus est ingenii Romani terminos in tantum promovisse quam imperii.*' *Natural History* VII, 117.

Despite his poor health, Piero showed sound business sense. His biggest coup was to gain control of the Societas Aluminum, formed by the Pope in 1462 to exploit and market Tolfa alum.

That Lorenzo influenced but did not control the scrutiny of 1484 is shown by Piero Guicciardini's *Ricordo*, published from the manuscript in the BN as an appendix to N. Rubinstein, *op. cit.*

Liberty as the basis of Florentine achievements: '*Haec omnia accepta referimus a sola libertate, cuius diutina possessio ingenia nostra ad virtutis cultum erexit atque excitavit.*' Poggio, *Opera* (Basel 1538), p. 337.

Agostino Campano: L. Pastor, *History of the Popes* iv (London 1894), pp. 44, 63, 442.

Leonardo Bruni and his quarrel with Niccoli: Bruni, *Epist.* v, 4: '. . . *et miramur, si ea opinio est vulgi, ut litterarum studio dediti nec Deum putent, nec vereantur . . ?*'

Leonardo Bruni dedicated his *De Militia* to Rinaldo degli Albizzi. The relevant texts in the debate about mercenaries are given in C. C. Bayley, *War and Society in Renaissance Florence* (Toronto 1961).

War in Italy: 'It was enough', says Machiavelli, 'for a horse to turn its head upon its tail to cause panic and defeat.' Da Porto wrote that it was more praiseworthy to fight 100 against 100 than 1,000 against 1,000, 'because in a small number everybody's *virtù* can be seen'. J. R. Hale, 'War and Public Opinion in Renaissance Italy', in *Italian Renaissance Studies*, ed. E. F. Jacob (London 1960), pp. 109–10.

The strictures on *condottieri*: Landucci, 1 August 1478.

Chapter 5: Man Whole and Complete (pp. 85–112)

S. Bernardino's admonition to husbands: *Prediche* II, p. 103. That women should not learn to read was advocated by Paolo da Certaldo in his *Breve Consiglio*.

Contessina commends her son Giovanni to the Holy Face in Rome in a letter dated 20 March 1444. Her letter about the cheeses is dated 25 October 1457. Y. Maguire, *The Women of the Medici* (London 1927) pp. 35–6, 50–1.

The petition to Lucrezia to help the Strozzi through her husband: Strozzi, p. 396.

Landucci, p. 8: '*Morissi la mia sopradetta donna e cara conpagna e tanta buona e virtuosa che non aveva pari: la quale in 48 anni stata meco, non mi fece mai adirare co lei.*'

Versatility: Vespasiano; G. Mancini, *Vita di L. B. Alberti*, 2nd ed. (Florence 1911). The anecdote about illegitimacy comes from *Tagebuch*, no. 336.

'When a youth . . .': Life of Alberti in *Rerum Italicarum Scriptores* xxv (Milan 1751) columns 295–6. '*Dimmi: che cosa ignorò mai quest'uomo?*' Mancini, *op. cit.*, p. 418. Description of a church: *Opere volgari*, ed. Bonucci (Florence 1843–9) I, p. 8; comparison of man to a ship: *ib.* p. 49.

The new view of time is found most strikingly in Leonardo. Having listed the qualifications for serious anatomical study, he declares: 'As to whether all these things were found in me or not the hundred and twenty books composed by me

will give verdict Yes or No. In these I have been hindered neither by avarice nor negligence, but simply by want of time. Farewell.' J. P. Richter, *The Literary Works of Leonardo da Vinci* (London 1939) II, p. 797.

One example of Medici wit is Piero de' Medici's reply to Agnolo Acciaiuoli, given by Machiavelli, *Istorie Fiorentine*, Bk. viii. Machiavelli, *Opere* (Florence 1873) I, p. 347.

Filelfo's epitaph on Vitelli: L. Domenichi, *Facetie* (Venice 1575), p. 252.

Etiquette after marriage is described by Giannozzo Alberti in L. B. Alberti, *Della Famiglia* (Florence 1908), Bk. iii, pp. 203-4.

Cosimo's business sense: he made his London partner promise not to gamble or play at dice; in case he did so, any winnings of over 10 ducats were to go to the company, while any losses were to be out of his own pocket. MAP, filza 94.

'*Magna est fides tua.*' *Tagebuch*, no. 173.

The profits of the Medici Bank are given by R. de Roover, *The Rise and Decline of the Medici Bank 1397–1494* (Cambridge, Mass. 1963) pp. 47, 69. Giovanni's profits between 1397 and 1420 were 113,865 florins.

The life of Archbishop Antonino: R. Morçay, *Saint Antonin* (Tours and Paris 1914). The records of the bishopric contain numerous payments made to agents of the Eight or to the Bargello with respect to police torture of loose-living priests. The most important of Antonino's writings is the *Summa Moralis* (Florence 1740). I have also consulted J. B. Walker, *The Chronicles of St Antoninus* (Washington 1933).

The dilemma about selling *Monte* stock at a profit is discussed in a letter from Alessandra Macinghi negli Strozzi to Filippo degli Strozzi dated 7 February 1465, in Strozzi, pp. 573-4.

Sigismondo Malatesta not only had himself depicted as a new star, in imitation of Augustus, but was hailed as such by the poet Basini:

> *Interea, tardus quamvis, ad Sidera Coeli*
> *Accedes, quondam serisque vocabere votis;*
> *Cum tamen in numerum Divorum veneris, opta*
> *Qua tibi parte Poli, qua sit regione manendum.*

(*Astronomicon* I, 24-7.)

Peter Abélard and glory. '*Querebat etiam quam de me gloriam habitura esset, cum me ingloriosum efficeret, et se et me pariter humiliaret.*' *Historia Calamitatum*, ed. C. Charrier (Paris 1934), lines 434-6. Also: '*Occurrebat animo quanta modo gloria pollebam, quam facili et temporali casu hec humiliata, immo penitus esset extincta*' (605-7) and '*Quanto autem illuc major scolarium erat confluentia, et quanto duriorem in doctrina nostra vitam sustinebant, tanto amplius mihi emuli estimabant gloriosum, et sibi ignominiosum*' (1102-5).

Cosimo and the ambassadors of Lucca: L. Carbone, *Facezie*, ed. Abdelkader (Livorno 1900), p. 64, in Gutkind, *op. cit.*, p. 216.

'*Diceva Cosmo che si dimenticano prima cento benefici che una ingiuria. E chi ingiuria non perdona mai.*' *Tagebuch*, no. 150.

Anticipating Gibbon, Pletho believed that Christianity had weakened the Greeks' fighting qualities, and in *The Laws* he sketched a new religion, based on Platonism, complete with liturgy, hymns and fast days.

Bruni had translated Plato's *Gorgias, Apology, Phaedo* and *Crito*. For these and other translations, E. Garin, '*Ricerche sulle traduzioni di Platone nella prima metà del sec. XV*', in *Medioevo e Rinascimento, Studi in onore di Bruno Nardi* (Florence 1955) I, pp. 339–74.

Despite his interest in Plato Cosimo did not abandon earlier favourites. According to Vespasiano, in the year before he died he had the *Ethics* of Aristotle and Donato Acciaiuoli's Commentary on them read to him by Bartolommeo Scala.

Piero de' Medici's report of Cosimo's death is contained in a letter to his sons Lorenzo and Giuliano at Cafaggiolo, dated 26 July 1464. Fabroni II, p. 251; Ross, p. 75.

The accounts for Cosimo's funeral: Ross, pp. 79–81.

Chapter 6: History and Religion (pp. 113–38)

Coluccio's examination of manuscripts of Gregory the Great: *Epist.* III, p. 624.

Despite improved spelling, Florentine painters continued to write *Agnius* for *Agnus*, as in Verrocchio's *Baptism of Christ* and Signorelli's *Virgin and Child* in the Uffizi.

The handwriting of Poggio and Niccoli is discussed by B. L. Ullman, *The Origin and Development of Humanistic Script* (Rome 1960). In this field also Petrarch is a transitional figure.

Leonardo Bruni, *Historiarum Florentii populi libri XII*, ed. E. Santini (Città di Castello 1914). Bruni's treatment of the flood in 1333 (Bk. VI) offers an instructive contrast with Villani's.

For Lorenzo Valla: G. M. Mancini, *Vita di Lorenzo Valla* (Florence 1891).

'Moses and the Evangelists are nothing but historians': L. Valla, *Historiarum Ferdinandi Regis Aragoniae libri tres* (Naples 1509): *Prooemium*.

L. Valla, *De falso credita et ementita Constantini donatione Declamatio*, ed. W. Schwahn (Leipzig 1928).

Independently of Valla, Reginald Pecock, Bishop of Chichester, showed the untenable character of the Donation of Constantine, in *The Repressor of Over Much Blaming for the Clergy* (1449).

For the Council of Florence I have chiefly followed the documents in Hefele and Leclercq, *Histoire des Conciles* VII, pt 2 (Paris 1916).

Pietro del Monte's promise to go to St Albans: J. Gill, *The Council of Florence* (Cambridge 1959), p. 164.

The text cited by the Greeks: 'the Holy Spirit is ἐξ αὐτοῦ καὶ οὐχ ἑτέρωθεν' is

from St Basil's *Serm. v. contra Eunomium*, ch. xiii. During the 19th session John of Ragusa explained this text in the light of another passage from the same work: 'Is it necessary for the Holy Spirit, if he is the third in dignity and classification, to be so also in nature? In dignity he comes after the Son, for he has his being from him.'

Mark of Ephesus's inflexible attitude may be partly explained by the fact that he had been Metropolitan of Ephesus since 1437, and doubtless felt a special loyalty to the decisions of the Council of Ephesus.

One unfortunate event indirectly forwarded union. The Greek Patriarch Joseph died on 10 June. On the eve of his death he wrote a note saying that he recognized the teaching of the Roman Catholic Church on all points and the supremacy of the Pope. On his tomb inscription in S. Maria Novella the Florentines declared the Council's purpose: '... *Unus et Europae cultus et una fides* ...'

One of the few well-attested Florentine superstitions was that of putting a key, sword, or other object of iron or steel between the teeth at the moment when the bells were first heard on Holy Saturday. This was denounced by Franciscus Florentinus, dean of the college of theologians in Florence in 1441.

Ficino's appearance and career are given by Giovanni Corsi, *Vita di Marsilio Ficino* (Lucca 1722). Ficino and his circle: A. della Torre, *Storia dell' accademia platonica di Firenze* (Florence 1927); E. Garin, *La cultura filosofica del Rinascimento italiano* (Florence 1961).

The trinitarian philosophy of love expressed in the inscription on Pico's medal— '*Pulchritudo—Amor—Voluptas*'—is explained by Ficino: '*Circulus . . . prout in Deo incipit et allicit, pulchritudo: prout in mundum transiens ipsum rapit, amor; prout in auctorem remeans ipsi suum opus coniungit, voluptas. Amor igitur in voluptatem a pulchritudine desinit.*' *De Amore* II, 2.

Ficino's reasons for believing both Plato's Loves to be good: M. Ficino, *Commentary on Plato's Symposium* (Columbia, Miss. 1944), pp. 192, 203.

Texts embodying Ficino's praise of marriage and procreation as a 'God-like' act: E. Garin, *L'umanesimo italiano* (Bari 1952), p. 55.

In the *rapprochement* with pagan religions, as so often elsewhere, Coluccio had been a precursor. In his *De laboribus Herculis* he likens the exchange of words between Jupiter and Juno portrayed by the poets to the Biblical conception of God speaking to Christ. Christians and non-Christians alike must take refuge in anthropomorphic representations.

'The idea of fire we call the god Vulcan ...' M. Ficino, *Commentary on Plato's Symposium* (Columbia, Miss. 1944), pp. 127–8.

The miraculous bull: O. Kurz, 'Filippino Lippi's Worship of the Apis' in *Burlington Magazine* lxxxix (1947). Pliny refers to the ritual in *Natural History* VIII, 184.

The Florentines were not above inventing inscriptions in order to suggest prophecy in non-Christian sources. The prime example is Ghirlandaio's *Adoration*

of the Magi. F. Saxl, 'The Classical Inscription in Renaissance Art and Politics', JWCI iv (1940–1).

Pico's character, career and thought: E. Garin, *Giovanni Pico della Mirandola* (Florence 1937) and G. Pico della Mirandola, *De Hominis Dignitate, Heptaplus, De Ente et Uno, e Scritti Vari,* ed. E. Garin (Florence 1942).

Chapter 7: Discovery (pp. 139–164)

Petrarch on Mt Venoux: *Epist. Fam.* IV, 1: to what extent this letter is a 'literary exercise' is still the subject of debate. Pius II in Scotland: *Commentaries,* Bk. I.

The change from qualitative to quantitative scientific thinking may have been hastened by two kinds of experience special to Florence. One is dyeing: a change in redness, say, being directly proportionate to the quantity of madder added to the vat. The other is familiarity with alum. No laboratory substance yields large crystals so readily as alum. They tend to be octahedral, an octahedron being one of the 'regular' or 'Platonic' bodies, all the sides and all the angles of which are equal. C. Singer, *The Earliest Chemical Industry* (London 1948), pp. 293–7.

Most of the facts and relevant documents concerning Toscanelli are to be found in Gustavo Uzielli, *La Vita e i Tempi di Paolo dal Pozzo Toscanelli* (Rome 1894). Also the section on Toscanelli in E. Garin, *La cultura filosofica del Rinascimento Italiano* (Florence 1961), pp. 313–34.

The work by Toscanelli on the comet of 1456, which Lynn Thorndike could not find and believed to be missing, is now in BN Banco Rari 30.

Contemporary opinion of comets is exemplified by Becchi in his *De Cometa* (1456) (BN classe xi, cod. 40). In the section *'De multiplici aeris impressione'*, after quoting classical writers on the nature of a comet, including Anaxagoras, Pythagoras and Aristotle, he presents the views of Albertus Magnus and Arab writers. Some writers say comets portend battles, because they inflame the air, and hence men's spirits. They may portend the death of princes, since princes are more delicate than other men. Becchi adds that a comet does not interfere with the freedom of the will: *'astra inclinant sed non cogunt.'* He compares a comet to a ring round the moon, cloud, fog, dew, snow, hail—all are 'impressions on the air'.

Copernicus writes in the preface to his *Revolutions of the Heavenly Spheres* (1543): 'I took on myself the task of re-reading the books of all the philosophers that I could get hold of, to find out if any ever held any opinion about the movements of the heavenly spheres other than the opinion held by those who teach mathematics in the Schools. And first I found in Cicero that Nicetas [a slip for Hicetas] thought that the earth moved. Afterwards I found some others in Plutarch who were of the same opinion . . . As a result, I too began to think about the possibility of the movement of the earth.' Copernicus found the views of Heracleides and Ecphantus in Plutarch's original, for he quotes in Greek, not as is sometimes said through the intermediary of Valla, *De expetendis et fugiendis rebus.* W. Oakeshott,

'Classical and Medieval Ideas in Renaissance Cosmography', in *Fritz Saxl: Memorial Essays* (London 1957).

'Philosophy is written in that great book which ever lies before our eyes—I mean the universe—but we cannot understand it if we do not first learn the language and grasp the symbols in which it is written. This book is written in the mathematical language, and the symbols are triangles, circles, and other geometrical figures, without whose help it is impossible to comprehend a single word of it . . .' Galileo, *Opere* (Florence 1842) IV, p. 171.

Pierre d'Ailly, a Chancellor of the Sorbonne, is credited with 174 books or treatises. His astrological views and predictions are given in his *Second Apologetic Defence of Astrology*, dated 3 October 1414.

Ficino's astrological warning to Lorenzo: letter dated 26 September 1480.

Petrarch records his experience with the astrologer in *Sen.* III, 1.

The story about Angelo, Bishop of Arezzo, is told by the lawyer Benedetto Aretino, arguing with Niccolò di Foligno, in Poggio, *Historiae convivales disceptativae.*

Lorenzo's circle is sometimes represented as living in a dream world, but the evidence points the other way. Ficino, for example, wrote a *Consiglio contro la peste* in 1479 (BN classe xv, cod. 89), and it was not a professional philosopher but the most famous physician of the day who requested from Lorenzo a loan of Proclus's commentary on the *Cratylus*. Letter dated 19 August 1491. MAP filza lx, no. 46. The translation in Ross, pp. 326–7, is faulty. Again, Poliziano's *Panepistemon* is a valuable hard-headed classification of all the sciences then known; of its author V. Rossi writes in *Il Quattrocento* (Milan 1933), p. 381: '*Noi lo diciamo filologo, e per questo titolo gli assegniamo nella storia della scienza un posto non meno cospicuo di quello ch'egli ha nella storia dell'arte.*'

The magic remedy for Lorenzo's gout was prescribed in a letter to Lorenzo from Petrus Bonus Avogarius, doctor of arts and medicine in Ferrara, dated 11 February 1488 (1489): Ross, pp. 301–2.

Pier Leone, according to Giovio, *Elogia doctorum virorum* (Basel 1556), was the first to go back to Greek sources, instead of knowing the Greeks through the Arabs. He treated a lady in the Medici household, one madonna Aurante, as early as 1477. His works in the Vatican Library, according to Fabroni, include a *Tractatus de Urinis*, *Commentarii in Galenum*, and *Commentariorum de Rebus Mathematicis*. He was Professor of Medicine, *theorice vel pratice*, at Pisa 1475–7 and 1482–7. By contrast, Coluccio's *Tractatus de nobilitate legum et medicinae* (1399) illustrates a typical attitude to medicine at the beginning of the fifteenth century. Coluccio says it is repulsive to inspect the viscera 'and whatever diligent nature has no less curiously concealed than constructed,—all which so far departs from humanity that one cannot even hear of it without a certain horror, and I do not see how the caverns of the human body can be viewed without effusion of tears.'

Antonio Benivieni of Florence (*ca* 1440–1502) composed a Rule of Health for

Lorenzo, whose father and grandfather had helped pay for his studies. His book, *On some hidden and marvellous causes of sickness and healing*, completed some time after 1496, is an original work which breaks free from Galen and Avicenna.

Leonardo's writings on anatomy are conveniently found in E. Belt, '*Les Dissections anatomiques de Léonard de Vinci*', in *Léonard de Vinci et l'expérience scientifique au XVIe siècle*, Colloques Internationaux du Centre de la Recherche Scientifique, Sciences Humaines (Paris 1953), pp. 199*ff*.

Leonardo's method of fusing details observed at various times into a single drawing is similar to the method of the poet and indeed of most artists. He justifies it as follows: 'And you, who say that it would be better to watch an anatomist at work than to see these drawings, you would be right, if it were possible to observe all the things which are demonstrated in such drawings in a single figure, in which you, with all your cleverness, will not see nor obtain knowledge of more than some few veins, to obtain a true and perfect knowledge of which I have dissected more than ten human bodies . . .' J. P. Richter, *The Literary Works of Leonardo da Vinci* (London 1939) II, p. 796.

Toscanelli and Martins may have met through their mutual friend Nicholas of Cusa, whose will they witnessed in the archbishop's palace, Todi, in 1464.

For Columbus I have drawn on the Hakluyt Society editions of his letters and log-book. Also S. E. Morison, *Christopher Columbus, Admiral of the Ocean Sea* (London 1942) and, for his debt to the classics, S. de Madariaga, *Christopher Columbus* (London 1949).

Columbus's experience in Galway takes the form of a note to his copy of Pius II's *Historia*.

Toscanelli's letters to Martins and Columbus: in *The Journal of Christopher Columbus*, trans. C. R. Markham for the Hakluyt Society (London 1893). The reconstruction of Toscanelli's map is taken from the same work.

The missionary motive. Columbus's language in the preface to his Journal of the First Voyage echoes Toscanelli's in his letter to Martins: 'the information that I had given to Your Highnesses concerning the lands of India, and of a prince who is called "Grand Khan" which is to say in our vernacular "King of Kings", how many times he and his ancestors had sent to Rome to seek doctors in our Holy Faith to instruct him therein . . .'

Vespucci and his voyages: *Letters of Amerigo Vespucci*, ed. C. R. Markham (London 1894); '*Una lettera inedita di Amerigo Vespucci sopra il suo terzo viaggio*', ASI xcv (1937).

Chapter 8: The Rise of the Artist (pp. 165–89)

General works: G. Gaye, *Carteggio inedito d'artisti dei secoli XIV, XV, XVI* (Florence 1839–40); G. Vasari, *Le vite de' più eccellenti pittori, scrittori ed architettori*, ed. G.

Milanesi (Florence 1878–1906); F. Antal, *Florentine Painting and its Social Background* (London 1948).

A note about my use of Vasari in this and the two next chapters. Despite his faulty dating and occasional blunders, he remains our fullest authority for *Quattrocento* art. Unless they conflict with better evidence, I see no good reason to distrust his anecdotes, for in a small community men are remembered in terms of eccentricities, *burle* and revealing stories, while dates of birth and of particular works are ignored or forgotten. From all we know of him Vasari was not the man to invent anecdote, nor would uncharacteristic anecdote have passed muster with the Florentines, always so critical. As his latest translator has said, Vasari's accuracy on this, that or the other point is often impugned by one scholar only to be vindicated by another: recently for example by L. D. Ettlinger, *The Sistine Chapel before Michelangelo* (Oxford 1965), p. 30: 'Our analysis of the working procedure in conjunction with the extant documents corroborates Vasari's assertion that Signorelli did take a share in decorating the [Sistine] Chapel.' On the previous page the truth of Vasari's anecdotes about Cosimo Rosselli is said to be borne out by an extant contract.

Although in the fourteenth century painters had sometimes been numbered in royal households, they ranked with fools and minstrels, barbers and other servants.

In Ghiberti's contract with the guild of bankers concerning the St Matthew statue for Orsanmichele in 1410 it was stated that the work had to be carried out 'in chel modo et forma che sia di loro piacere [the guild consuls]'. Gualandi, *Memorie originali italiane risguardanti le Belle Arti* (Bologna 1845).

Brunelleschi: the Lives by Vasari; and by A. Manetti, ed. E. Toesca (Florence 1927). His construction of the dome: Cesare Guasti, *La Cupola di Santa Maria del Fiore illustrata* (Florence 1887); F. D. Prager, 'Brunelleschi's Inventions and the Renewal of Roman Masonry Work', *Osiris* ix (1950).

Brunelleschi and the *burla*: A. Manetti, *Operette Istoriche*, ed. G. Milanesi (Florence 1887).

'Inventor' is used in the sense of discoverer by Cicero, in the *De Natura Deorum*: '*Aristaeus, qui olivae dicitur inventor*', and by Quintilian: '*Artes inventoribus afferunt laudem.*' Its medieval meaning as 'delator' is found in *Libert. Florent. ann. 1358*, vol. 8.

For Francesco di Marco Datini and his garden, Iris Origo, *The Merchant of Prato* (London 1957), p. 66.

Esteem for artists and their earnings: Pliny, *Natural History* vii, 126.

The Medici and their relations with artists: E. H. Gombrich, 'The Early Medici as Patron of Art', *Italian Renaissance Studies*, ed. E. F. Jacob (London 1960), pp. 279–311.

Apelles and Pankaste: Pliny, *Natural History* xxxv, 36.

When Domenico Veneziano wrote to Piero de' Medici in 1438, he used the servile language evidently expected of Venetian painters: 'In my low condition it

is not for me to address your Excellency'—a far cry from the Florentine Gozzoli who called Piero 'Amico mio singholarissimo'.

Piero's preference for youth and richness emerges in correspondence to him or his brother. Matteo de' Pasti's letter to Piero from Venice in 1441 continues: 'I have got the instructions for the Triumph of Fame but I do not know if you want the sitting woman in a simple dress or in a cloak as I would like her to be. The rest I know: there are to be four elephants pulling her chariot; but please tell me if you want only young men and ladies in her train or also famous old men.' In 1448 the Medici agent Fruoxino wrote from Bruges that he would have bought a tapestry of Narcissus 'if it had been of somewhat richer workmanship'. E. H. Gombrich, 'The Early Medici as Patrons of Art', in *Italian Renaissance Studies* (London 1960), p. 298.

Lucrezia's *Tobias*: I have consulted proofs of the unpublished edition of her *Poesie*, by H. Diller (Hamburg 1936), in the library of the Warburg Institute. '*Dalla celeste compagnia guidato, E 'l gial chan suo, come partir lo vede*'—ch. 5, ll. 35–6.

Lorenzo as art patron and collector: André Chastel, *Art et Humanisme au temps de Laurent le Magnifique* (Paris 1959), and A. Morassi, *Il Tesoro dei Medici* (Milan 1963). Lorenzo's successful efforts to revive the art of intaglio carving are described by Vasari, in his 'Life of Valerio Vicentino'.

'*Stette da giovane col Magnifico Lorenzo de' Medici; et dandoli provvisione per se il faceva lavorare nel giardino sulla piaza di San Marcho di Firenze . . .*' *Codice del-l'Anonimo Gaddiano*. Leonardo signed his contract for *The Virgin of the Rocks* at Milan on 25 April 1483. 'At the age of thirty', according to the *Anonimo Gaddiano*, 'Leonardo was sent by the same Lorenzo with Atalante Miglioretti, to take a lyre to the Duke of Milan, for he played this instrument exceptionally well.'

'*Quae scribimus, ea non nobis, sed humanitati scribimus.*' L. B. Alberti, *Opera inedita* (Florence 1890), p. 293.

Chapter 9: Sculpture and Architecture (pp. 190–211)

General sources: L. Ghiberti, *I Commentari*, ed. O. Morisani (Naples 1947), Vasari's Lives of Donatello and Brunelleschi; Vitruvius, *De architectura*; L. B. Alberti, *Ten Books on Architecture* (London 1955). I am much indebted to Kenneth Clark, *The Nude* (London 1956), but I consider Maitani's Eve not as derived from a nereid shape but as a more sensitive handling of the usual Eve posture, to be seen, for example, in Piero di Puccio's Campo Santo fresco.

'The Spinario', one of the few antique bronzes which survived the Middle Ages above ground, was probably in the Lateran cloisters at the time of Donatello's visit to Rome.

The anecdote of the two crucifixes comes from Vasari's 'Life of Donatello'. I am indebted to Mr George Bull, from whose translation I have quoted: Vasari, *The Lives of the Artists* (London 1965), p. 176.

The figure of Michelangelo's *Crucifix* originally wore a loincloth, the position of which was clearly visible when the overpaint was taken away during restoration. For this and the point relating to the inscription I am indebted to a letter from Dr Margrit Lisner, who discovered the *Crucifix*.

The proportions of S. Spirito: N. Pevsner, *An Outline of European Architecture* (London 1948), pp. 80–2.

The puzzling frieze at Poggio I take to be a representation of the good life, from the time of a man's creation until his arrival in Paradise, conceived in terms of Etruscan and Roman mythology, but with concious allusion throughout to Christian iconography. The scenes of war yielding to scenes of agriculture (peace) and the prominence of the temple of Janus would have been intended to evoke Lorenzo's role as peacemaker (Lorenzo's birthday was 1 January, chief festival of Janus). Chastel's view (in *Art et Humanisme au temps de Laurent le Magnifique*) that Janus is here 'a kind of regulator of time' seems to me unacceptable.

Georgina Masson, *Italian Gardens* (London 1961), chs. 2 and 3, describes Florentine gardens and their basis in geometry.

Even capital letters were fashioned according to a geometrical method, according to a booklet written by Felice Feliciano of Verona before 1481. 'The letter D is taken from the circle and a square. The straight limb must be one-ninth part thick between the crossings [of the circle and diagonals]. The body is thickened as in the other curves. The connecting portion at the top must be one-third as thick as the thick limb; that at the bottom a fourth more than a third.'

Town-planning: *Filarete's Treatise on Architecture*, trans. John R. Spencer (New Haven and London 1965). The caryatids of the Temple of Virtù are illustrated in Book xviii, f. 149r. A notable feature of this temple is its hemispherical dome.

Chapter 10: Painting (pp. 212–39)

Fear was an important ingredient of the Byzantine artistic tradition. Agathias (*ca* 536–82) praises a painting of the Archangel Michael: 'Imprinting the ikon within himself the spectator fears Him as if He were present.' G. Mathew, *Byzantine Aesthetics* (London 1963), p. 78.

Cross-sections through the human head: Piero della Francesca, *De prospectiva pingendi*, ed. G. Nicco Fasola (Florence 1942).

At least three members of the Academy—Lorenzo, Cristoforo Landino and the poet Nesi—belonged to the Company of the Magi Kings, a confraternity that met in the Medici church of S. Lorenzo.

Leonardo's recommendation to avoid compositions that are too finished and paralyse movement of the mind, *moto mentale*: *Trattato*, ed. A. P. McMahon (Princeton 1956), §261.

The description of the *Calumny of Apelles* is in Lucian, *De Calumnia* 5. The

metamorphoses of Lucian's text are given by Erwin Panofsky, *Studies in Iconology* (New York 1962), p. 158n.

The significance attached to pagan deities in the Middle Ages: Jean Seznec, *La Survivance des Dieux Antiques* (London 1940).

Boccaccio devotes Chapter 22 of his *De claris mulieribus* to Deianira. He sees Hercules's death as a vindication of Nessus's, but otherwise draws no moral.

Metamorphosis was one of the basic concepts of the Platonic Academy and appears in Lorenzo's poem *Ambra*. The nymph Ambra, pursued by the River Ombrone, prays to Diana to be saved, and is turned into stone. Poliziano's *Giostra* tells of Giuliano following through the forest a white hind, who turns into a nymph, Simonetta.

Ovid's account of Daphne is in *Metamorphoses* I, 452–567.

The medieval interpretation of the Daphne myth had been much more specifically Christian. Daughter of a river and cold by temperament, Daphne represents virginity; she is changed into a laurel, which like virginity is perpetually green and bears no fruit. She represents the Virgin Mary, loved by him who is the true sun; and when Apollo crowns himself with the laurel, he represents God putting on the body of her whom he made his mother. *Ovide Moralisé*, ed. C. de Boer, in *Verhandelingen der Koninklijke Akademie van Wetenschapen te Amsterdam* xv (Amsterdam 1915), p. 56. The same author sees in Syrinx '*Ces delis vains et variables, Qui sont faintis et decevables*', *op. cit.* p. 148. Deianira signifies the soul carried away by the devil: xxx, pp. 229–33. With their fuller understanding of pagan religion, the Florentines moved away from specifically Christian interpretations to a moral reading in harmony with Christianity. This is seen, for example, in Piero di Cosimo's *Death of Procris*, probably based on the play *Cefalo* produced in 1487, where the myth is interpreted as a warning against jealousy between husband and wife. Irving Lavin, 'Cephalus and Procris' in JWCI xvii (1954).

Ovid's account of Syrinx is in *Metamorphoses* I, 689–712.

Servius on Ec. II, 31 says that Pan is the god of 'all' nature: hence his horns like the rays of the sun and the horns of the moon, his seven-reed pipe, corresponding to the seven notes of the heavens, etc. He is described by the poets as being conquered by Love: Ec. x, 69: '*omnia vincit Amor.*' *Servius Grammatici . . . In Vergilii Bucolica et Georgica Commintarii*, ed. Gl. Thilo (Leipzig 1887), p. 23.

Botticelli's dream about marriage is given by Poliziano. *Tagebuch*, no. 197.

Botticelli's consistent beautifying of his subjects followed logically from the Academy's notion of the artist as one who loves. '[Lovers] do not see the loved one in his true image received through the senses, but they see him in an image already remade by the soul according to the likeness of its own Idea, an image which is more beautiful than the body itself.' Ficino, *Commentary on the Symposium* VI, 6.

Botticelli's picture of Vulcan at Spedaletti is described by Vasari in his 'Life of Ghirlandaio'. André Chastel dates it to 1484–5: *Art et Humanisme au temps de Laurent le Magnifique* (Paris 1959), p. 171.

Venus, when in conjunction with Mars ...' M. Ficino, *Commentary on Plato's Symposium* (Columbia, Miss. 1944), pp. 176-7. Quoted by E. H. Gombrich, 'Botticelli's Mythologies', JWCI viii (1945).

The efficacy of magic images: M. Ficino, *De Vita* III, 17, 18.

'If the soul is the mother of Love, then Venus is identical with the soul, and Amor is the soul's energy.' Ficino, explaining Plotinus, *Enneads* III, v, 4.

In interpreting the *Primavera* I have followed, with modifications, E. Wind, *Pagan Mysteries in the Renaissance* (London 1958), pp. 100-10. One cannot be absolutely certain that Botticelli intends Venus to be with child, since Florentine fashion at that time called for a very high waist-line and flared skirt. As regards the nine figures, Dante of course considered nine a perfect number; but now numerical allegory has become only one small strand in a rich complex of meanings.

'And if we assert that the Word of God was born of God in a peculiar manner, different from ordinary generation, let this, as said above, be no extraordinary thing to you, who say that Mercury is the angelic word of God ... And if we even affirm that He was born of a virgin, accept this in common with what you accept of Perseus.' Justin, *First Apology*, ch. xxii.

The symbolism of Noah being clothed is expressed somewhat differently in one of Lorenzo's *Laudi*:

> *Quest'è quel Noè santo,*
> *che'l vin dell'uva prieme:*
> *inebriato tanto,*
> *sta scoperto e non teme:*
> *allor Cam, quel mal seme,*
> *si ride, e' due ricuopron suo onore.*

> *E così nudo in croce*
> *Gesú, d'amore acceso,*
> *non cura scherni o voce*
> *di chi l'ha vilipeso;*
> *poi Nicodemo ha preso*
> *e involto in panni il dolce Salvatore.*

Pliny's description of the *Aphrodite Anadyomene* is in *Natural History* xxxv, 91, a passage which inspired several poems by Poliziano.

Venus depicted with myrtle and a dove: Filarete, *op. cit.* Bk. xviii, f. 148r.

Chapter 11: Magnificent Lorenzo (pp. 240-67)

General Sources: A. Fabroni, *Laurentii Medicis Magnifici vita* (Pisa 1784), G. Pieraccini, *La Stirpe de' Medici di Cafaggiolo*, vol. 1 (Florence 1924), and A. von Reumont, *Lorenzo de' Medici* (London 1876).

Lorenzo is described by Ficino in typically trinitarian terms: '*Tres illas gratias ...*

quae ab Orpheo describuntur, scilicet splendorem, laetitiam, viriditatem; splendorem, inquam, mentis, laetitiam voluntatis, viriditatem corporis et fortunae. Aspirant jam ex alto hae Gratiae Laurentio.' Ficino, p. 622.

The list of hounds names' in Lorenzo's '*Caccia col falcone*' is evidently modelled on Ovid, *Metamorphoses* III, 206–25.

Lorenzo's musical gifts: '*Io ho a le volte udito il magnanimo Lorenzo de' Medici nostro cantare al suon della lira certe cose molto simili a queste [laudi], invitato come penso da un divin furore*'. Ficino to Bernardo Rucellai. A. della Torre, *op. cit.*, p. 792.

Giannozzo Manetti wrote his treatise in reply to Innocent III's gloomy *De contemptu mundi*. By contrast with Manetti's book, a Ligurian living in Naples, Bartolommeo Fazio, about the same time wrote a book with the same title in which he claims that man's excellence lies only in the fact that he is destined for the beatific vision.

Lucrezia's letter to Piero describing Clarice is dated 21 March 1467: Ross, pp. 108–9.

The effects of Lorenzo's love-affairs: '*fu libidinoso, e tutto venereo e constante negli amori sue, che duravano parecchi anni; la quale cosa, a giudicio di molti, gli indebolì tanto il corpo, che lo fece morire, si può dire, giovane.*' Guicciardini, *Storia Fiorentina* (Florence 1859), p. 88.

Lorenzo's generosity in buying books: Poliziano, *Epist.* II, vii. His collecting of manuscripts: Giovanni Lascaris, preface to his *Greek Anthology*.

The balance of payments difficulty: R. de Roover, *The Rise and Decline of the Medici Bank* (Cambridge, Mass., 1963), pp. 373–5.

Aristotle's definition of the virtue of μεγαλοπρέπεια: *Nicomachean Ethics*, 1122a18ff. Also *Eudemian Ethics*, 1233a31ff.

Lorenzo's praise of the active life is most easily available in E. Garin's selection, *Testi inediti e rari di Cristoforo Landino e Francesco Filelfo* (Florence 1949).

'*Secol si rinova*'—*Purg.* xxii, 70. Virgil's Eclogue iv: *Magnus ab integro saeculorum nascitur ordo Jam redit et virgo, redunt Saturnia regna; Jam nova progenies caelo demittitur alto*. The lines may be an indirect imitation of Isaiah, for the Jews of Alexandria wrote a number of Sibylline verses largely based on Scripture, which they put into the mouths of the Sibyls.

The growth in papal pretensions can be gauged by the richness of that non-liturgical ornament, the tiara. Eugenius's tiara, made by Ghiberti, contained jewels worth 38,000 ducats; that of Paul II had jewels worth 120,000 ducats.

The Pazzi plot: A. Poliziano, *Conjurationis Pactianae anni MCCCCLXXVIII Commentarium*, ed. I. Adimari (Naples 1769), contains most of the relevant documents, including eyewitness reports.

Lorenzo's letter to Louis XI, 19 June 1478: Ross, pp. 198–9.

Lorenzo's arguments from history in favour of peace: Niccolò Valori, *Laurentii Medicei vita* (Florence 1756), p. 34.

Carafa thanks Lorenzo for the horse's head in a letter dated 12 July 1471. MAP

xxvii, 386. Other letters to Lorenzo thanking him for favours or recommending friends are dated January 1471 (xxvii, 5); April 1473 (xxix, 260), 2 June 1473, opening '*Magnifice domine et frater*' (xxix, 408), 28 February 1476 (xxxiii, 134), and 22 November 1476 (xxxiii, 964).

Francesco Sforza's twenty-four-year-old daughter, Ippolita Maria, who had married Ferrante's son Alfonso, may also have aided Lorenzo. She spoke good Latin, liked reading, hunting and dancing, and had a reputation for 'incredible modesty'. In 1474 she had asked Lorenzo for a loan of 2,000 ducats.

The marriage contract between Maddalena de' Medici and Franceschetto Cibo was signed on 20 January 1488. The Pope gave the couple jewels worth 10,000 ducats, and Lorenzo's dowry to Maddalena amounted to 4,000 ducats, part in cash, part in State bonds, but from a letter of Lorenzo to Lanfredini, dated 8 August 1488, it seems this sum was not ready at the time of the wedding: 'You know how many holes I have to fill up.' Reumont, *op. cit.* II, pp. 279–80.

Lorenzo's letter of condolence to Pope Innocent (on his gout!) is dated 1489: in *Lettere di Lorenzo il Magnifico al Sommo Pontefice Innocenzo VIII* (Florence 1830); Ross pp. 306–8.

A letter of Lorenzo to Alamanni, 17 May 1491, speaks of sending flasks of Casentino wine and pink cloth to the Pope, while another from Alamanni to Lorenzo dated 14 October 1491 says that the Pope has decided to make an agreement with the King of Naples, and would much rather the matter were conducted by the Florentines than by anyone else. *Catalogue of the Medici Archives*, compiled by Christie, Manson and Woods (London 1919).

Largesse after Cardinal de' Medici's consecration: Benedetto Dei, *Memorie storiche*, c. 12v. In Maria Pisani, *Un Avventuriero del Quattrocento* (Florence 1923), p. 60.

At the height of Lorenzo's period of influence a positive mania developed for turning everything into art. Domenico Ghirlandaio confided to his brother: 'A pity no one has commissioned me to paint stories the whole way round the city walls.' In 1491 Lionardo Balducci turned a work on the heavens into 186 stanzas: *La sfera di f: Lionardo di Stagio DATI in ottava rima colle figure* (BN classe XI, cod. 83). Dati's work is based on John of Holywood's *Sphere*. Cf. Mascarille in *Les Précieuses Ridicules*: '*Je travaille à mettre en madrigaux toute l'Histoire romaine.*'

Rebirth of time and a golden age: Ficino to Giovanni Unghero: '*La divina provvidenza ha ordinato che le cose antiche si rinnovino*', and to Giacomo Antiquario, secretary to the Duke of Milan: '*E che altro esser pensiamo le cose antiche rinnovare, che que' secoli d'oro far ritornare che allor che Saturno regnava così felici erano?*' E. Barfucci, *Lorenzo de' Medici e la Società artistica del suo tempo* (Florence 1945), p. 76.

In 1477 or 1478 Lorenzo secured from Piero Filippo Pandolfini, lord of Piombino, the entire output of Elba iron ore for a lump sum of 15,000 ducats. This contract apparently never went into effect or was not renewed because in 1489

Lorenzo made another effort to gain control of iron. This was successful, and the iron venture yielded handsome profits. R. de Roover, *op. cit.*, p. 165.

Lorenzo's so-called stealing from the *Monte* has been shown by L. F. Marks to have been sanctioned by the appropriate Government bodies. He cites *Deliberazioni dei XVII riformatori . . .1481–2*, cc. 72v and 80. L. F. Marks 'La crisi finanziaria a Firenze dal 1494 al 1502', ASI cxii (1954).

Lorenzo's armed bodyguard is criticized by both Giucciardini and Cambi. It is impossible to assess exactly the extent of popular opposition to Lorenzo's régime, but those who make much of it forget how easy it was to remove an actual or potential tyrant much better armed than Lorenzo: the Duke of Athens, proclaimed *signore* for life in September 1342, had been expelled in July 1343 through a unified effort of all classes. The best documented book on the subject, N. Rubinstein, *The Government of Florence under the Medici*, makes clear that Lorenzo's 'power was considerably greater than that of Cosimo, but in no sense tyrannical. Recruited from the inner circle of the régime, the Seventy could safely be expected to use its extensive powers according to Lorenzo's wishes. Yet it would be wrong to consider the Seventy merely an instrument in his hands, and incapable of the opposition which the *Cento* had occasionally put up even after its reform.' p. 226.

Chapter 12: A Friar with Lightning (pp. 268–77)

The documents pertaining to Savonarola's youth are given in *Savonarola: Prediche e Scritti*, ed. Mario Ferrara (Florence 1952).

Savonarola's desire for quiet and freedom: sermon of 21 December 1494.

Savonarola's appearance and the essentials of his mission in Florence are described in notes by the Dominican Serafino Razzi. They appear as an appendix to *Prediche*, pp. 647–62.

Proposed suppression of the *palio*: *Prediche*, p. 201.

The dowry system also acted as a deterrent to marriage. In 1384 a prosperous merchant, Lapo Niccolini, was content to receive a dowry of 700 florins with his first bride, but when twenty years later he remarried he required 1,000 florins from his second, and in 1465 Alessandra Macinghi negli Strozzi, who was looking for a wife for her son, contemptuously wrote that 1,000 florins was a mere craftsman's dowry. Strozzi, p. 395.

'*I sodomiti ancora, che meritano d'essere arsi, voi magistrati, a chi si aspetta, non ne volete fare iustizia.*' *Prediche*, p. 248.

Savonarola's political reforms: sermon of 14 December 1494. Denunciation of the rule of the Ottimati: *Prediche*, p. 357.

Denunciation of Aristotle, Plato and Ovid: *Prediche*, pp. 400–1; verification by the light of nature: *Prediche*, p. 425; also: '*i filosofi e i savi di questo mondo, i quali dicono delle cose soprannaturali: Io non me ne impaccio, e vogliono ogni cosa vedere col lume naturale, e delle altre si fanno beffe.*' *Prediche*, p. 456.

Condemnation of Platonic love: sermon on Ezekiel xxviii, 78.

Baptismal names: J. Roussey, *Les prénoms dans quelques villes d'Italie à la fin du Moyen Age*. Unpublished Diplôme Etudes supérieurs (Algiers 1961), quoted J. Heers, *L'Occident aux XIV et XV Siècles* (Paris 1963).

'God renewed his Church...' '*Dissi ancora che Dio avendo rinnovata la chiesa e tutto il mondo per i semplici e pescatori, che così farà al presente...*' Prediche, p. 106.

The cutting of boys' hair is noted by Serafino Razzi: '*Che ciaschedun fanciullo... sarà semplice nel vestire secondo il grado suo, senza scarselle, e co' capelli tanto tagliati, che scuoprino l'orecchie.*' Prediche, p. 655.

Cardinal della Porta was championed by Lorenzo, who claimed that this 'conversion' could also result in 'some greater general devotion' for the College of Cardinals. His career is given by Cardella, *Memorie storiche de' Cardinali* (Rome 1793), III, pp. 231–3.

Botticelli made his woodcut, *Il trionfo della fede*, as an illustration to Domenico Benivieni, *Trattato in defensione e probazione della dottrina e profezie predicate da frate Ieronimo da Ferrara nella città di Firenze* (Florence 1496).

Chapter 13: Invasion (pp. 278–98)

The French claims on Naples and the invasion of 1494: H. F. Delaborde, *L'Expédition de Charles VIII en Italie* (Paris 1888), including original documents.

The temper of Florence in 1494 probably owed something to Ficino's overgenerous view of human nature. Whereas Bruni had recognized the existence of aggressive motives and, under the influence of Seneca's *De ira*, defended a 'noble rage' as a virtue, Ficino is less realistic. In order to explain Nero's cruelty, for instance, he is reduced to arguing that 'Nero was, so to speak, not a man, but a monster, being akin to man only by his skin. Had he really been a man, he would have loved other men as members of the same body.' Ficino, p. 635.

Piero's letters to his father: 16 April 1479 and 26 May 1479. Ross, pp. 216–18.

In February 1493 the Pope wished to come to an agreement whereby he would stand by Naples and the Duke of Gandia would receive a part of Neapolitan territory (Piero to his ambassador in Naples, Dionigi Pucci 24 February 1493, MAP filza cxxxviii, no. 244). In a letter to Dionigi Pucci, dated 21 May 1493 Piero says he does not wish to join an Italian league, lest he forfeit the King of France's friendship (MAP filza cxxxviii, no. 252). He first becomes aware that the King of France seriously intends invasion on 16 February 1493, when he writes to Dionigi saying the King of Naples must actively prepare (MAP filza cxxxviii, no. 248). On 29 May 1494, writing from Pisa, he says Florence has spent 100,000 ducats on defence, though the budget calls for only 60,000 (MAP filza cxxxviii, no. 250). On 17 June 1494 he is urging the King of Naples '*temptare virilmente questa experientia*', and promises to stand by him as '*procuratori alla salute dell' Italia*' (MAP filza cxxxviii, no. 243).

Charles VIII's entry into Florence: Landucci, p. 80; Burchard, *Diarium*, 17 November 1494 (ed. Thuasne II, pp. 195–8).

A notable feature of Savonarola's 'government by virtue' was his recommendation of loans to the commune free of interest: *Prediche*, p. 563.

Inevitably Savonarola's stern brand of Christianity resulted in anti-Semitism, an outbreak of which Lorenzo had checked shortly before the Dominican's arrival in Florence. In 1495 the Jews were expelled from Florence. They had been allowed to settle in 1430.

The new hopes were expressed by Giovanni Nesi, a disciple of Ficino and Savonarola, in his *Oraculum de novo saeculo* (1496): '*Ecce iam ad novum illud saeculum per varios casus divino te nomine voco: ecce iam per tot discrimina rerum ad auream illam aetatem excito . . . Roman ad interitum usque destruendam . . . Ecclesiam ab interitu divina ope vindicandam atque adeo illustrandam; Mahumetanos ad Christianam fidem adsciscendos. Ovile tandem omnium unum, pastorem unum.*'

Pope Alexander's presents to the Cardinals who had voted for him: Infessura, *Diarium*, 11 August 1492.

'*Un capello rosso, un cappello di sangue, questo solo desidera*': *Prediche*, p. 427.

Botticelli would have been familiar with both Lucretia and Virginia through Boccaccio's *De claris mulieribus*. Boccaccio says that Lucretia's suicide not only restored her honour but led to the liberty of Rome.

In interpreting *La Derelitta* I have followed E. Wind, 'The Subject of Botticelli's "Derelitta" '. JWCI iv (1940–1).

After Savonarola's death Ficino changed his allegiance and wrote, in the spring of 1499, *Apologia pro multis Florentinis ab antichristo Hieronymo ferrariense hypocritarum summo deceptis.*

Chapter 14: Aftermath (pp. 299–306)

Guicciardini's view of Lorenzo: *Storie fiorentine* (Bari 1931), pp. 73–82. Similarities of language suggest that he drew on Savonarola's heavily biased *Trattato circa il reggimento di Firenze*.

Quotations from *The Prince* are in George Bull's translation (London 1961).

The movement of classical learning and values from Italy to France and to England: Gilbert Highet, *The Classical Tradition* (Oxford 1949).

The letters of Charles VIII and his courtiers, and the Italian notes of his poet, André de la Vigne, are given in H. F. Delaborde, *L'Expédition de Charles VIII en Italie* (Paris 1888).

Charles ignored perhaps the finest work in Naples, an *Annunciation* by the Florentine Benedetto da Maiano, but was captivated by Guido Mazzoni of Modena's realistic *Pietà*, terra-cotta figures coloured to resemble bronze. He knighted Mazzoni, who was later to make the King's tomb, destroyed during the French Revolution.

Poggio's comments on the English: *Epist.* I, 70; 43; 74.

Florentine Platonism in England: E. Cassirer, *The Platonic Renaissance in England* (London 1953), ch. 1.

In his lectures on the Pauline Epistles Colet expressly mentions and copiously cites Ficino's *Theologia Platonica*. F. Seebohm, *The Oxford Reformers: John Colet, Erasmus and Thomas More* (London 1869), p. 39. P. A. Duhamel, 'The Oxford Lectures of John Colet', in *Journal of the History of Ideas* xiv (1953), perceptively illustrates the change in methods underlying Colet's fresh interpretations.

The quotation from Nashe: *Piers Penniless*, in *Works*, ed. A. Grosart (London 1883–5) II, p. 38.

Castiglione, in *The Courtier*, defends his suggestion that gentlemen should know how to draw: 'I remember having read that the ancients, especially throughout Greece, desired that noble children should be set to work at painting in the schools as a thing both wholesome, honest and necessary, and this occupation was afforded a high place among the liberal arts. For it was forbidden by public order that it should be taught to slaves.'

W. Segar, *The Booke of Honor and Armes* (London 1590), p. 34.

Appendix A: The Context of the Florentine Renaissance (pp. 309–14)

C. H. Haskins, *Studies in the History of Medieval Science* (Cambridge, Mass. 1924), and *The Renaissance of the Twelfth Century* (Cambridge, Mass. 1927).

W. K. Ferguson, *The Renaissance in Historical Thought* (Boston 1948); Dr Richard Hunt, in *The Flowering of the Middle Ages* (London 1966), p. 200.

In favour of the view that the Italian Renaissance was the period of decisive change *par excellence*: G. Sarton, 'The Quest for Truth: Scientific Progress during the Renaissance', in *The Renaissance: Six Essays* (New York 1962), p. 57; H. Baron, 'Franciscan Poverty and Civic Wealth', in *Speculum*, xiii (1938). Baron reaffirms his view of the Renaissance as a new phase of psychological and intellectual development in 'Towards a more positive evaluation of the fifteenth-century Renaissance' in *Journal of the History of Ideas* IV (1943). E. Panofsky, 'Artist, Scientist, Genius: Notes on the "Renaissance-Dämmerung"' in *The Renaissance: Six Essays* (New York 1962), p. 123.

Petrarch, *Epist. Fam.* VI, 4; J. Burckhardt, *The Civilization of the Renaissance in Italy*, trans. Middlemore (London 1890), pp. 141–2, 177–8, 300–1.

L. Venturi and R. Skira-Venturi, *Italian Painting: The Creators of the Renaissance* (Geneva 1950), p. 153.

A Short Table of Dates

1331	Birth of Coluccio Salutati
1374	Death of Petrarch
1390	Giangaleazzo of Milan declares war on Florence
1397	Emmanuel Chrysoloras Professor of Greek
1400	Florence blockaded. Plague and famine
1402	Death of Giangaleazzo and end of war with Milan
1403	Ghiberti commissioned for first Baptistery door
1406	Capture of Pisa: Florence gains access to the sea
1414	First sessions of Council of Constance
1416	Poggio discovers Quintillian's *Art of Oratory* and other classical MSS.
1417	Rinaldo degli Albizzi head of the ruling régime
1422	War with Milan, lasting intermittently until 1433
1422	Bruni's *Concerning a Citizen Army*
1423	Masaccio begins work in the Brancacci Chapel
1425	Ghiberti commissioned for second Baptistery door
1428	New university curriculum
1433	Cosimo exiled
1434	Cosimo recalled and Rinaldo exiled
1435	Alberti's *Treatise on Painting*
1436	Uccello's monument to Hawkwood. Completion of Brunelleschi's dome
1439	Council of Florence
1440	Valla's treatise on the Donation of Constantine
1444	Building starts on the Palazzo Medici
1445	Antonino consecrated archbishop
1454–5	Peace of Lodi between Florence, Milan, Venice and Naples
1459	Cosimo commissions Ficino to translate the works of Plato
1464	Cosimo dies. Piero de' Medici first citizen
1468	Toscanelli installs his gnomon
1469	Lorenzo and Giuliano de' Medici first citizens
1471	First book printed in Florence. Sixtus IV Pope
1473	Re-establishment of Pisa University
1474	Toscanelli proposes to Fernão Martins a western route to the Indies
1478	Pazzi conspiracy. War with Rome and Naples
1480	Peace. Establishment of Council of Seventy

1481 Leonardo's *Adoration of the Magi*
1484 Sixtus IV dies. Innocent VIII Pope
1486 Pico promulgates his 900 theses
1488 Lorenzo's Art School
1492 Lorenzo dies. Columbus's first voyage to the New World
1494 Charles VIII invades Italy and enters Florence
1495 Battle of Fornovo
1498 Execution of Savonarola
1500 Botticelli's *Nativity*
1514 Probable date of Machiavelli's *The Prince*
1530 Fall of Florence

Index

Abélard, Peter, 107, 326
Acciaiuoli, Agnolo, 69, 326
Acciaiuoli, Donato, 24, 69, 75, 327
Accolti, Benedetto, 245
Adrian IV, Pope, 124
Aeneas, 37, 42, 107, 140
Agatharcus, 213, 214
Agathias, 334
Agostino di Duccio, 31, 276
Ahasuerus, King, 296
Ailly, Pierre d', 145, 330
Alberti, Giannozzo, 326
Alberti, Leon Battista, 57, 87, 93, 94, 95, 97, 98, 100, 107, 137, 144, 175, 188, 189, 201, 204, 205, 207, 208, 209, 211, 215, 225, 226, 250, 305, 313, 325, 326, 333, 343
Alberto of Cremona, 117, 129
Albertus Magnus, 310, 329
Albizzi, Rinaldo degli, 65, 67–9, 74, 90, 325, 343
Alcuin, 310
Alexander the Great, 177, 233, 290
Alexander VI, Pope, 276, 289–91, 341
Alfonso I, King of Naples, 93, 96, 99, 120, 122
Alfonso II, King of Naples, 286, 338
Alidosi, Iacopo, 114
Ammianus Marcellinus, 50
Anaxagoras, 213, 329
Andrea del Castagno, 207, 218, 314, 315
Andrea di Firenze, 315
Angelico, Fra, 30, 104, 180, 219, 315
Anne, Duchess of Brittany, 278
Anselmo di Sanvitale, 117
Antonello da Messina, 314, 315

Antonino, S., 30, 31, 69, 73, 100, 105, 106, 109, 119, 130, 154, 324, 326, 343
Antonio di Mario, 116
Apelles, 17, 177, 225, 233, 270, 332, 334
Apicius, 50
Apollo, 133, 229, 232, 335
Apollodorus, 228
Appian, 272
Archimedes, 187, 247, 277
Argyropoulos, Giovanni, 69, 111, 240, 324
Aristides (rhetor), 45
Aristippus, 323
Aristotle, 53, 63, 81, 87, 102, 110, 111, 127, 131, 138, 140, 143, 153, 210, 249, 250, 272, 273, 309, 310, 324, 327, 329, 337, 339
Atti, Isotta degli, 107
Augustine, St, 60, 86, 105, 139, 145, 158

Baldovinetti, Alesso, 189, 219
Balducci, Lionardo, 338
Bandini, Bernardo, 257
Bardi, Giovanni, 24, 101
Bartoluccio, 192
Basil, St, 126, 127, 328
Beaufort, Cardinal, 51
Beaujeu, Anne de, 263
Beccadelli, Antonio, 57–8, 79
Becchi, Gentile, 240, 329
Bellincioni, Bernardo, 90
Bellini, Gentile, 72, 315
Bellini, Jacopo, 224, 315
Benci, Donato, 246
Benci, Giovanni d'Amerigo, 101

22*

Petrarch, 38, 52, 54, 67, 86, 88, 89, 105, 113, 114, 139, 140, 145, 146, 189, 243, 288, 304, 309, 311, 321, 323, 327, 329, 330, 342, 343
Petrucci, Cesare, 256
Petrucci, Pandolfo, 189
Philip of Macedon, 139
Philo Judaeus, 133
Philostratus, Flavius, 224, 225
Philostratus the Younger, 224, 225
Pico della Mirandola, Giovanni, 134, 135, 136, 137, 138, 145, 146, 147, 199, 201, 222, 235, 242, 247, 249, 265, 269, 275, 280, 289, 294, 296, 303, 304, 328, 329, 344
Piero della Francesca, 218, 219, 314, 317, 334
Piero di Cosimo, 263, 335
Pilatus, Leontius, 52
Pippin, King of the Franks, 124
Pisanello, 40, 217, 317
Pisano, Andrea, 190, 194
Pisano, Giovanni, 195, 317
Pisistratus, 247
Pitti, Luca, 207
Pius II, Pope, 73–4, 83, 93, 140, 148, 154, 155, 158, 161, 209, 324, 329, 331
Plato, 36, 52, 80, 86, 102, 110, 111, 127, 130–3, 135, 138, 141, 142, 143, 147, 151, 182, 183, 186, 187, 200, 203, 204, 205, 218, 220, 221, 223, 236, 244, 247, 250, 270, 272, 273, 275, 300, 304, 322, 327, 328, 339
Plautus, 38, 51
Pletho, Gemistos, 110, 127, 138, 153, 327
Pliny, 52, 113, 133, 148, 154, 177, 192, 233, 237, 321, 322, 324, 328, 332, 336
Pliny the Younger, 209
Plotinus, 183, 186
Plutarch, 53, 97, 144, 154, 187, 248, 329
Poliziano, Angelo Ambrogini il, 31, 91, 132, 148, 185, 187, 189, 199, 230, 237, 246, 247, 265, 275, 303, 304, 319, 330, 335, 336, 337

Pollaiuolo, Antonio, 17, 150, 181, 182, 189, 219, 222, 225, 226, 227, 228, 229, 257, 263, 294, 317
Pollaiuolo, Piero, 189
Polo, Marco, 153, 158, 159, 161, 162
Polyclitus, 198, 317
Pontano, Giovanni, 259
Pontelli, Baccio, 209
Porta, Cardinal Ardicino della, 277, 340
Portinari, Tommaso, 221
Priscian, 114
Ptolemy, 53, 143, 144, 150, 152, 153,
Polyclitus, 198, 317
Pontano, Giovanni, 259
Pontelli, Baccio, 209
Porta, Cardinal Ardicino della, 67, 277, 340
Portinari, Tommaso, 221
Priscian, 114
Ptolemy, 53, 143, 144, 150, 152, 153, 154–6, 160, 162, 306, 310
Pucci, Dionigi, 340
Puccio, Piero di, 195, 317, 333
Pulci, Luigi, 79, 161, 242, 248, 274, 280
Pythagoras, 141, 187, 329

Quintilian, 50, 54, 59, 92, 116, 120, 121, 176, 193, 322, 332, 343

Raleigh, Sir Walter, 306
Raphael, Archangel, 181, 182
Raphael Sanzio, 206, 317
Razzi, Serafino, 339, 340
Riario, Girolamo, 253, 254, 255, 261, 296
Riario, Piero, 251, 252, 253, 254
Riario, Raffaello, 254, 255, 256
Ricci, Antonio, 100
Ricci, Leonardo, 100
Ridolfi, Antonio, 255
Riquinus of Magdeburg, 194, 317
Robbia, Luca della, 17, 31, 170, 189, 200, 201, 255, 317
Robert I, King of Naples, 321